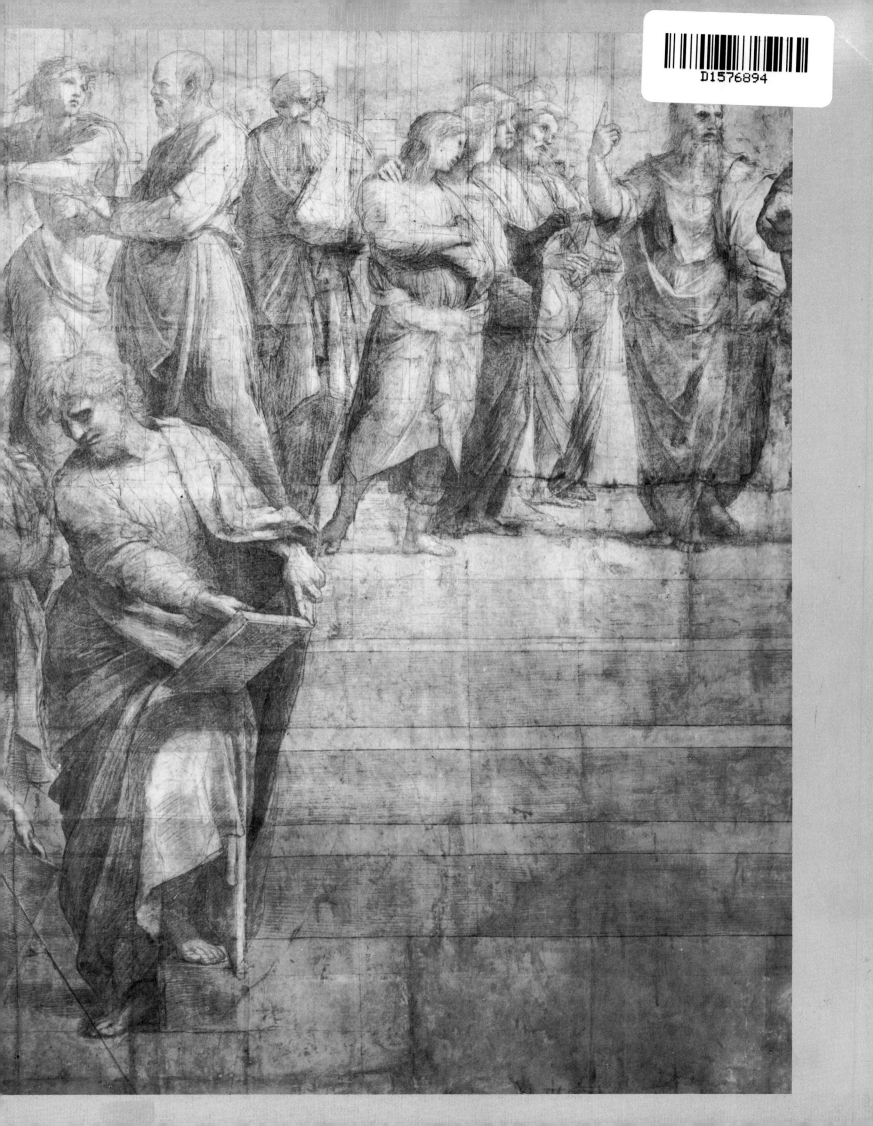

D1576894

PHL

54060000061035

THE DRAWINGS OF
RAPHAEL

THE
PAUL HAMLYN
LIBRARY

DONATED BY
THE PAUL HAMLYN
FOUNDATION
TO THE
BRITISH MUSEUM

opened December 2000

WITHDRAWN

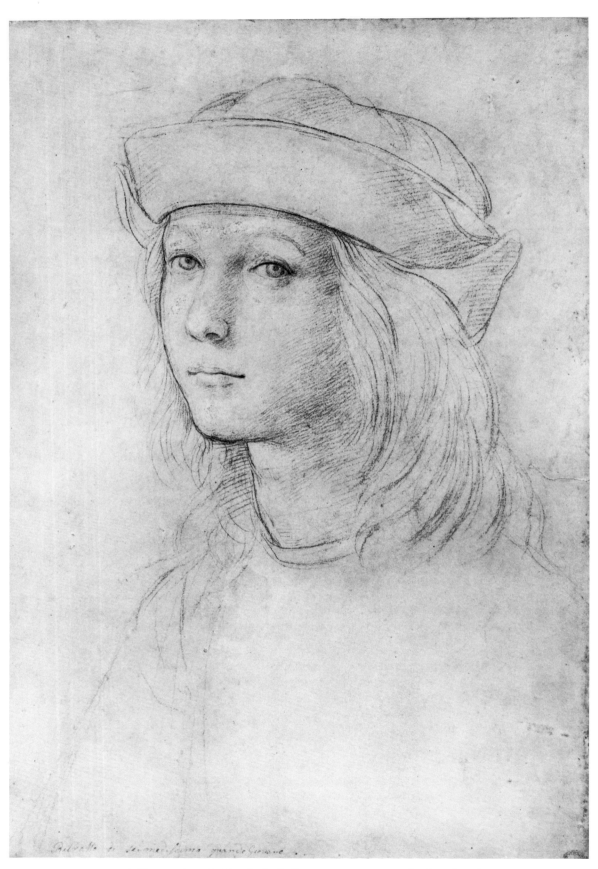

FRONTISPIECE: *Self-portrait, c.* 1499. Black chalk. 380 × 260 mm. Oxford, Ashmolean Museum.

THE DRAWINGS OF
RAPHAEL

WITH A COMPLETE CATALOGUE

PAUL JOANNIDES

PHAIDON · OXFORD

Phaidon Press Limited, Littlegate House, St Ebbe's Street, Oxford

First published 1983

© Phaidon Press Limited 1983

All rights reserved. No part of this publication may be
reproduced, stored in a retrieval system, or transmitted in any
form or by any means, electronic, mechanical, photocopying,
recording or otherwise, without the prior permission of the
publishers.

British Library Cataloguing in Publication Data

Joannides, Paul
 The drawings of Raphael.
 1. Raphael—Criticism and interpretation
 I. Title II. Raphael
 741.945 ND623.R1

 ISBN 0-7148-2282-5

Set in Monophoto Apollo 645 and printed in Great Britain by
BAS Printers Limited, Over Wallop, Hampshire

ENDPAPERS: The cartoon for the *School of Athens*. 1510 (?),
charcoal, black chalk, and white heightening,
2800 × 8000 mm. Milan, Ambrosiana.
(Alinari: composite photograph)

Contents

To my mother and the memory of my father

More than any other Renaissance artist, Raphael resembles the greatest of the moderns: like Picasso he is never static. Again and again he develops a range of artistic possibilities sufficient to satisfy anyone else for a lifetime, exploits it for a few years and then turns to something new. No artist was ever more committed to his art; none was ever less so to any particular style or category of it. Raphael was a supremely intellectual artist and his role became increasingly that of a conceptualizer and an arbiter of taste in painting and architecture. By the time of his death he had established something of a monopoly among the most important patrons in the western world's most important artistic centre, Rome, and it was rumoured that the pope intended to make him a cardinal. There is no documentary confirmation, but the story is entirely believable, for the essential logic of Raphael's career was the career itself.

Raphael is one of the most influential of all western artists, and until the late nineteenth century was probably the most respected and best loved. Today he is less popular, and while various phases of his work have their devotees it is doubtful whether many admire the whole range. But since his drawings demonstrate his thought processes in the most immediate way, a book which concentrates on them may help to make his protean genius more accessible, for with the exception of his architectural work, for which very few drawings survive, most aspects of his paintings are reflected, and prepared for, in his drawings. Their stylistic variety is enormous: it would be very nearly true to say that Raphael never drew in the same way for more than a few months at a time, and his drawings make use of the full range of media available in early sixteenth-century Italy.

The introduction to the book attempts to provide a general account of Raphael's drawings in the context of his artistic production, discussing not only their varying functions, but also the artist's changes of style and the possible reasons for them. The plate section, focusing on particularly beautiful or significant drawings, is designed to complement the introduction. These parts of the book are primarily intended for the general reader. The third part, the catalogue, aims to make available between two covers Raphael's complete graphic *œuvre*, and will, I hope, interest both the general reader and the specialist.

In the course of my study of Raphael I have come into contact with many of the finest scholars in the field: to them I owe a great debt of thanks. As a student between 1966 and 1969 I was fortunate enough to attend lectures and classes given by three art historians eminently qualified to teach Raphael: Michael Jaffé, Konrad Oberhuber and John Shearman, all now professors. The first has published little

on Raphael, but my intellectual as well as personal debt to him is by far the greatest. From the teaching and the books and articles of the latter two scholars I have benefited more than I can say or judge; many of the views that I now think of as my own have been absorbed or developed from theirs.

I have incurred many other debts. The first in time is to my fellow-students, in particular Kirsten Dunthorne, Margaret Greeves, Deborah Howard, Ronald Parkinson, Ronald Ryer, David Sommerlad and Katia Tsiakma; to my own long-suffering pupils, whom I have plagued with the problems that plagued me, I can only apologize.

I have almost without exception encountered the greatest kindness from private collectors, and museum curators and officials, but I should like to thank particularly those who have shown generosity over and above the call of duty, although I am aware that in doing so I may simply be encouraging equally unscrupulous demands on their time and patience: Walter Antoni, Sylvie Béguin, Noelle Brown, David Blayney Brown, J. H. van Borssum-Buisman, Ulf Cederlof, Christian Clemm, Vincent Ducourau, Kenneth Garlick, Teriz Gerszi, Catherine Monbeig-Goguel, Richard Harprath, Amélie Lefébure, Christopher Lloyd, Borje Magnusson, Charlotte Miller, Henrietta McBurney, Giovanna Nepi Sciré, Annie Scottez, David Scrase, Alice Strobl, Anna-Maria Petrioli-Tofani, Françoise Viatte, Jon Whiteley, Reginald Williams. It is a great pleasure to thank others, in some cases colleagues and friends, in others benevolent strangers, who provided me with information, photographs and ideas: Noël Annesley, Adeline Cacan de Bissy, David Alan Brown, Malcolm Cormack, David Landau, Philip Pouncey, Francis Russell, Julien Stock and, particularly, Cecil Gould, from whose lectures and conversation I have benefitted greatly over several years.

I am also deeply grateful to Roseline Bacou, who gave up her valuable time to discuss with me some of the more problematic drawings of Raphael and his school preserved in the Cabinet des Dessins, and who bore with saintly patience my obstinate defence of positions I now recognize to be untenable – seeds that she planted have emerged into the light here. My debt to Sylvia Ferino Pagden is still greater. We have discussed subjects Raphaelesque for a number of years, particularly the early work of which her knowledge is unequalled. She has listened with great forbearance to the expression of wild opinions and has corrected me with charity and clarity. She has informed me of numerous discoveries before she herself published them and she has had the generosity not to object when my interpretation of her material differed from her own. But for her I should have missed, or failed to appreciate, the

following drawings: 1, 2, 13, 19, 20, 38, 39, 53, 57, 73, 96, 131.

In the later stages of my research I had the very good fortune to be able to study the collections at Oxford and Windsor in the company of John Gere and Nicholas Turner. I learned a great deal from them both and, as a result, made many changes to my catalogue; I also found working with them to the highest degree enjoyable. Both were kind enough to look through an earlier draft of this book and save me from a number of errors, as was Jane Shoaf; Nicholas Turner in particular knew when to be cruel was to be kind, and I shudder to think of the text before his critical acumen was brought to bear on it. I must, however, claim full credit for any errors that remain.

Finally I should like to thank my publishers who, from the beginning of the work, could not have been more helpful or supportive: Roger Sears, who initiated, and Simon Haviland, who oversaw the project; Peg Katritsky, who obtained many of the photographs; Marie Leahy, who X-rayed my ideas and performed plastic surgery on my prose with such dexterity that it was almost painless.

PAUL JOANNIDES
September 1982

Acknowledgements

The Publishers are grateful to all museums, institutions and private collectors who have give permission for the works of art in their possession to be reproduced. They have endeavoured to credit all known persons holding copyright or reproduction rights for the illustrations in this book. (References are to catalogue numbers.)

Berlin (West), Kupferstichkabinett, Staatliche Museen Preussicher Kulturbesitz, 30, 70, 71, 104, 326, 391, 403, 422; Cambridge, Mass., Courtesy of the Fogg Art Museum, Harvard University, 5 (Gift: The Honourable and Mrs Robert Woods Bliss), 194 (Bequest – Charles A. Loeser); Chatsworth, Devonshire Collection, Reproduced by Permission of the Chatsworth Settlement Trustees, 111, 176, 291, 311, 320, 362, 364, 380, 383, 398, 399, 409, 415, 419, 420, 424, 426, 434, 435, 440, 445, 455, 458; Cleveland, The Cleveland Museum of Art, 273 (Purchase from the J. H. Wade Fund); Dresden, Staatliche Kunstsammlungen Dresden, Kupferstichkabinett, 417; Frankfurt, Städelsches Kunstinstitut Frankfurt, 19, 37, 106, 205, 232, 255, 256, 282, 293, 313, 339, 452; Holkham, Norfolk, by courtesy of Viscount Coke, 123; London, British Architectural Library, R.I.B.A., 296; London, Reproduced by Courtesy of the Trustees of the British Museum, 7, 10, 35, 44, 50, 55, 66, 67, 79, 81, 85, 89, 97, 128, 130, 133, 139, 153, 180, 187, 188, 191, 204, 206, 209, 217, 235, 243, 249, 271, 275, 277, 281, 286, 287, 295, 302, 310, 433, 436, 446; London, Reproduced by courtesy of the Trustees, The National Gallery, 31; Los Angeles, The Armand Hammer Collection, 297 (photograph: Seth Joel); Munich, Staatliche Graphische Sammlung, Bayerische Staatsgemäldesammlungen, 192, 208, 348, 355; Naples, Soprintendenza ai Beni Artistici e Storici di Napoli, 344; New York, The Pierpont Morgan Library, 83 (I, 15), 361 (1977.45); Oxford, Christ Church, The Governing Body, 147, 164, 292; Paris, École nationale supérieure des Beaux-Arts, 126, 179; Paris, Musée du Louvre, Cabinet des Dessins, Fig. 9, Fig. 11, Fig. 14, 6, 18, 20, 22, 23, 39, 51, 60, 61, 93, 120, 125, 143, 152, 155, 160, 167, 175, 224, 226, 250, 254, 318, 330, 334, 335, 341, 347, 358, 360, 366, 370, 376, 389, 393, 404, 410, 412, 414, 427, 431, 439, 442, 448, 450, 454, 457; Salisbury, Wilton House, The Earl of Pembroke, 459; Vatican, Biblioteca Apostolica Vaticana, 145, 156, 157; Washington, National Gallery of Art, 119; Weimar, Staatliche Kunstsammlungen zu Weimar, 260; Windsor, Reproduced by Gracious Permission of Her Majesty The Queen, Fig. 1, Fig. 13, 49, 98, 103, 151, 189, 197, 200, 241, 248, 257, 288, 307, 308, 350, 357, 359, 363, 325, 408.

Particular acknowledgement is also made to the following for providing photographs: Alinari, Florence; A. C. Cooper Ltd. and The Courtauld Institute of Art, London; Bulloz, Giraudon and Musées Nationaux, Paris.

INTRODUCTION

1 Techniques

Shortly after Raphael's death, Sebastiano del Piombo, with Michelangelo's support, tried to obtain the commission to decorate the Sala di Costantino. Raphael's pupils, Giulio Romano and Giovanni Francesco Penni, fought to retain it, informing the pope that they had Raphael's designs for the scheme. They won. Raphael's drawings were seen to be central to his work.

The history of Raphael's drawings is that of his art as a whole. Most surviving drawings are functional, preparations for painting, their style an indication of intended pictorial effects. Drawings were to produce not only the right shapes, but also the right tones, volumes and textures. But drawings were also a means of storing and recording information about the visual world, and the world of art. Vasari states that Raphael corresponded with draughtsmen throughout the Mediterranean, and he himself must have copied extensively antique art and architecture and the work of other artists, and he no doubt made books of landscape and cityscape drawings – almost all of which have been lost. The Venice sketchbook, once attributed to Raphael but probably by an artist closely associated with him c. 1500–6, reflects the type of compilation that he certainly made. His surviving drawings can only be a small proportion of the thousands he must have produced, perhaps no more than ten per cent.

Raphael lived at a turning-point in the history of Italian draughtsmanship, at the moment of a fundamental shift in vision and technique. When he was born the most important graphic media used in Italy were metalpoint and pen, both often combined with another medium, ink wash or white lead. When he died the dominant medium for figure studies was chalk, both black, which had long been known but which had been used more often as a loose preparatory tool, and red, whose great popularity in central Italy was largely due to Leonardo da Vinci, the key figure in this development. Leonardo's Flemish-influenced use of oil paint required a method of preparation that emphasized mass rather than line and was flexible in thickness and density. Although it is an over-simplification, the transition within Raphael's lifetime was from linear to painterly, from separation to continuity, from local hue to tonal homogeneity, from flatness to volume. Despite the change in direction of central Italian art after Raphael's death – its conscious revival of the stylized, the patterned and the hieratic, and its consequent re-adoption, though revised and rethought, of earlier modes – figure studies continued to be executed mainly in chalk, and on this founding link between chalk and life was built the great edifice of Baroque figure draughtsmanship.

The main media available in Raphael's lifetime, used either separately or in conjunction, were metalpoints (essentially a short piece of wire inserted in a holder) of silver or, much more rarely, gold, or of different alloys of lead and tin; pen and ink; ink wash applied with a brush; white lead, also applied with a brush; chalk of one hue or another; and charcoal, often employed for rough underdrawing and then erased. Although a leadpoint would leave a trace on ordinary paper, it was not extensively used by Raphael. Silverpoint (and goldpoint, which Raphael does not seem to have used) required a prepared ground, frequently coloured to create a particular overall tone or even mood, in which it left a relatively unvarying line that could not be erased, akin to an engraving line in purity; its use therefore demanded great dexterity and decisiveness. In addition, Raphael frequently used a metal stylus leaving no trace to draw blind into unprepared paper, and then followed the indented lines with his pen, or his chalk. A design could also be transferred from one sheet to another by blackening the verso with charcoal and then indenting the preferred contours of the recto so that a dark line was left on a second page – a method similar to the use of carbon paper.

Pen was very flexible, though the potential of thick quills, reed pens and broad application of ink was little realized. Pen was generally used for small initial sketches, with the springy quill allowing the accentuation of key lines and the diminution of others; it could be used for analysing the structures of figures or objects; it also allowed very rapid handling. Employing different types of hatching – bracelet, parallel, cross-, or multi-directional – pen could model forms with great density and precision, though not with the solidity and clarity of silverpoint at its best. But finished pen-drawing was a laborious and difficult process where form could easily be lost in a profusion of lines, and it was something of a test of virtuosity. Wash and white lead were generally used as auxiliary media to expand tonal range: wash of varying intensities for shadows, and white lead for highlights. But occasionally a drawing might be composed of a faint chalk or charcoal outline and all the volumes filled in with wash and white. At other times they could be used singly, to accentuate features of very precise drawings – it was a frequent practice to indicate highlights in white lead on silverpoint drawings. Usually wash was employed to define volumes more precisely, but occasionally – an effect which seems to have been invented by Leonardo – it could be thrown across forms to create an impression of a particular fall of light, even of a time of day,

descriptive of form in context and atmosphere, not structure alone.

Finally, chalk, either red or black, was the most versatile medium. Available in many different shades and hardnesses, it could be handled in many ways. Hard and well sharpened, it could approximate to silverpoint; and it could even be used for stippling, a technique much employed by Michelangelo. It could be moistened to obtain a denser, more emphatic line, and it could be used more broadly: rubbed over a sheet to build up masses of shade. Chalks existed in gradations from intense black to light grey and from brown to orange – and both red and black or two shades of the same chalk were occasionally used together on the same drawing, just as, occasionally, two different shades of ink were used. The reasons for the choice of colour of chalk, or indeed for the choice of medium, are not always immediately apparent, and the fineness of calculation of a Raphael, or a Leonardo, cannot be fully elucidated. Yet the effort should be made for, while on occasion he may simply have seized the medium nearest to hand, the way Raphael drew and what he drew with were generally the product of intention and directed to a purpose, although this might be modified in the act of drawing.

The differences between black and red chalk are often very subtle. The latter is usually harder and cannot be erased, but black chalk cannot be erased without considerable difficulty either. It is in their colouristic effects that they differ most obviously and importantly. Black chalk allows greater contrast – the artist can go down more deeply in the shadows and, using the paper or white lead, or both, as highlights, can obtain very bright areas by contrast. It is therefore excellent for the preparation of scenes where high contrast is required, or for blocking out a figure where the suggestion of broad masses of light and shade is more important than rendering detail. Red chalk does not permit such depth in the shadows, although it can be fused for pits of shadow. But its great advantage is that, as a medium inherently lighter in tone, it allows for greater subtlety and more gradations. It can thus create effects of greater density and solidity than black chalk. In addition, of course, it comes close to the colour of flesh and is therefore an obvious medium for nude studies, and more appropriate for most fresco painting, where the tonal range tends to be blond.

Raphael mastered all the media of his time, and most of the possible ways of handling them. Others perhaps used different media more fully, but none had his range and variety. Frequently his experiments in handling one medium opened his eyes to new possibilities in another: there is much cross-fertilization among his different techniques, and he never used the same medium in precisely the same way for more than a few months, although he sometimes revived old methods in new ways. Nor did he readily abandon media. He continued to use silverpoint for specific purposes until c. 1515, when most of his contemporaries had discarded it, and indeed was the last great silverpoint draughtsman in Italian art.

2 Functions

Each stage in preparing a painting required a different type of drawing. First would come the initial sketch, the *concetto*, usually small, usually in pen. Sometimes, in the case of a single- or two-figure composition – a Virgin and Child, for instance – the starting-point might be a sketch from the living model, but for multi-figure compositions it was more likely to be imaginary, although of course the artist could make use of small wooden or wax figures to help him deploy his cast. There mght be numerous *concetti*, and from these the artist would choose to develop one, or perhaps in Raphael's case a number, for his fecundity of invention was well known. He would then prepare a larger compositional draft, maybe several, clarifying poses and figure relations, sometimes in pen, sometimes in wash and white lead. Then would follow studies from the model made to explore movement, gesture and expression. Raphael was, at certain points in his career, particularly concerned that the anatomical details of his figures should be correct, and sometimes the same model can be recognized in several drawings. Drawings from individual figures might well produce changes in the compositional arrangement, which would lead to further drafts and further individual studies. Then, for particularly important schemes or particularly difficult ones, a new compositional draft might be made entirely from figures posed in the nude. Detailed studies of drapery, facial expression and gestures might follow. Then would come the *modello*, a detailed drawing (often subsequently engraved) usually in mixed media: chalk underdrawing, pen outline, wash and white heightening, to create a complete picture of the composition, with light and shade, gesture and expression fully described. This would then be enlarged, by careful squaring, to produce a cartoon the full size of the required area. The contours of the composition would then be pricked through the cartoon, and chalk dust pounced through the perforation to leave a dotted outline upon the surface to be painted. Alternatively the contours could merely be incised with a stylus, though this tended to damage if not destroy the cartoon. If the cartoon was particularly precious the outlines could be pricked through to another simplified cartoon which would itself be transferred to the surface, thus preserving the original. Finally, for projects where facial expression had especial importance, there might follow auxiliary cartoons, heads being pounced from the master cartoon onto separate sheets to be worked up in greater detail or differently. These would guide the artist when he came to paint.

This sequence is an ideal construct, not necessarily a real one, as demands would differ for each project. Some stages might be endlessly repeated as problems arose or as Raphael changed his mind. Some might be omitted altogether – for small paintings, a well-worked-out compositional draft might serve as the cartoon. And although nude studies were of great importance to Raphael throughout his career, he did not invariably make them, especially when pressed for time.

3 The Umbrian Period

Raphael was born on 6 April 1483 in Urbino, a small but wealthy dukedom with a highly cultivated court. His father, Giovanni Santi, was a money changer and merchant as well as an artist; he was also a poet and wrote a long, if undistinguished, epic on the life of Duke Federigo da Montefeltro, who, however, did not employ him. He was an intellectual, not an artisan, and the example was certainly important for his son. But during the reign of Federigo's son, Guidobaldo, Santi seems to have attracted the attention of the Court. For different members of it he executed altar-

pieces, including an *Annunciation* (*c.* 1490) for Giovanna Feltria della Rovere, née Montefeltro, to celebrate the birth of her son, Francesco Maria, later to become Duke of Urbino on Guidobaldo's death in 1508.

From his surviving paintings, Giovanni Santi seems to have been as eclectic as the references to a wide range of painters in his poem would suggest – influences from Piero della Francesca mingle with those from Melozzo da Forli and Signorelli. He looked carefully at northern art (especially that of Justus van Ghent, one of Duke Federigo's favourite artists), and studied the Pollaiuolo brothers and Mantegna. His work is variable in quality, at times attaining clarity and some force in overall arrangement, and real delicacy in the landscapes. It is never better than provincial, but is not without sophistication. He also enjoyed success as a portraitist, and was sent to Mantua to paint Eleanora d'Este, but none of his portraits has been identified. He was clearly also a man of charm and popularity, again like his son. A letter from Elisabetta Gonzaga, Duchess of Urbino, in which his death was announced, in 1494, shows great sympathy, and that written on Raphael's behalf to Piero Soderini in 1504 by Giovanna Feltria refers to Giovanni as much loved, a considerable compliment a decade after his death.

At Giovanni Santi's death, Raphael was 11. He was old enough to have learned a great deal from his father, but Giovanni died before Raphael could be affected by his limitations. In all probability Giovanni was a better draughtsman than painter: the only drawing with a good claim to be his is a careful *modello*, drawn in brush and wash with white heightening on a prepared ground, and with vegetation picked out in white (Fig. 1). The different elements of the drawing are well integrated, the modelling is solid, plastic and finely graded. Drawings of this type undoubtedly influenced Raphael, but none survive in his *œuvre* before *c.* 1503, so precise links are hard to find.

Raphael's training and experience between 1494 and 1500 when he received the commission for the *Coronation of St Nicholas of Tolentino* (D. pp. 1–3) are not documented. It has been conjectured that Giovanni's workshop was continued (perhaps under Evangelista da Pian di Meleto, Giovanni's assistant), with Raphael largely educated there; or that he trained with Francia's former pupil Timoteo Viti, also resident in Urbino, certainly a close friend of Raphael's in later years, and the possessor of many of his early drawings. But it is difficult to see how Raphael could have developed as he did in Urbino, and the correspondences which can be established with the work of Viti show that although Viti was influenced by Raphael, the reverse was not the case: several Viti drawings look like imitations of Raphael, but no Raphaels look like imitations of Viti, whose early drawings although proficient in the use of black chalk, are weak precisely where Raphael's are strong, in rhythm and relief.

Vasari's account, which he probably had from Giulio Romano, that Raphael trained with Perugino, is the most convincing. He describes Giovanni taking Raphael to Perugino, conscious that he could teach his son no more. The anecdote is suspect (especially since Vasari believed Giovanni to have lived until *c.* 1506), but children were sometimes apprenticed as young as 10 or 11, and it may well rest on fact. Certainly Giovanni admired Perugino, whose style swept Umbria and the Marches in the 1490s, and Perugino's studio was the obvious place for Raphael. But Raphael was no ordinary apprentice. From an intellectual background, and undoubtedly enjoying moral and perhaps

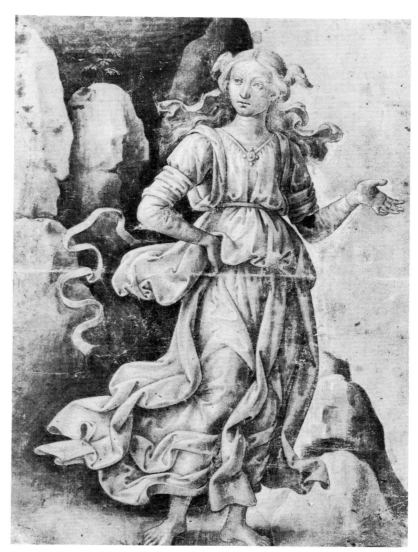

1. Giovanni Santi: *Standing Muse c.* 1485 (?) Wash and white heightening on green ground. 248 × 179 mm. Windsor, Royal Collection.

financial support from the court at Urbino, it is likely that he was less an apprentice proper than a privileged trainee. Certainly influences other than Perugino's may be detected in his earliest paintings and drawings, but Perugino's is indubitably dominant, and it is only with drawings by Perugino, and perhaps Pinturicchio, but not with those of Signorelli or Viti that Raphael's drawings are likely to be confused.

Recent discoveries by Sylvia Ferino Pagden (cat. 1, 2), although controversial, seem to support the traditional view that Raphael was involved with the design, though not necessarily with the execution, of the predella of Perugino's altarpiece in Santa Maria Nuova at Fano, completed in 1497. Attempts to detect Raphael's hand in other works of the late 1490s by Perugino and his shop are legion, but there is no general agreement. However, one surviving drawing (cat. 6) suggests that Raphael may have been involved in the design of some of the *Cambio* frescoes, and another (cat. 5) that he was in Perugino's studio when the *Assumption* (Florence, Accademia) was being prepared. In any case, the ebb and flow of Perugino's influence in Raphael's work very much suggests that he maintained an association with the older man until at least 1504.

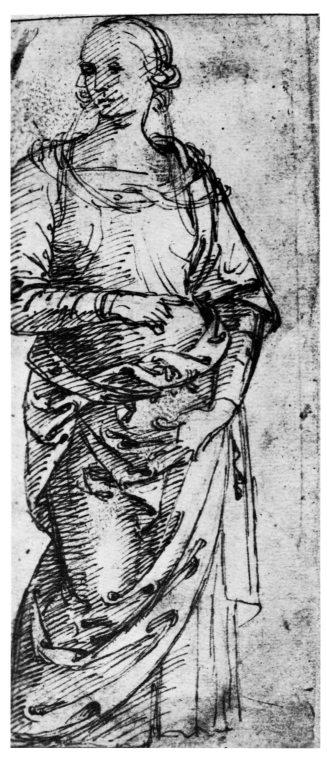

2. Pietro Perugino: *Standing Sibyl*. *c*. 1497. Pen and ink. 202 × 85 mm. Florence, Uffizi.

The 1490s were the last great years of Perugino's art, when clarity of arrangement and understated emotion were reinforced by a close study of life. After 1500 his style underwent a change. Surface pattern is exploited and larger and bulkier figures are deployed across the plane. This attempt to create his own version of the grandiose styles of Florence led rapidly to a certain emptiness in his work: studio execution and his decreasing interest in life studies were also contributory factors. In the 1490s, however, the

period when Raphael would have learned most from him, Perugino was a vital and impressive figure.

As a pen draughtsman, Perugino was lively and incisive, making use of vigorous parallel hatching in his figure and compositional studies (Fig. 2). In Raphael's earliest pen drawings, Perugino's influence is evident in the shading and outlines and in the pot-hook folds of the drapery, a trick of hand that remained with him until he went to Florence (e.g. cat. 19, 68). However, the young Raphael also practised pen techniques that are not found in Perugino's surviving drawings: close hatching in a small section of the figure to bring out volume, for example (cat. 11r); and tense, varied contours to register the inner pressure of the form (cat. 52). Such interest in sculptural volume was of little concern to Perugino.

Late in the 1490s, when Perugino was preparing the polyptych for the Certosa of Pavia (three panels of which are in the National Gallery, London), he made careful and brilliant studies from life in silverpoint. One of them, Tobias and the Angel (Fig. 20), is a direct study of models in contemporary dress, with details repeated at the sides of the sheet. Such life studies would also be fundamental to Raphael's method of preparation, and the same concentration on expressive detail can be seen in many of his drawings. Indeed, the *Tobias* was attributed to Raphael in the past, but his drawings show a greater sense of rhythm and swelling form, especially in the limbs. Perugino also made portrait studies in silverpoint, and here he achieves a smooth and solid modelling (Fig. 3). Although it is more rounded, Raphael's self-portrait drawing (cat. 7) shows awareness of Perugino's example.

It is perhaps in chalk drawings that Raphael and Perugino come closest together. Perugino frequently made studies in black chalk, for it allowed him relatively easy generalization of form. The handling of the chalk in thin lines, laid closely together in Fig. 4, is close to the manner of Raphael's studies in cat. 11r. But Raphael seems from the start to have been more inventive in his handling of chalk. He was primarily concerned to build up volumes and was always more interested in relief than his Umbrian elders and contemporaries.

By the age of 17 Raphael must already have acquired a reputation, since in December 1500 'magister Rafael' received a commission with Evangelista da Pian di Meleto, his father's senior assistant, to execute a very large altarpiece of the *Coronation of St Nicholas of Tolentino* for the church of Sant' Agostino in Città di Castello, a picture of which only fragments survive. Probably the year before, he had painted a double-sided banner of the *Crucifixion with Sts Sebastian and Roch* and the *Creation of Eve* (Città di Castello, Pinacoteca (D. p. 3) as an *ex voto* during the plague that had struck the city. Although the *St Nicholas* is heavily Peruginesque, there is great liveliness and volume in the individual figures and a powerful sense of space. At the same time the design displays a command of surface geometry, both mathematical and instinctive, which few other artists have ever approached. Despite weaknesses of execution in the surviving fragments – weaknesses which do not appear in the preliminary drawings – the painting demonstrates that, however deeply Raphael was embedded in the Peruginesque tradition, he was always an independent voice within it.

Although Evangelista was a much older man Raphael was certainly in charge. The collaboration shows that Raphael

had assistants or associates from the beginning of his career, and although none is mentioned in surviving contracts (with the exception of that for the Monteluce *Coronation of the Virgin* of 1505, which states that the predella was to be painted by the minor Perugian painter, Berto di Giovanni), he must always have made use of others in order to sustain his large output. In the three years following the completion of the *Coronation of St Nicholas* in September 1501 he painted three altarpieces, the *Mond Crucifixion* (London, National Gallery; D. pp. 8–9) probably in 1502 for Città di Castello, the *Coronation of the Virgin* (Vatican; D. p. 10) in 1503 for Perugia, and the smaller *Sposalizio* (Milan, Brera; D. pp. 10–11) signed and dated 1504, also for Perugia. The Ansidei altarpiece (London, National Gallery) and the *Pala Colonna* (New York, Metropolitan Museum; D. pp. 13–15), both also for Perugia, were probably begun in 1504 but not completed until 1505, after Raphael's first stay in Florence.

In these works Raphael developed the possibilities of Peruginesque altar painting, experimenting with soft atmospherics and a precise geometrical arrangement of circle and square in the *Mond Crucifixion*, pivoting the apostles round an obliquely placed sarcophagus in the *Coronation of the Virgin*, analysing character in the *Sposalizio* and simultaneously bettering one of Perugino's compositions. But throughout this period he seems, in comparison with the

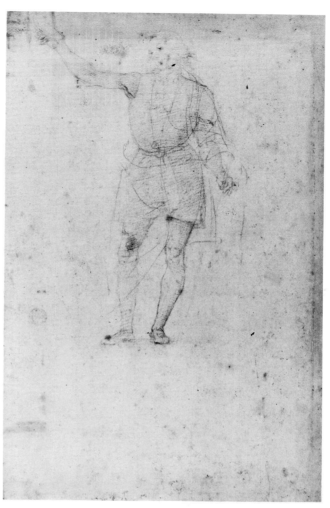

4. Pietro Perugino: study for St John the Baptist. *c.* 1500 (?) Black chalk, touches of red chalk, over stylus. 311 × 198 mm. Oxford, Ashmolean Museum.

speed of his later development, to have been marking time. In part, this was due to the conservative nature of Umbrian patronage. The commission for the Monteluce *Coronation* (Vatican; D. p. 55) – which remained unfinished during Raphael's lifetime – required him to imitate an altarpiece of 15 years earlier by Domenico Ghirlandaio. And his real brilliance at this time can be seen more clearly in his narrative paintings, especially the central predella panel of the *Coronation of the Virgin*, representing the *Adoration of the Magi*. In this he succeeded in relating a large number of figures in a coherent and natural flow which looks forward to the *Disputa*. Even *c.* 1503 he must have been aware of some of the designs of Leonardo, though probably at second hand, and his range of artistic experience was certainly wide: the Monteluce contract specifies that the final judgement of the painting may take place in Perugia, Rome, Siena, Florence or Venice, so he must already have been peripatetic.

Raphael's early genius as a designer was confirmed by his participation in one of the few large-scale secular fresco schemes of the period – the decoration of the Piccolomini library in Siena with scenes from the life of Aeneas Sylvius Piccolomini, Pope Pius II. The commission was given to Pinturicchio in 1502, but Raphael's involvement, though not stipulated contractually, was exceptionally important.

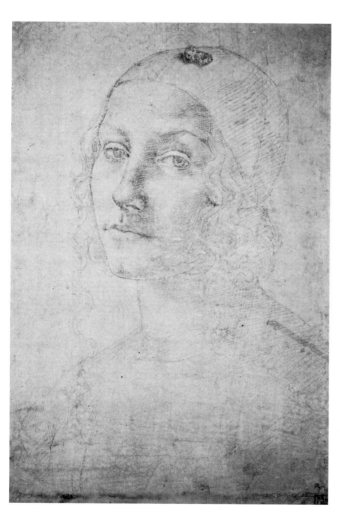

3. Pietro Perugino: *Head of a Young Woman. c.* 1500 (?) Silverpoint and touches of wash on grey ground. 377 × 243 mm. London, British Museum.

He certainly designed three of the scenes, possibly more, and also made drawings for the putti which stand between the arches (cat. 56–61). It is not impossible that he devised the whole scheme, for in no other project did Pinturicchio show such architectonic skill. Raphael prepared large multi-media *modelli*, akin to the drawing attributable to his father, but more atmospheric and with much more subtle use of wash. They provided Pinturicchio with all the information he needed with the exception of colour. Raphael's designs, probably made in 1503, were not as inventive or innovative as the contemporary work of Michelangelo and Leonardo in Florence, but in clarity, spatial control and drama they quite equalled the work of any other Italian artists then working on a comparable scale. Consideration of the Piccolomini designs makes it quite clear that in most of Raphael's Umbrian altarpieces his creative interest was not deeply engaged.

A notable feature of Raphael's early graphic work is his *ad hoc* use of different media. They are means, not ends, and what was important was the effect. He was prepared to employ any sort of stroke to entice the forms from the page. Generally he used pen for initial *concetti* (cat. 11v), for analytical figure studies (cat. 7), and for finished compositional designs (cat. 52). Some cartoons for little pictures were also made in pen (e.g., cat. 30 and cat. 31), and in these drawings his control of direction and density of hatching produces the subtlest gradations of light and shade over rounded volumes, or, alternatively, cancels less important areas. Black chalk was frequently used for drapery studies (cat. 55), but it was also employed for compositional sketches where the intended layout was known and where mass was more important than detail (e.g. cat. 14r). Black chalk was also used with particular success in portrait studies and auxiliary cartoons (e.g. cat. 48–50).

As a silverpoint draughtsman Raphael was uniquely gifted, able to sketch with a fluency that most artists could not match even in pen (cat. 58r). In his preparations he often followed pen or chalk drawings with silverpoint ones in order to produce particular plastic emphases. His experiments in silverpoint probably helped him to develop the strengths of his pen draughtsmanship, for after the earliest matchstick-style *concetti* (cat. 11v), the mode does not recur and he increasingly exploited pen as an accentual medium where a slight increase in pressure could convey the direction of a gaze or the particular set of a mouth (cat. 32).

In all Raphael's early graphic works one finds an inherent functionalism of handling: a strongly emphasized contour in one place, an entire omission of it in another, a willingness to leave parts of forms undefined in order to emphasize them elsewhere. And Raphael was not afraid of drawing in irregular or even apparently clumsy ways in order to obtain the formal and psychological stress he required. Graphic purity or virtuosity for its own sake was very rarely his aim, nor was he interested in stylistic consistency.

4 The Florentine Period

It was inevitable that Raphael should go to Florence. Perugino worked extensively in Florence and may have encouraged Raphael to study there. Raphael certainly knew of Leonardo, and his stay in Siena would have made him aware too of Michelangelo, commissioned in 1501 by Pinturicchio's patron to complete the sculptural decoration of an altar in the cathedral, only a few yards from the library. There is no evidence that he visited Florence before October 1504, when Giovanna Feltria della Rovere wrote a letter of recommendation to Piero Soderini, the Gonfaloniere, stating that he had come to Florence to study; a preliminary reconnaissance earlier that year is not unlikely, however. The letter proves that he was not just a young artist on his *wanderjahre* – the recommendation is addressed to the ruler of a city. He came to Florence with high social connections and an established reputation. And he seems rapidly to have become *persona grata* in a powerful banking circle, which included two of Michelangelo's patrons, Angelo Doni and Taddeo Taddei. Raphael refers to the latter as his friend in a letter of 1508. During his Florentine period, he travelled to Perugia and Urbino to complete old commissions and undertake new ones – such as the small *St George* (Washington, National Gallery; D. p. 13) and the uncompleted fresco of the Trinity in the church of San Severo, Perugia (D. p. 68) – and to maintain old contacts, for with a della Rovere pope, Julius II, on the throne, the court of Urbino suddenly became an avenue to papal attention.

The fact that Raphael's output in Florence consisted largely of Madonnas should not be interpreted as failure to obtain more important commissions; rather it is an indication that he had no immediate intention of establishing himself in a workshop organized for large-scale projects, but preferred to confine himself to small paintings and to his self-education. He may already have foreseen that his path led to Rome.

Few aspects of Florentine art escaped Raphael's interest in the period 1504–8, during which he perhaps spent no more than half his time in the city. He probably also made trips to Rome. He looked at great artists of earlier generations – Antonio Pollaiuolo (cat. 93r), Domenico Ghirlandaio (Michelangelo's first master; cat. 138r), Donatello (cat. 192) and Masaccio (cat. 365). He was not uninterested in artists apparently alien to his taste, like Botticelli (cat. 323), and Filippino Lippi (cat. 3v) was certainly already known to him. He was rapidly accepted in artistic circles and became friendly with Fra Bartolommeo, whom, according to Vasari, he aided in the study of perspective and from whom he learnt a greater range and harmony of colour and a more coherent tonality. The only large commission that he undertook in Florence, the *Madonna del Baldacchino* (Florence, Pitti, D. p. 26) for the Dei family, left unfinished in 1508, is, with its enclosed architectural setting, solid figures and strong contrasts of light and shade, very like the altarpieces which Fra Bartolommeo had under way at the same time.

But the artist from whom Raphael learnt most was Leonardo da Vinci, then over 50 years old. Leonardo became an acquaintance and probably a friend, and Raphael was able to study his drawings as well as his paintings. So many of Leonardo's preparatory studies have been lost, however, that it is difficult to define the exact scope of his influence. Nevertheless, it is clear that Leonardo reinforced what in Raphael was an innate skill, the ability to link figures to one another in movement and gesture, and to pose them so that the design also possessed an abstract geometrical clarity. The great unfinished *Adoration*, virtually a large drawing, was carefully studied by Raphael (cat. 197), but it was compositions like Leonardo's suite of variations on the Virgin, Child and St Anne theme, with their blend of complexity and clarity, action and stasis, that most im-

mediately affected him. An example is the *Madonna of the Meadow* (Vienna, Kunsthistorisches Museum; D.p. 20), which experiments with the pyramidal group of a seated figure at full length and two smaller ones. The composition is still fairly static, but by 1507 Raphael was able to create, in the tiny *Holy Family with the Lamb* (Madrid, Prado), signed and dated that year (a copy, D.p. 11), and in the large *Canigiani Holy Family* (Munich, Alte Pinakothek, D.p. 19), structures as complex as, though perhaps less organic than, those of Leonardo himself.

In portraiture, too, the influence of Leonardo was enormous. At least two of Raphael's Florentine portraits, that of Maddalena Doni (Florence, Pitti; D.p. 17) and that of the unidentified sitter in the unfinished portrait in the Galleria Borghese (D.p. 64; Fig. 17), are based directly on the *Mona Lisa*. From Leonardo, Raphael learned the expressive possibilities of the slightest modification of pose, the potential of movement, and the arrangement of the hands, as indicators of character and mood. The spiral movement beloved of Leonardo in single figures was also absorbed by Raphael. Copying Leonardo's design for his standing *Leda* (cat. 98), he made use of it at the very end of his Florentine phase in his *St Catherine* (London, National Gallery; D.p. 25), and in this painting Leonardo's influence can also be felt in the wider colour range, more *changeant* than hitherto, and in the complex play of textures.

Other aspects of Leonardo's work must have interested Raphael in Florence, but they found no immediate echo in his art. The psychological possibilities of heavy chiaroscuro were not taken up until much later, and never to the monochromatic extremes of Leonardo's *St John* (Paris, Louvre). And although Raphael was certainly excited by the possibilities of violent action in Leonardo's *Battle of Anghiari*, which he studied carefully (cat. 99), he had little opportunity to emulate him at this stage of his career.

With Michelangelo, Leonardo's great rival and the defamer of Perugino, Raphael's artistic relations were different. Given his charm and affability, Raphael might have succeeded in winning temporarily the friendship of the solitary sculptor, but there can have been little personal sympathy between them. Nevertheless, he clearly had some knowledge of Michelangelo's drawings (e.g. cat. 129). Initially, he was attracted primarily by those works in which Michelangelo himself had been heavily influenced by Leonardo: the Taddei tondo and the *Bruges Madonna*. He copied the former (cat. 93v, 111v), and the Child in the latter was incorporated into the *Belle Jardinière* (Paris, Louvre; D.p. 22). More complex and energetic aspects of Michelangelo's art, his dynamic nudes in the *Battle of Cascina*, for example, were also copied by Raphael (cat. 157v), but he found them difficult to use. Michelangelo's art was largely one of isolated figures, essentially metaphoric rather than descriptive. The knowledge, skill and obsessiveness required to manipulate the body for poetic expression were at this time beyond Raphael. It was only in Rome that he grasped, more fully, the grandeur and spirituality of Michelangelo's figural inventions. Yet Raphael did attempt to utilize Michelangelo's more heroic work, combined with inspiration from antique Roman relief sculpture, and he made a number of drawings of fighting men (cat. 185ff.) *c*. 1507–8, and also drew a sequence of the Labours of Hercules (cat. 188ff.). In these he was attempting to create his own version of the heroic nude, but his knowledge of the body was limited – his very few *écorché* drawings are

exceptionally weak (e.g. cat. 139r). He devised a system of running curved lines along the hip and around the shoulderblades and breastbone to suggest an internal mobility; but the effect was to weaken structure and to let the parts of the body run into one another ineffectually. This method could only be productive when combined with dense hatching, and this tended to produce a static effect. And, in using a more elongated figure type (based on Michelangelo's *David*), Raphael did not at first see the difficulties of its use. He tried to deploy a range of elaborate foreshortenings and then contradicted this by overemphasizing the contours which he found attractive. He found that certain abbreviations of form and certain arrangements of the body which allowed the play of a sinuous or rounded line were acceptable enough for draped figures but not for those which were nude or wore skin-tight garments. Then the contradiction with real anatomy became disturbing. But it is important to realize that although Raphael's attempt to combine the proportions of the *David* (cat. 97, 85v) – the most difficult of models – with violent movement was a comparative failure, it was still bolder and more adventurous than contemporary Florentine work.

No one graphic medium had dominated Raphael's Umbrian period, but by far the largest proportion of his known Florentine drawings are in pen, usually but not invariably over stylus indentation or soft chalk. With its flowing lines and its great flexibility, qualities which he had not hitherto fully exploited, pen enabled him to produce bolder, more dynamic forms, analysing them into their basic components, and concerning himself less than before with detail. As a consequence, there is a decline in his use of silverpoint – until he revived it in Rome – and while he used black chalk for his cartoons and occasionally for rough sketches, it is largely absent in drapery and facial studies. It was pen, largely under the influence of Leonardo, that helped Raphael toward more organic form. There is a sense of speed and vivacity about many of his Florentine drawings, as he raced at his studies with growing confidence. The pen sketches for the predominantly two-, three- and four-figure groups that constitute his main production in this period suggest that he usually began with drawings of some scale rather than tiny *concetti*. He tended to divide his forms into a series of planes by the use of separated blocks of parallel hatching, and the relief in his images became still more important, with contours swelling, duplicating and sometimes breaking to express the fullness of the flesh. This attitude towards pen drawing affected his painted compositions – increasingly during this period his forms expand to fill the picture surface, and themselves create the space. This was perhaps a consequence of one of the key discoveries that Raphael made in Florence, the method of pentimento drawing originated by Leonardo. It enabled Raphael to escape finally from the additive figure arrangements of Umbria.

In later quattrocento drawings it is more usual to find figures repeated than extensively altered. Leonardo, instead of attempting to keep his drawings neat, made creative use of his changes of mind, his pentimenti, to obtain more rhythmic and organic form; at times his drawings become a maze of lines as one modification sets off another. The method worked most effectively in compositions with a limited number of figures, such as Virgin and Child groups (Fig. 5). It allowed Leonardo to produce a series of differing interpretations of the same figures almost instantaneously

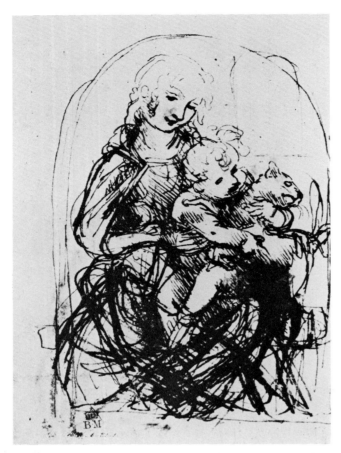

5. Leonardo da Vinci: *Virgin and Child*. *c*. 1478. Pen and wash over stylus. 132 × 96 mm. London, British Museum.

and to gauge the response of one character to another. He was also able to incorporate a much greater range of movement, and alternatives presented themselves with every flourish of the pen. Leonardo's pentimento drawings had great influence on Raphael, but whereas Leonardo's work always retained the fragile angularities that he relished, Raphael employed Leonardo's method with a more geometrical bias, tending to move his pen in ovals (cat. 180). This approach also encouraged instantaneous generation of groups: in some cases one can find three or four arrangements on the same sheet, each of which could be worked up into a finished painting with very little adjustment.

While Raphael made some compositional studies in brush and wash to establish the main masses (e.g. cat. 112), and some *modelli* also in wash with white heightening, in Florence, for the *modello* stage or in compositional drafts, he usually employed systematic cross-hatching. This may have had the auxiliary purpose of impressing potential patrons with his command of this most difficult of skills, but it also had functional and stylistic roles and consequences. Sometimes it was adopted to clarify form. For example, in a drawing made for his Perugian associate Domenico Alfani in 1508, he probably used the method so as to aid Domenico, not a technically gifted painter, to translate the composition into his own naïve idiom (cat. 174r). And cross-hatching could be varied to encompass any mode of sculptural relief that Raphael desired, an important requirement in his later Florentine work (e.g. cat. 125). It could equally suggest deep sculptural volumes, or, particularly if combined with a hard regular contour, a shallow relief. Both were effects that Raphael wished, at different moments, to exploit. In the past

many of these closely cross-hatched drawings have been described as re-worked, but close examination does not bear this out, and the practice is too consistent over a range of drawings in the years 1506–7 for it to be anything but Raphael's. This technique was largely the result of Michelangelo's influence, for he had developed cross-hatching to the highest level of precision and flexibility that it had known, and by obsessive, but never mechanical, control of every line was able to obtain effects of mass and light which few other artists could approach even in chalk (Fig. 6). In one or two surviving examples, Michelangelo demonstrated his skill by devising forms entirely from cross-hatching without contour lines, so that they seem to be conjured from the paper out of nothing. Raphael imitated this in a few instances, and with considerable success (cat. 129), but it was a passing interest which he soon abandoned.

The most significant painting of Raphael's Florentine period, though it was executed in Perugia, was the *Entombment* (Rome, Galleria Borghese; D. pp. 23–6). Signed and dated 1507, it was probably in preparation from at least 1506. The many stages of its design, which can be followed from the surviving drawings, demonstrate the range of Raphael's sources, the variety and ambition of his aims, and the awareness with which he inserted recognizable quotations, advertisements for modernism, in the late stages of its design (cat. 124ff.). The first project, probably in answer to a demand from the commissioner, Atalanta Baglione, a Perugian noblewoman, was a Peruginesque *Lamentation*, with Christ's body on the ground, supported by the Virgin and surrounded by mourners (cat. 125). Subsequently, alert to Michelangelo's unfinished *Entombment* and Mantegna's engraving of the same subject, and having examined in reality the transport of shrouded bodies, Raphael considered the variant subject of the laying of Christ's body in the tomb (cat. 129). Finally he decided on the transport to the tomb. The first rendering of this was relatively naturalistic , with Christ's body supported in a shroud (cat. 130r). Then, perceiving the relevance of an antique relief of the death of Meleager (cat. 132r), he minimized the shroud, and gave the bearers more statuesque poses (cat. 133r). For a moment he thought of adapting Michelangelo's unfinished *St Matthew* for one of the bearers (cat. 133v), but finally settled for more restrained poses largely derived from Mantegna (cat. 134). The body of Christ, however, was adapted from Michelangelo's most poignant sculpture, the *Pietà* in St Peter's. The positions of the mourning women caused him some trouble, as did the role of the Magdalen (cat. 131r). She was finally shown running forward to caress Christ's body, a movement derived both from the Meleager relief and from Ghirlandaio (cat. 138r), and the Virgin and the three Marys were moved to the right to form a self-sufficient group (cat. 139r). The kneeling woman supporting the Virgin is a direct quotation from the Virgin in Michelangelo's Doni tondo – that arrogant demonstration of a more than Leonardesque complexity painted with a colouristic shrillness which sharply opposed Leonardo's tonal approach. The *Entombment* is thus a demonstration of Raphael's awareness of, and command of, the most advanced currents in Florentine and Paduan art, as well as of the antique. It reflects his essentially Leonardesque preoccupation with the interaction of character and with quasi-realistic arrangement, as opposed to the presentational style of Michelangelo's *Entombment*, but it is also evidence of his interest in high relief. Although in places slightly strained

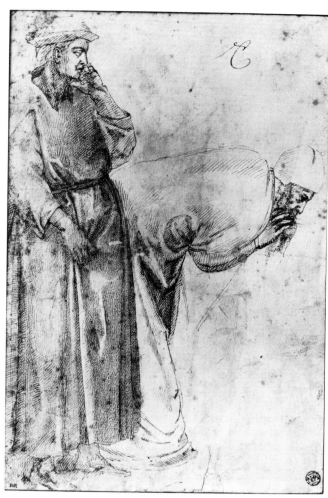

6. Michelangelo: copy after Giotto. *c.* 1490. Pen. 315 × 206 mm. Paris, Musée du Louvre.

and awkward, the *Entombment* is a work of high ambition, more complex and heroic in composition and figure scale than any work by his Florentine contemporaries. He himself had become an important presence in Florence. The early Madonnas of both Andrea del Sarto and Franciabigio show his influence, and his ideas were useful to Fra Bartolommeo and, perhaps, Albertinelli (cat. 317v), as well as to the Umbrian friends whom he kept supplied with drawings.

5 The Stanza della Segnatura

In early 1508 Pope Julius II commissioned the decoration of a suite of rooms in the Vatican from a team of artists including Sodoma, Perugino and Peruzzi. Raphael was still in Florence in April and cannot be documented in Rome until January 1509, but he seems to have been called there in the early summer of 1508. His first task was to participate in the decoration of the pope's new private library, a room which under Julius's successors came to house the court of the Segnatura and thus to acquire its name.

Apart from his designs for Pinturicchio in Siena, Raphael had not yet been involved with large-scale projects. But the commission produced an explosion of genius that he himself could hardly have expected. Like Michelangelo, confronted with the Sistine ceiling at the same moment, Raphael had had little experience of fresco painting, but after joining as one of a team he very rapidly established his superiority

over the other artists working in the Segnatura (and, indeed, in the suite of rooms). He redesigned the vault while Sodoma was actually painting it, and had the corners plastered out to regularize the room and integrate the vault and walls, an idea which had eluded even Bramante. The programme, planned by Julius himself according to Vasari, was extremely elaborate and drew from Raphael perhaps his most intense intellectual effort. The resulting union of Peruginesque clarity and Leonardesque complexity was a résumé of everything Raphael had learned. It was also a radical new departure.

Each wall is devoted to one of the four faculties: Theology, Philosophy, Poetry and Jurisprudence. Each, except *Jurisprudence* where there was a last-minute change of plan, is represented by an ideal assemblage of its most significant figures, centred on Apollo in the *Parnassus*, on Plato and Aristotle in the *School of Athens*, and on the Eucharist in the *Disputa*. On the vault the walls are labelled, as it were, by simulated mosaic roundels containing allegorical personifications of the faculties. These were first painted by Sodoma in 1508 (cat. 132v?), and then, according to Vasari, replaced by Raphael on Julius's orders, probably *c.* 1510, as were the small narrative scenes in the corners of the vault (cat. 246r, etc.).

Raphael worked on the designs of all four frescoes simultaneously, for three-dimensional alignments were central to his conception, but the *Disputa* was certainly the test-bed. More drawings survive for the Segnatura than for any other project, and more for the *Disputa* than for the other three walls combined. That the *Disputa* drawings make use of the full range of media, with the exception of red chalk, is perhaps an indication of Raphael's uncertainties at the beginning of the work. For although the media of the *Disputa* drawings are used with functional intent, in the subsequent frescoes in the Segnatura and in his later work, he was surer of the effects he desired, and therefore more economical in his means.

In the earliest drafts, prepared in brush, wash and white heightening, the individual figures do not seem to have been carefully studied. A narrowly architectural conception dominates, and Raphael did not at first perceive the possibility of freeing his actors from geometrically fixed locations (cat. 197–9). He seems also to have thought of the fresco as darker than its final high-key, for his dark wash looks back to Leonardo's *Adoration* in tone as well as in compositional and figure borrowings. In the later drawings he used much lighter wash. The earliest drawings lack a central focus, but once he had hit upon the key feature of the altar raised upon the steps (cat. 204 ff.), he had a firm but not rigid structure within which he could give his cast freer rein. He used pen, both for studies of groups and for separate figures, obtaining lively movement and smooth or jagged rhythms as required (e.g. cat. 207, 208). Then he made nude drawings from several models posed successively in different positions in the studio. This was to test his designs against nature, and to work out a compromise between the flow of the compositional sketch and the life of the individual figure (cat. 205). Such a drawing provided the basis for the next stage, the more detailed figure and drapery studies, where further refinements of pose, attitude and tonal modulation could be devised.

For studies of draped figures, Raphael made use of soft black chalk or wash and white heightening. Wash and white heightening seems to have been reserved for particularly

important figures, where drapery had to be sharper and clearer (cat. 212r). He established deep shadows, with subsidiary lights within the folds and strong highlights. By applying the media with a fine brush and keeping the brush strokes separate, he obtained the most subtle modulations of light and shade.

The most advanced drawings for the *Disputa*, however, are those for the seated figures on the upper level. Further from the eye, they were intended to be seen less sharply, and for these Raphael made most of the drawings in black chalk. In this he was probably influenced by his recollection of Fra Bartolommeo's *Last Judgement* in Florence and its preparatory drawings. He desired a generalized effect but without loss of relief, and soft black chalk achieved this admirably – though there were variations in its use. For the St Stephen, for example, he adopted rounded swelling contours, accentuating the forms with bracelet hatching (cat. 213). For the Adam he used precise contours and fairly simple areas of shading, employing for the most part parallel hatching (cat. 210r). For the Virgin he produced a drawing of extraordinary softness in which lines are hardly visible and which is conceived entirely in vaporous masses (cat. 211r).

At a later stage Raphael produced an elaborate, highly detailed multi-media *modello* for the lower left side (cat. 222), undoubtedly once matched by one for the right. Significantly, however, it does not include the outermost figures. Raphael developed his composition from the centre outwards, and at the edges he created more complex and energetic figure poses, preparing them in vigorous pen drawings with hard, aggressive contours and strong hatching, and in silverpoint, a medium which he elsewhere employed in the *Disputa* only for accentual studies of hands and heads (cat. 224, 225).

Silverpoint in fact dominated the preparation for the *School of Athens* (cat. 229ff.), perhaps because Raphael had devised a very solid architectural setting for this fresco, and within it wished to display more individualized groups and figures. The world of Philosophy is less unified than that of Theology, and the figures of the *School of Athens* correspond in style to those at the edges of the *Disputa*. Raphael employed the precision of silverpoint to the fullest effect to create complex poses and rich characterization. He used pink, grey and green grounds; the lower tones, grey and green, with the addition of fairly heavy white heightening, conveyed an effect of greater density, which was ideal for the foreground groups; the lighter, pink ground was mostly reserved for figures further back, where an equally precise, but less ponderous mode was required. The studies for the *School* show Raphael's ability to use silverpoint with the speed of pen and the clarity of burin, and are among the most beautiful of all his silverpoint drawings.

In one drawing for the *School*, a study for the fighting men in the relief under the statue of Apollo (cat. 233), Raphael used red chalk. For a simulated sculpture which had to be legible but which he had not included in the cartoon, he wanted a combination of precision and breadth. He applied the chalk in separated lines with comparatively few areas of fusion. This represents in part silverpoint handling transferred to a different medium; it may have been a way of learning to use red chalk, but it was also consciously directed to the particular purpose.

Very soon, however, Raphael was using red chalk in an entirely different manner in his studies for the *Massacre of the Innocents* (cat. 253v, 288r). It is uncertain whether the composition was expressly designed for engraving in order to publicize his prowess in depicting the nude, or whether Marcantonio's print was the by-product of an unrealized pictorial project, but the latter is more probable. The figure style is based both on 'soft' Hellenistic sculpture, like the Apollo Belvedere, and on the work of Jacopo Sansovino, the most expert younger sculptor of classicizing inspiration in Rome. It seems likely that Raphael's new confidence with the long-legged, small-torsoed nude reflects the influence of Jacopo. The subdivisions of the body are now clearer, and the drawing also suggests new possibilities of organizing stresses for emotional effect. Red chalk was the ideal medium for balancing body surface against body structure, and Raphael was quick to realize its potential. His handling is extremely varied, with areas of fused chalk playing against others with different directions and thicknesses of hatching. He found himself equally able to convey sleek and mobile nudity and elaborate drapery within the same sheet, and to model them in light and shade.

The drawings that survive for the *Parnassus* are in pen, with the exception of two in silverpoint and two auxiliary cartoons in black chalk (cat. 235–45). In this fresco the figures had to be in a light key, to be visible round the window; and their scale was also increased, partly for the same reason. The graphic style was here developed from the studies for the figure at the edges of the *Disputa*. The drawings for the *Parnassus* contain some of Raphael's loveliest pen-work, in which sharp contour and hatching are set against sensuous rounded form: the effect is of an austere voluptuousness which approaches that of Poussin – indeed, Poussin owned a copy of cat. 238v, which apparently was one of his favourite drawings.

The two auxiliary cartoons demonstrate the special importance of heads in the *Parnassus* – none survive for other frescoes in the Segnatura – and in their grandiose simplifications foreshadow those of the Sibyls in Santa Maria della Pace (cat. 244, 245).

Although the Segnatura was planned as an ensemble, during its execution Raphael made changes. These were prompted partly by a desire to experiment, but also visible is a progressive response to Michelangelo. Vasari tells us that Bramante, a kinsman of Raphael, secretly let him into the Sistine Chapel so that he could see Michelangelo's work before it was completed. The story is undoubtedly a simplification, but since there were two competing artistic camps at Julius's court, one Umbrian, comprising Bramante and Raphael, the other Florentine, comprising Giuliano da Sangallo and Michelangelo, no doubt some espionage occurred. The few Michelangelesque elements discernible in the *Disputa* are taken from his Florentine work. In the *School of Athens* the prominent figure of Heraclitus, added after the cartoon, is patently derived from the Sistine ceiling (it may even be a portrait of Michelangelo). In *Parnassus* there are two borrowings. The derivation of the Muse Euterpe from the *Creation of Adam* is restrained and disguised, but in Sappho, taken from the ignudo next to Adam, Raphael revealed his source openly. In *Jurisprudence*, replanned after Julius's return to Rome in July 1511 from an unsuccessful military campaign, and probably painted rapidly in the following months, the personifications of Prudence, Temperance and Fortitude are patently Michelangelesque; the last, indeed, is copied from Michelangelo's *Moses*, which at that moment Raphael can have known only in model. The same source lay behind the

small fresco of Isaiah in Sant' Agostino (D. p. 69), below which was placed a group of the Virgin, Child and St Anne (dated 1512) by Andrea Sansovino, with whose design Raphael may well have been associated.

The period 1511–13 is the high point of Michelangelism in Raphael's art, when he produced the earliest and most successful of all adaptations of Michelangelo's style. *Isaiah* is virtually pastiche, but for the most part Raphael re-invented in a Michelangelesque mode or assembled his figures from different Michelangelesque indications, rather than simply borrowing them. But he was not overwhelmed by the older master, and was precisely aware of the ways his work should be employed: it was appropriate for the personifications in the *Jurisprudence* lunette, but in the ceremonial scenes below of *Gregory and the Decretals* and *Justinian and the Pandects*, Michelangelo might never have existed. For different purposes Raphael produced different images, and he was sufficiently in control of his means to do this at the same moment on the same wall.

6 The Early Roman Easel Paintings and Work for Agostino Chigi

While he was decorating the Segnatura Raphael also painted several Madonnas. Most of his sketches for these are silverpoint (cat. 269–80): there is a particularly delightful series of a recumbent baby for the *Madonna di Loreto* (Chantilly, Musée Condé; a copy is D. p. 27), which must have been studied from life, and in these Raphael attains an intimate fluency that Leonardo did not surpass (e.g. cat. 272). Paintings like the *Aldobrandini Madonna* (London, National Gallery; D. p. 26) and the *Alba Madonna* (Washington, National Gallery; D. p. 35) present highly worked surfaces and exploit a grey–blue, grey–pink colour range, with the addition of rich green, an experiment with the dominant colours of the *School of Athens*. They are jewel-like in intention and execution and required preparation in the most precise media, silverpoint and red chalk. But this highly finished manner was reserved for small panels, and Raphael's immediately subsequent move was towards more painterly execution: the altarpieces the *Madonna di Foligno* (Vatican; D. p. 31) and the *Sistine Madonna* (Dresden, Gemäldegalerie; D. p. 36) are in a brighter and more lustrous range of colours. Both were prepared in black chalk (cat. 281, 282r).

It was probably in the spring of 1511 that Raphael received the commission for the chapel of Agostino Chigi in Santa Maria della Pace. This marked an important addition to the ranks of his patrons and a major expansion of his activities. Agostino Chigi was Julius's banker, and had been permitted to quarter his arms with Julius's own. He was probably the wealthiest man in Italy, and also a great builder – after the pope the most important patron in Rome.

The decoration of Agostino's chapel was to consist of frescoes, an altarpiece and two bronze roundels. The fresco decoration was probably begun immediately. It consists of two pairs of prophets at the top level, painted, according to Vasari, by Timoteo Viti to Raphael's design, and below, four opulent Sibyls, gracefully interlinked in a series of flowing curves. The figures are consciously reminiscent of the Sistine prophets and Sibyls, but their role here is more precise – they hold scrolls referring to Christ's Resurrection

which was to be the subject of the altarpiece, flanked by the two roundels of *Doubting Thomas* and the *Descent into Limbo*. The altarpiece, which proceeded no further than the design stage, was superseded by work on the second stanza, the Eliodoro, where Raphael made use of some of the same ideas and, indeed, some of the same figures. The *Resurrection* was an attempt to combine a drama of light, of a sort that Leonardo might have conceived, with Michelangelesque poignancy in the depiction of figures whose fear at the physical resurrection is also an allegory of the awareness Christ brings. At about the same time, Chigi gave Raphael two architectural commissions. One was to design a funerary chapel for himself, to incorporate the richest possible materials, coloured marbles, mosaics and a painted altarpiece, in the Della Rovere family church of Santa Maria del Popolo. For Chigi Raphael also designed a large building combining stables and a banqueting hall, adjacent to his villa on the Tiber.

The drawings for Santa Maria della Pace are excellent guides to Raphael's aims (cat. 297–315). For the prophets and Sibyls the *concetti* depict separate doll-like figures, rhythmically related (cat. 228v). For the altarpiece, on the other hand, Raphael made dynamic pentimento drawings, generating figures in violent movement (cat. 306v). Thus the different styles of the fresco, with heroic figures announcing the message of Christ's Resurrection, and the *Resurrection* itself with its explosive actions, were registered from the beginning. Apart from a single drawing for Hosea and Jonah (cat. 297) in pen and wash, the other two prophets, the Sibyls and their accompanying angels were prepared in red chalk (cat. 299ff.). The style is close to that of cat. 233r, with sharp contours and broad cross-hatching in the shadows, which Raphael did not want too dark, since each figure was to stand out complete against the feigned architectural setting. The requirement was breadth rather than weight, and Raphael carefully fitted his drawing style to this demand.

The altarpiece was to be a night scene, and the Resurrection taking place in a burst of light was to be the main source of illumination. For his figure studies Raphael here used black chalk (cat 306ff.), but he did not exploit the powers of contrast as fully as he might have done. Still thinking in Michelangelesque terms, he wanted complex and expressive internal modelling and tried to avoid eliminating details of form in the shadows or highlights. The resultant compromise, though it produced drawings of great beauty, was not altogether satisfactory. The figures tend to brittleness and over-elaboration, and in the second phase of the design, which must have followed very soon after the first, the drawing style becomes noticeably broader (cat. 310, 311). As a contrast Raphael conceived the bronze reliefs in a style of Neo-Classical precision, and the drawings for these are in pen and silverpoint, both used with great sharpness (cat. 312–15).

7 The Stanza d'Eliodoro

In the Stanza d'Eliodoro the break with the Segnatura is not quite total, but there are few other examples of a painter making such a radical change in style. Decoration of this room had been begun in 1508, but any painting already on the walls was destroyed to make way for Raphael's frescoes, and the ceiling, painted by Peruzzi and Ripanda, was greatly

modified in 1514 to incorporate large narrative scenes. The theme of the room, clarified by this re-planning, was God's protection of His Church, with episodes from the book of Maccabees (of particular interest to Julius) and the Acts of the Apostles, followed by two events in papal history to demonstrate the continuity of God's concern.

The first three frescoes, probably completed before Julius's death in February 1513, seem to have been executed in the order: *Expulsion of Heliodorus*, *Mass of Bolsena*, *Release of St Peter*. Raphael here deployed fewer and larger figures than in the Segnatura and exploited the dramatic possibilities of action, colour and light. The tonal range is much wider than hitherto, and the handling of paint, more like oils than fresco, is completely unprecedented. The cope of Julius in the *Mass of Bolsena* is given a rich creamy-white highlight on the shoulder, which is then glazed over lightly with scarlet, a technique rarely used so broadly even in oil painting of the period. The stool against which the pope kneels is constructed out of different tones of dark golden yellow, a purely optical painting without the use of defining lines which looks forward to Velázquez. The technique is much more advanced and inventive than that of Titian in his contemporary frescoes in Padua, and the objectivity and coolness in the portraiture of the Swiss guards also anticipates Velázquez.

In both the *Expulsion* and the *Bolsena*, Raphael places modern spectators in the historical scene, and in both he stresses the different status of the participants through costume, characterization and differing handling of paint — free and rich for the modern parts of *Heliodorus* and *Bolsena*, smooth and rather stony for the historical section of *Heliodorus*, and thinner and more liquid for the chorus of women and children in *Bolsena*.

Michelangelo is still present in the figure types, especially in the startled women on the left of *Heliodorus* and *Bolsena*. But Leonardo was also a great influence, and the group of the avenging angel and the crushed Heliodorus is taken from him — probably from his designs for the Sforza monument. The use of a dark background to give greater intensity to the half-tones and highlights must also derive from Leonardo's experiments.

Spatially, the frescoes show a progressive degree of liberation from the centralized pattern of the Segnatura. *Heliodorus*, with its elaborate and highly inventive temple interior, is structurally close to the *School of Athens*. *Bolsena*, while centralized on the purely painterly concept of the bleeding Host, is utterly inconsistent spatially, though the viewer is hardly aware of it. The *Release*, with its simplified setting and repeated figures, is openly artificial, and it was here, with clear subdivisions, that Raphael developed a full panoply of lighting effects: playing the great flare in the centre against the subdued radiance of the angel on the right, and the contrast of warm torchlight and cold moonlight on the left. It was a *ne plus ultra* of his art, and Raphael was to return to it only once in a modified form, in the *Transfiguration*.

The election of Giovanni de'Medici, the son of Lorenzo the Magnificent, as Pope Leo X after the death of Julius, was enormously important for Raphael. Having known Michelangelo from boyhood, the pope might have been expected to lavish favours on him, even though the sculptor was busily engaged on the enormous Tomb of Julius II. Instead his patronage went to Raphael, not merely for commissions in painting, but for tapestry designs, architecture, work in the

Vatican palace and, above all, the architecture of St Peter's, which Raphael took over on Bramante's death in 1514. It was under Leo that Raphael became pre-eminent in Rome, and the result was, with the enormous burden of work that was placed upon him not merely by the pope, but also by the pope's entourage, by Chigi, and by his own insatiable ambition, that the quality of his painting began to suffer in execution, and even, sometimes, in conception. This is exemplified in the *Repulse of Attila*, designed for Julius, but modified for the new pope, who is inserted, damagingly, in the left foreground in a space intended to be left open. This fresco marks a stylistic break and a qualitative decline. The forward sweep of Attila and his cavalry is based upon a study by Leonardo for the right wing of *Anghiari* (Windsor, Royal Collection; 12339r), while the landscape and incident seem to have been intended to transport the chiaroscuro richness of the other scenes to an outdoor setting, imitating the lush painterliness of the background of the *Madonna di Foligno*. And the complexity and heroism of the Michelangelesque figure type have been wholly abandoned. The composition is conceived in a relief manner, and the source for the figure style is, appropriately, Roman relief sculpture. Raphael consciously reduced the depth of his figures (as in the *Entombment*), to obtain a surface pattern and an action that were simultaneously violent and frozen. But the potentials of this conception, exploited further in the Stanza dell'Incendio and in the Psyche Loggia, were vitiated by the coarse execution, lack of colour harmony and weakness of modelling, quite apart from the failure to adjust the rest of the composition to take account of the changes on the left.

The survival rate of drawings for the first three frescoes is low. The compositional draft for the *Release of St Peter* survives, however; in broad wash and white heightening over a rough chalk sketch, it prefigures the painterly qualities of the fresco (cat. 338). This loose manner was to characterize many of the *modelli* produced in Raphael's studio, probably mainly by Penni, over the next few years.

The figure studies and cartoon fragments for *Heliodorus* (cat. 332ff.) are among Raphael's most dynamic, and lack the slight stiffness of most of the nude studies for the *Resurrection*. Black chalk is used with the greatest freedom for the most part, with relatively simple hatching, sparingly applied, for the shadows, curving lines for the drapery folds, and the lightest inscription of contour. The touch is everywhere light, and the deliberately restricted definition of forms obtains perfectly the effect of bodies in movement. All is evanescence and vitality, nothing is static or regular in these drawings, the perfect preparation of painterly painting.

The soft–hard alternation of media found in the Segnatura, however, certainly continued in Raphael's work. For the ceiling the compositions were prepared in vigorous but sharp-contoured pen and ink. In the cartoon (cat. 344), of course, Raphael employed black chalk, but in a different manner from hitherto. The chalk is rubbed so that comparatively few internal lines are visible, but the contours are kept hard. The style is in essence that of *schiacciato* relief in paint, with a sharp outline and subtle grading of the internal modelling.

At this point in his career, Raphael was using black chalk with extraordinary imaginativeness, but having reached this pitch of proficiency, he seems largely to have abandoned the medium. Only in the great projects of the very end of his life, the *Transfiguration* and the Sala di Costantino,

did black chalk become of primary importance once again. It is the *Repulse of Attila* that marks the moment of transition. Two preparatory studies survive for the fresco, and both are in silverpoint (cat. 339, 340). The second *modello* (cat. 341) (the first survives only in copies), although probably by Penni, registers the change: it is carried to a new pitch of hardness and density. Raphael seems to have felt the need to tighten his style, though there is an element of uncertainty in the actual process.

This change of style was possible in part because Raphael had continued to develop his silverpoint technique. In c. 1511–13 he made a number of designs for Holy Families, some of which remained unused (cat. 319ff.). These vary in complexity, but little in style and in quality of draughtsmanship. Raphael used a grey ground in order to approximate to grey underpainting, and white lead was applied lavishly and thickly. The line itself also tends to be thicker and more weighty than in the Segnatura silverpoints, and there are therefore strong contrasts of line and white around the low half-tone. The technique was ideal for transfer to engraving, and Raphael used it to obtain the most exquisite cameo effects. But in essence it represents a move from the rich, smoky surfaces of paintings like the *Aldobrandini Madonna* (London, National Gallery; D.p. 26), to the heavier, darker, more enamelled colours of the *Madonna del Pesce* (Madrid, Prado; D.p. 38) and the *Impannata* (Florence, Pitti; D.p. 38), where the form gains, or is intended to gain, in density and radiance. A hard but lambent style in panel and fresco, in a high or a low key, was clearly what Raphael was working towards after his peak of painterliness.

8 The Tapestry Cartoons

Apart from the massive architectural project for St Peter's, which must have preoccupied Raphael through much of 1514 and 1515 as he was preparing a design which made considerable changes to Bramante's plan, the work to which most of his energies were directed from c.1514–17 was the preparation of 10 coloured cartoons for tapestries depicting the missions of Sts Peter and Paul, to hang on the lowest level of the Sistine Chapel. In the seven cartoons that survive, the standard of execution is very much higher than in the contemporary Stanza dell'Incendio, and it is evident that for Raphael and Leo this project had priority. It was a necessary completion of the scheme of the chapel as a whole, for once the 12 apostles originally intended to fill the pendentives had been replaced by the prophets, Sibyls and Genesis scenes of Michelangelo's scheme, the succession of Christ was unaccounted for.

In undertaking the Tapestry cartoons, Raphael decided on an effect of heroic and austere simplicity. Large figures, severe and simple gestures, simplified areas of drapery, restrained colours and austere architectural settings gave these works a narrative stateliness that made them the founding models of the grand style.

The drawings for the Tapestry cartoons (cat. 355–66), like the cartoons themselves, are slightly apart in Raphael's later work. It was above all the ensemble that concerned him, and the need for clarity. The large pen sketch for the *Miraculous Draught* (cat. 356v) shows that breadth of form was a requirement from the earliest stages, and this was maintained in the compositional drafts. The style of the red-chalk drafts is a development of that of the Pace Sibyls: fast

parallel and cross-hatching for areas to be simplified or played down, and finer hatching, lightly rubbed, for features of more significance. In one of the drawings (cat. 358), thin repeated lines are used to define the pleated shirt of the model in studio dress; this drawing was presumably followed by one where the drapery patterns were established. But in another chalk drawing (cat. 365), Raphael economized by posing his models in generalized antique costume. He simplified the folds by establishing the highlights with a couple of bounding lines and allowing a ridge of spared paper to appear between them. The modelling method is also different. Rather thin parallel hatching lines are applied uniformly, with variations of thickness or direction corresponding to changes of plane and distinctions of significance. Subsidiary figures are treated with less incisive contours, and with lighter pressure of the chalk. Breadth of form was maintained in the *modelli*; even that drawn in silverpoint is simplified in detail with the drapery arranged in bold patterns, and the shadows kept light. And the other *modello* by Raphael (cat. 360) shows an overriding concern with clarity. In the two which are probably by Penni (cat. 357, 366), an index of Raphael's increased use of his studio, the comparative emptiness which is a feature of Penni's work is hardly a disadvantage.

9 The Roman Studio

One result of Raphael's many commitments was that he delegated much of the work on the Stanza dell'Incendio (1514–17) to his studio. The wall frescoes, intended to illustrate the election capitulations of Leo X, depict four stories of earlier popes with the name of Leo. The vault, frescoed by Perugino in 1508 and among the best of his late works, Raphael left intact, Vasari says as a tribute to his master. The scheme lacks the visual homogeneity of the earlier rooms, and two of the frescoes, the *Coronation of Charlemagne by Leo III* and the *Oath of Leo III*, allude to events in the reign of Leo X which occurred respectively in December 1515 and December 1516; thus there must have been last-minute alterations, if not completely new inventions.

The Stanza dell'Incendio poses a number of problems. Stylistically, the most significant frescoes are the *Fire in the Borgo* and the *Victory at Ostia*, the former an allegory of the pope extinguishing the flames of war, the second an exhortation to a crusade against the Turks. The other two frescoes are more or less successful and imaginative variants of the realistic ceremonial style which Raphael had employed on the Jurisprudence wall in the Segnatura. But the *Fire*, the *Victory* and to some extent the *Coronation* show, despite their differences, characteristics which had been implied in the *Repulse* and which were to be the foundation of much of Raphael's later work. These are, in summary terms, theatricality and self-consciousness, intellectuality of structure, the continued reference to Classical sculpture and the development of a simplified figural rhetoric. And despite their weaknesses all three were highly influential.

Both the *Fire* and *Ostia*, in different ways, call attention to themselves as artificial constructs. The first is divided into three parts corresponding to different moments of response to the fire, and, like the action, the architectural setting is self-evidently stagey. The design aims to provide a conspectus of human reactions and to evoke specific associa-

tions. The *Ostia* is less complex, but, on the right side, the ferryman bringing the prisoners to shore holds his boat against land by bracing his pole against the inside of the dado – an illusionistic trick. This attitude to representation, this play of different levels of reality inside and outside his pictures, was to be of great importance to Raphael in subsequent decorative schemes.

In the *Fire* and in the *Ostia* Raphael included more nude or semi-nude figures than before; Vasari saw here an effort to compete with Michelangelo, but this is only half true. Raphael was no longer trying to paint Michelangelesque figures, rather he was attempting to propagate an alternative mode of the nude, one based much more closely on Roman and Hellenistic sculpture. This was part cause, part consequence, of his increasing interest in all aspects of Classical antiquity. It corresponded to Leo's tastes and was part of Raphael's campaign to be recognized, like Mantegna before him, as the supreme exponent of the antique.

The antique also underlay Raphael's clothed figures, especially those of the women in the centre of the *Fire*, derived from a Niobe group. He has treated the women as individual expressive units, like sculpture, and with sculpture's density. His aim was to create figures which were neither realistic representations of action, nor metaphorical evocations of states of mind, but which partook of both, which were stylized for communication, but which remained real, which were expressive but not exaggerated. It was the heightened figure style evolved here which was to be an important foundation of Baroque classicism.

The *Ostia*, despite its much weaker execution, was also significant, for it was in the design of this fresco that Raphael further developed the formula of stressing the pictorial surface by adapting the principles of high-relief sculpture on an enlarged scale. The system provided a natural way to fill a surface, it avoided difficulties both of perspective and, to some extent, of foreshortening, it made the search for classical models easier and, depending on an antique principle, it was in keeping with Raphael's archaeologizing bent. Finally, it was a style which was easily assimilable. Still in its early stages in the *Ostia*, it was to be the system of the much more successful scheme on the vault of the Psyche Loggia in Agostino Chigi's villa, largely painted in 1518, and of Raphael's last great fresco project, the decoration of the Sala di Costantino.

The relief style was also intended to facilitate increased production and studio participation. Preoccupied with the Tapestry cartoons and with St Peter's, and perhaps bored with fresco painting and with the awkwardly shaped stanze, Raphael allowed his studio a large role. Earlier the pupils must have been kept very closely under his control, and their work is clearly visible only in the *Repulse of Attila*. But now large-scale studio participation was inescapable. Raphael realized that to avoid the sterility of the studio practice of a Perugino, he required assistants who were talented artists in their own right, and who would therefore have to be allowed some freedom. In this way, although he would lose a degree of control, he would gain a harmonious working team (and indeed all his pupils seem to have held him in great affection), a wider input of ideas and the capacity for more extensive production under his aegis. This would allow him to transform himself more and more into a conceptualizer and entrepreneur.

But the Stanza dell'Incendio represented a false start. Raphael gave his studio excessive freedom and seems to have allotted three of the walls entirely to assistants. The *Fire* he painted largely by himself, and also executed the cartoon. For the *Ostia* he probably provided sketches and certainly one detailed figure study (cat. 371); for the *Coronation*, sketches of different parts and probably a *concetto* of the composition (cat. 372 etc.); in the *Oath* it is doubtful whether he participated on any level (Fig. 7). The overall result has many weaknesses of design as well as of execution, and Raphael nowhere subsequently abdicated personal responsibility so completely, though it remains inexplicable that he did not correct the more glaring errors in his pupils' work.

It is in the Psyche Loggia in Agostino Chigi's Villa Farnesina that the working of the studio is seen at its most efficient. Here the scheme was of the utmost sophistication. Heavenly episodes of the story of Psyche are depicted in the pendentives (further heavenly episodes, in the lunettes, and the earthly scenes on the walls were never painted), and on the ceiling are the *Council of the Gods* and the *Marriage of Cupid and Psyche*. Raphael designed the decoration as though the Loggia were a temporary structure for a marriage feast. Within it he incorporated different levels of pictorial reality: the gods and goddesses in the pendentives stand in high relief in a shallow but indefinable space, as though on narrow ledges just outside the room; the airborne putti, cavorting with attributes of the gods in the spandrels, are seen as though in three-dimensional space; in the scenes in the crown of the vault the figures are treated like statuary – many deriving from known antiques, others brilliant inventions in an antique style – but they are arranged like relief sculpture, represented on simulated tapestries but painted in fresco. The effect is light-hearted and witty, elegant and ironic.

The 'studio' years of the Incendio and the Psyche Loggia, 1514–18, are the years of red chalk. Pen was used for *concetti* and rapid figure studies, although few survive; black chalk was sometimes used for composition sketches, and *modelli* were prepared in the usual combination of media. But red chalk was used for figure studies and was, in effect, the dominant medium.

The reasons for the prevalence of red chalk are impossible to elucidate fully, but they seem to concern both Raphael's figural ideals and his studio practice. The solidity, continuity and density of effect that could be obtained in red chalk were perfect for the essentially sculptural style of the Incendio and the Psyche Loggia, and in the mid- and late 1510s Raphael was concerned to give as much weight as possible to the individual figure. The frescoes in the Stanza dell'Incendio deliberately make play with display figures and with displaced emphases. Thus at the lower left of the *Coronation of Charlemagne* a partially nude figure, prepared in red chalk drawing (cat. 373), climbs into the fresco field, labouring excessively under the weight of a table and gazing at the spectator. What is in essence a genre detail, a porter shifting furniture at a ceremony, is given heroic emphasis, without obvious allegorical intent. This is an extreme case, but a tendency towards eccentricity of attention and redundant display runs through the frescoes. It had a great influence on later Roman cinquecento fresco painting.

Raphael, pressed for time as he was, also attempted to economize. Many of his drawings of 1514–18 have been lost, a larger proportion certainly than for the Segnatura phase. But it is undoubtedly the case that he produced fewer, and that those he did were mainly individual, highly detailed

figure studies; and the preparatory stage represented by drawings of this type became the central one. For the Psyche Loggia he seems to have prepared designs side by side with his pupils. It is significant that the poses and expressions decided upon in the detailed figure studies were usually not modified in translation to the fresco, even when they might appear weak. These drawings increasingly determined subsequent work, and there is no evidence that Raphael exerted consistent later control in the Psyche Loggia.

In this period Raphael employed such a range of red-chalk styles, most of which his pupils tried to imitate, that judgements of authorship are particularly difficult and controversial. In no area of his drawings is there so much dispute about attributions, and so much justifiable un-certainty. The problems are compounded by the fact that red chalk is the best medium for taking counterproofs, and many were taken. In some cases, both original and counter-proof have survived (e.g. cat. 408, 409), in others only the counterproof (cat. 410, 419). But since counterproofing can make a considerable difference to quality, weakening and flattening the original, this also gravely affects judgement, and can sometimes make an original seem no more interesting than a copy.

Virtually every red chalk drawing by Raphael that has survived for the Stanza dell'Incendio and for the Psyche Loggia is subtly different. And his pupils' work can usually be perceived (and then controversially) more by weaknesses of expression, coarseness of psychology, minor failures of rhythm and certain tricks of hand rather than by genuine differences of style. And working side by side with Raphael, the vigour of his personality produced in them talents which they were unable to realize out of his presence. Significantly, his two most important pupils, Giulio and Penni, seem to have made no use of red chalk after Raphael's death, and precious little of black.

The variety of Raphael's red chalk drawings may be demonstrated by some examples. The group of Aeneas and Anchises (cat. 367), for instance, was designed with the greatest care. Fine parallel hatching, carefully rubbed, predominates, but there is enough modulation to bring out details of musculature and texture. This can also be found in the most refined studies for the Psyche Loggia and the *Transfiguration*, where there is a consistent regularity of lines, conveying relief by the slightest variation of pressure. Regularity of line produces an effect of ease and fluency – it carries its own grace. For the *Fire*, however, Raphael also made a nude drawing for the young man hanging from the wall (cat. 368); here he wanted to create strain and a certain brittleness and exaggeration (although he has only a few inches to drop, the young man looks terrified, as though he might shatter). So Raphael used the chalk more laboriously, imitating pen. The hatching continually changes direction, sharply modelling the surface of the body, guided by a network of fine lines laying out the musculature. The contours are sharp, and much of the body is left with very little shading. The result is marmoreal, as though the surface of the body were reflecting the light.

In the studies for the women in the same fresco (cat. 369), the system is different once more: the forms are indicated with thin lines, the shadows are blocked in leaving ridges of highlight; and the hatching, which varies in direction, is laid on flatly, to divide the form into strongly legible planes in a manner influenced by Raphael's silverpoint drawings, such as cat. 322. In the famous study for *Ostia* sent

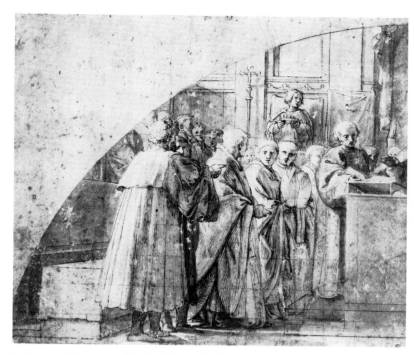

7. Giovanni Francesco Penni: *The Oath of Leo III*. 1516–17. Pen, wash and white heightening, stylus ruling squared in black chalk and scaled to 20 mm. 226 × 256 mm. Florence, Horne Museum.

to Dürer (cat. 371), the effect is different again, and this drawing, a demonstration piece, is handled with every imaginable sort of line. In some places Raphael made use of the finest bracelet hatching to convey the roundness of the limbs, and he took this up again, as did Giulio, in drawings for the Psyche Loggia (Cat. 420). In examples like these, red chalk is used as finely as silverpoint (cf. cat. 232). Raphael also produced fast sketches in red chalk, brilliantly evoking light and shade on drapery with the fastest and most regular of hatching, which could be played either against sharp contours for more plastic, or against thicker, vaguer contours for more atmospheric emphasis (cat. 372).

In drawings preparing panels, rather than frescoes, one finds other systems. In a study for the head of *St Michael* (Paris, Louvre; D. p. 47; cat. 397), for instance, the chalk is used in the cross-hatched manner developed from the Pace drawings; in the studies for the *Spasimo di Sicilia* (Madrid, Prado; D. p. 44; cat. 384), sharp and angular contour is filled with thin, energetic hatching, with large areas left more or less unarticulated. The method is akin to some of the Incendio drawings, but carried out with a sharper chalk.

The versatility that Raphael displayed in red chalk, dragging his pupils in his wake, was almost endless, and a drawing like cat. 412, probably done late in work on the Psyche Loggia, shows that he was capable of wringing entirely new possibilities out of the medium – using flickering hard accents of moistened chalk in the draperies – which anticipate Watteau.

10 Raphael and Giovanni da Udine

In the years 1516–19, Raphael also practised another form of collaboration, that of partial subcontracting. Here the important figure was Giovanni da Udine, the greatest expert on ancient Roman grotesque painting and stuccoing.

Giovanni's designs were almost indistinguishable from Roman originals (such as those in the recently excavated Golden House of Nero) and another area of expertise was thus opened to Raphael's organization, one where the master could entrust design and execution to Giovanni and his own team. This seems to have been the principle applied in the Loggetta and bathroom of Cardinal Bibbiena, painted in 1516, where only a few small figurative scenes were included, designed by Giulio Romano. In the Sala dei Palafrenieri in 1517 Giovanni was given a large, highly decorated frieze to paint, while the feigned statues of apostles in feigned niches were a comparatively easy task, for which Raphael undoubtedly made sketches and supervised some of the execution, but which he left mainly to Penni, who made the surviving drawings and seems to have painted the surviving fresco fragments.

The decoration of the third storey of the great loggia that fronts the east wing of the Vatican is the crowning example of the collaboration between Raphael and Giovanni da Udine; work probably began in 1516 and continued until 1519. Its 13 vaults contain 48 narrative scenes from the Old Testament and 4 from the New. They are of prodigious inventiveness, were enormously influential, and Vasari's statement that Raphael designed them can be generally accepted. Although only one sketch by Raphael survives for a narrative scene, this is a broad but incisive drawing in black chalk (cat. 390), where he situated only the main figures, intending, presumably, that a pupil should add the rest. Of the considerable number of surviving *modelli*, small and loose in handling because larger and more elaborate drawings were unnecessary for such small frescoes, only one can confidently be claimed as his (cat. 389). The rest are by Penni, though one or two come deceptively close to Raphael (Fig. 8). Finally, the executants, Giulio, Penni himself, Perino del Vaga and Polidoro da Caravaggio, made minor changes as they saw fit.

With the distinctive talents of Giovanni da Udine added to his own, Raphael was able to develop a wide range of

8. Giovanni Francesco Penni: *Jacob's Dream*. c. 1516. Pen, wash and white heightening over black chalk, squared in black chalk at 30 mm. 199 × 263 mm. London, British Museum.

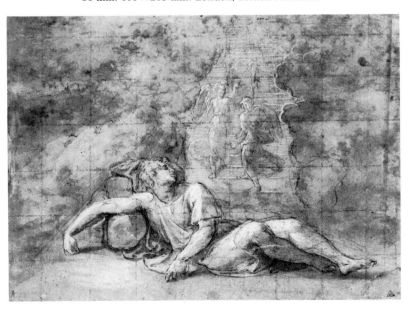

possibilities in these years. The introduction of grotesque decoration was to have incalculable influence throughout the cinquecento, and underwent a revival in the late eighteenth century. The use of feigned statuary to articulate interiors was to become a fundamental element in future fresco decoration. And the clear narrative structure of the Loggia scenes became a fundamental source for Poussin.

11 The Sala di Costantino

The last great fresco project of Raphael's life was the decoration of the Sala di Costantino (D. pp. 86–8). Although fairly dark, with a low ceiling, it was the largest room in the papal suite, and it gave Raphael one very long uninterrupted wall to paint on a grand scale. As in the Psyche Loggia, the sculptural narrative scenes are arranged on simulated tapestries, but in the Sala di Costantino Raphael attempted a further complexity and had the walls prepared for oil to attempt to achieve the hard, pearly lustre of his late panel paintings. The richer shadows and warmer sheen of oil paint would have glowed in the dark room, and he adjusted the style so that both selective and unselective focus was possible. When the room was fully lit the scenes would have been resplendent with detail; when penumbral, the central features would have stood out against the shadows. After his death, his pupils removed the oil preparation and executed the scheme in fresco, but two trial figures in oil, undoubtedly painted in Raphael's lifetime, remain. The feigned tapestries are strung between large niches containing enthroned popes, important figures of the early Church. They are flanked by wide pilasters, before which are seated personifications of Virtues. Above them, male, female and hermaphroditic figures notionally supported the beams of the ceiling, replaced in the later sixteenth century by the present vault, which greatly alters the original appearance of the room and makes it very much lighter.

The scheme treated four episodes from the life of Constantine: his vision of the True Cross (the *Adlocutio*), his subsequent victory over Maxentius, his baptism and his donation of temporal sway to Pope Sylvester. The *Donation*, a key scene, since the document confirming it, on which the papacy rested much of its territorial claim, had recently been attacked as a forgery, underwent several changes of plan after Raphael's death (cf. cat. 448, 449, Fig. 10), as did the *Baptism*. Only the *Battle* and, to a lesser extent, the *Adlocutio* can really be called his. The programme, with its large crowd scenes, called for great skill, but above all it enabled Raphael to prove himself as a battle painter. Like other late work, the *Battle of the Milvian Bridge* is in part a return to Leonardo, to the *Anghiari*, from which it borrows several details; but for his basic composition Raphael chose the relief mode – and for the *Battle* drew specifically on a relief on the Arch of Constantine, as he also did for the *Adlocutio*.

For this rich scheme for dark oil painting, Raphael prepared his drawings in soft black chalk. These differ according to the required degree of definition: in his single surviving figure study for the *Adlocutio*, for example (a composition much altered by Giulio and Penni after Raphael's death), the style is harder and sharper than in the studies for the *Battle*, because the wall is seen under a raking light with a window opening directly on to it (cat. 444r). In drawings for the *Battle*, however (e.g. cat. 441), where the

lighting is more diffused, Raphael took up the mode of cat. 345 of five or six years earlier. The contours are relatively unmodulated, the soft black chalk, lightly applied, is rubbed in the shadows until it creates a broad mass of shade, then the lights are enriched with white laid on – perhaps with a fingertip – so that brush strokes are invisible. Thus the figure is built up of masses of light and shade, with only a few elements accentuated with a sharper chalk.

In the studies for *Charity* and the caryatid above her (cat. 452, 453), the style is taken perhaps as far as it could be towards the evocative and the lyrical. The thin lines appear to float onto the paper, the areas of shadow seem brushed on, yet the forms are nevertheless conjured into warm fleshly rotundity by minimal means. In contrast with this silky delicacy, the head of Leo (cat. 455), a form which required powerful emphasis, is a study of brutal power, where fine subtleties of grading in the shadows are set against the most lavish and forceful application of white. In Raphael's hands the vaporous and the aggressive could coexist, both triumphantly realized.

12 *The Last Years and the* Transfiguration

During Raphael's last half decade in Rome, his career expanded still further: probably in 1518 he became Maestro delle Strade; he began an elaborate reconstruction of ancient Rome; he procured antiquities for the pope; he received from Cardinal Giulio de'Medici, the cousin of Leo X, the architectural commission for the Villa Madama, the largest secular building of the period; he built the Palazzo Branconio dell'Aquila, which marked an epoch in palace façades, employing frescoes, stucco figures and a syncopated rhythm of niches standing above columns; and he planned a new palace for himself in the Via Giulia. His role as an architect led him increasingly to architectural theory. He planned an edition of Vitruvius and wrote Leo X a long disquisition on the need to revive the rich materials of Roman architecture. And artistic and intellectual success was closely allied to social success. In 1514 he could write to his uncle that Cardinal Bibbiena had offered him one of his relations in marriage, and the fact that he temporized about this offer, a rare honour for an artist, demonstrates how powerful his position was, and what potential he considered he had.

In his last years Raphael's shop was working with supreme efficiency. Antonio da Sangallo the younger was a reliable draughtsman and executant for Raphael's building projects, as was Giovanni da Udine for his decorative schemes. Marcantonio Raimondi and his assistants published many of Raphael's works in refined and elaborate copperplate engravings, propagating his inventions on a scale which approached that of Dürer. And his major pupils, Giulio Romano and Giovanni Francesco Penni, were by now able to design and paint frescoes and panels of very high quality. Such were the demands on Raphael's time that even important paintings might be delegated entirely to his assistants, although he himself, like Rubens later, made a firm distinction between what was actually from his own hand and what was not. Thus when the Duke of Ferrara, who had seen the portrait of *Joanna of Aragon* (Paris, Louvre; D. p. 63) in France in 1518, wrote to ask for the cartoon, Raphael sent it to him, but stated that both it and the painting were by an assistant, whom Vasari identifies as Giulio Romano. The Duke's request demonstrates the esteem in which Raphael's drawings were held, for he had already given him the cartoon for the *St Michael*, and a cartoon for a 'history of Leo IV', undoubtedly the *Fire in the Borgo*, as part compensation for his delays with the Duke's commission, a *Triumph of Bacchus*. In the execution of paintings, Raphael was a law unto himself: the portraits of *Castiglione* (Paris, Louvre; D. p. 33) of early 1516, and that of the *Donna Velata* (Florence, Pitti; D. p. 32), probably his mistress, of a year or two later, are certainly by his hand alone. But in the *Madonna del Pesce* (Madrid, Prado; D. p. 38), for example, designed c. 1514 but probably not completed till around 1516 (cat. 351, 352), he painted the face of the Virgin and very little more, and in the *Spasimo di Sicilia* (Madrid, Prado; D. p. 44; cat. 384, 385), probably of 1515–16, he likewise painted only the faces of Christ and Joseph of Arimathea. In the *St Cecilia* (Bologna; D. p. 39; cat. 381, 382) of 1515–17, which marks the apogee of the 'columnar' style, all except the still-life of musical instruments, by Giovanni da Udine, was due to Raphael. His system of production, then, was not mechanical, it changed according to the time he had available, and also, undoubtedly, to whim or mood – his melancholy and moodiness are commented on towards the end of his life.

Raphael worked in two main styles of easel painting in the last years of his life: the painterly, atmospheric mode of the *Castiglione*, reserved for works on canvas, and the hard and lambent *sfumato* of the *St Michael* (Paris, Louvre; D. p. 47; cat. 397), for works on panel. It was the latter, representing a renewed interest in the later work of Leonardo, and perhaps also Fra Bartolommeo, which was his main public style, referred to by Sebastiano as 'steel and smoke'. Raphael's revived interest in Leonardo extended also to his compositions, as in, for example, the most beautiful of his late Madonnas, the almost entirely autograph *Perla* (Madrid, Prado; D. p. 51; Cat. 422), which is a rectilinear re-working of Leonardo's National Gallery cartoon.

In the last five years of his life, Raphael was sufficiently confident of his position to patronize other artists whom he had formerly ousted; Peruzzi and Sodoma both worked again for Chigi in the Farnesina in these years, the latter even making use of Raphael's inventions. And Michelangelo, who had become a bitter enemy, had been virtually compelled to return to Florence. But Sebastiano, another of the artists whom Raphael had supplanted in the service of Chigi, was tougher. He had greater gifts as a painter than any other rival and was provided with drawings by Michelangelo. A whispering campaign was mounted against Raphael, attacking the inadequacies of execution of his later fresco schemes. This was acknowledged by Cardinal Giulio in 1516 when, as a contest, he commissioned large altarpieces of identical size from both artists, ostensibly to be sent to the Cathedral of Narbonne. Sebastiano, helped by Michelangelo's drawings, completed his *Raising of Lazarus* (London, National Gallery) quickly. Raphael pondered his *Transfiguration* (Vatican; D. p. 52). First he treated the scene simply, with a very large figure of Christ, in direct competition with the manner of his rival (cat. 423). Then he returned to the strategy of his youth, by juxtaposing two episodes not strictly linked but assimilable, as in his *Coronation of the Virgin*. He devised a composition on two levels, the Transfiguration above and the Healing of the

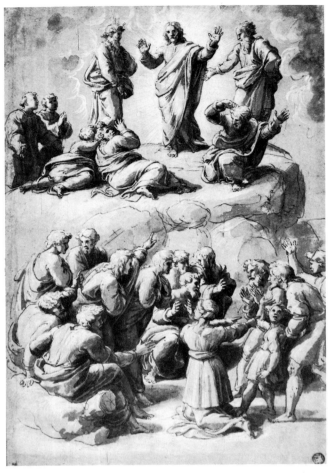

9. Anonymous copy after Giovanni Francesco Penni after Raphael: the second project for the *Transfiguration*. Pen, wash and white heightening. 413 × 274 mm. Paris, Musée du Louvre.

however, is more simplified (cat. 427), as befits their position in space and the fact that their lower limbs play no part in the painting. Raphael also allowed his pupils to participate in this stage, and it is notable that although their drawings are efficient, they are less convincing spatially, less unified rhythmically and less precise texturally and emotionally (cat. 428, 429). Next Raphael clothed his figures, employing black chalk with white heightening for his drapery studies (cat. 431). Then he probably made careful studies of the different actors (cat. 432), and only then drew, or had drawn, the cartoon. Finally he produced a series of his most sublime drawings as auxiliary cartoons, studying the apostles' faces in the greatest detail and creating a range of expressive portraiture which combines human response and a rational distribution of emotion (cat. 433–8). In this painting, then, there was no economizing in the preparation, and Raphael returned to the full range of drawings that he had employed in the Segnatura, but on new levels of realism and idealism, his careful studies of the nude making themselves felt in the authenticity of gesture and response. The result, both in painting and drawing, is a summary of everything he had learned in 20 years of activity. He could not foresee that the painting would be his last, but he could not have made a more profound statement.

Raphael died on 6 April 1520, and a week later Sebastiano took the *Raising of Lazarus* to the Vatican to compare it with the *Transfiguration*. He said that he was not disappointed. But it was Raphael's painting that was kept in Rome, and Sebastiano's that was exiled to Narbonne. Raphael's triumph was posthumous, but nevertheless a triumph. He had produced a painting which, for coherence and complexity, for unity of whole and individuality of part, has never been surpassed.

13 Giovanni Francesco Penni and Giulio Romano

Of Raphael's many pupils, the two leading ones were the Florentine, Giovanni Francesco Penni, and the Roman, Giulio Romano: he named them as his artistic heirs and they completed the commissions left unfinished at his death. Penni never succeeded in establishing himself as an independent artist, but Giulio Romano, a strong personality, was from late 1524 court artist and architect in Mantua and eventually occupied a position there even more authoritative than his master's position in Rome. And in the years 1520–4, when he and Penni were working together in Rome – the demigods in Cellini's phrase – Giulio was clearly the leading partner.

Penni was born in 1496, Giulio probably in 1499. Both were probably taken into Raphael's studio at an early age; Penni perhaps while Raphael was still in Florence. Both were in their teens when they began to play a noticeable part in Raphael's artistic production in the mid-1510s, and Giulio, for whose authorship of the highly sophisticated *Joanna of Aragon* (Paris, Louvre; D. p. 63) in 1518 there is unimpeachable evidence, must have been as precocious as Raphael himself. According to his own testimony to Vasari, Giulio also collaborated on the portrait of *Leo X with Two Cardinals* (Florence, Uffizi; D. p. 46), painted in the same year. Giulio added that he had never had his own compositions engraved in Raphael's lifetime out of respect for his master, and this

Possessed Boy below. At first Christ was shown standing on the upper level (Fig. 9), but then Raphael decided upon an airborne Christ, thus making this area a visionary experience for the spectator as well as for the disciples (cat. 424, 430). Once again there are large debts to Leonardo: the composition derives in part from the *Adoration*, and there is a complimentary quotation to acknowledge the relationship. The figure style contains little trace of Michelangelo, however. It is developed from the heroic, rhetorical manner of the *Fire*, now more fluidly and fluently employed. The use of light is a revival of the effects of the unexecuted *Resurrection* and of the *Release of Peter*, united now to the rich enamel of the *St Michael*. Much use is made of colour-change modelling in the draperies, in part to keep all areas of the picture in action, in part to create a colouristic instability to echo the emotional tension. And in the landscape background Raphael created a view as rich as a Lotto and as structured as a Poussin.

Only pupil drawings or copies survive to document the first two stages (cat. 423, Fig. 9), but when the two-level composition had been determined (see, for example, cat. 424), Raphael made an extensive series of figure drawings. First he made fast, sharp sketches from the model to check poses and gestures (cat. 425), and only then fully elaborated red chalk studies. The drawing for the left foreground, for example (cat. 426), could hardly be more detailed and informative. The study of the next pair,

implies that he had made paintings and designs on his own account. For Penni, who died in 1528 and who was personally unknown to Vasari, there is much less reliable information. He seems always to have been a shadowy and dependent figure, less inventive and less imaginative than Giulio, though it is virtually certain that he too produced some paintings of his own while Raphael was still alive.

Thus for the last five years of Raphael's life there were three personalities in constant movement in his workshop: the master, perhaps the most protean of all artistic geniuses, hiding an intensely nervous disposition under the most urbane surface, in a continual ferment of activity and experiment; the elder pupil taking his colour from his surroundings; the younger pupil, a powerful and rapidly developing artist, also continually changing to meet his master's demands.

The difficulties of distinguishing the hands in paintings are considerable. Paintings were not intended to look like composites, and anomalies could, if necessary, be corrected by retouching. Theoretically, in drawings the problem should be easier. It is rare that more than one artist worked on the same drawing, although at least one is generally recognized as showing the collaboration of Giulio and Penni after Raphael's death (Fig. 10). But the difficulties are in fact great, partly because there are so few fixed points to go on. Raphael's own drawing styles were multiple and continually changing, and when actively involved in a project his pupils naturally followed his stylistic decisions, adapting their manner of drawing to accord with them.

By Giulio there are two early independent works, both Madonnas. The first, a *Madonna, Child and St John* (Paris, Louvre), based in composition on Raphael's *Madonna della Sedia* (Florence, Pitti; D. p. 36), is probably to be dated

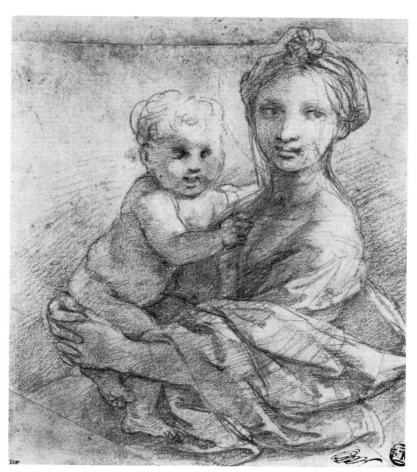

11. Giulio Romano: Virgin and Child for the Louvre *Virgin, Child and St John. c.*1517 (?) Red chalk over stylus. 210 × 176 mm. Paris, Musée du Louvre.

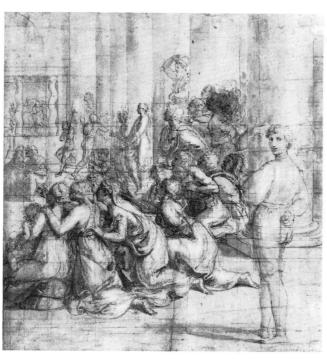

10. Giulio Romano and Giovanni Francesco Penni: *The Donation of Constantine* (right half). 1521 (?) Pen, wash and white heightening over black chalk, indented and with faint auxiliary lines in red chalk, squared in black chalk at 18 mm. 273 × 247 mm. Oxford, Ashmolean.

c. 1516–17. The other, the *Madonna and Child* (Rome, Galleria Nazionale), is usually dated after Raphael's death, but was probably painted before 1520. There are drawings connected with both. The former (Fig. 11) comes close in style to Raphael's studies for the dome mosaics in the Chigi Chapel in Santa Maria del Popolo (cat. 386, 387), but is stiffer in rhythm: Giulio straightened the head of the Virgin, originally bent forward, to avoid too close a similarity to the *Sedia*. The Child, His forms half dissolved by the fall of light, is particularly lively and charming, but flabbier in modelling than one would expect from Raphael. The Virgin's left arm has thick, inexpressive contours, and lacks volume – a deformation Raphael sometimes exploited for positive reasons, but which is here awkward. Giulio has also experienced some difficulty with the drapery, which is too angular in arrangement. The treatment of the arm especially supports the attribution to Giulio of several other drawings (cat. 393, 402, 403).

The second drawing (Fig. 12), in black chalk, is very close to the finished painting, almost a *modello*. In feature – the Virgin's almond eyes, pencilled eyebrows and full mouth – the similarity to Fig. 11 is very close, as also is the slightly clumsy angularity of the drapery. The chalk is not, for most part, densely worked, and the hatching is multi-directional, coming closest to the *Ganymede* (cat. 404) of *c.* 1518; there are also links with cat. 379 (which must, however, be earlier than it is usually dated, perhaps *c.* 1515), and with cat. 378, presumably of 1517, which shows precisely the same

difficulties with the contour of the right side. The simple hatching of the Child's leg, more naïve than anything to be found in Raphael, also supports the attribution to Giulio of cat. 440. The composition is worked out with a firm, perhaps too firm, sense of geometry, which links it with Raphael's late classicizing phase, but despite Giulio's efforts, there is a lack of differentiation of textures. As Giulio's paintings show, he could be a craftsman of the highest quality, but his flesh, draperies and still-life details all have the same metallic texture, and where Raphael glows he glints. Fig. 12, incidentally, strongly supports the thesis that Giulio completed the portrait of the *Fornarina* as Venus in the Galleria Nazionale, Rome (D. p. 43).

Giulio's hard style can be seen clearly in the drawings at Chatsworth that were prepared for Marco da Ravenna's engravings of the 12 apostles, dated 1516, and also in the drawing (Fig. 13) which probably served as *modello* both for the delicate *Small Holy Family* (Paris, Louvre; D. p. 49) and for the engraving of it by Caraglio. This stony manner was ideal for an engraver to follow. Thus although Giulio's work in the years 1516–20 can hardly be said to undergo a coherent development (at least in the present state of knowledge), it does seem increasingly to be definable. Giulio follows Raphael very closely indeed, but his divergences from the master's work connect with one another. The adaptability of Giulio's mind and hand was almost as great as Raphael's own, but Raphael was protean while Giulio was only versatile. After the master's death Giulio's versatility evaporates, and although he remained among the most brilliant designers in an antique manner, his drawing style

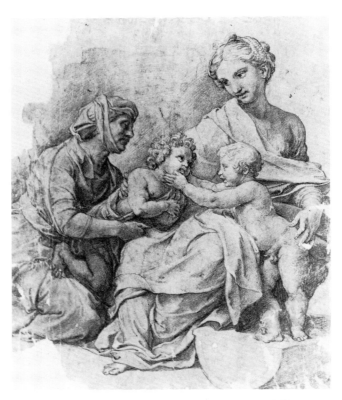

13. Giulio Romano after Raphael (?): *Virgin and Child with St Elizabeth and St John. c.* 1517 (?) Red chalk over stylus. 269 × 224 mm. Windsor, Royal Collection.

becomes increasingly uniform, although at times of great beauty, and his use of media limited to pen, brush and wash.

Penni is much less definable as a chalk draughtsman. He seems to have had a less incisive approach to form than Giulio and generally to have aimed for greater softness of texture. What may be his red chalk style was most heavily influenced by the soft broad mode that Raphael developed around 1514–15 for the Tapestry cartoons, e.g. cat. 365. Penni aimed for continuity of form, but combined this with a lack of appreciation of dynamic relief and a stumbling sense of rhythm. Insofar as can be judged, given the uncertainties of attribution, during the preparation of the Psyche Loggia he came increasingly under the influence of Giulio – by 1518 they probably worked at least as much together as either did with Raphael – and in some cases it is very unclear to which of the pupils a drawing should be allocated (e.g. cat. 400).

Penni's style in pen seems clearer. A drawing in Munich (Graphische Sammlung 2989) for *Martha Presenting the Magdalen to Christ* for the decoration of the Massimi Chapel in Santa Trinità (a *modello* in pen, brush and wash, also by Penni, is Chatsworth 63) shows characteristics of Penni's later independent drawings in the elongated and willowy figure types and the comparative vapidity of the facial expressions. The style is very close indeed to that of a copy of a lost Raphael drawing for the *Disputa* (Fig. 18); it strongly supports the attribution of this to Penni, and implies his formation in Raphael's early Roman studio. Comparable handling of pen can be seen in the *modelli* for the *Oath of Leo* (Fig. 7) and for the *Coronation of Charlemagne* (cat. 374), both of which are generally accepted as by Penni.

Penni's preferred medium seems to have been brush, wash and white heightening over black chalk underdraw-

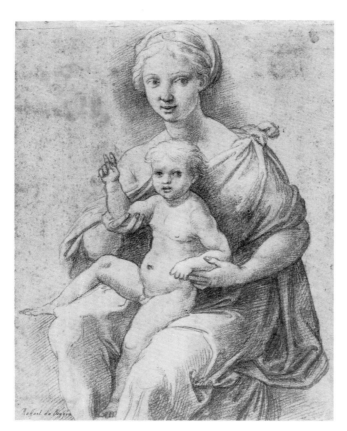

12. Giulio Romano: Virgin and Child for the *Barberini Madonna*. Black and white chalk over stylus. 274 × 210 mm. Private Collection.

ing, usually with a pen outline, and sometimes with internal pen hatching to strengthen the relief. It was in this technique that he obtained his most delicate effects, and one of his most important functions for Raphael was as a drafter of compositional studies, *modelli*, and perhaps, presentation drawings (e.g. cat. 366r, 381). He may well have performed the same role for Giulio after Raphael's death.

There seem to be three modes of brush and wash drawing by Penni, all of which derive from Raphael. The loose preparatory studies of light and shade were done as compositional drafts. In some cases, for the Loggia for example, these seem to have been as far as graphic preparation went; Fig. 8 is a particularly fine example. Then there were much tighter and more elaborate multi-media *modelli*, highly finished and carefully outlined, which were, presumably, immediately preparatory to the cartoon stage (e.g. cat. 366r). There are also brush and wash drawings, deriving from Raphael's (e.g. cat. 112) which are pure studies of form and light: the study of a child (cat. 353) is one of them, of very high quality, and cat. 324 combines both qualities. Cat. 324 is the only drawing that can be connected with a more or less independent painting by Penni, the tondo at Cava dei Tirreni which is traditionally ascribed to him. It was probably done around the middle of the 1510s.

The defects of Penni's drawings seem also to be those of his paintings, a careful but somewhat mechanical grading of tones and a failure to seize upon the selective focus of Raphael, with the result that the works have an all-over uniformity. Penni could sometimes sketch landscape details of extreme beauty in white lead – a capacity which also derived from Raphael – but was less successful in integrating figures and background. Even when, under Giulio's sway, he produced harder painting, his forms lack solidity, weight and relief. Under Raphael his textures are soft and blurred, but he fails to pass from the unincisive to the evocative. Psychologically his characterization tends towards the pathetic and the vapid, entirely unlike Raphael's penetrating sympathy or Giulio's passionate intensity. Left to himself, Penni was incapable of sustaining inspiration, and a painting which Vasari records as his, the full-size copy of the *Transfiguration* now in the Prado, lacks unity, tonal harmony, and strong relief despite its very dark tones. Eventually Penni's real forte seems to have been small, Emilian-style figure compositions with doll-like figures attractively if unenergetically disposed within large spaces. His life after his master's death must have been as empty for him as it appears to us, but he does have the

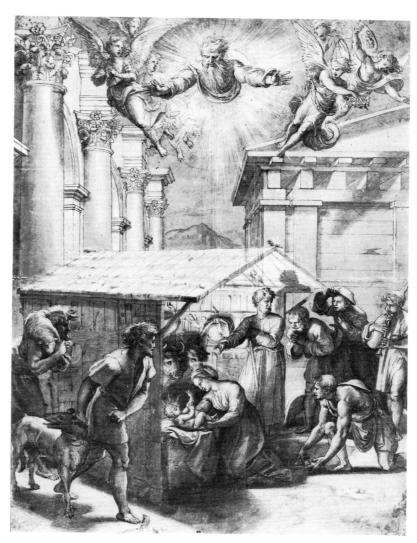

14. Giovanni Francesco Penni after Raphael: *Nativity. c.* 1520. Pen, wash and white heightening over black chalk. 543 × 401 mm. Paris, Musée du Louvre.

permanent glory of having collaborated with one of the greatest of all artists and, in some cases, of preserving ideas of his master that might otherwise have been lost. Perhaps the most remarkable is the *Nativity* (Fig. 14), one of Raphael's most brilliant late inventions, whose influence was incalculable, affecting artists from Correggio through Annibale Carracci and Domenichino to Rubens.

PLATES

1. God the Father Creating Eve

archer (copy after Signorelli)

Oxford, Ashmolean 501r
Black chalk, pen
254 × 216 mm, cut down left, right and top (recto of Plate 2)

The chalk drawing for God the Father was used, with some changes, in the banner Raphael painted for the Confraternity of the Holy Trinity in Città di Castello (Città di Castello, Pinacoteca; D. p. 3)). It was probably executed as an *ex voto* during the plague of 1499. The copy is after an archer on the right-hand side of Signorelli's *Martyrdom of St Sebastian*, originally painted for the church of San Domenico in the same town and now in the Pinacoteca. Probably in 1502 Raphael painted the *Mond Crucifixion* (London, National Gallery; D. p. 8) for the same church, to be installed opposite Signorelli's painting.

The study of God the Father focuses on the drapery, studied either from a bending model (though the position would be difficult to hold) or from a lay figure. Raphael had obviously determined the basic pose and was concerned to organize the pattern of folds. He decided upon a heavy material, and his use of the chalk reflects the choice, for it is densely handled, particularly in the shadows, and extremely regular in application. The chalk is rubbed slightly in the deepest shadows behind the left leg and in the cascade of folds that falls inside the right knee, but there is comparatively little differentiation of texture and no tonal modification to suggest changes of colour.

Even as early as 1499 Raphael's structural sense is firm. The fold of drapery that tightens across the figure's right wrist links directly with a fold of drapery below it, thus stressing the movement of the hand within the material. Similarly, the lower side of the left hand continues the upper fold of the drapery on the right knee. These features were all modified in the painting, where greater tonal contrasts achieve a more plastic and less obviously surface-stressing effect. The movement of the drapery is also made less ponderous and more lively in the painting; the lower edge of the material on the left leg ascends smartly in a curve which counters that rising from the right foot, in the painting though it is largely hidden behind Adam. This sets a pattern for much later work by Raphael, where changes and modifications are made even after drawings that seem definitive. The use of the deep shadow behind the left leg, where the outer contour of the drapery echoes the inner contour, is a notably ingenious device which allows the figure to provide its own frame; a dark edge of drapery adds to the bulk of the figure conceptually, but at the same time compels attention centripetally.

The copy from Signorelli (cf. also cat. 3v, 34v) demonstrates Raphael's selective concern. He has made every effort to achieve a swelling rhythm in the form of the leg, and this heralds an interest which will be expressed repeatedly over the next three or four years; the contour in fact is much livelier than in Signorelli's original.

CAT. 11r

2. Sketches of the Virgin with the Child and St John

sketch of a castle

Oxford, Ashmolean 501v
Pen, over traces of black chalk in the groups centre right and lower left
254 × 216 mm., cut down left, right and top (verso of Plate 1)

Raphael has experimented with three different versions of the theme. At upper right an elongated standing Virgin gazes down at the reclining Child over whom St John leans; immediately to the left she is studied again with her head and arm in different positions; in the centre she is shown striding forward in a way that looks backward to Ghirlandaio and forward to Raphael's own Magdalen in the *Entombment* (cf. cat. 138r). The St John upper right may have been studied from a mature model, for he looks far older than a child and is in a more complex pose than a child could assume; Raphael has shown little concern with the figure scale. While this composition was presumably intended to be considerably higher than wide, that beneath, depicting St John supporting the Child on the pack saddle would have been square; here again the proportions of the Virgin are unusually large. This motif was common in Perugino's circle towards 1500, but Raphael's variant (probably, like the recto, of 1499) places new emphasis on the relationship between the children. The study lower left is of considerable complexity and is more effectively unified than the others – the sway of St John's hip locking into the curve described by the Virgin – and the psychological links are much more sharply focused. The page shows the range of Raphael's *concetto* style, from the stick-like treatment of the limbs, to the rounded and expressive heads. The modelling of the central group on the right, for example, is exceptionally effective, with a highly sophisticated use of broken contours on the Child, and doubled lines for the calf-bone (as on the lower left). The stressing of the pen line on the contours reveals an instinctive feel for the tension between skin and flesh, and the shape of the saddle, created by swift parallel hatching on interior and exterior, is set against the soft inner padding, indicated merely by a few dots.

A careful examination of the study for the Fano predella of the *Marriage of the Virgin* (Fig. 15) reveals such a close similarity of conception and technique – the double lines for the legs, the swell of the head, the concentration of expression – that the attribution to Raphael seems inescapable. The urinating putto top right, similar to putti in Perugino's paintings of the late 1490s (for example those in the Marseilles altarpiece), is again very like the children centre right, especially in the use of the two lines defining the basic position of the leg, and the two swelling lines for its contour.

The sheet of studies also includes a drawing of buildings at upper left. It is difficult to decipher, but seems to show a church from the right side, on a plinth, with a campanile and tower behind it, a small tower in front of it, and a line of buildings against its left flank. The small towers on the right are difficult to locate spatially, but the assemblage of motifs was common property in the Perugino workshop, deriving ultimately from northern painting.

CAT. 11v

15. Raphael: suitor breaking his wand for the predella panel of the *Marriage of the Virgin* to the *Madonna and Saints* by Perugino in Santa Maria Nuova, Fano; urinating putto. Pen. 163 × 121 mm. Florence, Uffizi.

3. *Compositional study for the*
Coronation of St Nicholas of Tolentino

Lille, Musée des Beaux-Arts 474
Black chalk, over stylus for upper three figures, much compass, stylus and divider work; squared in black chalk at 30 mm.
409 × 265 mm., cut all round (?) (recto of Plate 4)

This drawing, dateable late 1500, is the largest surviving study for the painting, fragments of which are now in Naples, Capodimonte; Brescia, Pinacoteca Tosio Martinengo; Paris, Louvre. The upper figures were probably first studied on separate sheets and then transferred to their places here. Raphael shows God the Father and the Virgin still as studio models, but St Augustine (cf. cat. 17r) has here been given his final(?) characterization. Below, the figures of St Nicholas, Satan and the accompanying angel have been loosely sketched (cf. D. pp. 1–3). The pose of St Nicholas and the angularity of his chest, hips and limbs, come very close to Perugino, both in conception and in style of drawing, although even here the jutting of the left knee and the rhythm of the left calf are bolder and more lively than they would be in Perugino's work. The figure of Satan, with his crushed wings under his shoulders and his tail curling out from under his thighs, is treated in broader strokes, and in his calves the chalk takes on virtually a charcoal consistency. There is thus a considerable range of handling and a wide variety of aims and objectives within the same study. The proliferation of compass work demonstrates the mathematical exactness that underlies the clarity of Raphael's arrangement. The intersection of mandorla and arch, for example, is a brilliant device for isolating God the Father within an overall harmony, since His figure is designed to make productive use of the architecture that He conceals. The lower arch of the loggia cuts across His body at the level of the crown He is holding, and the next arch at the level of His eyes. Nothing is wasted; everything is intensely cogitated, and the capacity for using the half-obscured arch to counterpoint and complement the figure superimposed upon it suggests a mind of great subtlety and clarity. The crowns held by God the Father, the Virgin and St Augustine form the upper three points of a diamond, slightly weighted downwards as the fourth intersection is at the middle rather than the top of St Nicholas's head; the head of the left-hand angel stands in the same relation to the head of St Nicholas as does the head of the Virgin to that of God the Father; the smallest arch of the loggia, continued in a circle, intersects with St Nicholas's head: the geometrical alignments that Raphael has devised here are numberless.

CAT. 14r

4. Head of St Nicholas

drapery studies, the corner bay of a cortile, studies of birds

Lille, Musée des Beaux-Arts 475
Black chalk, pen
409 × 265 mm., cut all round(?) (verso of Plate 3)

The drapery studies on this page for the angel to the left of St Nicholas are drawn incisively with a shallow, surface-stressing relief. The architecture of the cortile bay is not dissimilar to that of the Palazzo Ducale in Urbino, but the decorative pediment on the *piano nobile* window occurs frequently in Perugino's work, and is not necessarily drawn from a real building. It is interesting to note that Raphael has hinted at an overlap in the pilaster framing the corner bay, suggesting that he was already thinking of the differential stress that became so important in High Renaissance architecture. The birds are densely drawn but texturally convincing, and modulate between the accurately rendered perspective of the standing swan and the more patterned treatment of the nesting bird. Despite their liveliness, it is unlikely that they were studied directly from life: they may have been taken, as Michael Jaffé has suggested, from embroideries.

The most remarkable drawing, however, is the study of a head. Drawn from the life, it clearly attempts to impart a pensive and slightly melancholy mood (crushing Satan like an earthly St Michael is, for St Nicholas, an inevitable but not a triumphal task). The drawing demonstrates Raphael's precise command of mood and brilliant abilities as a portraitist from the beginning of his career. The handling ranges from the thin parallel strokes on the side of the hat to the still thinner, and lightly rubbed, chalk strokes on the left side of the face, which indicate shadow but preserve form. The eye and mouth are put in as precisely as with silverpoint, probably with a slightly moistened chalk; the control is such that one even perceives the play of light over the eyelids. The shadows under the nose and chin are more heavily drawn, to weight the face downwards towards the sombre realm. And in a particularly bold move, Raphael has darkened the hair that curls out on the lighted right side of his face, in contrast with the broader but more widely spaced lines on the left side, in order to frame his face and hold it in the plane in tense balance with its turn. The level of skill attained in this drawing is astounding for a seventeen-year-old, and is superior in its economy and precision to anything produced by Raphael's Umbrian contemporaries and elders.

CAT. 14v

5. Head and right hand of an angel playing the viol da braccio

London, British Museum Pp. 1–67
Silverpoint on white ground
276 × 196 mm.

A sharply focused study for the angel on the right of the *Coronation* (1503; Vatican; D. p. 10), as posed in the final version; like the other silverpoints for this painting, the drawing is on a light ground to prepare for the high Pieresque key of light and colour. The silverpoint has been used with complete confidence to study the bony elegance and musical movement of the hand, and, in a series of whorls to bring out the hair, lightly blown across the angel's right cheek and out behind the left side of his head. The hatching is particularly economical: the solid blocks around the eyes and under the nose are increasingly tightly spaced down the right side of the face and under the chin. The light falling from the right creates a movement counter to the direction of the wind, which registers the significance of the central action. At this late stage in the composition, when Raphael had decided upon a Coronation instead of an Assumption, he aimed for the utmost clarity and distinctness of every part, and the irregular movements of the silverpoint take on the sharpness of a burin. The slight difference in angle between the hatching on the right side of the cheek and that in the hair serves to stress the differences of position and texture – the hair does not blow out parallel with the cheek. The broader, heavier contour, which exploits the very limited capacity for modulation of silverpoint (whose emphasis therefore becomes doubly effective), is used on the left side of the hand as on the left side of the face. The effect is to give a leading edge to the forms, a partial framework around which the rest coheres.

CAT. 44

6. *Auxiliary Cartoon for the Head of St James in the* Coronation of the Virgin

London, British Museum 1895–9–15–610
Black chalk over pouncing
274 × 216 mm., cut down at all four corners

As one of the key rhetorical figures in the *Coronation* of 1503 (Vatican; D. p. 10), situated at the right edge and therefore partly a lead-in (following the fall of light) and partly a closure (following the normal left-to-right scanning), St James's head is studied in a manner which is significantly different from that of the other auxiliary cartoons. The sculpturesque analysis of the large expanse of neck, with open cross-hatching laid like a mesh over the throat, gives it a smooth volume but also a surface texture; they act in conjunction with the slight shadow to form a plinth for the upturned face. The drawing is also an exercise in linear rhythm, for the left side of the face, accentuated by repeated lines rather than by a thicker chalk, takes up the curves of the front of the neck in the lower part of the cheek, and the back of the neck in, successively, the chin and the forehead. The shading on the neck even at the left under the ear is still open and light, but in the hair Raphael has pressed harder to create a vital and luxuriant growth which acts both as a halo and as a frame.

The *Coronation of the Virgin* is the earliest painting by Raphael for which auxiliary cartoons survive. They were probably used more widely than the small number of surviving examples suggests, but on the whole Raphael seems to have employed them for particularly important projects, such as this the most complex of his early altarpieces. Auxiliary cartoons do not seem to have played a major role in Perugino's workshop, but they may reflect the experiments of Verrocchio and Leonardo in the 1470s; their use suggests that Raphael's range of reference was wider than that of his associates. At this stage of his career, however, his efforts were bent on achieving a superior version of the regional style rather than on establishing stylistic independence. It is interesting to see also how Raphael has here not been afraid to create anatomical inaccuracies for formal and emotional effect – the back of the head can hardly be located, the nose is deliberately twisted slightly to the right so that it intersects with the inward bend of the eye-socket but does not break through it, reinforcing the upward curve of the whole head.

CAT. 50

45

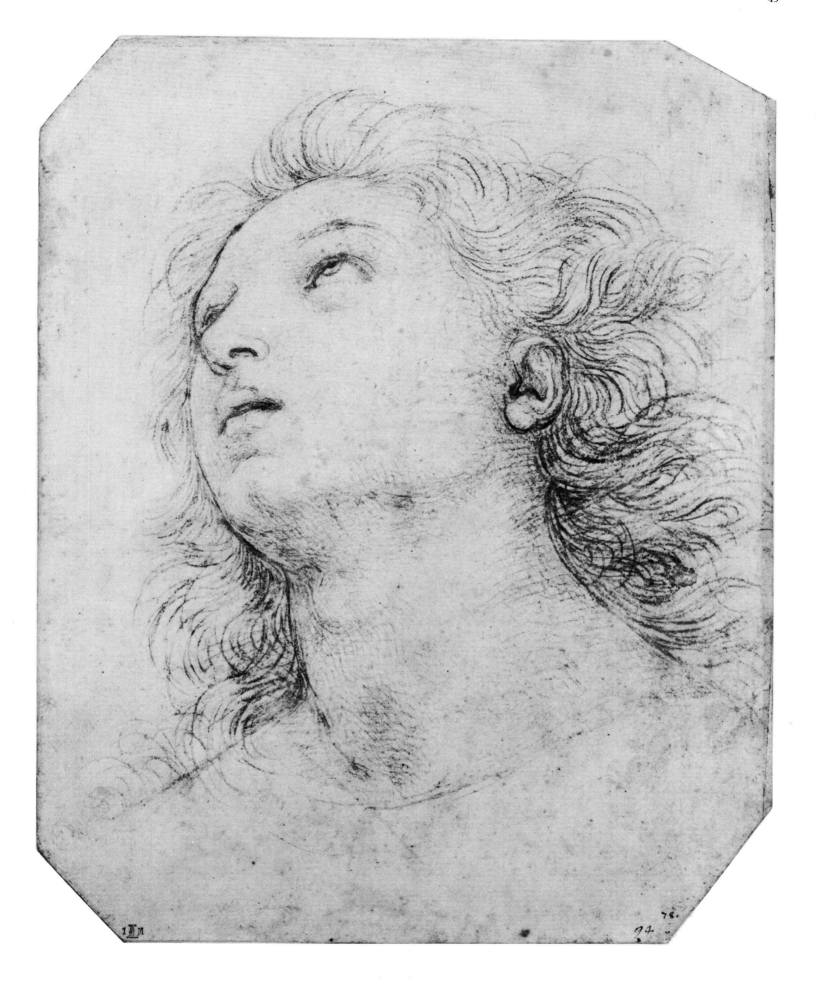

7. *The Adoration of the Magi and Shepherds*

Stockholm, Nationalmuseum 296
Pen over stylus and traces of black chalk
272 × 419 mm.

This is one of the most brilliant of Raphael's early pen drawings, for the rigorous clarity of the stroke, the confident creation of form by stressed outline, and the extremely complex arrangement of the figures. The composition of the predella panel to the *Coronation* of 1503 (Vatican; D. p. 10) extends considerably further to the left, showing more of the Magi's entourage, but this study, which does not appear to have been cut down, describes fully the most important groups. The basic pattern is of two diagonals leading in from left and right towards the Virgin and Child. But this is complicated by the subsidiary pyramid formed by the kneeling shepherd and the kneeling king, both of whom are situated nearer in space to the spectator than the Virgin, and both of whom lead the eye up to her head. This group is enclosed by the struts and walls of the stable, and the two kings, one kneeling, one standing, together with St Joseph, the Virgin and the Child, are given an additional emphasis by the coincidence of three of the heads with the struts of the stable. Quintessentially Raphaelesque is the grouping on the left, with the halberdier seen from behind looking away

from the central action, and the soldier next to him, battleaxe lowered, moving towards it. The contrasting centres of gravity balance one another and render the movement into the centre scintillating and adventurous, as the eye registers counter movements within the overall progression.

The handling of the pen is unerring, with widely spaced, unemphatic hatching employed for shadow rather than local modelling, though it is varied to convey the roundness of calves or the angles of planes of drapery. But most of the work is done by the contours, of which Raphael's control here, at the age of twenty, is awesome. He achieves, for example, real tension in the feet and ankles of the axeman on the left, who, his attention caught, advances in a movement of awakened comprehension.

Raphael's design had great impact in Umbria and was quickly borrowed for much larger paintings. The composition as a whole looks forward five years to the left side of the *Disputa* (Plate 18).

CAT. 52

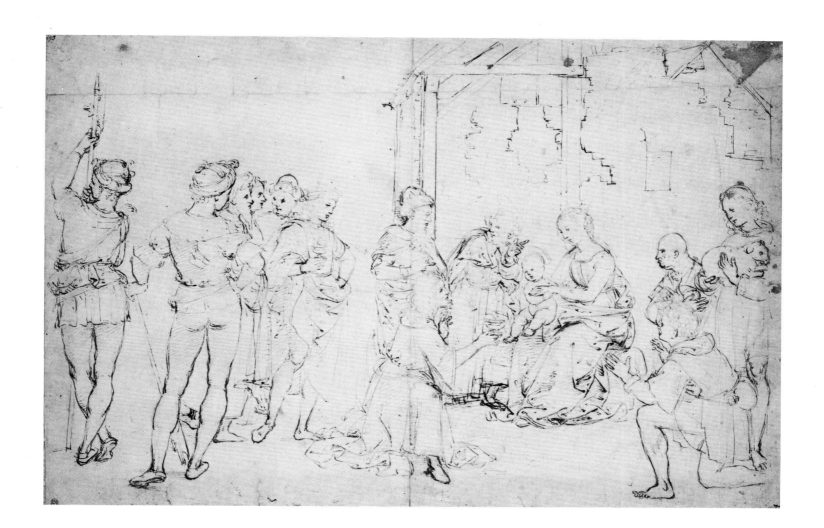

8. *The Journey of Aeneas Silvius Piccolomini to Basle*

Florence, Uffizi 520E
Pen, brush and wash, white heightening over traces of black chalk and stylus; squared in pen at 27 mm.
705 × 415 mm. maximum (arched top)

Comparison between Raphael's *modello* of *c.* 1503 and Pinturicchio's fresco (Fig. 16) shows immediately why the twenty-year-old artist was called upon to help a man some thirty years his senior, and clearly demonstrates the latter's conceptual inferiority. The energy and complexity of Raphael's design was greatly weakened in the fresco, where Pinturicchio's decorative forms were superimposed. Thus the sequence of rounded shapes in Raphael's drawing – the chest of the left-hand horse, the hindquarters of the horse in the middle, and the Signorellian buttocks of the halberdier on the right – are travestied and blurred in Pinturicchio's transcription. There the bold central feature, the hindquarters, is largely hidden by the long, formless tail which replaces the curling tail, flicked outwards by the lively horse, of Raphael's design. As in the *Adoration* (Plate 7), Raphael has made a particular use of an oblique arrangement, in this case the horse and rider just left of centre and the distant ship above them, so that the left to right movement, which is first slowed by the juxtaposition of the ass's and horse's heads on the left, is then propelled at a different angle and rhythm into the picture space. In some respects, the disposition foreshadows much later work by Raphael in that the attendants are placed in the foreground and it is through their screen that the more important figures of the clerics are observed. The composition also specifically serves as the introduction to the series. The sequence of frescoes begins in a minor key, corresponding to Aeneas's own career; it ends on the opposite wall with the hero, now Pope Pius II, carried forward out of the fresco. Thus the left to right movement, and the intentional lack of stability of Plate 8, leads us into the next compartment and into the biography. The balance between the self-containment of the individual scene and the awareness of the part it must play within the sequence is already inherent in this composition, and was a concept entirely beyond Pinturicchio. The use of wash and white heightening was to be characteristic of Raphael's *modelli*, and may have owed something to the example of his father. Unexpected for Raphael are the detailed depictions of ships in the background, which must have been prepared in numerous studies now lost – evidence of his visual omnivorousness which should not be forgotten. The pose of the soldier on the right is virtually identical with that in cat. 94r, and the interest shown in stretched limbs in his early paintings and drawings here finds its most complex manifestation. He uses the turning and twisting limbs of men and horses to throw the weight of

his composition upwards, for they provide a latticework foreground support for the mass of individually characterized heads which form more or less the half-way horizontal. Perugino and his followers tended to line their casts up in a flat, monotonous way showing all the limbs of all the figures. Raphael learned early on the value of variety and judicious omission, and here just enough is shown for the scene to seem physically convincing. The careful differentiation of garments adds liveliness to the procession.

CAT. 56

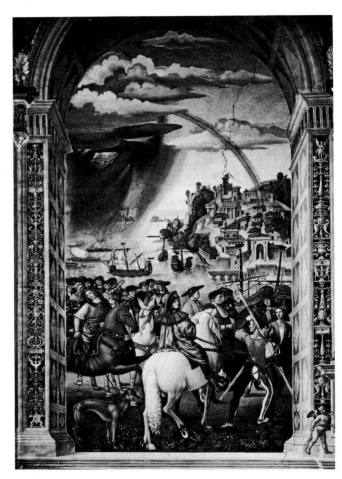

16. Pinturicchio: *The Journey of Aeneas Silvius Piccolomini to Basle.*
c. 1503. Siena, Piccolomini Library.

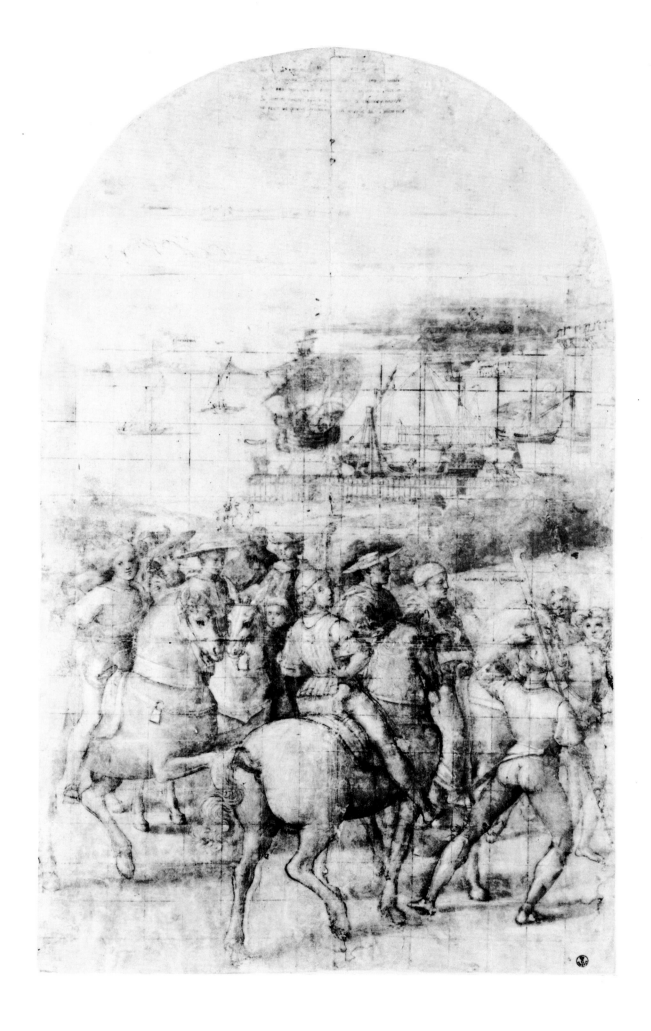

9. *Four Soldiers*

Oxford, Ashmolean 510
Silverpoint on blue ground
213 × 221 mm.

One of the most unexpected and adroit of Raphael's early silverpoint drawings, this study of four soldiers, probably of 1503, is a preparation for a background group in the *Coronation of Aeneas Piccolomini as a Poet on the Capitoline Hill*, the third fresco in the biographical sequence painted in the Piccolomini library. The blue ground does not seem to have had a definite function in this case, for the key of the fresco is high, although Raphael may perhaps have wanted to lower the tone of the background figures slightly so that they did not intrude upon the foreground. The choice of silverpoint was, however, quite deliberate, and it provided the sharp image for the group that was particularly necessary for this fresco, where the composition is open, with scattered loci of interest, unlike others whose compositions are more architectonic.

The drawing shows a dynamism more familiar from the pen sketches of the Florentine phase than from an Umbrian silverpoint. The changes in position of the right arm of the second soldier from the left – first drawn lightly held up above the shoulder, then held out at waist level grasping a sword, and then close to the thigh – demonstrate a very early awareness of the advantages of pentimento drawing in obtaining physical coherence and organic movement. The soldier immediately to his left was also drawn in several positions; in one, his left arm grasps the left elbow of his comrade; similarly, the head of the soldier at far left was drawn facing inwards as well as outwards. All this may suggest a precocious knowledge of Leonardo. The soldier at the far right, leaning on his lance, is obviously related both to the figure in the *Adoration* (Plate 7) and to one in the fresco on the exterior of the Piccolomini Library. This type of figure, which later in the sixteenth century was often to take on the function of a quasi-independent virtuoso piece within ceremonial compositions, is a bold combination of realistic observation and clever stylization in the way it expands upwards from the crossed calves to the raised arms. In the figure at the far left a similar positioning of the arms is contrasted with the wide spread of the legs. The four figures together show the infinitely greater variety of poses in Raphael's work than in that of his Umbrian seniors.

The extremely vigorous and confident hatching, which analyses the figures into broad forms, is also worthy of note; once more Raphael adopts a technique more usually associated with pen than with silverpoint.

CAT. 58r

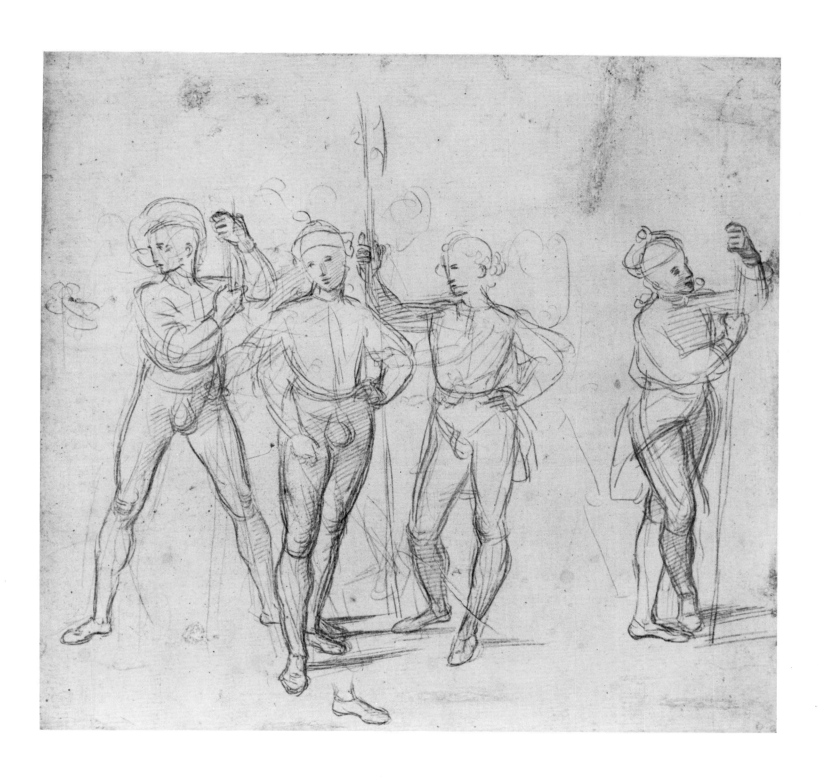

10. *Studies for the* Trinity *in San Severo, Perugia*

copy after Leonardo's Battle of Anghiari

Oxford, Ashmolean 535
Silverpoint and white heightening on white ground
212 × 274 mm.

This page provides a conspectus of Raphael's exceptionally varied use of silverpoint early in his Florentine period (*c.* 1505). The small sketch after Leonardo (top left) was made from one of his lost preparatory drawings for *Anghiari* rather than from the fragmentary mural formerly in the Palazzo Vecchio, Florence, for it shows the left-hand rider, the standard-bearer, with his left arm bent under the staff of his banner, rather than over it as in the final version; also, the horse seen from the rear was never incorporated in the painting and was probably copied from a drawing by Leonardo now at Windsor (Royal Collection 12339r). Though tiny, the *Anghiari* copy is extremely precise and constitutes an invaluable record of Leonardo's preparatory work; it is also remarkable for the way in which Raphael has succeeded in achieving sufficient variety in the contours to suggest the tension of physical action – the grip of the standard-bearer's thighs on the body of his horse, or the effort of the fighting men on the ground. The heads of the two horses in the centre are sketched again in outline within the shoulder of the young saint.

The profile of the aged saint (a study for the *Trinity* (D. p. 68)) is also closely derived from Leonardo, but the handling is typical of Raphael at his most instinctively brilliant; the basic structure is achieved by fairly regular parallel hatching, and the bumps and hollows of bone and flesh are brought out with an apparently infinite range of small, scratching strokes. Raphael completed the study by drawing a hard contour line down the profile, and re-worked the area round the eye, the brow and the bag of flesh underneath it with a hard and ruthless loop of the silverpoint.

Most remarkable of all, perhaps, is the solemn and intelligent head of the young saint, one of Raphael's most geometrical conceptions, as pure as a Brancusi. Using a very fine point, Raphael has woven a microscopically thin and varied mesh over the face, with minimal gradations of line serving to define the form. In this drawing Raphael equals Leonardesque *sfumato* in a medium which one would not have thought capable of sustaining it. Certainly the desire for clarity and plasticity in a head which was to be seen from a certain distance must have played a part in the choice of medium and handling, but the drawing is also the result of Raphael's sheer joy in his own virtuosity.

CAT. 99

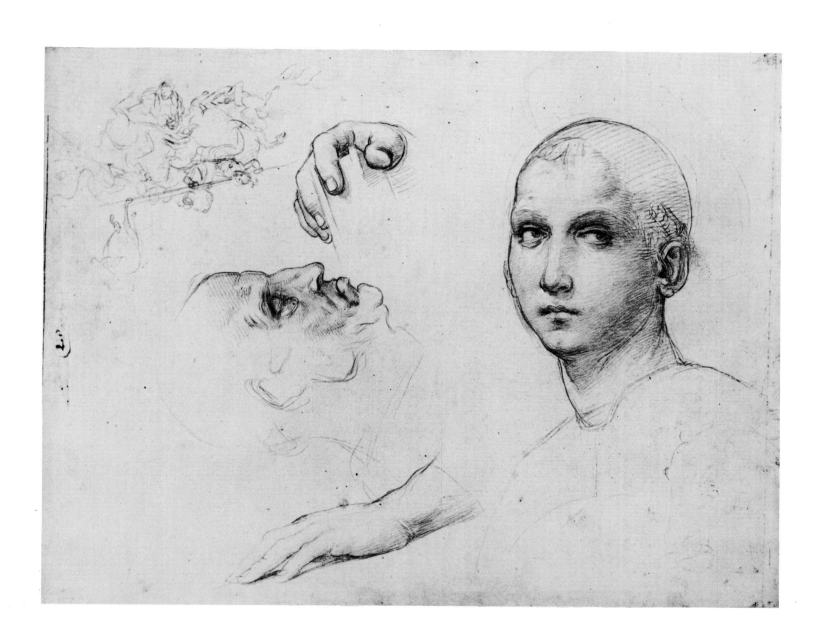

11. *Studies for the* Madonna of the Meadow

Vienna, Albertina Bd. IV, 207
Pen over stylus
362 × 245 mm., cut at bottom, right and perhaps left, a patched hole upper centre

The recto of this sheet of studies for the *Madonna of the Meadow* (1505 or 1506; Vienna, Kunsthistorisches Museum; D. p. 20) seems to antedate the verso. Raphael presumably took the sheet, folded it, and used each of the two rectangles thus obtained in a horizontal plane (for the most part); he then opened the sheet out and drew on the other side as a whole, also in a horizontal plane. The upper section was used first: here he drew the basic arrangement of the seated Madonna supporting the standing Child with both hands, one at His chest, the other at His back, with the Child accepting the cross from the infant Baptist. Alongside he made studies of the two children, with the Baptist now turning away to his right. He next experimented with another pose for the Baptist, facing inwards once more just to the left of this group, and sketched him again, very faintly, at far left. Then, using the lower section, he first reconsidered the basic arrangement and extended the Virgin's right leg out to her left, a motif (deriving from Leonardo's designs of the Virgin, Child and St Anne) which he exploited much more vigorously on the verso, though he modified it somewhat in the painting. It was next the exact role of the Baptist that preoccupied him. In the main group the infant St John advances solemnly from the left with folded arms,

carrying not the cross, but perhaps fruit, a symbol of the Passion. The figure was studied again at the centre. Further to the right he showed the Baptist now leaning eagerly forward; he briefly considered showing him tugging his forelock in respect, but this whimsical idea was quickly cancelled. Above, the Baptist's facial expression is studied – on the left dignified, at the right exhortatory – and at the far right there is a bold revision of his overall location; he is now depicted coming round from behind the Virgin, with his head drawn at two different angles. The sketch lower right is probably another version of this.

This series of studies clearly emphasizes that much precise thought went into the creation of mood and character in the Florentine Madonnas. Their form is not merely formalism, but a coherent blend of human character, prospective tragedy and immanent divinity.

The sketch of the Virgin with the Child on her lap (upper centre) was pursued further on a sheet of studies for Madonna compositions (cat. 108r). In all probability it was developed into the *Northbrook Madonna* (Worcester, Mass., D. p. 61), which was largely executed by an associate(?) on Raphael's design.

CAT. 110r

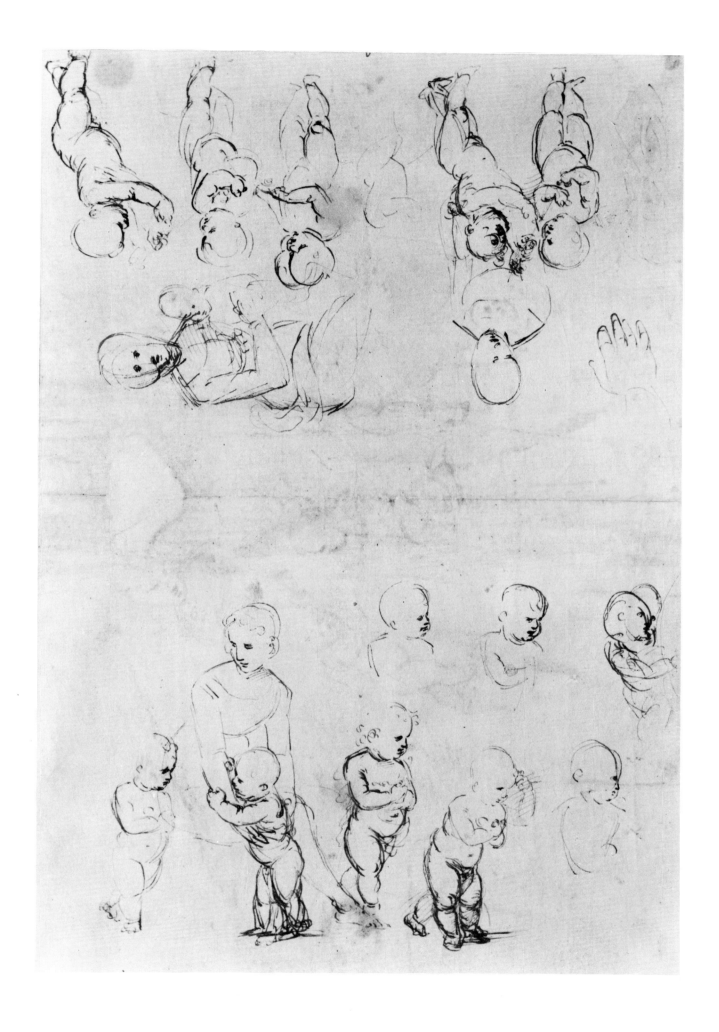

12. St George and the Dragon

Florence, Uffizi 529E
Pen over black chalk, minutely and comprehensively pricked for transfer; a central plumb-line first incised and then pricked above
St George's helmet and below the dragon's right hind paw
263 × 213 mm.

Perhaps the cartoon for the small painting of *St George and the Dragon*, probably of 1506; (now in Washington D. p. 13). Compared with the earlier painting of the subject, now in the Louvre (D. p. 5), and the silverpoint drawing (cat. 117), which shows an earlier version of the present design, the concentration and energy of this pen drawing are remarkable. St George's head is the highest point in the composition, lying on the centre vertical. His horse's hind legs occupy the lower right-hand corner. The whole arrangement thus forms a triangle, and the lance – the diagonal – thrusts all the weight of St George and his horse on to the dragon squirming in the lower left corner. (The rodent-like movement of the dragon suggests that Raphael had observed otter-hunting and the reptilian forms seem to demonstrate knowledge of Leonardo's drawings.) The composition shows how the pyramidal form, usually associated with Virgin and Child compositions, could be productively employed even within an action scene. Although this drawing is highly finished, Raphael made a number of changes in the painting. Thus the sword is omitted here, but its strap was lightly outlined and pricked close to St George's thigh. Subsequently, in the *modello* (cat. 119), and, more clearly, in the painting, Raphael saw that the strap would be most effective meeting the scabbard at the corner of the saddle-blanket. In this drawing it is also unclear what he intends for the back of the saint's neck, since the hatching lines merge directly into the cloak, and at this stage St George's chainmail skirt seems not to have been envisaged. These features were remedied in the *modello* (cat. 119), which was probably pounced through from this. The hatching is very lively, ranging from the very tight mesh on the horse's hindquarters to the broad and very rapid strokes on the dragon's cave on the left, where Raphael has deliberately blurred the detail; it is probable that this section was inked in after the main group had been established. The quality of the pen line is as sharp and precise as etching, although the ink is now somewhat faded.

CAT. 118

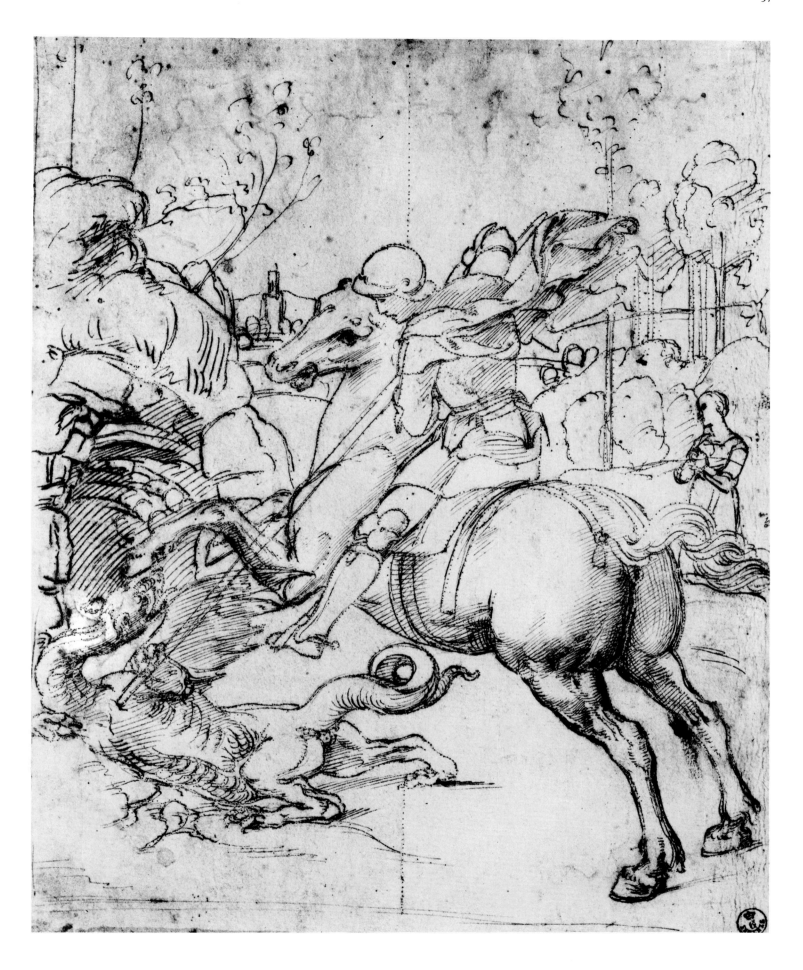

13. *Study for the* Entombment

Florence, Uffizi 538E

Pen over traces of black chalk, squared in pen at 24 mm., in red chalk and stylus at 27 mm.; the head of the bearer at far left pricked
289 × 298 mm.

This study for the main group in the *Entombment*, (1507; Rome, Galleria Borghese; D.p. 23) is a late stage in the development of the most complex composition of Raphael's Florentine years, and one which clearly displays the effort he has put into it. Some changes were still to be made in the deployment of characters – the holy woman at the right was later incorporated into the right-hand group with the fainting Virgin, which had clearly not been devised at this point – and many minor adjustments were made in the exact positioning of limbs and heads. Nevertheless, the drawing is of particular interest since it shows how Raphael conscious-ly determined the final effect of the painting, and intended the figures to stand away from the background in silhouette rather than to exist in depth. For here the very close cross-hatching, which is not the product of later re-working but was developed very much under Michelangelo's influence, is deliberately used in order to create a smooth but shallow relief, within carefully bounded contours. Thus although the characterization of the right-hand bearer was altered in the painting, the lack of depth in his shoulders seen here was transferred with minimal change – it was not physical

reality that Raphael desired in this instance, but a clearly readable pattern across the surface. On the whole, the cross-hatching is here used to simplify form and create a marmoreal surface texture, and not particularly to bring out subtleties of modelling. Yet in Christ's face it can easily be seen that the features are composed virtually without contour lines, simply by adjustment of the hatching – a virtuoso practice again derived from Michelangelo and present in other drawings connected with the *Entombment* (e.g. cat. 129). The local brilliance of this treatment, which can also be seen in a slightly less developed form in the faces of the three bearers surrounding Christ, emphasizes that the restricted handling of the pen in the rest of the drawing was quite intentional, the polished bas-relief mode being very much desired.

The squaring in pen seems to be the final one, and the difference in dimension between that and the red chalk squaring may have been due to Raphael's desire to expand the central section of the painting, and group the Virgin and her attendants into a narrower space.

CAT. 137

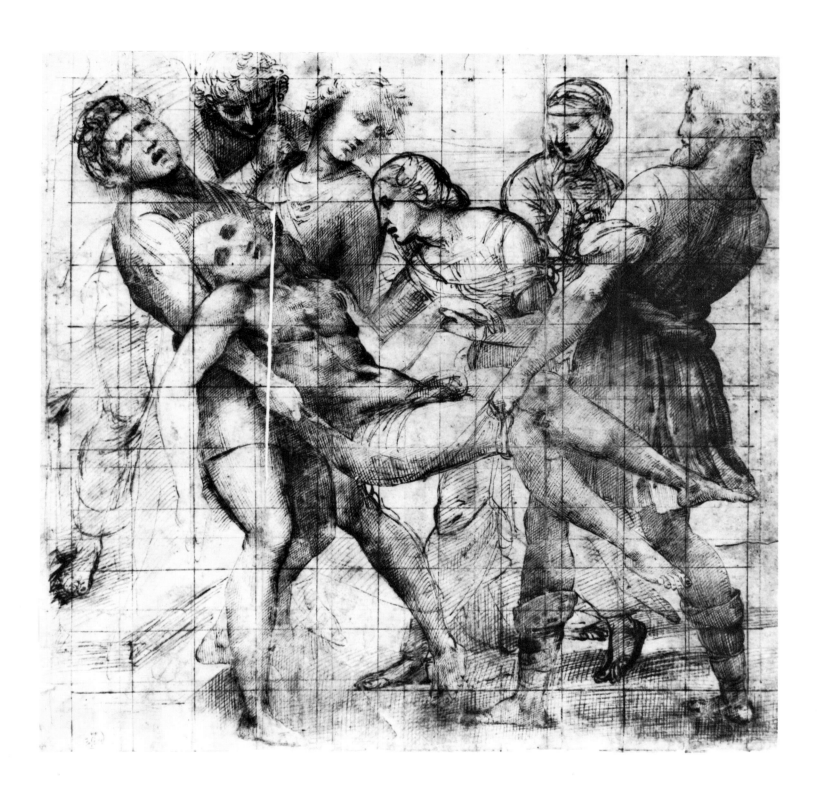

14. *Cartoon for* St Catherine

Paris, Louvre 3871
Black chalk and white heightening, pricked for transfer
587 × 436 mm., on four sheets, two large, two small; cut at left and below; some holes repaired

The best-preserved of Raphael's surviving cartoons for a painting of 1507 or 1508 (London, National Gallery; D. p. 25) on which he clearly lavished enormous attention in design and execution and which has the most varied and rich colours of any of his late Florentine/early Roman pictures. Having thought initially of a full-length figure (cf. cat. 158r), Raphael soon realized that the three-quarter length would create a more potent upward movement; and indeed, the tapering thighs and broad hips provide the base of a spiral which propels her gaze upwards with such force that far from being the passive receiver of grace she is instead launched towards it. The pose was inspired by Leonardo's standing *Leda*, which Raphael had copied (cat. 98), and whose voluptuousness he transmuted into religious ecstasy.

The design is virtually a textbook demonstration of *contrapposto* and interlocking curves. The drapery fold over the advanced left thigh, more of which is seen in the painting, runs into the left hand and wrist, forcing the left shoulder back so that the head comes forward, discreetly rather than emphatically. The loop of drapery that curves up the right hip links visually with the sash that crosses her breast and glides under the cloak covering her left shoulder. Thus, reading across the surface, a reversed 'S' links at her left shoulder with a broader curve which pushes the saint's head also towards her right. But these formal devices are only part of the emotional structure. The open mouth and upraised eyes signify St Catherine's fervour; her right hand, hovering over the breast in a gesture of adoration, is carefully modelled and, although deriving from the conventional physical vocabulary for worship and modesty, indicates in its particular tremulousness the saint's absorption in her celestial vision. Significantly, Raphael has resisted the temptation to reduce the size of the left hand which, solid and broad, suggests the saint's physical as well as spiritual strength.

The execution of the cartoon is uniformly soft and painterly, with the tonal level kept high, except in the shadows at the right.

CAT. 160

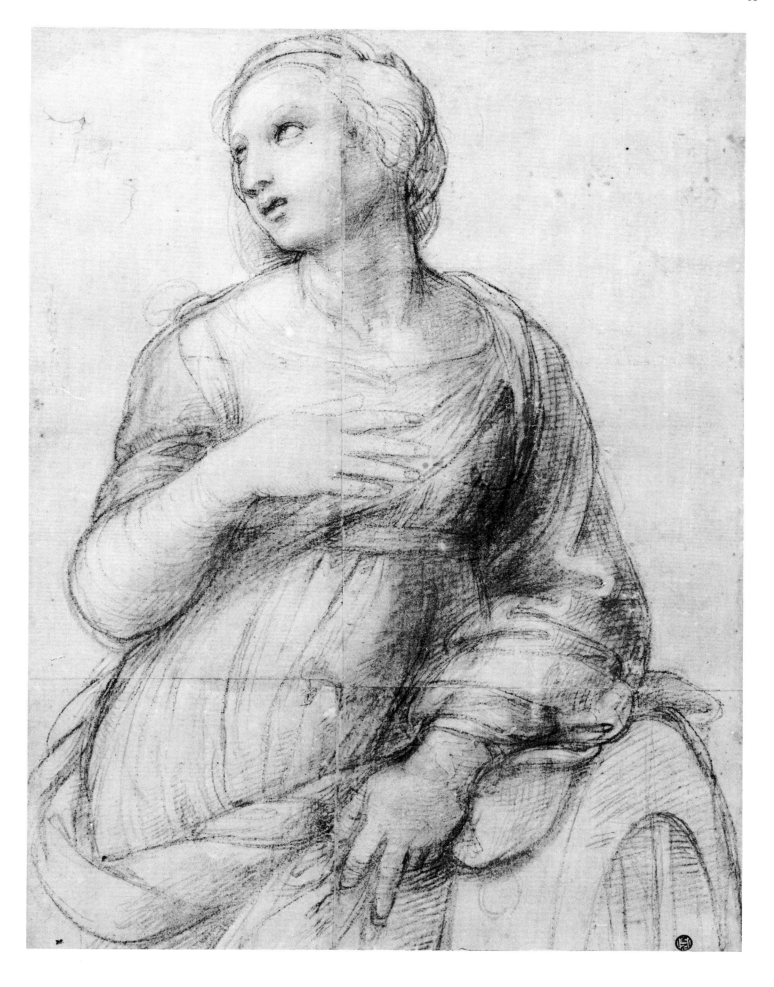

15. Portrait of a Girl

Paris, Louvre 3882
Pen over traces of black chalk, brush and a touch of wash round the hands
223 × 158 mm.

Clearly based on the *Mona Lisa* in the pose and setting, and probably a preparatory study for the portrait in the Galleria Borghese (D. p. 64; Fig. 17) which was laid in by Raphael and finished by another artist, probably Ridolfo Ghirlandaio. Unlike his source, and unlike his completed female portraits of the Florentine period, where an attention to solid volumes and fixed expressions can create an impression of stolidity, the characterization here is eager and vivacious, playing against the serenity and timelessness of the Leonardesque arrangement. The subject seems to be seated at a (?) table, and this, together with the alignment of the parapet and the top of her bodice, creates a powerfully rectilinear frame for her soft form. Looked at casually the drawing would seem to suggest the early Florentine period in its simplicity and openness, but when examined closely it reveals itself to be a study of considerable sophistication, and probably dates from *c.* 1507, when Raphael was attempting to broaden and embolden his pen style. Although a Leonardesque contour hatching is employed to model the eyes and bridge of the nose, there is a strong analysis of the form into planes in the cross-hatching on the nose and cheek. But despite the effort to grasp a broader form, a concern which can be seen in other drawings (e.g. cat. 142r), great attention is paid to textures. The thin lines on the bodice convey both the pressure of the breasts beneath and the texture of the material. The hair is drawn with a fine pen pressed rather harder than elsewhere, and the abundant tresses are played against the rounded crown of the head, where the hair has been gathered by a fillet.

CAT. 175

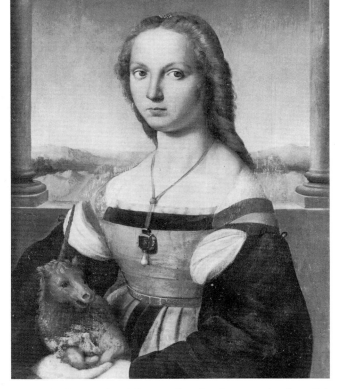

17. Raphael, completed by another hand: *Portrait of a Girl*. *c.* 1507. 650 × 510 mm. Rome, Galleria Borghese.

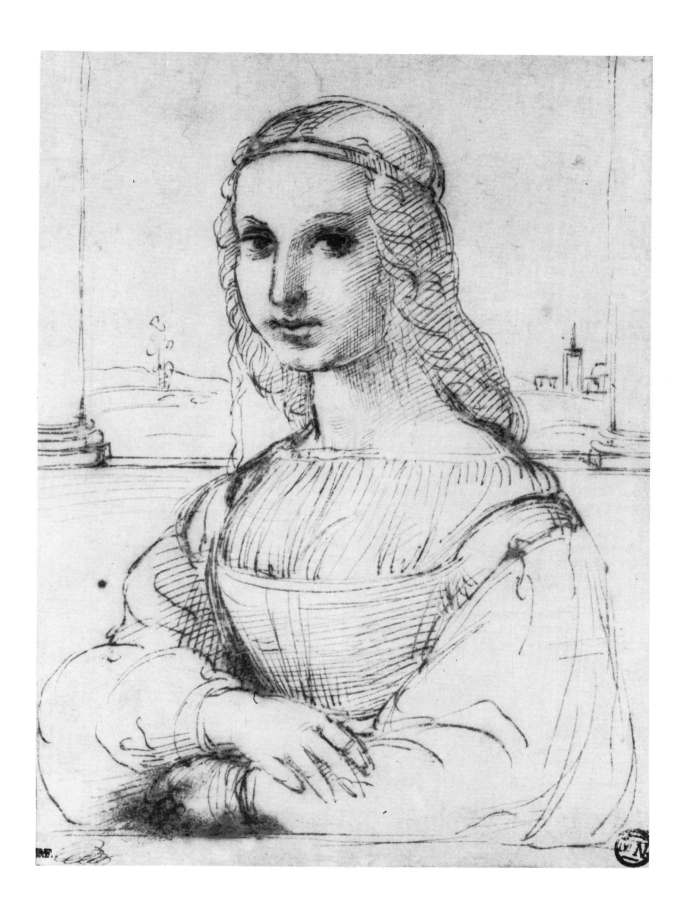

16. Soldiers Retreating with Pinioned Prisoners

Oxford, Ashmolean 538
Pen over black chalk
268 × 417 mm., made up upper left corner, lower right edge; cut at left, right and bottom

This drawing of soldiers and prisoners, together with its verso and cat. 185, presumably form a sequence connected with an unknown project of the late Florentine or early Roman period, c. 1507–8. The traditional connection with the *Victory at Ostia* (D. pp. 83–4), which also shows prisoners being pinioned, is certainly incorrect, for these drawings are at least six or seven years earlier, but the similarity of subject and the crowded, even confused, arrangement suggests that Raphael had the ideas preserved in these drawings, if not the drawings themselves, in his mind when he and his pupils came to prepare the later composition.

Although rapidly drawn, there are nevertheless puzzling discrepancies in quality within the drawing, (as in its verso). The pulling figure on the left, whose back is derived from an antique Apollo Sauroctonos to which Raphael returned on several occasions in 1508–9, is quite convincingly drawn and relies mostly on the use of stressed contour, with little internal modelling. Yet the figure on the far right, leaning forwards with a shield, immediately above the dead, is incorrectly foreshortened, and the torso is weak in relation to the legs. The join of the right arm to the shoulder is also awkward; in fact few of the figures show a convincing junction of thighs and hips – a recurrent problem for Raphael. Raphael was making an effort at this point to bring the heroic nude into his repertoire – a natural desire with the presence of Michelangelo so strongly felt – but his manner follows Michelangelo's example only in part. He shows less interest in the isolated, highly expressive individual figure and is more concerned with a style based on Roman high relief, in which a general unity prevails. Certainly, some of the figural inventions here are of high quality – especially the bodies of the dead – but Raphael's lack of practice in drawing the nude is clear. Nevertheless, despite its weaknesses, the drawing is bolder and more vigorous than anything Raphael's Florentine contemporaries could have devised, and the tendency to spread the figures out with a quasi-geometrical arrangement of the limbs and with near repetitions of form, does anticipate, albeit in a limited fashion, the style which he eventually mastered in the Sala di Costantino. The rapid handling of the pen represents an attempt to embody in the technique the violence of the action.

CAT. 186v

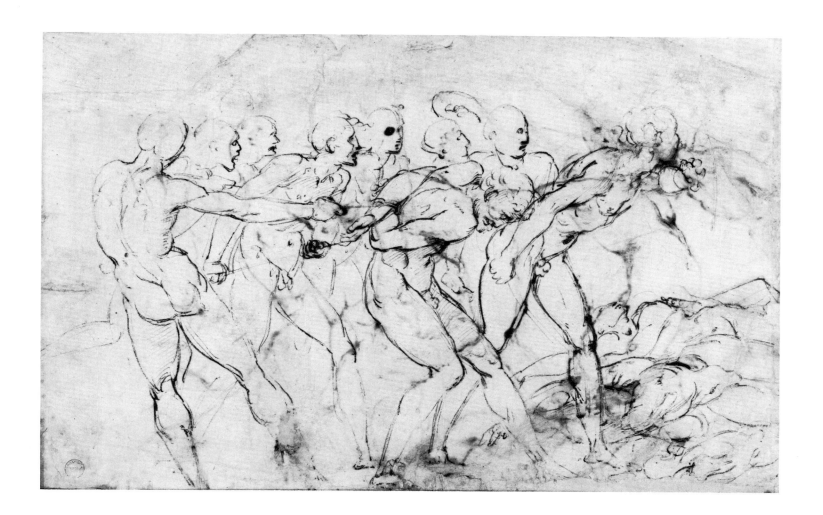

17. *Study for the* Madonna of the Meadow

Oxford, Ashmolean 518
Brush and wash with touches of white heightening (largely oxidized) over lead point (?) with red chalk; squared at 57 mm. in red chalk
218 × 180 mm., cut at left

This simplified study for the *Madonna of the Meadow* (1505 or 1506; Vienna, Kunsthistorisches Museum; D.p. 20) defines the basic volumes of the group and their behaviour under the fall of light. The deliberate restriction to rounded forms firmly establishes the plasticity of the figures and the spatial relation of the Child and St John to the Virgin. One of a sequence of preparatory drawings (cf. cat. 111, 113), it may have been made as a study for the underpainting. The drawing operates within a narrow tonal range; there are no dark shadows, and subtle gradations of lighting are obtained both by sparing the paper between individual brush strokes on, for example, the Virgin's shoulder, and by a variation in the tone of the wash in the light which falls across her legs. Although there is no attempt to achieve continuous gradations in the saturation of the wash, the effect is very much one of continuity, and not of a simple juxtaposition of different grades of tone, which tends to be a feature of the wash drawings of Raphael's school. The honey-coloured wash employed here evokes an indefinable but perceptible sweetness which is carried over into the painting – the calmest, most limpid of the three seated Madonnas that Raphael painted in Florence, and one in which the influence of Leonardo on expression and motif is held in balance with the peaceful clarity of Perugino at his best.

The red-chalk sketch at the upper left, postdating the main study, shows Raphael's ceaseless experimentation with detail. He has radically altered the relation of the Child's head to the Virgin's abdomen, and has given a new position to the Virgin's right hand, which here holds the Child's shoulder. This gesture was not pursued in the next drawing (cat. 113), but the Child was moved slightly towards the left so that He is more exactly in vertical alignment with the Virgin's face.

Clearly Raphael's capacity for producing a play of volumes of abstract richness did not distract him from his concern with character; the little St John, for example, is no more than hinted at against the strong fall of light which dissolves his back, yet the deferential but alert angle of his head is caught without any need of further detail.

CAT. 112

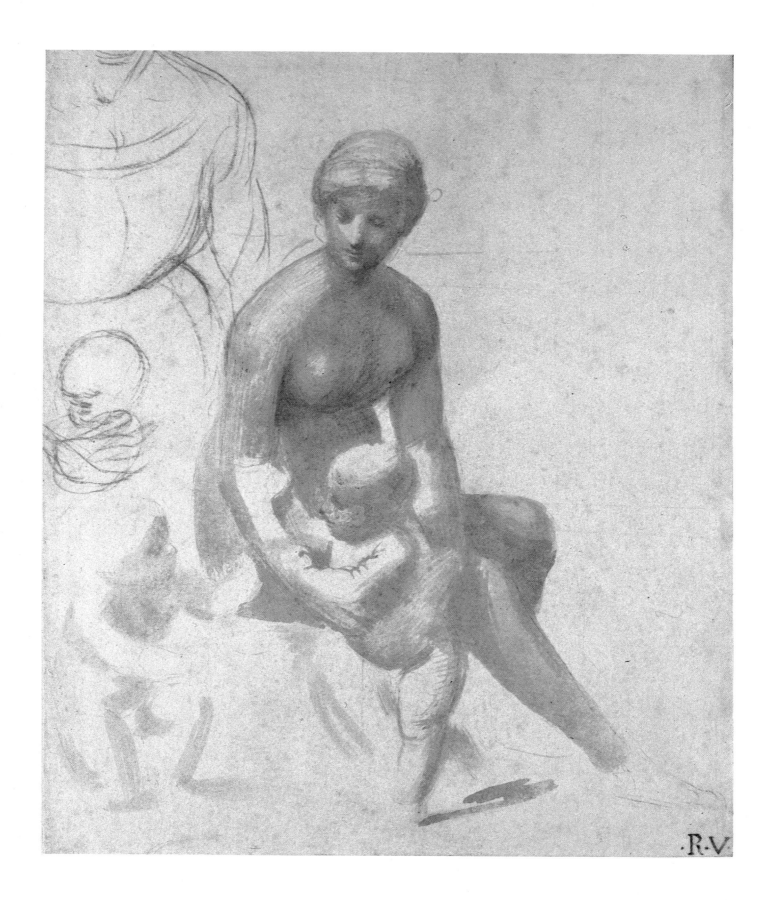

18. *The Left Side of the* Disputa

London, British Museum 1900–8–24–108
Pen over stylus, brush and wash; figure seen from the back on the left in brush and wash with white heightening
247 × 401 mm.

This is the first surviving study for the *Disputa* (probably mid-1508; D. pp. 71–3) which shows the central altar, the vital focus of the fresco, and the stairs leading up to it. Many drawings must, however, have followed his earlier compositional study (cat. 199) before this fluent and graceful solution was reached. Unlike the first wash drawings for this fresco, which are predominantly sombre in tone (cf. cat. 197–9), here a bright, airy setting has been created by the delicate thin wash. Evoking the lightest of shadows, it is used not as a supplement to the unemphatic but effective hatching which it overlays, but as a continuous and liquid medium which establishes areas of tone and brings the paper to life as light. The hatching, although used primarily to define the distribution of light and shade prior to the application of wash, also has another function, that of unifying the composition rhythmically and imposing on it a forward movement. The use of similar hatching throughout the multi-figured composition imparts an overall regularity and vitality to the scheme which allows the individual figures space to gesture and move without disruption. The drawing is a prime example of Raphael's powers of paragraphing a composition, and although he made numerous changes, particularly at the left edge, and inserted a standing figure to the right of St Gregory's throne in order to slow down the inward movement, the basic alignments were determined here. Thus the three acolytes crouching by the throne are unified by pose and drapery, locking into one another, while the three figures at the left edge form a most complex system of outward movement and inward return, as do, though less dramatically, the three clerics standing behind St Gregory's throne.

Despite the fluency of the drawing, a number of changes are evident: in the stylus underdrawing the leg of the foremost acolyte is extended some way down the steps; several other details have been revised with a broader pen, for example the cowl of the figure sixth from the left, the mitre of that third from the left, and the drapery of the figure fourth from the left, who looks outwards while gesturing inwards. (This figure went through possibly more revisions than any other in the fresco; here it has been overdrawn to give a more ovoid rhythm.) As the copy of a lost drawing (Fig. 18) indicates, Raphael continued to make adjustments in further group studies, where individual relations could be defined within the whole.

CAT. 204

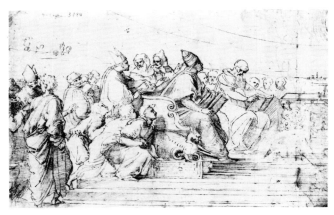

18. Giovanni Francesco Penni after Raphael: the left-hand side of the *Disputa*. Pen. 270 × 400 mm. Paris, Musée du Louvre.

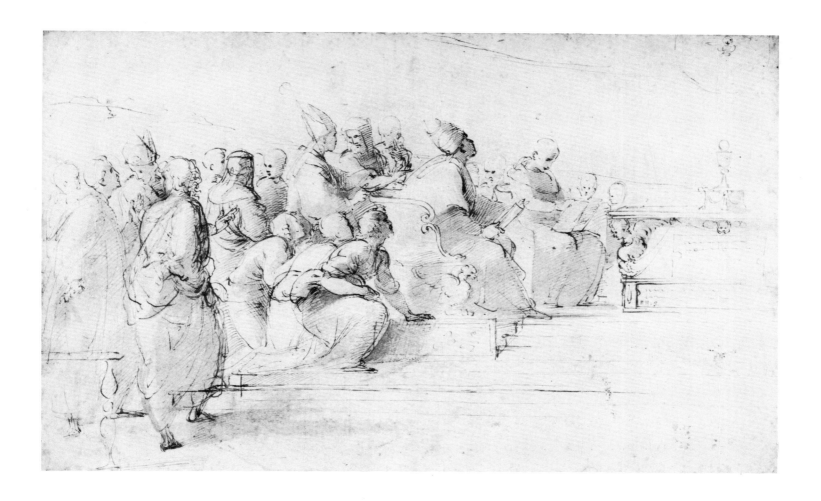

19. *Virgin and Child Studies*

London, British Museum Ff. 1–36
Pen, over traces of red chalk in the centre
254 × 184 mm., cut all round (?)

A sheet of Virgin and Child studies which is closely connected with cat. 181r and v. Cat. 181v takes further the main study on this sheet for the *Bridgewater Madonna* of 1507–8 (Sutherland Collection, on loan to the National Gallery of Scotland, Edinburgh; D. p. 23). The second largest study, at the right, is preparatory for the *Colonna Madonna* (Berlin–Dahlem; D. p. 25, completed by another hand) and the sketch top centre bears some resemblance to the *Large Cowper Madonna* (Washington; D. p. 26, signed and dated 1508). Thus on this sheet and cat. 181 we see Raphael generating in a single burst of creative energy three of the half-length Madonnas of his late Florentine period. Raphael seems also to have thought of including the child St John in one of the compositions, for the two sketches lower centre and lower right seem to represent him rather than the infant Christ; they thus look forward to small three-figure paintings of his early Roman period, such as the *Aldobrandini Madonna* (London, National Gallery; D. p. 26).

Even in his Umbrian work there were some instances (for example his study of four soldiers; Plate 9) in which Raphael made use of pentimento drawing to modify poses and gestures without losing rhythm and balance; but in Florence, with direct access to the drawings of Leonardo (Fig. 5), who had developed the method in the 1470s, he attained a new level. Here the pen strokes, moving in ovoid patterns, generate rather than depict the forms; they do not give the impression of being studied from models but of growing out of the interaction of pen and paper. Even Leonardo's most elaborate pentimento studies retain the restricting angularity of life. Here, although the play of rhythms is much more abstract, given the vitality and emotional power of the theme of the relation of mother and child, there is no sense that intimacy is sacrificed to formal values – indeed the abstraction renders the relation more elemental. The final arrangement of the *Bridgewater Madonna*, with the Christ Child swimming across the Virgin's lap (a quotation inserted, as so often in Raphael's designs, at a very late stage and deriving from Leonardo's *Madonna of the Yarn Winder*), has overtones of resurrection; it seems unlikely, however, that Raphael envisaged this from the start; it is rather that his passion for complex forms led to a more subtle, more evocative content. In these drawings everything is in motion, and with the increasing dissolution of the hieratic new possibilities of allusiveness were created.

CAT. 180

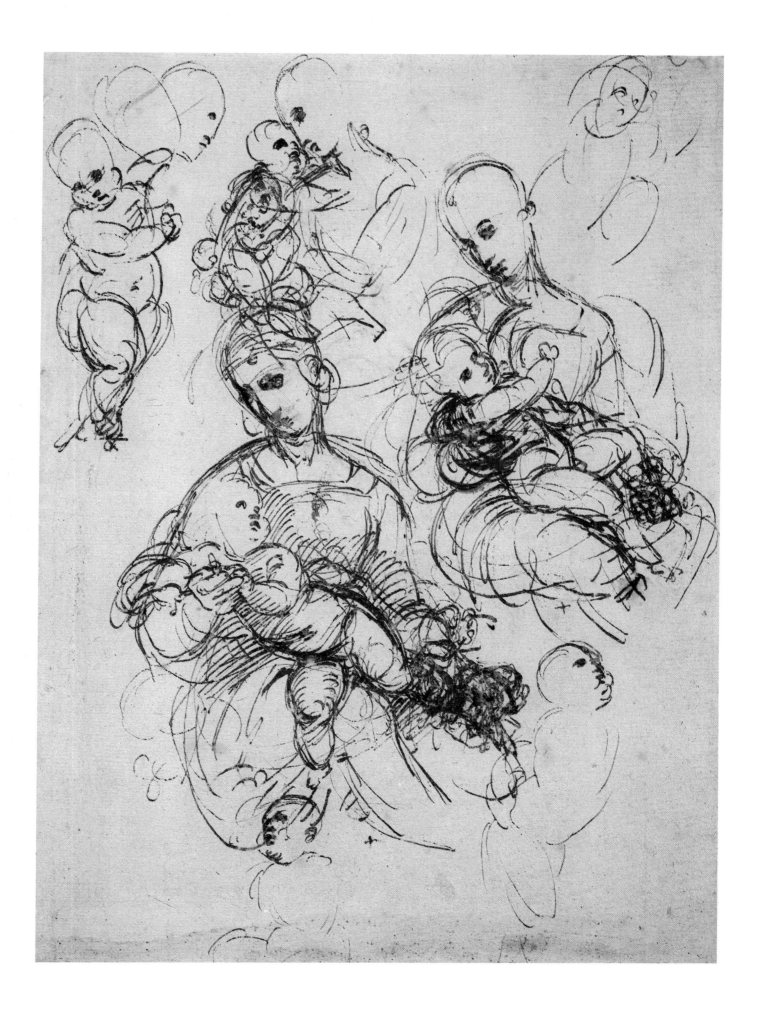

20. Nude Study for the Disputa

Frankfurt, Staedel 379
Pen, over traces of black chalk on right and stylus on left; elaborately pricked
280 × 416 mm., made up upper left corner

Despite the occasionally unconvincing spatial arrangement of the figures (for example, those by the altar), caused by standing a limited number of models in a succession of different positions, the clarity of the grouping and the precision of the individual figures in this study is remarkable. Raphael's command of the nude has improved enormously since the *Battle* drawings, and the structure of the bodies is clear and cogent, reflecting Raphael's study of the nude model. There are few pentimenti, so this drawing, probably of mid-1508, must follow very closely a lost study where the details of pose and gesture had already been fixed; but there are some minor adjustments, particularly to the contours of the third figure from the left, which have been re-worked with a slightly thicker pen.

This is the most extensive of Raphael's surviving multi-figure studies from the nude, and it demonstrates his concern to have accurately rendered bodies under the draperies on which so much of the flow of his composition depends. The *Disputa*, the most complex composition he had yet devised or, arguably, was ever to devise, had to be prepared with obsessive care. Yet despite the enormous expenditure of effort in this study, only the seated Doctors of the Church were carried over into the final fresco relatively unchanged. The clarity and sharpness of the drawing to some extent reflects Raphael's silverpoint technique as well as Michelangelo's cross-hatching in pen, and the overlay of short, multi-directional hatching lines in some areas – on the back of the third figure from the left, for instance – builds up the form in a way more usually associated with an additive medium than with Raphael's more flexible pen technique. Yet despite the emphasis on individual forms, the integration of the figures is skilfully achieved by the use of echoing lines, linked contours and, of course, the play of balance between one figure and another. At this stage of Raphael's career the alternation of 'hard' and 'soft' drawings enabled him to combine structure with atmosphere, physical individuality with tonal unity, and differential focus with homogeny.

The long-legged, rather short-chested figure-type that characterizes the Ashmolean study of soldiers and prisoners (Plate 16), inspired ultimately by Michelangelo's *David*, is here completely convincing. It was to be the dominant mode of the drawings for the *Massacre of the Innocents*, and only began to change with the studies for the Pace *Resurrection*.

CAT. 205

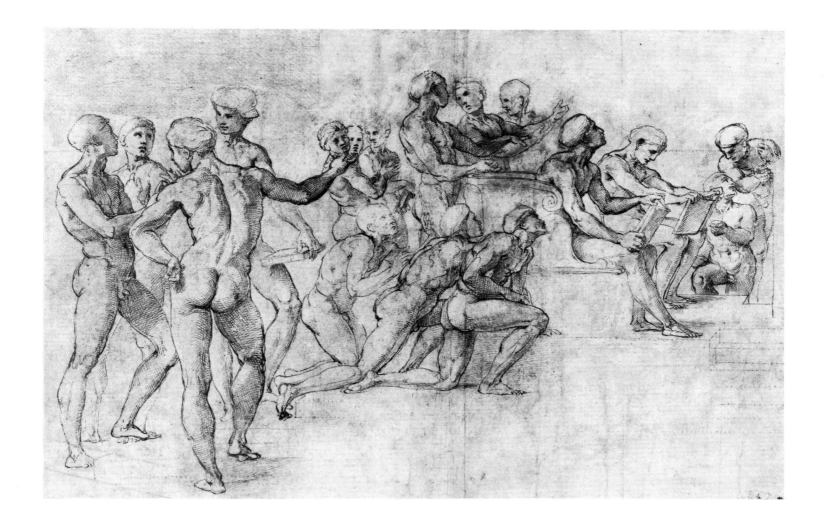

21. Diogenes for the School of Athens

Frankfurt, Staedel 380
Silverpoint on pink ground; a fragmentary circle incised upper right
244 × 284 mm., cut at bottom and right edge

A study from the model for one of the most complex single figures in the *School of Athens* (D. pp. 73–4), and a prime example of Raphael's ability at this moment in his career (*c.* 1509–10) to describe in silverpoint the most precise inflections of anatomy and the minutest gradations of relief without having recourse to a supplementary medium. The Diogenes, which is particularly well preserved, marks a peak in his work, for although he employed a hard-edged, angular style akin to this in many of his pen studies for the *Parnassus,* he was there aiming for greater breadth and freedom, and modified his style accordingly. Here he attained the most sharply focused precision, but was in danger of descending into minutiae difficult to integrate in a composition. For an angular, isolated figure the technique was entirely appropriate, but the medium, although it could certainly be used more broadly (as other silverpoints for the same fresco demonstrate), did not easily allow the swelling, rhythmical masses of, for example, the figures in the *Expulsion of Heliodorus,* whose magnitude could only be properly prepared in chalk.

The choice of silverpoint for most of the surviving drawings for this fresco was undoubtedly due to Raphael's desire for clarity, since the *School of Athens* contains more individualized figures than the *Disputa* and they are arranged less architectonically. Raphael's choice of a pink ground may have been intended to indicate a certain warmth, and to serve as a reminder of the need to set colouristic vitality against the coolness of the architecture. Indeed, much of the central part of the fresco makes use of pink–blue chords, and the ground may have helped him to visualize the colours.

Raphael continued to use silverpoint until *c.* 1515, but as he moved towards a greater colourism and more grandiose figure style it became increasingly an accentual aid rather than a major preparatory device.

The execution of the drawing hardly requires discussion. The hatching is entirely subservient to the local modelling in the legs, but is slightly more unifying over the chest, where the longer parallel strokes establish a broader plane to support the head. And to look at the way that features such as the cheekbones are unerringly emphasized by sparing the paper is to be convinced of Raphael's preternatural sureness of hand and watchmaker's keenness of eye.

CAT. 232

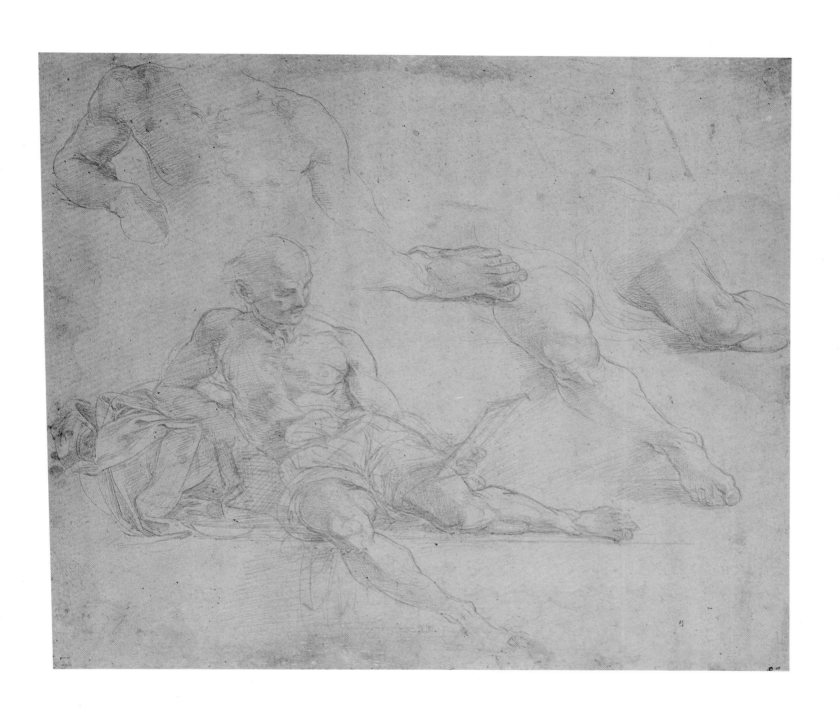

22. *St Paul for the* Disputa

Oxford, Ashmolean 548
Black chalk of two different shades, partly stumped, touches of white heightening
387 × 265 mm., cut at top corners and probably at both sides and top

This is the softest and most vaporous of the series of black chalk studies, probably of later 1508, for the saints and patriarchs in the *Disputa* – a series in which Raphael was concerned to block out broadly the forms on the upper level of the fresco in order to establish a powerful foundation in light and shade for the final detail. Here, although the chalk on the torso, the left arm and the drapery that falls behind the seat is rubbed so that lines are virtually dissolved, Raphael has nevertheless sharpened certain areas of drapery – between the calves, for example, and behind the left arm – with a harder, slightly darker chalk, though this in no way detracts from the breadth of the whole.

This soft chalk technique was practised in Florence most effectively by Fra Bartolommeo, from whom Raphael probably learned it (indeed the shorthand used for St Stephen's face in the accompanying study (cat. 213) is very much in the Frate's style). Yet whereas Fra Bartolommeo created rational and cogent studies, most obviously for his *Last Judgement* of 1499 (a composition which profoundly influenced the *Disputa*), there is a nervousness and volatility about this drawing which puts Raphael in a different class. Nothing about it is fixed, every element is in a process of becoming. Raphael was uncertain whether the saint should be shown in strict profile or looking in towards Christ. First he drew a profile, then altered it, bending the head forward and inward and giving a bull-like strength to the shoulders. Then, to the left, he again tried a profile. In the drawings below he experimented further with minor changes, and finally, in the haloed head on the left, where the chalk seems to have been breathed onto the paper, he saw its potential for an entirely different character, a head that, isolated, could be by the aged Titian (cf. Fig. 19).

Raphael's Florentine experience can also be seen in the pose of the saint, whose torso and arms are heavily indebted to the Levite and Pharisee flanking St John in Rustici's group for the Baptistry. These figures, designed by Leonardo, were certainly underway before Raphael left Florence, and Leonardo's attempt to equal Michelangelo must have greatly appealed to Raphael, who so often sought to combine the strengths of the two masters. (Perhaps coincidentally, the profile on the left is similar to that of Michelangelo's Zacharias on the entrance wall of the Sistine Chapel.)

CAT. 214

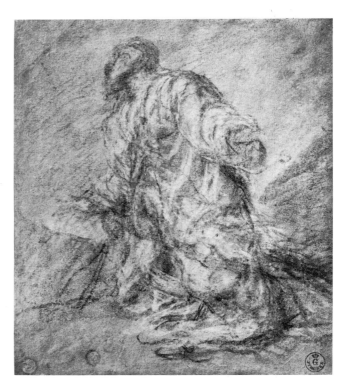

19. Titian: *Christ at Gethsemane*. Late 1550s (?) Black and white chalk. 232 × 199 mm. Florence, Uffizi.

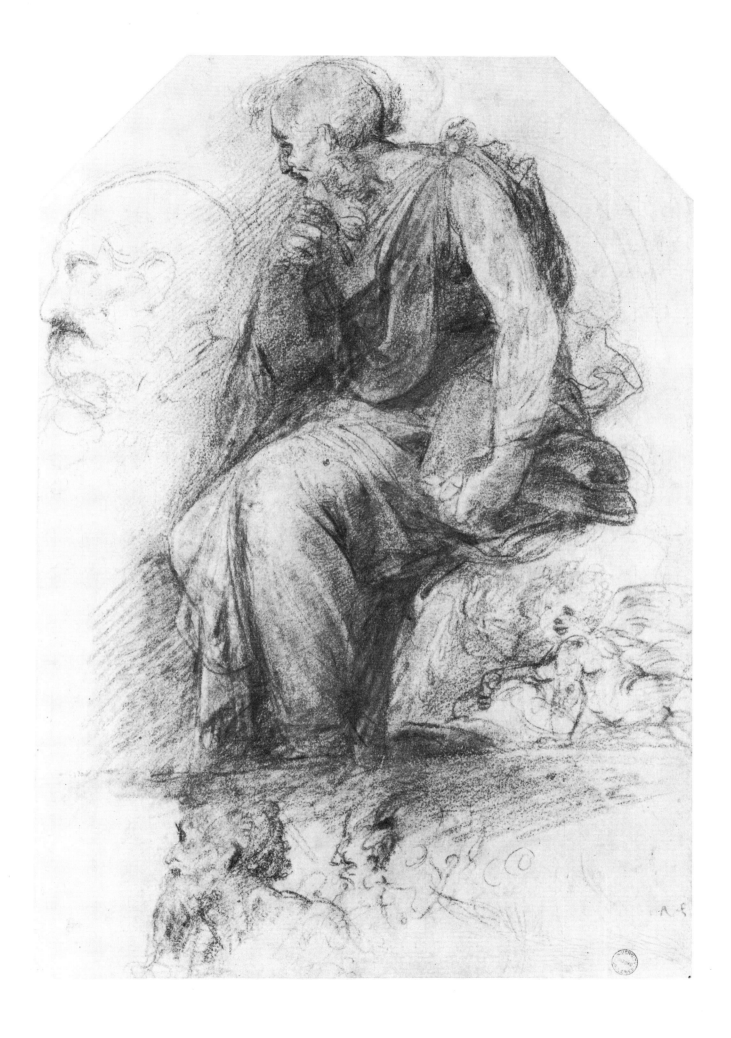

23. Portrait of Pope Julius II

Chatsworth 50
Red chalk
360 × 250 mm.

One of Raphael's few surviving portrait studies, drawn from the life shortly after Julius returned to Rome in July 1511, penitentially bearded after an unsuccessful campaign. The head is very close indeed in angle and expression to that in Raphael's portrait of Julius in the National Gallery, London (D. p. 29), and it was certainly drawn with the painting in mind. It was in all probability also adapted for the portrait of Julius as Gregory the Great on the Jurisprudence wall of the Segnatura, where the light falls from the opposite direction.

The cap, where the texture has been indicated by broad, soft chalk strokes, with breaks to indicate the different segments of the material, Raphael may have added later, but the facial study has the hallmarks of an opportunity rapidly seized – for Julius, with his legendary impatience, would have had little time for sitting to painters – with a vigour verging on brutality. Indeed, the finished portrait is an exceptionally tough and powerful image, with harsh contrasts of red and green, and a sweepingly revised background; like the drawing, it also gives the impression of a work carried out in haste, without Raphael's habitual refinement, but with his strength and energy unleashed.

The face in the drawing has been demarcated into areas, with little attention to texture. The beard is slashed in with long strokes, the hard edge of the bottom of the moustache alleviated only by a sequence of small lines, with no attempt to describe the texture of the hair. The eyes have caused some difficulty, as if Julius was unable to keep them still. He has attempted to give form to the left eye by the short strokes on the lower lid and the patch of light on the upper, set against a swiftly rubbed shadow; but the right eye lacks clear structure, and Raphael has compensated for this by stressing the dark pupil. The near side of the forehead is hatched as though it were a flat surface (an impression reinforced by the straight line of the cap, though this was altered in the painting); in the area of untrimmed hair on the cheekbones, just above the beard proper, Raphael has overlaid the longer hatching lines with simple, shorter ones. The neck is also simplified, and to indicate the shadow within the collar of the *mozzetta*, he has moved his chalk so quickly that the hatching is simply a zigzag. The resultant image is one in which nothing interrupts the direct communion between the artist and his subject, and where the great pope's character comes across all the more powerfully for the lack of polish with which it is recorded.

CAT. 291

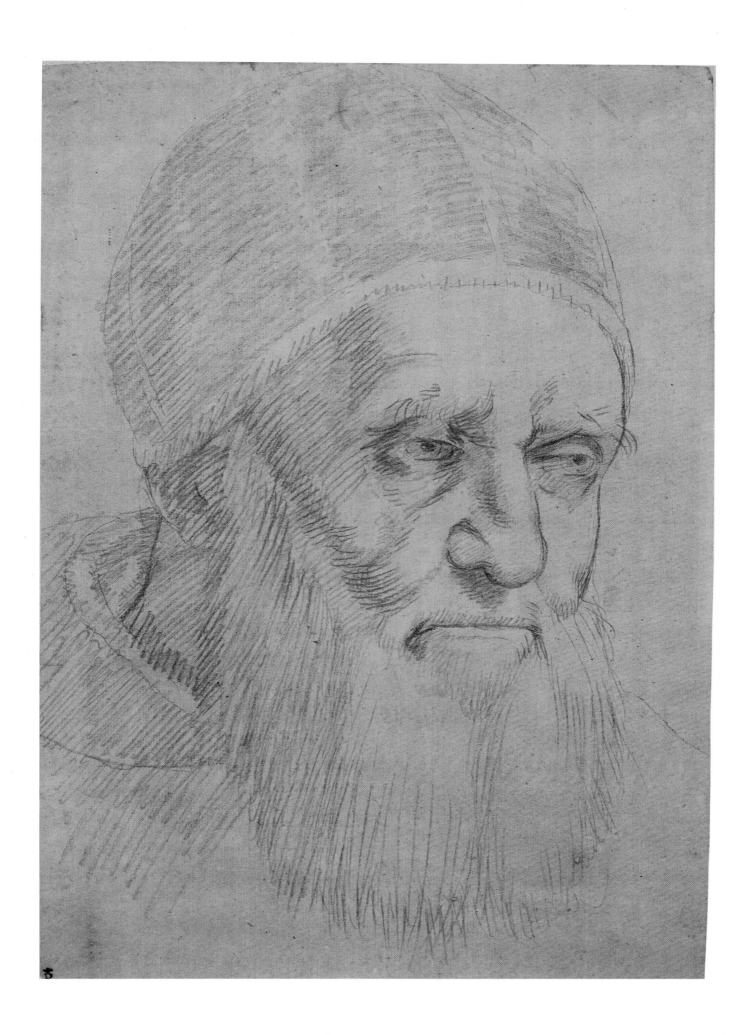

24. *Two Men in Discussion for the* School of Athens

Oxford, Ashmolean 550
Silverpoint and white heightening, partly oxidized, on faded pink ground
278 × 200 mm.

Despite fading and the oxidization of the white heightening, this remains one of Raphael's most brilliant drawings, where every difficulty has been effortlessly conquered and where an extraordinarily complex spatial, intellectual and emotional interchange has been set on the pink ground with a sharp silverpoint, as though dictated by a divine intelligence. One figure climbs the stairs, advancing with his left leg and right shoulder, while looking up to his right and gesturing down towards Diogenes on his left. The other descends the stairs, advancing with his right leg and with his left calf bent back orthogonally into space. His right shoulder advances but he points across the plane of the composition – a detail that was modified in the fresco, where his pose is still more complex, twisted further back towards Aristotle. Dispute over differing philosophies is made flesh in their opposed movements, yet simultaneously the two figures are united. The drawing enshrines a dialectic of difference and synthesis: both men are pursuing the true and the good, and together their bodies make a broad diamond. The lines of the shoulders run into one another, the draperies over their legs form a continuity of edge and of interior folds. In the fresco the philosophers were further distinguished, with the descending man shown as older and heavier; but even here the germs of the contrast of character can be seen as the climbing figure gestures with impulsive gracefulness and the descending man with more measure and force.

Details of the hair, the left hand, and the right foot of the left-hand figure are studied again at the sides of the sheet, the foot and hair with an exquisite precision, the hand more diagrammatically. Although drawn some ten years later, in 1509 or 1510, and with the experience of Leonardo's work intervening, the drawing is still reminiscent of Perugino's silverpoint study for *Tobias and the Angel* (Fig. 20): despite Perugino's weaknesses, Raphael's debt to him was great.

The screaming head lower right is a study for the Medusa head on Minerva's shield, and had been used before by Raphael in his study of soldiers and prisoners (Plate 16). Leonardo began the vogue for it in the *Battle of Anghiari*, and it had a long life.

CAT. 231

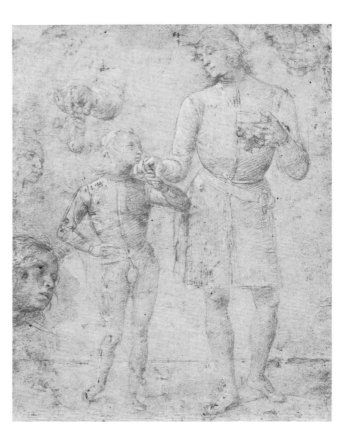

20. Perugino: *Tobias and the Angel. c.* 1499. Silverpoint and white heightening on pink ground. 238 × 183 mm. Oxford, Ashmolean.

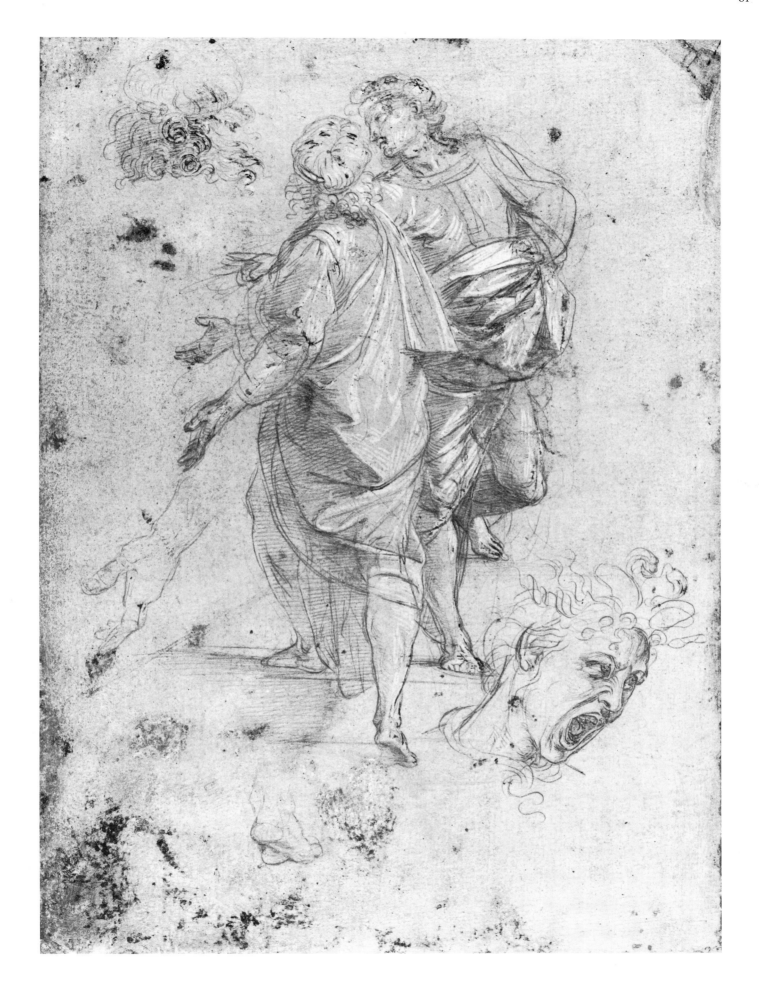

82

25. *Detail of the Cartoon for the* School of Athens

Milan, Ambrosiana
Charcoal, black chalk, white heightening, pricked for transfer
2800 × 8000 mm., on many sheets of paper, patched lower centre

The cartoon for the *School of Athens*, probably of 1510 (see also endpapers), is the largest that has survived from the High Renaissance. It demonstrates perhaps more clearly than any other work the vigour and virility of Raphael's art, and his ability to animate so complex and precisely planned a fresco without allowing the difficulties of organization to weaken the vitality of individual figures. The cartoon shows Raphael at his freest, his most instinctive and his most decisive, blocking in the forms with a force and economy which does not exclude passages of great delicacy. Although the brooding figure in the centre (Heraclitus?, possibly a portrait of Michelangelo in a very Michelangelesque pose) was added after the cartoon stage – possibly even after the fresco had been finished, on a new segment of plaster – Raphael made very few changes in transferring the composition to the fresco. He seems to have realized that he had produced a masterpiece on which he could not improve, and clearly made efforts to preserve the cartoon. It was not used directly on the wall, but the outlines were probably pricked through to another sheet, which was transferred piece by piece to the damp plaster; the original may have been kept on rollers, and used as a guide for the *giornate*. Surprisingly, before he began drawing the cartoon, Raphael plotted out a large-scale ground plan of an enormous building; this he probably devised as the initial plan for the

great hall, an intellectual empyrean, in which the concourse of philosophers meets.

The composition is divided into independent but interlinked groups; that of Euclid and his pupils is one of the most striking. Raphael was faced with the problem of rendering intellectual, and specifically mathematical, discovery in paint. He chose for his central image the compass with which Euclid inscribes his tablet – his body a larger compass which describes the arc of his pupils. They gaze at his demonstration with differentiated reactions, the kneeling youth at the left, in a pose of absorbed concentration, following Euclid's explanations; the boy above him, bending forward and trying to foresee the next step; the youth in the centre turning to indicate something to his friend – who, however, has already anticipated the solution, and raises his arms in the involuntary movement that registers the moment of awareness. The group might be Joseph and the shepherds bending over the crib, and it was surely from Nativities that Raphael developed his arrangement. The reference is significant, for like Leonardo, Raphael was an artist for whom thought had religious breadth and force. In the *School of Athens* he conveyed, incomparably, its seriousness, its variety, its joy, its compulsion.

CAT. 234

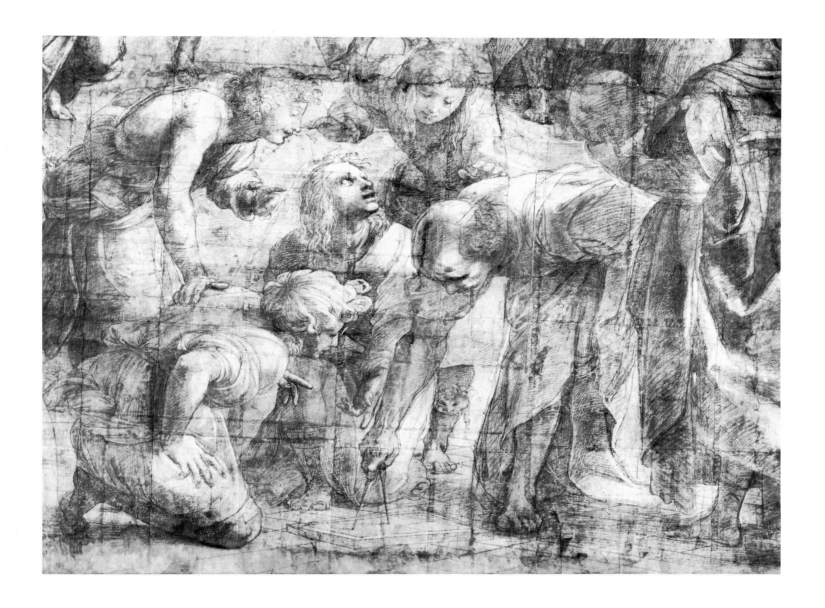

26. *Melpomene for the* Parnassus

Oxford, Ashmolean 541
Pen over traces of black chalk
330 × 219 mm., cut at left and top

This study is linked with both the first and second versions of the *Parnassus* (D. pp. 74–6), recorded in an engraving by Marcantonio and in a copy of a lost nude study by Raphael (Fig. 21). In the fresco the figure was greatly modified and the face turned only half right, the returned profile being reserved for Virgil.

The drawing shows some range of techniques: a much thicker pen has been used to redefine the swirling drapery lower left, and, indeed, so much ink has been applied that it has run slightly and the final forms are difficult to read. But most of the drawing is done in the wire contour style that Raphael adopted for the *Parnassus*. To some extent, this derives from his silverpoint technique, but nowhere in the silverpoints would such a firm, unwavering and continuous line be found as that which defines the right shoulder and arm. And the profile too, though delicate and expressive (it has a hint of the best of Cocteau's classicizing heads), is drawn with the simplest outline, modified only slightly on the mouth and chin.

At this moment Raphael was trying to create forms that were structurally as firm as the Diogenes (Cat. 232; Plate 21),

but which were broader and more voluptuous, both in physical type and in the internal modelling. Here the female type is more grandiose than we have seen hitherto, and indeed the arrangement of the legs in particular is based on antique spandrel figures of Victories (cf. cat. 343v), though the upper part, bent back in a delicious counter-curve, is a splendid invention by Raphael. The link with antique sculpture, however, does suggest that he was aiming for a more, literally, statuesque quality; and the women in the *Parnassus* as painted are magnificently full figured.

To some extent the drapery here constitutes a *jeu d'esprit*, which Raphael could not bring himself altogether to abandon. The proliferation of folds and curves is so joyous, with no justification in Melpomene's movement or in a breeze playing through the scene, that it clearly delighted Raphael as a means of decorating the simplified areas of the shoulder and arm. The combination of voluptuous form and severe pen style was a potent one, and although comparatively few pen drawings survive for the later Roman period, studies like this clearly look forward to the 'woodcut' style that Raphael employed around 1514.

CAT. 238v

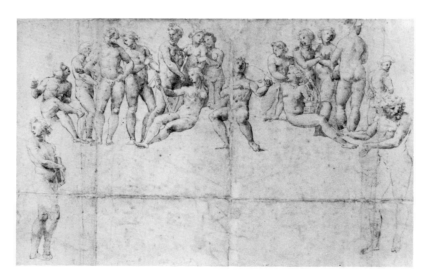

21. Anonymous copy after Raphael: the second project for *Parnassus*.
Pen over black chalk. 292 × 458 mm. Oxford, Ashmolean.

27. Angel with Scroll

with the right arm of the Cumaean (?) Sibyl for the Chigi Chapel in Santa Maria della Pace

Vienna, Albertina Bd. V, 17573
Red chalk
215 × 217 mm., cut down all round, made up lower left corner, bottom right corner and top; the top of the head and some of the thumb are restoration

Despite the poor condition of this sheet, it is one of the purest and most effective examples of Raphael's use of red chalk in the period *c.* 1511. Although he had used red chalk in Florence, it was only as he completed his work in the Segnatura that Raphael seems to have taken it up again. It provided the smoothness and continuity of black chalk, without tonal extremism. Usually harder than black chalk, it could be used, as here, with the individual lines kept distinct. Raphael's aim in this drawing seems to have been to unite the continuity and subtle tonal variations of chalk with the clarity and precision of silverpoint, and the breadth of the pen studies for the *Parnassus*. Here there is only slight rubbing in the shadows and most of the modelling is achieved by the subtlest of multi-directional hatching. Within the sharp contours of the angel's left forearm, for example, one strand of hatching, partially overlaid with others, models the tightening curvature towards the wrist with an increasingly steep stroke. Two faint but consistent lines of minute cross-hatching create the tendons, and a further light web of hatching the shadow under the arm. Both in the angel's hands and in the hand of the Sibyl, Raphael has carefully but lyrically described the flat backs and the long fingers, the most significant being brought into sharp focus by bracelet hatching. Yet the precision is curiously ethereal, the forms are idealized, composed from the various suggestions provided by the model, with the blemishes of existence expunged. The angel's face, too, is a radiant piece of characterization, though this is slightly coarsened in the succeeding sheet (cat. 300). Dreamy and compassionate, he slowly extends his scroll to confirm the divine truth of the seer's vision.

Interestingly, red chalk drawings of the Pace phase (D. pp. 93–5) appealed both to Perino del Vaga and to Polidoro da Caravaggio, and Raphael may have set them to be copied by his pupils. A particularly fine copy is in the Ashmolean (Fig. 22), and in this there is actually underdrawing in stylus which is not present in the original – a warning that stylus underdrawing does not confirm authenticity.

CAT. 299

22. Anonymous copy (Perino del Vaga?) after Raphael: *Angel and Arm of the Cumaean (?) Sibyl.* 1510s (?) Red chalk over stylus. 326 × 205 mm. Oxford, Ashmolean.

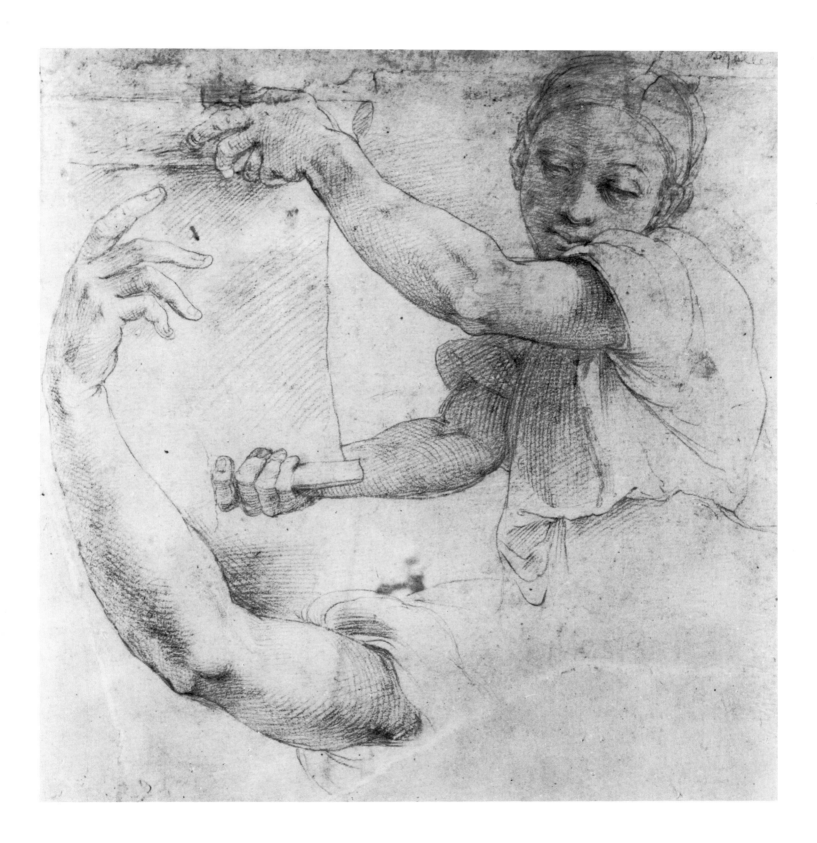

28. *Study for the Phrygian (?) Sibyl*

London, British Museum 1953–10–10–1
Red chalk over stylus
262 × 167 mm., cut at right, top and bottom

Unlike the other red chalk drawings for the Sibyls and accompanying angels, this study (and its verso) shows a richer, denser use of red chalk, with less fine hatching. As he came closer to finalizing the forms (probably in late 1511 or early 1512), Raphael seems to have wanted more solid modelling, especially on the right-hand side of the fresco, where the contrasts of light and shade, being closer to the window, were made slightly stronger. In keeping with the Michelangelism that prevails in his work at this moment, Raphael has turned to the Delphic Sibyl from the Sistine Chapel as the source for the powerfully turned head and for the left arm resting on the thigh; but he has, however, abandoned the idea of having the arm bent across the breast, as it appears in Michelangelo's Sibyl and in his own earlier drawing for this figure (cat. 301).

Here, perhaps for the first time, Raphael has taken full advantage of the versatility of red chalk. He has used a series of sharp lines to define the edges of the folds, and these have been reinforced, for example round the sleeve, by internal shading lines which move in the same way. This creates the sense of soft but palpable material, and acknowledges the variations of its movement and texture in a way that systematic cross-hatching would have largely obscured. This method of treating the folds, though it requires the most precise observation in the choice of which lines to stress, nevertheless demonstrates how red chalk can on occasion match the potential of black chalk, for example in such details as the sleeves of the woman in the study for the *Expulsion of Heliodorus* (cat. 333r, Plate 31); but Raphael has made use of the capacity of red chalk to modulate more precisely in the areas of shadow. Thus under the right arm the chalk has been fused to give it a waxy texture, creating a deep, but still faintly luminous shadow. Below the arm there is a passage where Raphael has hatched swiftly across the curving lines of the drapery, largely concealing them, but retaining enough of their movement to prevent the area from becoming completely flat. Yet these hatching lines are laid on with vigour, and the stress creates an overall impression that is darker than the more even, less emphatic, but denser network of hatching that sets off the main fold falling from the shoulder. In effect, Raphael has greatly extended the range of his medium in the mid-tones. The verso study of drapery takes this still further, creating a texture of dark velvet with an almost palpable pile.

CAT. 302r

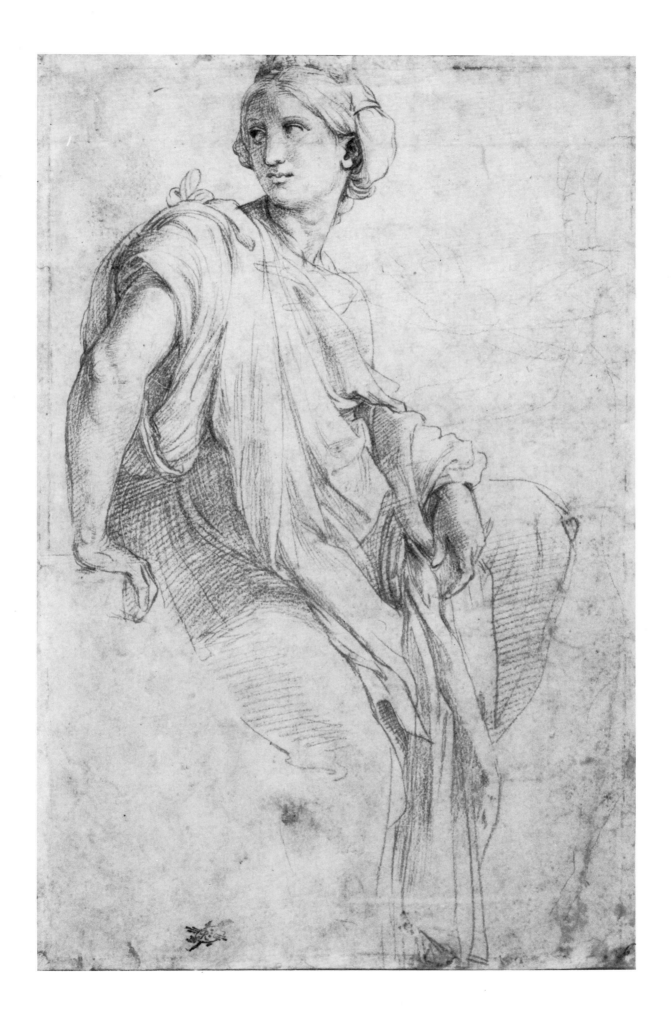

29. *Studies for the* Resurrection

Oxford, Ashmolean 559
Pen over stylus and traces of black chalk
345 × 262 mm., cut at bottom, left and right, made up lower left edge

One of the most dynamic of all Raphael's drawings, where the whirl of pentimenti is so furious that parts of the composition are illegible. The drawing, probably of late 1511 or early 1512, presumably comes before cat. 304r and cat. 305r and, like those, spawned a number of magnificent figures that were not finally used (e.g. the one recorded by Perino on cat. 255v). Here Raphael is primarily concerned with the right side of the *Resurrection* (D. pp. 93–5). He seems to have considered at the right edge a standing figure, turned away from the centre and holding up his shield with both hands swung behind his head; a standing soldier facing the tomb and straining to hold his banner, which is being bent backwards by the turbulence of Christ's resurrection; and a figure falling backwards, holding a spear, at the lower right corner. The figure with the standard was repeated, enlarged, to the left, and his head tried briefly turned upwards, but then bent down again. (This figure, broadly inspired by one in the *Cascina*, but with many changes, does not recur in the *Resurrection* series, but was developed further as a separate figure which was subsequently engraved both by Marcantonio Raimondi and Agostino Veneziano; it was borrowed by Titian in his *Triumph of Faith* woodcut of c. 1516.) The falling figure was also studied again at the right edge, in two larger close-ups. In addition to these figures, none of which was used in subsequent drawings, Raphael also sketched at the right edge, just below the soldier lifting up his shield, a soldier fleeing, who was taken up at the right of cat. 304r and cat. 305r, and finally studied in detail in cat. 307r. Raphael also experimented with a number of other figures on this page whose intended location in the painting is difficult to determine. Thus at upper right there is the soldier sprawling backwards who is placed nearest the angel in cat. 305r. Sketched twice at the upper left, and again at the middle right, is a reclining soldier, shown in the first two sketches lying on his shield, then lifting it up for protection (with another head visible just above this); this figure was developed subsequently on cat. 305r, and finally in cat. 309. In the centre of the sheet is a crouching man facing left, with his head turned outwards and his right arm bent over his head, apparently leaning on his shield; this highly Michelangelesque figure might, like the three figures sketched lower left, have been intended for the left side of the painting.

The fecundity of the invention thus matches the triumphant energy of the draughtsmanship; in the following studies this energy was restrained in favour of more statuesque figures, but subsequently, in the final stages of the design, something of this vitality re-infuses the drawings.

CAT. 306v

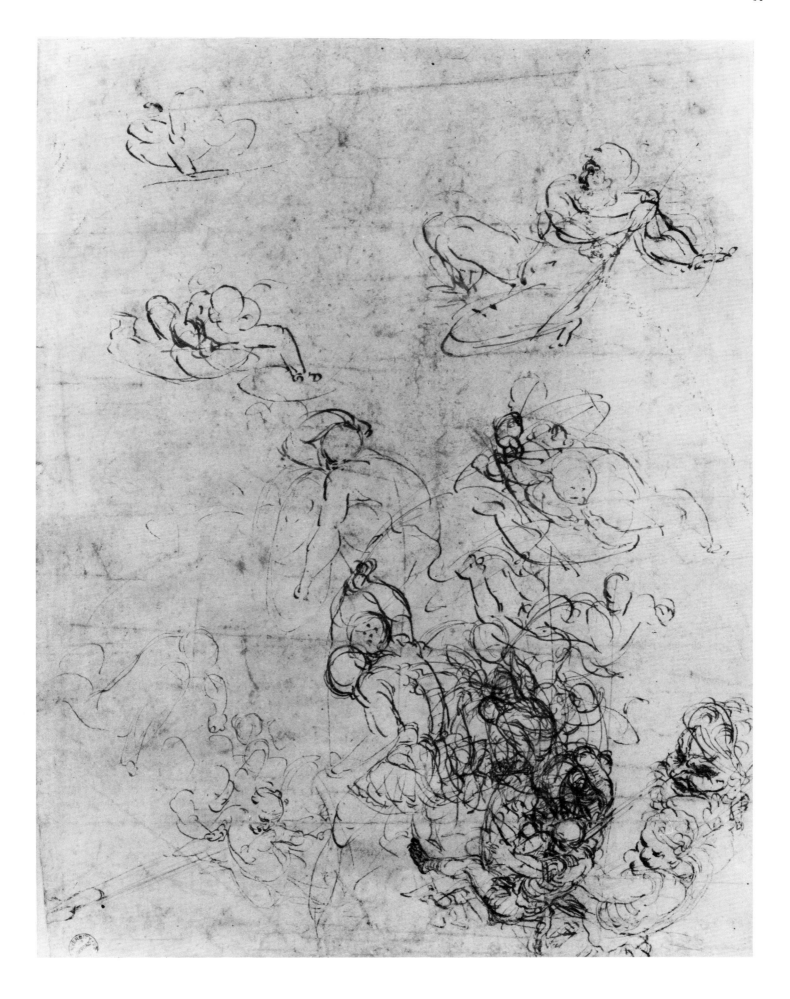

30. *Guard in the* Resurrection

London, British Museum 1854–5–13–11
Black chalk
293 × 327 mm., irregular, cut all round, the top and lower left corner and top edge made up; the upper part of the right forearm is restoration

This figure belongs to the second phase of work on the *Resurrection* (probably late 1511 or early 1512); like the figures on cat. 311, it does not occur on any of the compositional drawings, and must represent a major revision of the left-hand(?) side, and probably of the whole lower section. Like all the nude studies for guards, it reveals the strong influence of Michelangelo – in this case, the figure combines the hips and legs of Eve in the Sistine *Fall* and the torso and arms of one of Michelangelo's projected slaves for the tomb of Julius II. Unlike the first phase designs, however, this drawing is more open in treatment and less concerned with the definition of every element of the form. The left knee and thigh are more summarily modelled, and in comparison with, say, cat. 307r, much more broadly conceived. The earlier drawings for the *Resurrection* had such a great effect on the *Expulsion of Heliodorus* and the *Release of St Peter* in the Stanza d'Eliodoro that it seems likely that this drawing and cat. 311 reflect Raphael's experience with the painterly chiaroscuro adopted for that room.

Raphael realized that too great a concentration on detail could lead to stiffness, and his scheme to make the *Resurrection* a virtuoso figural display was modified by a desire to create a greater overall dynamism in the spirit of the original sketches. Significantly, in this drawing Raphael provided an alternative position for the right leg, which opens the figure out more than the initial pose. This was probably the final choice for it was adopted, together with two of the figures from cat. 311, for a later print of a Bacchanal by the monogrammist HFE. The fact that this drawing bore for some time an attribution to a follower of Michelangelo is not without significance, for like cat. 311 (once attributed to Michelangelo himself) it represents the nearest Raphael approached to his great rival; the slight inhibition of most of the drawings of Raphael's Michelangelesque phase is missing, and the freedom and willingness to sacrifice regularity for expression that characterize Michelangelo are equalled.

CAT. 310

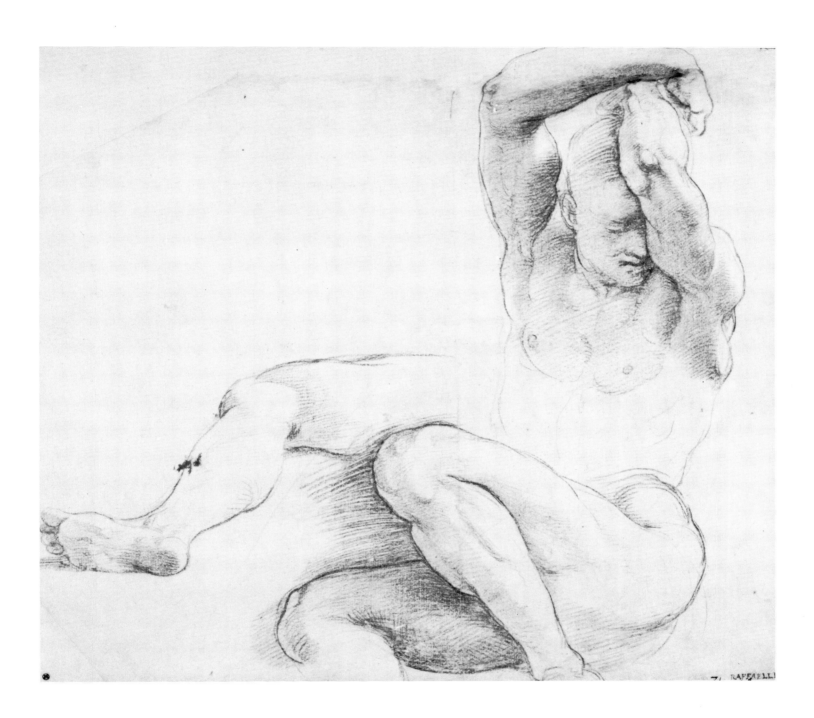

71 RAFFAELL

31. *Frightened Woman for the* Expulsion of Heliodorus

Oxford, Ashmolean 557r
Black chalk
395 × 258 mm., cut slightly all round (recto of Plate 32)

The pose is inspired by Michelangelo's Libyan Sibyl, painted in all probability in early 1512, which Raphael must have seen very soon after its completion. But the style of the drawing, too, indicates that Raphael was adopting a Michelangelesque manner to re-work his source, for the way the figure expands beyond the confines of the page, with the feet taken up again on the right, and the swelling outline of the left arm, are features found in Michelangelo's black chalk drawings for the *Battle of Cascina* and for the early phase of the Sistine Chapel ceiling; for the *Expulsion's* particular combination of vigorous movement, broad painterly style and dark setting, black chalk was the obvious choice (D. pp. 78–82).

This drawing excels in combining vigour and rhythm; hatching is sparing and large areas of the body are left unmodelled. Raphael creates broad swelling masses, subsidiary curves within the curving outline of the whole. Thus the bottom, and the loop of drapery that hangs over the left buttock, generate the movement of the figure as a whole, and the series of swinging curves of which it is composed.

The drapery across the back takes up the swing in the opposite direction. Here the oval is only partial and runs back from the right hip (the main line of the fold runs into the waistband immediately above the right edge of the fold over the buttocks), up to the left shoulder. Since it is incomplete as a surface pattern it thus contributes to the movement of recoil. It also provides a psychological opening to the action taking place on the right side, at which the woman is looking. To a certain extent, the detailed reprises modify this series of curves in the greater angular expressiveness of the feet, and in the shoulders, which are turned round further into space. The right hand now appears more visibly behind the neck and the balance of the figure is shifted slightly to the left, so that the right side of the body describes a more containing and less thrusting movement. This is particularly appropriate as the figure's role in the fresco is formal and expressive, summarizing the emotions of the spectators. To contribute to this change of balance, Raphael lowered the left arm a little, a development not predicted here.

CAT. 333r

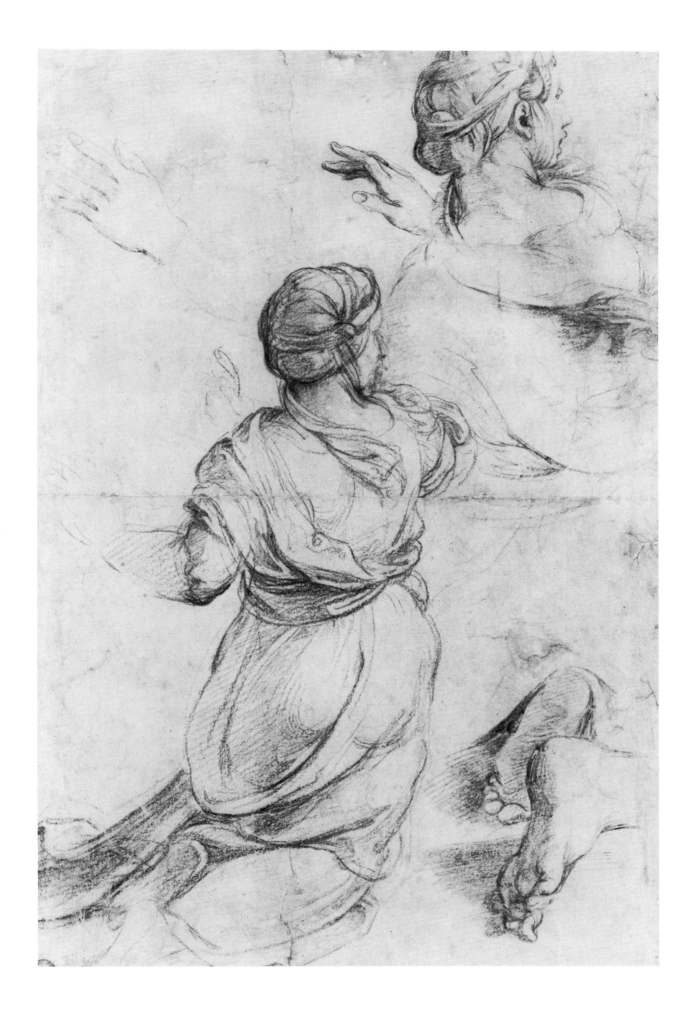

32. *Woman and Two Children for the* Expulsion of Heliodorus

Oxford, Ashmolean 557v
Black chalk
395 × 258 mm., cut slightly all round (verso of Plate 31)

In this study for the *Expulsion*, probably of early 1512, Raphael first drew the child turned away from the scene of the action, with his head tilted slightly to his left (our right) and his right arm locked over his mother's, which curved upwards. Then he perceived a more interesting counter movement which contributed to psychological variety as well as formal complexity, and he redrew the child so that he now faced right, actually straining against his mother's arm as he pushes forward to see what is going on. Raphael outlined only lightly the head of the second child immediately above the head of the first, looking also to the right. The position of his body has not been worked out, although Raphael may first have intended him to be sprawled across his mother's lap; subsequently he decided to place him standing on her far side.

The drawing style is broadly similar to that of the recto (Plate 31). The figure is based on a series of swelling curves; in this case the right shoulder is the generating centre, bent forward protectively to shield the child, and echoing the head, turned inwards and upwards towards the High Priest. Although not as systematically organized as the *Fire in the Borgo*, the *Expulsion* also contains a time-lapse temporal compression of the action, with the appeal being shown at the same moment as its result, and Raphael had to weigh carefully the psychological implications of everything he drew. As a second thought Raphael tried the head looking up, towards the angel on horseback, but in the fresco he reverted to his first idea (the second head incidentally comes very close to the repeated head at the lower centre of cat. 288r). Raphael has even indicated the different colours, or rather the tones of the different colours, that make up the woman's cap – a feature that he dropped in the fresco, but pursued further in the *Mass of Bolsena*.

At the lower left he sketched a sequence of garlands whose function has not been elucidated, and at the lower right a first idea for the prophets in the upper left lunette in the Chigi Chapel in Santa Maria della Pace, though the poses are more like those finally adopted in the upper right lunette. Both sketches were probably drawn after the main study, but the delay is unlikely to have been long, and together with the other relations between the Pace project and the frescoes in the Stanza d'Eliodoro, strongly supports the view that they were conceived at the same time.

The woman and child make a particularly interesting comparison with the red chalk drawing of some three years later for the *Fire in the Borgo* (cat. 369). Here, poses are weightier and more compact, proportions thicker and heavier, internal movement is less and the form is divided into planes of light and dark. The change of style is a general chronological development, and was specifically influenced by antique sculpture, but the differences correspond also to variations seen in the Florentine period, where Raphael was capable of producing stiff, planar forms at the same moment as mobile and rounded ones.

CAT. 333v

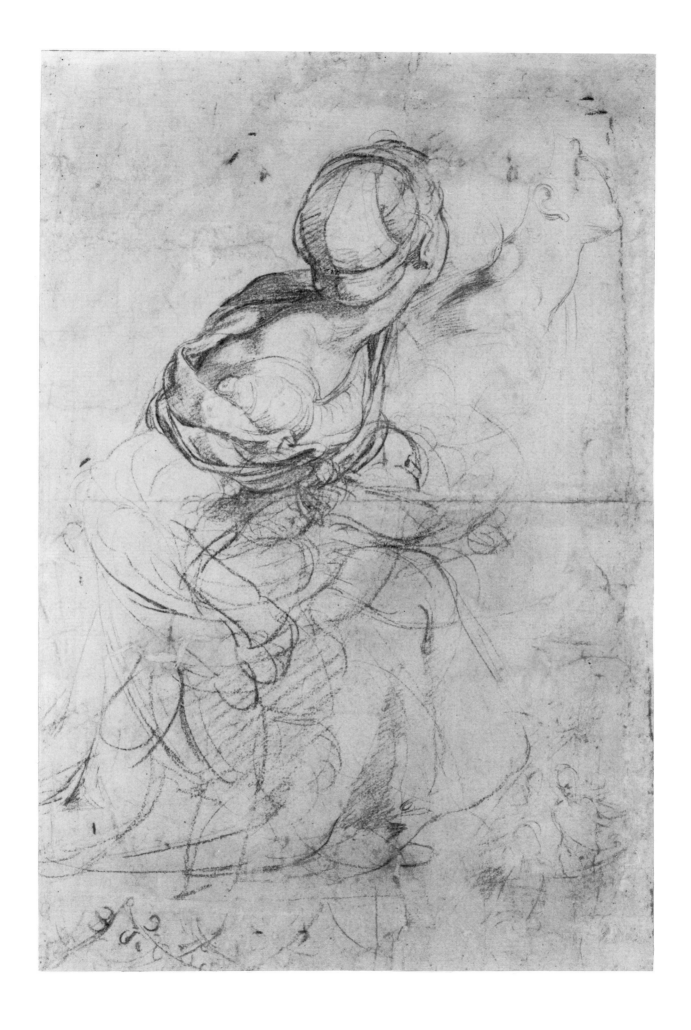

33. *The Coronation of the Virgin with Sts Peter, Paul, Jerome and Francis*

Oxford, Ashmolean 565
Pen over stylus, putti in front of the throne in stylus only, and stylus framing lines at top and bottom
making a composition 326 × 288 mm.
353 × 288 mm.

This drawing was developed from the complex sketches on cat. 328 for a rectangular composition of a format slightly higher than wide. The arched top of the throne shown in the upper sketch of cat. 328v and the arched setting with *baldacchino* shown below are both abandoned here, which might indicate either a change within the scheme or the projected utilization of the design in a new context; if the former, then the lower study on cat. 328v might well be for an altar fresco in a chapel, whereas this design would presumably be for an altarpiece on panel or canvas, perhaps to be framed by frescoes. Whatever the solution, the design cannot be connected with either of the two obvious possibilities, the Chigi Chapel in Santa Maria del Popolo, where the altarpiece seems always to have been intended to be a round-topped Assumption, or the round-topped *Monteluce Coronation*, for which a new contract was signed in 1516, some three or four years later than the date of this drawing; the second contract refers back to the first (of 1505) for the design and iconography, and neither that nor the painting finally delivered by his pupils after Raphael's death bears any relation to this composition (see also cat. 391). The design was, however, known in Umbria, for it was used by Berto di Giovanni for a panel dated 1517, painted for St Agnese in Perugia (Perugia, Galleria). Since the time-lag for Umbrian derivatives of Raphael's works was usually fairly protracted, this also suggests that this drawing is somewhat earlier. The design was also used for a tapestry in the Vatican which bears the arms of Paul III (1534–49); this date is usually considered to rule out the possibility that the drawing was intended for the tapestry, but it is by no means impossible that the existing tapestry is merely a copy of an earlier one. Finally, it formed the basis for several other drawings, notably one by Penni (Fig. 23), which includes additional figures; this is one of the few examples which throw light on the relation between drawings by Raphael and *modelli* by his pupils, though in this case Penni's drawing could be a later exploitation of the master's ideas, rather than a work produced on Raphael's instructions.

The drawing has been variously dated, but the comparative conservatism of the design, which is related to that of the *Madonna del Baldacchino* (Florence, Pitti; D. p. 26), the

standing figures of saints, which are similar to drawings for the *Disputa*, and above all the drapery of the Virgin, which relates to the Pace designs and to the silverpoint Madonna drawings of *c*. 1512, support an approximately similar date for this. It may also be that Raphael was constrained by the demands of the commission. The fine pen-work on the central group is of engraver's precision and clarity, and contrasts with the freer and less defined forms of the surrounding saints.

CAT. 329

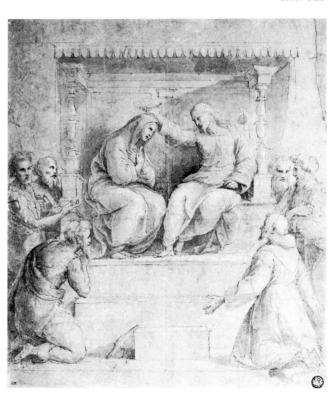

23. Giovanni Francesco Penni after Raphael: *Coronation of the Virgin*. Pen, wash and white heightening over black chalk, stylus under kneeling figures. 319 × 271 mm. Paris, Musée du Louvre.

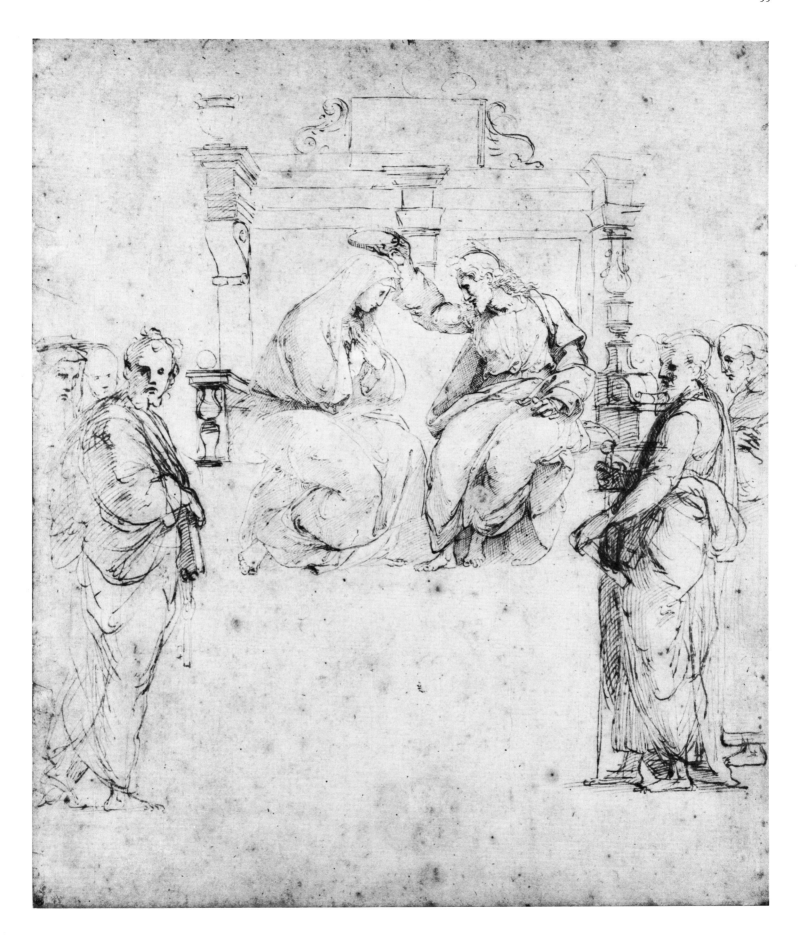

34. *God the Father Appearing to Moses*

for the Vault of the Stanza d'Eliodoro

Oxford, Ashmolean 462
Pen over traces of black chalk; squared in black chalk at 30 mm.
271 × 401 mm., cut at top, bottom and right

This drawing has sometimes been attributed to Peruzzi, who has also been held responsible for the painting of the Old Testament scenes on the Eliodoro ceiling. There is no justification for either view, and the recent discovery of cat. 342r has confirmed both Raphael's authorship and the date. Doubts were probably caused by the very hard technique, but this has a particular purpose besides revealing a changing facet of Raphael's pen style. There are very few highly developed pen drawings by Raphael dating after *c.* 1512, but the handling here is congruent with cat. 355 and with cat. 375. As in those, but here more clearly and consistently, Raphael has adopted a style influenced by woodcut; the debt to Dürer is underlined by the action of the angels, who pull back in strips the clouds of smoke that arise from the burning bush – a formula pioneered by Dürer. The drawing documents a reaction, also visible in the studies for the *Repulse of Attila*, against the painterly mode that dominates the walls. Here, for a ceiling fresco designed to simulate tempera painting on coarse canvas, Raphael composed for clarity, and he has wittily adapted Michelangelo's God the Father in the *Creation of Adam* for

his purpose; the right forearm is raised in a gesture of command and the left points back towards Egypt; it is the left arm and hand, of course, that imitate Michelangelo's *Creation* gesture. The borrowing is made with insouciant competence, and marks the end of Raphael's Michelangelesque phase.

The pen line is hard and unchanging, and Raphael drew on soft paper to facilitate this. He wanted a sharply focused, quasi-diagrammatic image for the simulated canvas of the ceiling, where flatness, hard contour, and surface pattern were at a premium. The short lines used to model the arm of the angel centre right, and the short, curving lines round the biceps and inside the elbow of God the Father's left arm (a method which, in fact, influenced Peruzzi) bring the form into hard life against the relatively unmodulated contour. The long lines defining the shadows, and the angels' draperies and wings are as though incised in a tablet. The drawing is a model of strength and decision and produces a dynamic image, perfectly calculated for the re-planned vault where eight fields were reduced to four.

CAT. 343r

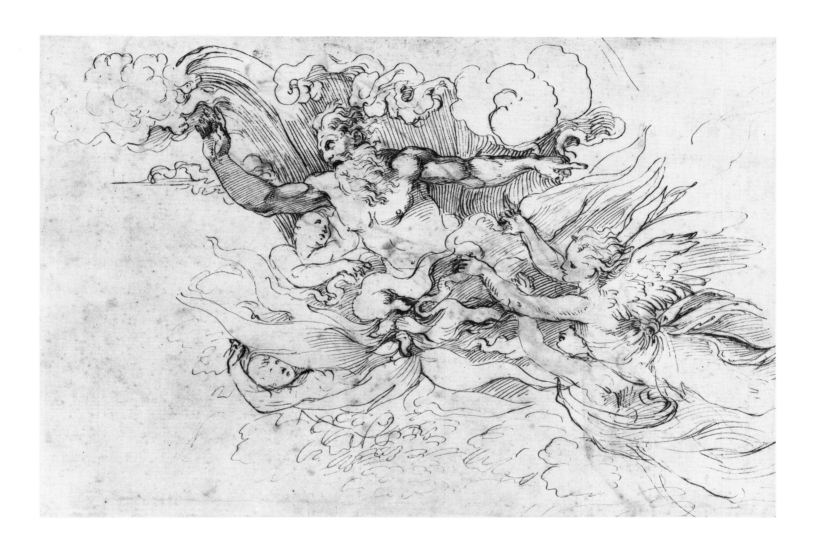

35. *Modello for the* Pasce Oves

Paris, Louvre 3863
Pen, brush and wash, white heightening over black chalk on grey washed paper; squared in black chalk at *c*. 33 mm.
221 × 354 mm.

Work on the cartoons for the tapestries to be hung in the Sistine Chapel is first documented in 1515, but it probably began the year before. The project dominated Raphael's other work in painting until *c*. 1517, and partly explains the comparative failure of the Stanza dell'Incendio. Raphael had to face major problems: the powerful competition of Michelangelo's vault; the need to relate his designs to those of the quattrocento fresco cycle immediately below which the tapestries were to hang; the new medium of tapestry itself. His solution was a positive exploitation of all three problems. He chose a simple, columnar and extremely solid figure-style which was loosely based on that of Michelangelo's great exemplar, Masaccio, with shorter and bulkier figures than he had hitherto used. He adopted the clear sub-divisions, relatively uncomplicated poses and foregrounding of figures from the quattrocento cycle (although after an experiment in a different manner, cf. cat. 356r); and he transformed into strengths the limitations of tapestry – its preference for clear arrangement, bright, distinct colours and lack of atmospheric subtlety.

The *modello* for the *Pasce Oves* (D. pp. 101–2) demonstrates his concerns. The composition is loosely based on Perugino's great fresco the *Delivery of the Keys* in the quattrocento cycle, but the figure style is heavier and more solid. Raphael's figures are large in proportion to the space available, and are arranged like a bas-relief – a sculpturesque quality which is stressed in the monochrome *modello*.

The comparative separation of the figures and the clear, largely planar arrangement of their draperies is ideal for tapestry. Raphael's unequalled command of rhythm and spacing can be seen in the carefully planned sequence of Christ, the kneeling St Peter heading the block of ten apostles, itself divided into two blocks of four and five by the fifth apostle, who turns round to his neighbour. The first four standing apostles are posed at different angles, only St John is approximately in profile; of the last five apostles, however, four are more or less in profile, thus the emotional reactions in the figures nearest Christ are contained by the calm and solidity of the disciples furthest from Him. Christ, with both arms outspread, forms a pyramid, and gains enormous power from His isolation, but His left hand also links downwards through St Peter's body, thus forming a triangular group of the Saviour and His rock within the basic rectangle.

Compared with the compositional draft (cat. 359), the *modello* makes great use of drapery: the patterns are endlessly analysable, but one example will suffice – the cloak of St John sweeps up and opens out into a triangular swathe across his shoulders, which helps direct his whole body toward Christ. Despite the difference in style, the integration by drapery demonstrated in the drawing of the two men for the *School of Athens* (Plate 24) also underlies this design; and the lessons of this grandiose manner were not lost on Andrea del Sarto.

CAT. 360

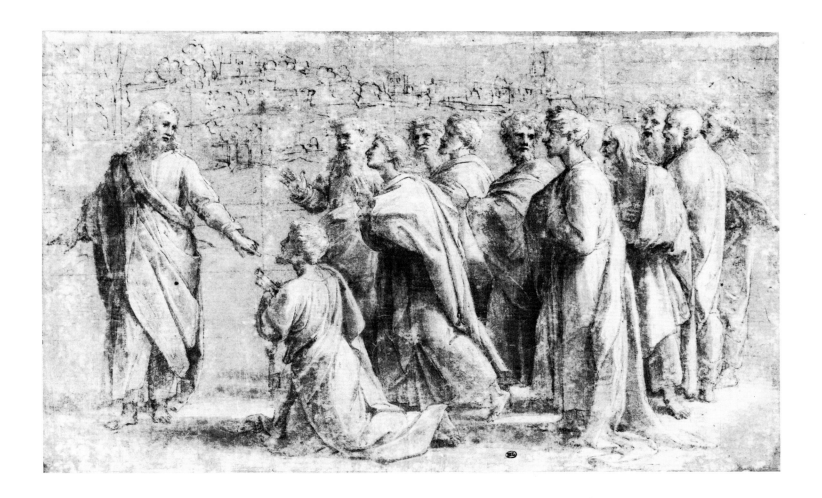

36. Figure Study for the Fire in the Borgo

Vienna, Albertina Bd. V, 4881
Red chalk
300 × 170 mm., irregular, cut at top, bottom and right

This study from two models, probably of 1515, is drawn with extreme care and with a concern both for detail and for sculpturesque weight. The concentration is understandable, for this group had a particular symbolic function within the context of the fresco (D. pp. 82–3), and Raphael had to create an outstanding composition. The group could be a design for a piece of sculpture, and indeed it was among Bernini's sources for his early *Aeneas and Anchises*. Raphael has in fact conflated these anonymous victims of a Roman fire of AD 847 with Aeneas carrying Anchises away from burning Troy (in the fresco, Aeneas's son, Ascanius, accompanies them). The clue to the significance of the group for Leo X is provided by the head of Anchises in the fresco, for the old man is given the features of the great founder of the Medici fortunes, Cosimo il Vecchio. And it is probable that Ascanius represents the young Giovanni de' Medici who, as Leo X, was to salvage the family fortunes in Rome. The *Fire in the Borgo* is thus equated both with the destruction of Troy and with the expulsion of the Medici from Florence in 1494. Significantly, the symbolism and references are allusive and elusive, partial rather than systematic and covert rather than overt. The most substantial figure, 'Aeneas', lacks a Medici equivalent and the chief clue to the meaning is a profile (based on a medal) which would have been recognized only by a few. The division of the fresco into three more or less separate sections corresponding to the beginning, middle and end of the crisis, is based on the Aristotelian analysis of classical tragedy; this arrangement, in which groups are seen as separate entities, with minimal interrelation, enhances the sculpturesque effect, and focuses attention on the individual forms.

Although tattered and worn, the drawing is remarkable in its precision and certainty; there are only the slightest pentimenti in the right forearm of 'Aeneas', and in the top of his right thigh. The chalk, although densely rubbed in the shadows on the chest, does not lose modelling, and the sparing of the paper for muscles and sinews is achieved with a miniaturist's accuracy, organized by the very slightest boundary lines. It is interesting to compare this drawing with a study for a comparable figure, a table bearer, of a similar date (Fig. 24), possibly by Penni. Here the contours are stiff and inexpressive, registering nothing of the physical tension of the action. The legs are heavily hatched, but three-dimensional relief is not created, and in the chest, especially, modelling is entirely lost except for an attempt made at articulation by laying a few light lines over the surface of the hatching – a literally 'superficial' method, which mocks Raphael's deep structures. This draughtsman is most successful with features like the feet, the hands and the hair, but they seem like still-life details within a whole which is not organic; the simultaneous emphasis and subordination of parts illustrated by the 'Aeneas and Anchises' is entirely beyond the artist of the 'Table Bearer'.

CAT. 367

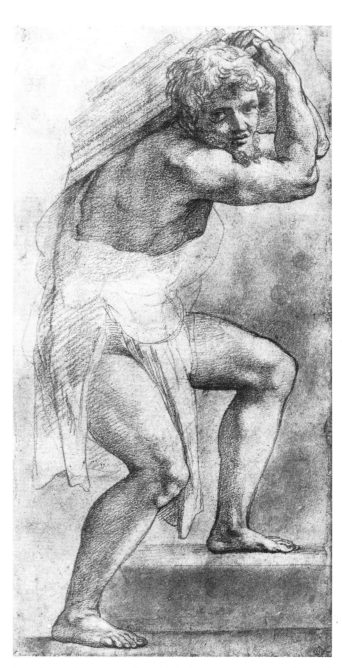

24. Giovanni Francesco Penni (?): *Porter Carrying a Table*. Red chalk, subsequent silhouetting in pink wash. 322 × 162 mm. Chantilly, Musée Condé.

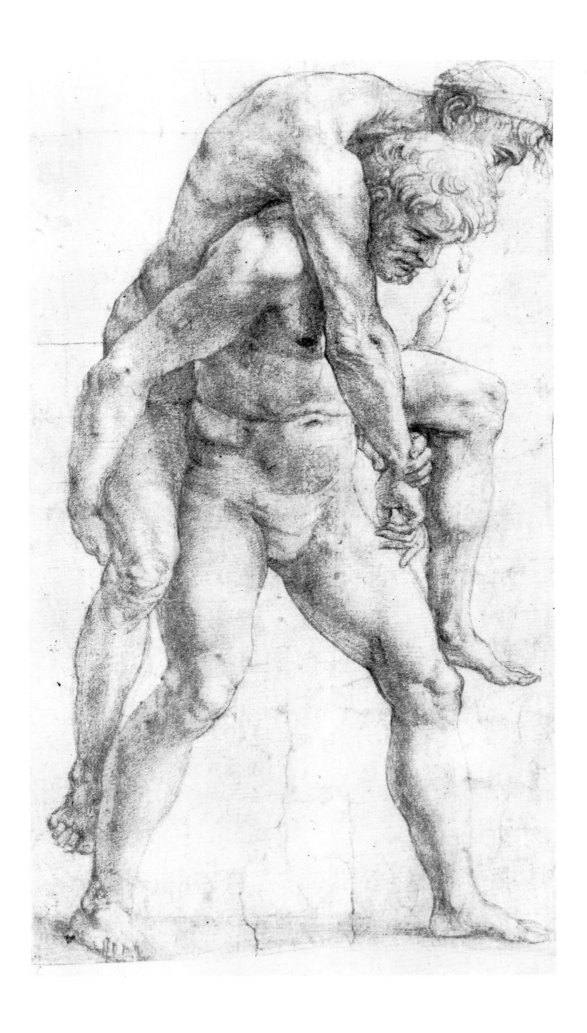

37. *Two Men for the* Victory at Ostia

Vienna, Albertina Bd. V, 17575
Red chalk over stylus; Dürer's inscription in pen
403 × 281 mm., cut at right

This, one of Raphael's most famous and controversial drawings, was sent, as the inscription shows, to Dürer in 1515 as part of an exchange of gifts between the two artists. However, in spite of this evidence, the drawing has sometimes been attributed to Giulio Romano. Certainly, compared with the study for the *Fire in the Borgo* (Plate 36) this drawing presents a less integrated whole and is more laborious in appearance. This is largely because Raphael has consciously adopted a different chalk technique: based once more on the finest type of silverpoint drawing, it makes use of the thinnest possible lines, fusing the chalk only in a few selected areas of shadow, and uses a thicker point only in the hair. Raphael had based his red chalk drawings of *c.* 1511–12 on pen and silverpoint, but not to this level of precision. The lines are consistently thin, and Raphael must have kept his chalk very sharp.

Clearly making his study from the same thick-set model in two different positions, Raphael did not copy him slavishly: the buttock of the left-hand figure has been lowered from its first position by a hard contour line in order to create a more solid shape with a lower centre of gravity. But the drawing nevertheless has the look of a deliberate exercise in describing form by means of a particular graphic technique – one which Raphael found appropriate as a demonstration of his skill to Dürer. The fact that generations of students were to copy the cast or the model by a systematic convention has probably prejudiced critics against the drawing. But it is a study of the highest quality and perhaps it owes its slight self-consciousness to the fact that it was a presentation drawing as well as a preparatory drawing for the *Ostia* (D. pp. 83–4). The forms of the back and leg of the right-hand figure are described with the utmost precision; the basic shapes of the internal modelling of the shoulder blades, for example, were initially established with slight variations in the hatching; they were then brought out by means of a web of thin lines laid across the divisions of shadow. The method is the reverse of that used in Plate 36, where the internal contours were established first, and closer, though drawn with infinitely greater skill than that employed in Fig. 24. The method is thus additive and could be readily grasped by a pupil, and such a drawing would therefore have been of value for teaching. The effect, although sculpturesque, is so in a way different from Plate 36. The technique creates a shinier surface and more artificial and elaborate, less human, textures. It marks a move on Raphael's part towards a style based on antique sculpture in surface treatment as well as figural proportion. This was to be combined with new surface effects in fresco, an attempt to come closer, although with a shriller colour-range, to the polished, enamelled quality of paintings like the *Madonna del Pesce* (Madrid, Prado; D. p. 38). Ultimately it was an endeavour which succeeded in a darker manner in the Sala di Costantino, and there it was prepared in different graphic techniques.

CAT. 371

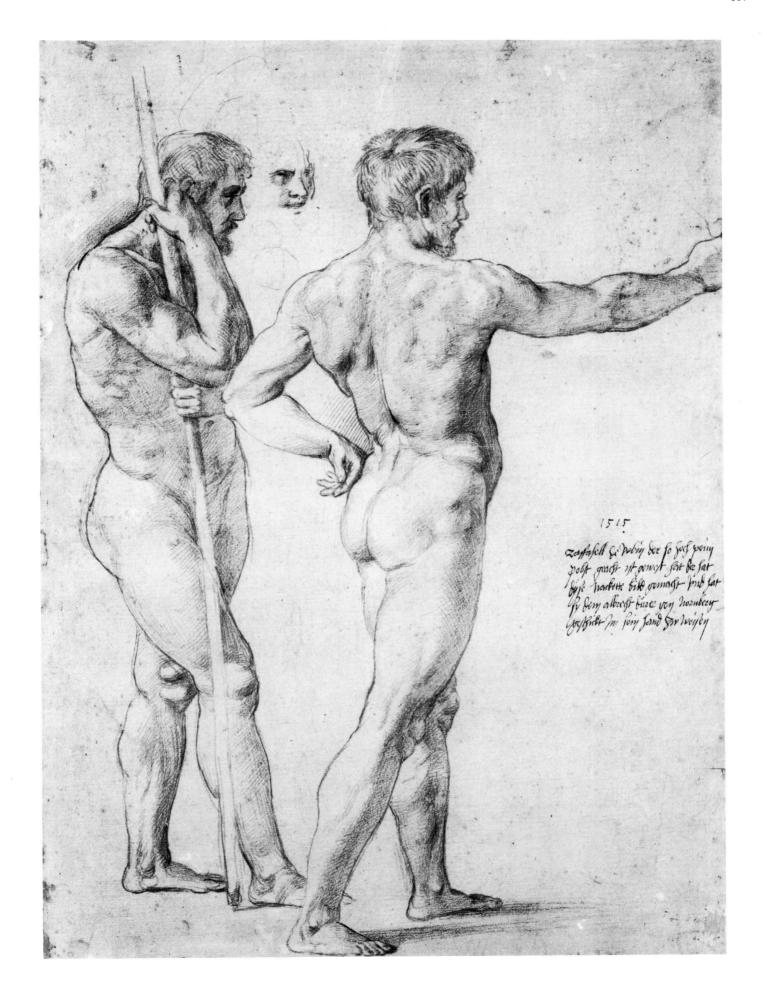

1515

Zataßell ... der so hoch vom
... ist gewest hat die hat
... hackette bild gemacht und hat
es dem albrecht dürer von nornberg
geschickt in sein land zu weißen

38. God the Father Welcoming the Virgin

Oxford, Ashmolean 556r
Red chalk over stylus (probably counterproofed)
214 × 209 mm., cut at top and right, several holes patched

A drawing of 1515–16 which shows, in reverse, Raphael's design for the central oculus in the mosaic dome of the Chigi Chapel in Santa Maria del Popolo. (The work was carried out by the mosaicist Luigi de Pace, signed by him, and dated 1516 (D. pp. 95–6). God the Father is here shown with His left hand forward, whereas the verso study (Fig. 25) is posed in the opposite direction; this was to be the direction of the final cartoon since the technique of mosaic involves, like that of tapestry, a reversal of the cartoon; Raphael probably took counterproofs of both sides in order to facilitate the reversal of the recto from the verso (which was drawn first) and to reverse the recto for the cartoon.

The drawing shows Raphael at his most confident; even features which might appear as weaknesses elsewhere here become strengths. For example, the putti supporting the Almighty are somewhat bland, and the foreshortening of the left arm of the right-hand putto is not completely convincing. But these small, rounded figures are simplified for execution in mosaic, and also in order to set off by their firm smoothness God the Father's heavy drapery. The forms of the Almighty, although forming a convincing unity, are rendered in different ways. His left arm is divided into rectangular segments of shadow and light, with the edge of the shadow sufficiently varied for the arrangement not to seem mechanical. (There is a close similarity to the arm of the standing mother in cat. 369, but the effect is here more strongly realized.) The handling of the drapery emphasizes masses of light and shade rather than thin ridges of light, although these are used in the fold across the abdomen and, very lightly, at the top of the left sleeve. The style is not far from that employed in the Tapestry cartoons (e.g. cat. 365) and, for the analysis of the scoops of drapery which give the lower part of the figure such sculptural force, there is an angling of hatching similar to cat. 354.

Raphael has balanced the left and right sides of the drawing and the top and bottom. At the left he uses a softer, less dense hatching for the sleeve, in order to underline its receding position in space; at the same time he has allowed it the brightest highlight of the whole drawing, to draw attention to it and bring it forward to the front plane. And the denser modelling of the head, seen in sharp fore-shortening and therefore on a smaller scale, with the heavy accentuation of mouth and eyes and the dark halo of the hair, is forceful and commanding and is in no sense diminished by the foreground swathe of drapery. Raphael plays the variable stressing of chalk against the systematic organization of hatching with consummate skill.

CAT. 386r

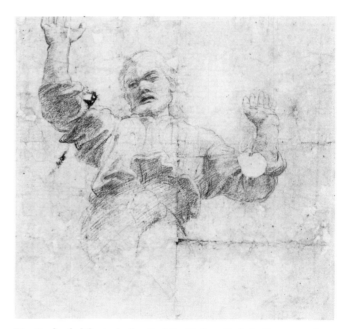

25. Raphael: life study for God the Father. Red chalk over stylus. 214 × 209 mm. Oxford, Ashmolean.

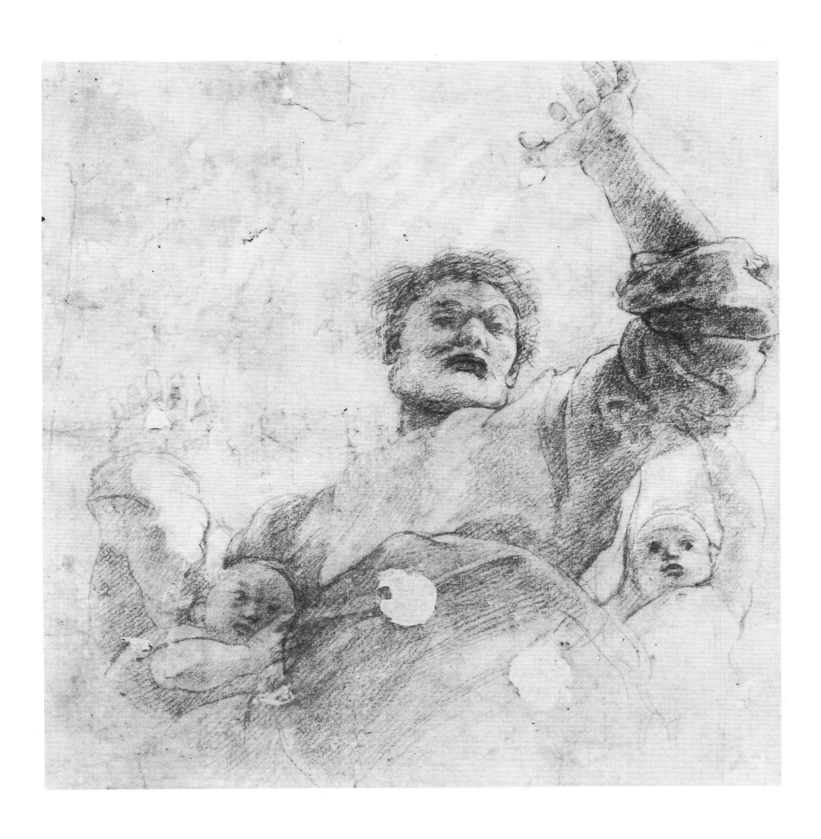

39. Angel with Raised Arms

Oxford, Ashmolean 567
Red chalk over stylus
199 × 168 mm., made up at upper left and lower right corners, patched at left and right edges

This study, in reverse, for the angel above Jupiter in the vault of the Chigi Chapel in Santa Maria del Popolo, of 1515 or 1516, is comparable with but subtly different from Raphael's drawing of God the Father (Plate 38). Not designed to be seen in such sharp foreshortening, and playing a much less important role, the figure is treated more atmospherically and with less emphasis on a precise modelling of the robes. Yet despite the figure's subsidiary position, the study clearly bears the hallmark of enormous instinctive intelligence. Particularly remarkable is the treatment of the arms. The right arm is rounded and softly focused, with pentimenti along the contours and round the fingers. The left arm is treated very differently, with sharp contours and flat areas of shadow and light, very similar to the arm of God the Father in Plate 38. The near arm was intended to be more plastic, more emphatic, and the treatment demonstrates this to perfection: the ridging of light on the lower part of the sleeve acts almost as a frame for the forearm. The drapery over the thigh and leg is left unarticulated, brushed in with sweeping strokes of the chalk as though in preparation for the most painterly painting. Only a few sharper lines, reinforcing the thin guide lines previously sketched to establish the shading, determine the folds at the right.

The face is left almost uncharacterized, with emphasis placed only on the mouth and the lowered eyelids; but there is nevertheless an indefinable sweetness and spirituality in this visage. Notable, too, is the arrangement of the wings, which were altered in type and in position in the mosaic. At the right, Raphael has shown the angel's left wing set broadly on a diagonal opposite that of the arms, and roughly aligned with that of the lower leg. The right wing, lightly outlined, spreads horizontally out to the left, roughly parallel with the line of the thigh, and acting as a backdrop for the right arm and the head. Thus the whole composition has an upward and outward movement which is appropriate to the heavenly nature of the planet-guiding angel.

The grace and vivacity of the drawing, its rapidity and apparently spontaneous ease, make it one of the most charming of the red chalk studies of Raphael's mid-Roman period.

CAT. 387

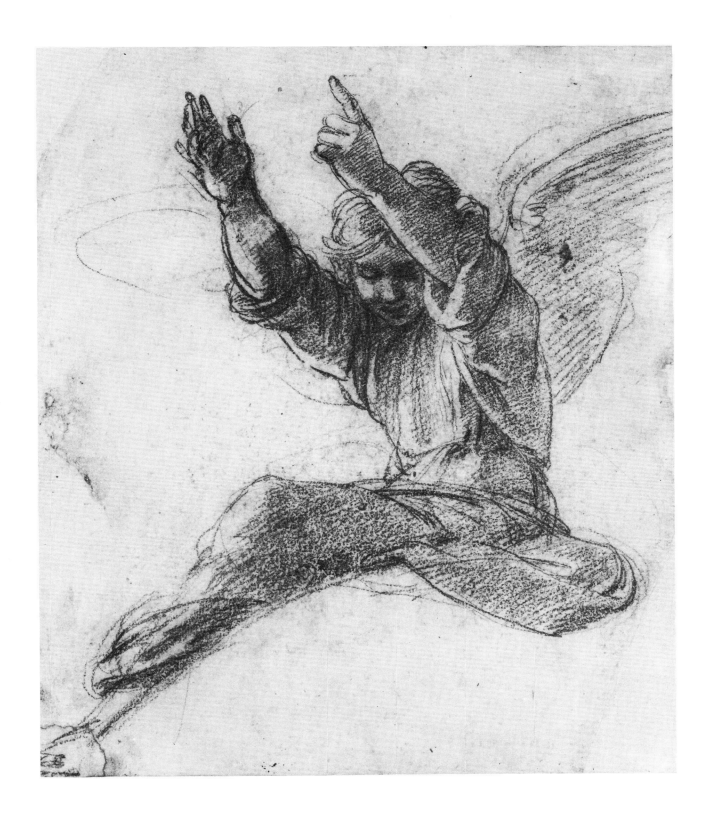

40. *David and Goliath*

Vienna, Albertina Bd. VII, 178
Black chalk
243 × 321 mm., cut at right

The only surviving preparatory sketch for the narrative frescoes in the Loggia of Leo X (D.p. 90), this study of David and Goliath was drawn from the model, as the figure on the right, in contemporary dress, indicates. A number of changes were made between this drawing, probably of 1516, and the final design: the fleeing figure was dressed in armour, the lightly indicated figure moving forward at the left was abandoned, a number of other figures were added, and the composition was reversed. Within the drawing there are a number of significant pentimenti: David's head was first sketched much lower, appearing in profile beneath his raised arms as he delivers the *coup de grâce* – a pose which perhaps had greater energy but less elegance. Raphael also tried two positions for Goliath's shield – tilted in perspective over his right arm and lying beneath it; the latter was adopted for the fresco.

Despite the lack of comparable studies (but cf. cat. 365), this drawing does suggest that Raphael, who, Vasari says, prepared all the histories for the Loggia, designed only the key figures in the scenes, and left his pupils to complete the compositions more or less independently; this would

account in part for the mixture of narrative coherence with gaucheries of form that can be seen in many of the surviving *modelli* and in the frescoes.

The drawing shows Goliath still alive as David presses down upon his back; the fingers of his right hand, sharply bent, seem still to be twitching; his left forearm and hand, bent in a vain effort to push himself up, still register the tension of life; both are details that are blurred in the fresco.

The style is softer and more open than in any earlier surviving drawing, with the forms composed of masses of shadow and soft and thin bounding lines, drawn with a very light pressure of the chalk. The system is one of evocation rather than description. It is not unrelated to black chalk drawings like the Medici putto (Plate 41), but it is much less emphatic in its contrasts and much less defined in its forms. The drawing does not attempt to delineate too closely the final image, and as such was a generous method of inspiring assistants. It also formed the basis for developments in Raphael's own drawing when he came to prepare his last major fresco scheme in the Sala di Costantino.

CAT. 390

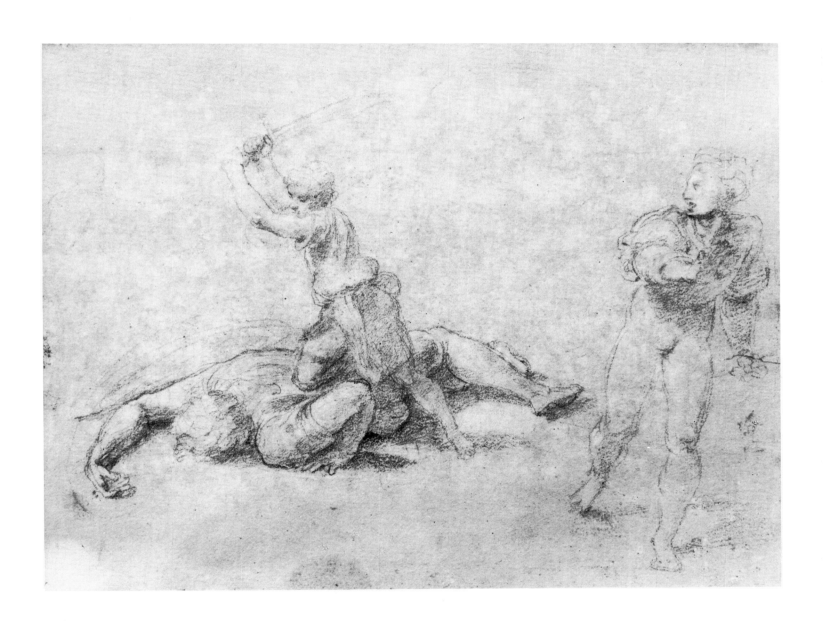

41. *Putto Carrying the Medici Ring and Feathers*

Haarlem, Teylers Museum A.57
Black chalk heightened with white
339 × 186 mm.

In conjunction with the rearrangement of the central part of the Eliodoro ceiling in 1514 (see Plate 34), Raphael also had the pendentives plastered out, as in the Stanza della Segnatura, in order to regularize the corners. These were frescoed by Raphael's assistants with small heraldic and symbolic figures whose full significance has not yet been clarified. This drawing was prepared for the pendentive to the left of the *Release of St Peter*, and presumably also dates from 1514.

A central difficulty is understanding why the drawing was made at all. The exact level of Raphael's participation in the design both of the *Repulse of Attila* and of the *dado* of this room is controversial (see cat. 347), but his pupils were certainly responsible for most of the execution of the former, and all of the latter; in the next room, the Stanza dell' Incendio, they were also heavily involved at the design stage. It is therefore strange that Raphael should have produced one of his most beautiful drawings for a distinctly minor figure, when more obviously important areas did not receive comparable care. Perhaps it was because the putto carries the *impresa* of his patron that Raphael prepared the figure himself; but no explanation is entirely satisfactory and the existence of this drawing, whose function is clearly indicated by the curved line of the edge of the pendentive on the left and the vertical of the wall on the right, supports the view that despite his efficiency, Raphael's energies were

not as coherently directed nor his studio as rationally organized as might be expected.

The drawing represents a considerable modification of the black chalk style of the studies for the *Expulsion* (Plates 31 and 32). The contours are rather thick, with comparatively little modulation; the shadows on the body, obtained by careful rubbing, are even and firmly bounded, and they are set against much denser surrounding shadows. The soft convexities of the child's body – his chest, belly and thighs – are rubbed with white lead, which Raphael had barely used on earlier black chalk drawings. The effect is to establish four tones (with, of course, an infinite variation within and among them) which are fairly clearly demarcated, creating a form which is solid and inherently geometrical, and extremely soft in texture. The use of both black chalk and white lead may to some extent have been conditioned by the planned grisaille execution, but it represents in essence a sleek new manner. Surprisingly, Raphael did not, at least in so far as can be judged from surviving drawings, pursue it, and for the next four or five years concentrated on red chalk. But this drawing remained one of the models for the chalk style that Raphael adopted at the end of his life. The softness of the flesh, the wispy mop of hair, the pensiveness of the expression and the rhythmical control of the pose (which comes close to that of the Child in cat. 319) make this one of Raphael's most affecting treatments of children.

CAT. 345

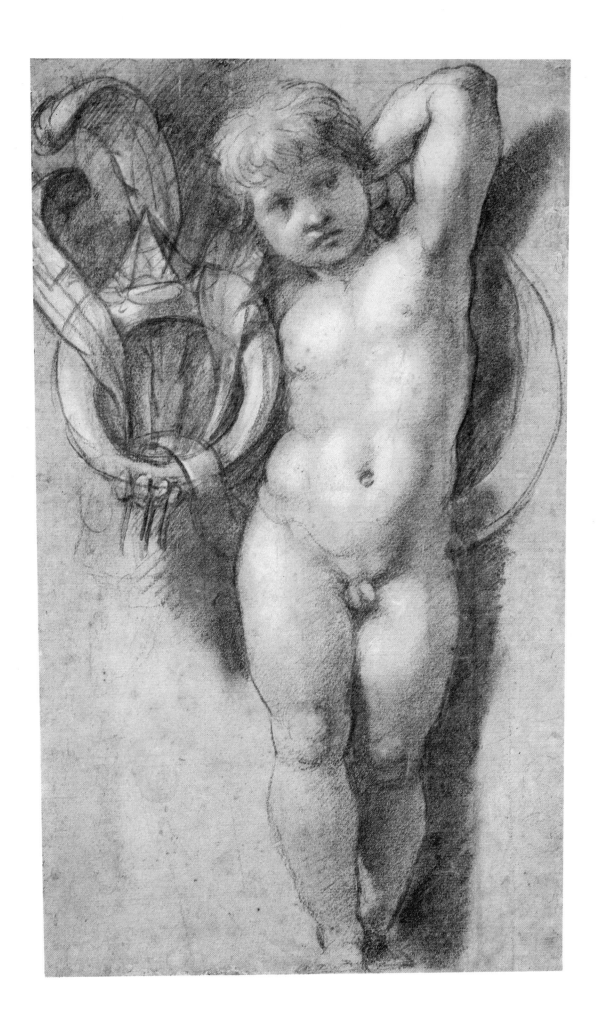

42. *Madonna for the* Holy Family of Francis I

Florence, Uffizi 535E
Dark red chalk over stylus
336 × 214 mm., a tear made up at the lower right side

The painting (Paris, Louvre; D.p. 48), commissioned by Lorenzo de'Medici, Duke of Urbino, for Francis I of France, was executed between March and May 1518, and the drawing can be dated to early in that year (D. p. 48). It is significant that this radiant study, primarily of drapery but also of expression and emotion, should have been drawn after Giulio Romano's vivacious initial sketch (cat. 393). Comparison demonstrates the superiority of the master's intelligence: the calf is shortened so that it forms a visual support for the back and does not jut out beyond it; the bend of the thigh is decreased so that the eye climbs the Virgin's body in a slow reversed 'S' rather than the sharp 'Z' of Giulio's design; the Virgin's arm is bent to draw the Child towards her and to lift Him up, rather than being thrust out at an angle which is awkward and without meaning; the right leg is eliminated by a swathe of drapery which leads up to the Virgin's head – in short, Raphael's drawing displays a bodily architecture and a capacity for perceiving and refining upon the most fundamental of human emotions which place his design, intellectually as well as technically, in a wholly different class. It is revealing that Raphael should first have drawn the Madonna's arm and breast with only the lightest of coverings – a thin, clinging garment – in order to obtain the precise relation between the Virgin and the Child without interference from drapery. It was only when this had been done to his satisfaction that he redrew it at the upper right, devising a small cascade of folds on the arm, and a sequence of loops over the breast, to provide a

ruffled area to set off more effectively the smooth face of the Virgin and the smooth body of her Child. He also lowered the arm slightly, and turned it fractionally inwards, so that it responds more precisely to the Child's position in space: it proved too complicated for his pupils to execute and was modified in execution.

The drawing makes use, opportunistically, of a great variety of dimensions and angles of hatching and much precise rubbing. There is also a technical novelty. Stylus underdrawing occurs in most of Raphael's chalk drawings, but here it is not merely a device for blocking out the form: it has a definite role in the image. Raphael realized that the satin drapery he intended for the painting would reflect the light in complex and arbitrary ways; he needed a lambency in the shadows, and the stylus tracks here serve that function. They run along the edges of the ridges of highlight, blurring the severity of the outline; they snake across areas of shadow, opening them up in flickers of light. In fact Raphael here creates, more effectively than in the completed painting, the effect of the shimmer of satin in a darkened room, the elaborate dress of Francis I's queenly Virgin.

The priority of cat. 393 is important, since it demonstrates that Raphael was prepared to let his pupils work on the early stages of some compositions, and then act in a critical capacity to improve and refine them. Such a pattern shows once again the variety and flexibility of Raphael's working procedure.

CAT. 394

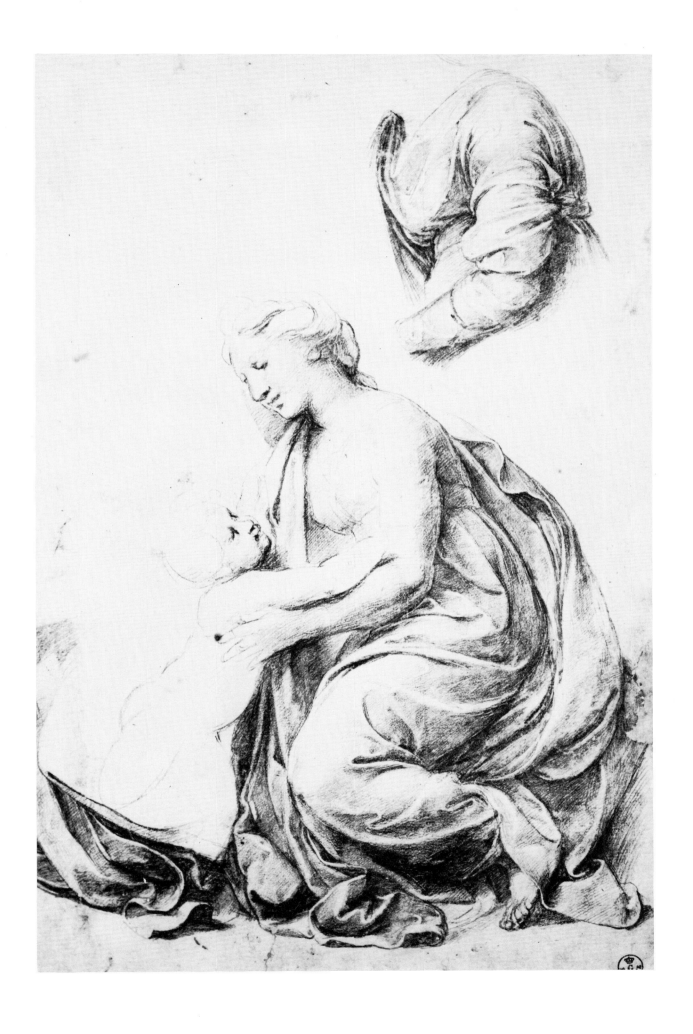

43. *The Three Graces for the* Wedding of Cupid and Psyche

Windsor, Royal Collection 12754
Red chalk over stylus (counterproofed on cat. 409)
203 × 260 mm., cut at lower left and right corners and below after counterproofing

This study of the same model in three different positions shows Raphael's mastery of the female nude; paradoxically (cf. Plate 41), he has in this project, executed in 1518, once again paid enormous attention to comparatively unimportant background figures and relied on his pupils both to design and to execute those in more prominent positions.

Red chalk was the ideal medium for conjuring this firm young flesh to life. Its application, though slightly weakened by counterproofing, ranges from the thinnest of lines picking out the left hand of the leftmost girl, to the most delicate rubbing in the shadow under her breast. While the direction of the hatching was modified on the back and shoulders of the central Grace in order to obtain volume, the dominant impression is one of technical consistency across all three figures.

Raphael is here revealed as the most elegant of sensualists. The study is erotic without overtness: the Graces are responding to the married pair, over whom they sprinkle perfumes; the delicacy of their gestures, coarsened and partly lost in the fresco (D. pp. 96–9), where the central amphora is concealed by Cupid's wing, reveals their character, and it is this which marks Raphael's true percipience. For he sees their bodies not as objects of desire, but as vessels of the spirit. His beauties are autonomous, performing silent action, unaware of observation. And generalized passion is confirmed by precision: in the girl in the centre, the buttocks rhyme with the swell of the stomach, which, in a piece of incisive observation, is drained of volume by the fall of light.

Of particular beauty is the relation among the three figures, for they seem to be – and in reality are – the unfolding of a single form. The Grace at the right is largely in profile, her left side slightly pushed forward; in the centre the girl is more upright, her left side also pushed forward but her head turned out and down to the left. The third, bent forward, her body turned outwards and her right arm outstretched, is the mirror image of the probable next movement of the central figure; she seems to sum up the others as she anoints Love and his bride.

Raphael's drawing makes a revealing comparison with a study for the Three Hours which may be by Penni (cat. 407). Here, dealing with a similar group for a similar position in the same fresco, the pupil has produced a study devoid of the selective detail, the life of the flesh, the vitality of contour, and the differentiated but still unified expression which distinguish the Three Graces.

CAT. 408

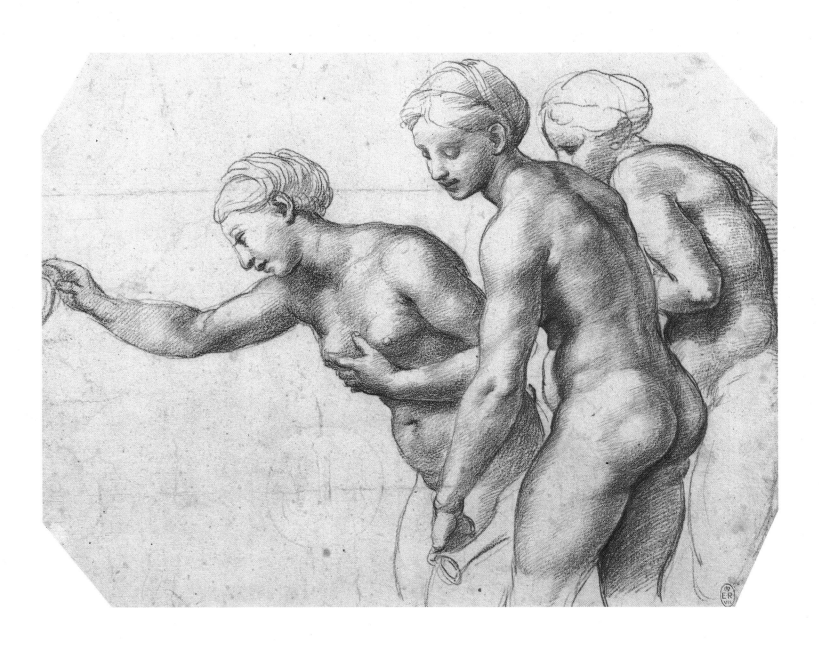

44. *Two Soldiers Climbing into a Boat*

Oxford, Ashmolean 569
Black chalk and white heightening, partly oxidized, over stylus
257 × 362 mm., cut at right

This study from the same nude model in two different poses was certainly drawn before the *modello* for the *Battle of the Milvian Bridge* (late 1519 or early 1520; cat. 442) in which the figures appear in reverse relation and clad in armour, but otherwise identical, whereas in the fresco they are modified (D. p. 86–8). Nevertheless, the poor quality of Penni's *modello* betrays the care taken here (cf. Plate 47), and it is likely that the drawing's function was twofold: to prepare the poses, and to act as a guide to texture and modelling for Giulio Romano, who was to draft the cartoon (cat. 443). By this stage the roles were clearly defined: the edge of the boat can be seen under the right knee of the left-hand figure, and the line of his back is shown intersecting with the head of the right-hand figure, who is clutching him. The weakness and appeal in the raised head imply the context: as in Michelangelo's *Flood*, these fleeing soldiers are going to be cut down by their comrades to prevent them from overloading the boat.

The Sala di Costantino marks a return to black chalk. It is a large room, not well lit, and Raphael had the walls prepared for painting in oils. He hoped to obtain the polished lustre effects of his late panel style on the walls, and indeed the two figures that survive from his experiment, Justice and Comitas (Kindliness), although buckled and warped, do show a greater richness than the frescoes executed after his death by Raphael's pupils. The dark style allowed a more selective focus in the room, as in the Stanza d'Eliodoro, but here the effect is richer and sleeker. Raphael seems to have desired a pictorial art which combined *sfumato* modelling with the greatest possible intensity of colour, and which at the same time had the density and solidity of polished sculpture.

The drawing technique here, with its more extensive use of white, represents a reprise and an elaboration of that of the Medici Putto (Plate 41). Areas of rubbed chalk are played against areas of light in two intensities – the spared paper and the white heightening here applied, as in Plate 41, in patches rather than in lines. The range is extended by a flexible use of hatching to create intermediary tones and to model key features such as the shoulder of the left-hand figure. The smoothness and generalization of texture shown in this study, however, is also a function of the figures' roles: their slickness of surface emphasizes their wetness, and their bodies reflect the light more than, for example, that of the advancing soldier (cat. 444), drawn from the same model but with a different function. And it should be noted that the submerged lower back and upper thigh of the right-hand figure are deliberately blurred.

In a study of some eight years earlier for the *Resurrection* (cat. 306r), an effort was made to model every expressive element with a comparative uniformity of emphasis and a resulting stiffness. Here this has changed: all is transition and the modelling is mobile, as though the forms had been pressed out in clay by the artist's thumbs. A sculptural influence is still present, that of the Belvedere Torso, but the Michelangelesque emotionalism is gone, and the poses are simpler than in the *Resurrection* studies. The result combines the painterly and the sculptural, structure and surface, description and impression, strain and poignancy.

CAT. 441r

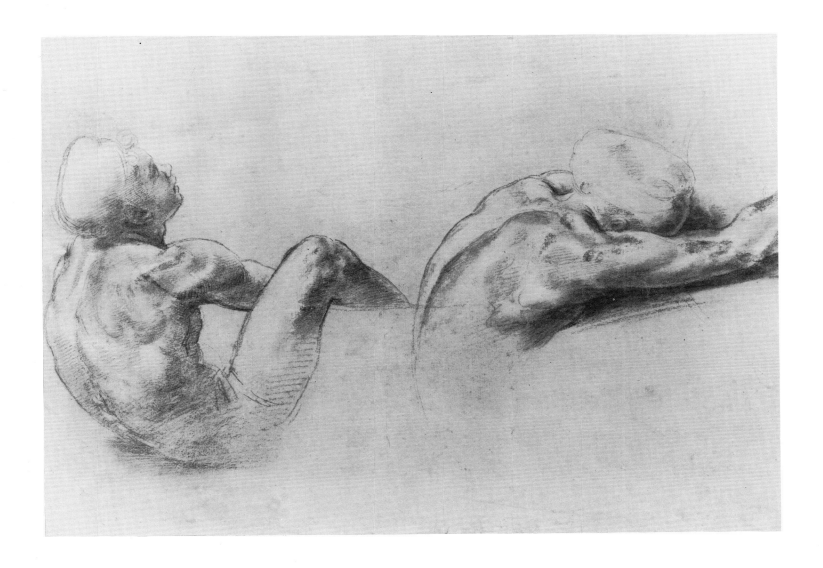

45. *Pope Sylvester I in a Sedia Gestatoria*

Boston, Isabella Stewart Gardner Museum 24093
Black, white, yellow and red chalk, brush and wash, squared in black chalk twice, at 32 mm. overall under the drawing, and at 27 mm. over the central group
398 × 404 mm.

This drawing, probably sketched in outline from a group of appropriately draped models set up in the studio, was the source of the two pupil drawings which depict the *Donation of Constantine* (Fig. 26 and cat. 448). The subject was finally rendered in a radically different form by Giulio Romano and Penni on the resumption of work in 1524 after the interval between the death of Leo X in December 1521 and the election of his cousin Cardinal Giulio de'Medici as Pope Clement VII in November 1523 (cf. Fig. 10). The two subsequent drawings show modifications to this design which are similar to the differences between the *modello* for the *Adlocutio* and the fresco.

The authorship of the drawing is controversial and a comparable use of coloured chalks occurs in only one other drawing (cat. 459). Precedents for multi-coloured chalk drawing can be found in Umbria (Signorelli sometimes used coloured chalks), but it is more common among the followers of Leonardo in Lombardy, and Raphael may have adopted it as a result of his resurgence of interest in Leonardo late in the second decade. Many features of the drawing speak for Raphael's authorship: the lightness of the black chalk underdrawing; the geometrical clarity of the arrangement combined with a deliberate perspectival compression of the image; and the inventiveness of the technique itself which,

had his pupils devised it, would probably have been continued by them after his death; however no later drawings of this type can be attributed to Raphael's pupils.

CAT. 447

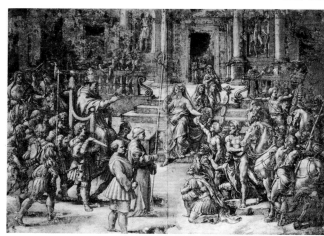

26. Giulio Romano and (?) Giovanni Francesco Penni: *The Donation of Constantine*. 1521 (?) Pen, wash, white heightening, some stylus work. 395 × 549 mm. Amsterdam, Rijksmuseum.

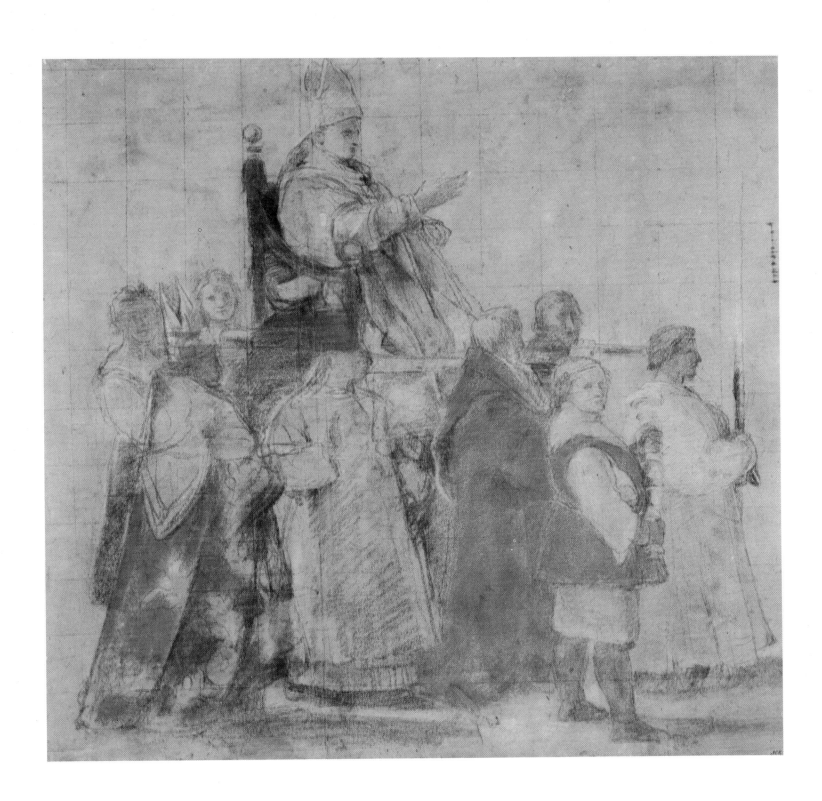

46. *Charity*

Oxford, Ashmolean 665
Black chalk and touches of white heightening
311 × 154 mm. maximum, irregular, cut all round

This study was made for the figure of Charity who, with Justice, flanked the enthroned Urban I at the far right of the long wall of the Sala di Costantino (D.p. 86–8). This wall was first prepared for, and partly painted in, oils but of this endeavour only Justice remains. It is therefore virtually certain that this drawing (and cat. 452, from the same model for the caryatid immediately above Charity) were prepared within Raphael's lifetime – probably in late 1519 or early 1520. The model, with a heart-shaped face, also served for the Virgin in the preparatory study for the *Small Holy Family* of *c*. 1517 (Paris, Louvre; D. pp. 49–50; Fig. 13). The attribution of this drawing, like that of cat. 452, is controversial, but needlessly so, for its inventiveness, both of arrangement and drawing style, is quite beyond any of Raphael's pupils. The only other serious candidate, Giulio Romano, certainly employed black chalk, as can be seen in his important preparatory drawing for his small *Madonna* (of uncertain date but presumably not long before 1519), where the handling is much cruder and sharper (Fig. 12). Giulio never possessed Raphael's lightness of hand or his ability to evoke rounded form.

This drawing, conveying the sweet and serious humanity of Charity in tattered robes, is one of the high points of Raphael's evocative style. Prepared for an important figure, but not one which required the greatest plastic emphasis, the forms are conjured from the paper by the silkiest outlines and patches of shadow. The modelling, achieved with only the slightest addition of white heightening, combines firmness, accurate foreshortening and the differentiated textures of skin and material with a lyric certainty; but the group could also serve as a design for sculpture as well as painting, such is its solidity and rotundity; and the surface luminosity, where Raphael has made the most delicate play of white on white, is reminiscent of the alabaster translucency of Desiderio da Settignano. As with the use of stylus underdrawing for light in the study for the *Holy Family of Francis I* (Plate 42), here very fine chalk lines, crossing the expanse of barely articulated drapery, serve to evoke its crumpled textures. The restraint of hand and the vaporous lightness of touch left maximum freedom to the executant, while defining the forms beyond any possibility of misunderstanding.

CAT. 453

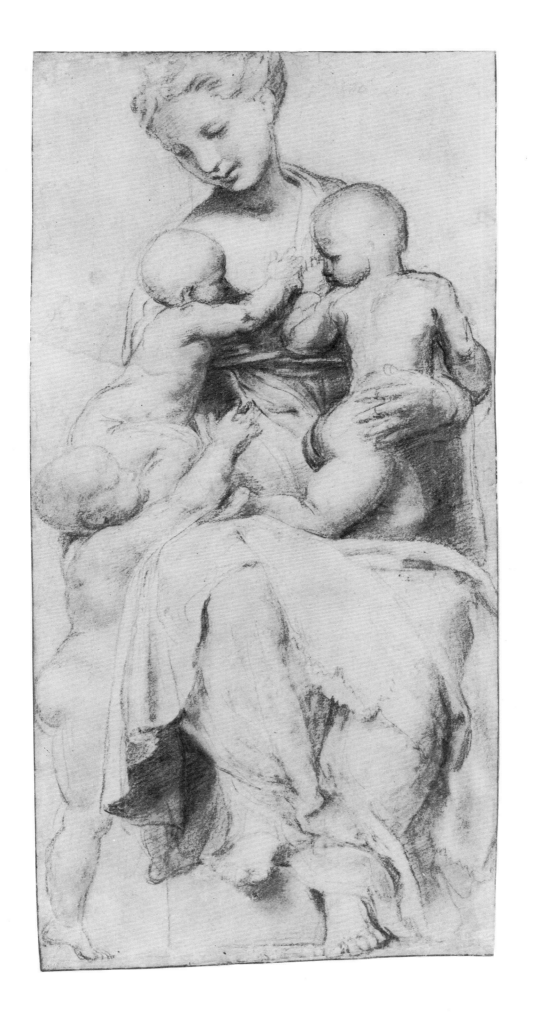

47. *St Andrew and another Apostle for the* Transfiguration

Chatsworth 51
Red chalk over stylus
328 × 232 mm., irregular

The *Transfiguration* (1517–20; D. pp. 52–5) was painted in competition with Sebastiano del Piombo, who was assisted in the design by Raphael's great rival, Michelangelo. Raphael therefore prepared his composition with the same care that he had expended on the *Disputa*, with the figures first studied nude, then draped. Not all the drawings for the *Transfiguration* are autograph, as comparison between this and cat. 428 underlines; Raphael's pupils assisted him in the preparation, and perhaps to a limited extent in the execution, but in this project, on which his reputation depended, whatever he did not draw or paint he certainly supervised closely. Red chalk was used for the nude studies, black chalk for the draperies. Although a certain amount of hatching is visible, the drawing depends on the careful rubbing of the chalk in a manner akin to that used in the study of 'Aeneas and Anchises' (Plate 36). Raphael preserves luminosity and modelling in the shadows and adjusts the intensity of light precisely according to the particular emphases he wishes to make: thus the highlights on the toes and fingertips of St Andrew are placed against the deep shadows on the palm of his hand and the sole of his foot; the hair of both figures is rendered as lightly as possible (a feature that is pursued in the painting) and seems to flame with a Pentecostal faith and inspiration.

The drawing is full of the most precise felicities: the powerful right hand of St Andrew holding his book; the rippling pages; the single line formed by the left arm; the head and upper right arm of the second apostle (cf. cat. 439), whose right forearm also links with St Andrew's back; the gnarled but warm texture of the tree trunk which acts as a visual support for the figures. The texture of the paper is used to preserve vitality in the shadows on the ground, with light vibrating through the rubbed chalk. The precision of the drawing is appropriate for a figure intended to be painted in the nude – it is quite the equal of any of the studies for the Psyche Loggia. The fact that it was simply a preparatory stage demonstrates the intensity of Raphael's concern.

Raphael here shows that he had emancipated himself from the influence of Michelangelo. The inwardness and powerful pathos has gone, and while Raphael comes close to equalling Michelangelo's command of complex nude forms, his work has a more communicative, more extrovert mood. His nudes are defined by the geometry which was so central to Raphael, but they have a new fullness and richness of form. It was, above all, this grand combination of complexity controlled in the service of communication, grandeur of gesture, and dramatic intensity which was to be the source of the great achievements of the early Baroque.

CAT. 426

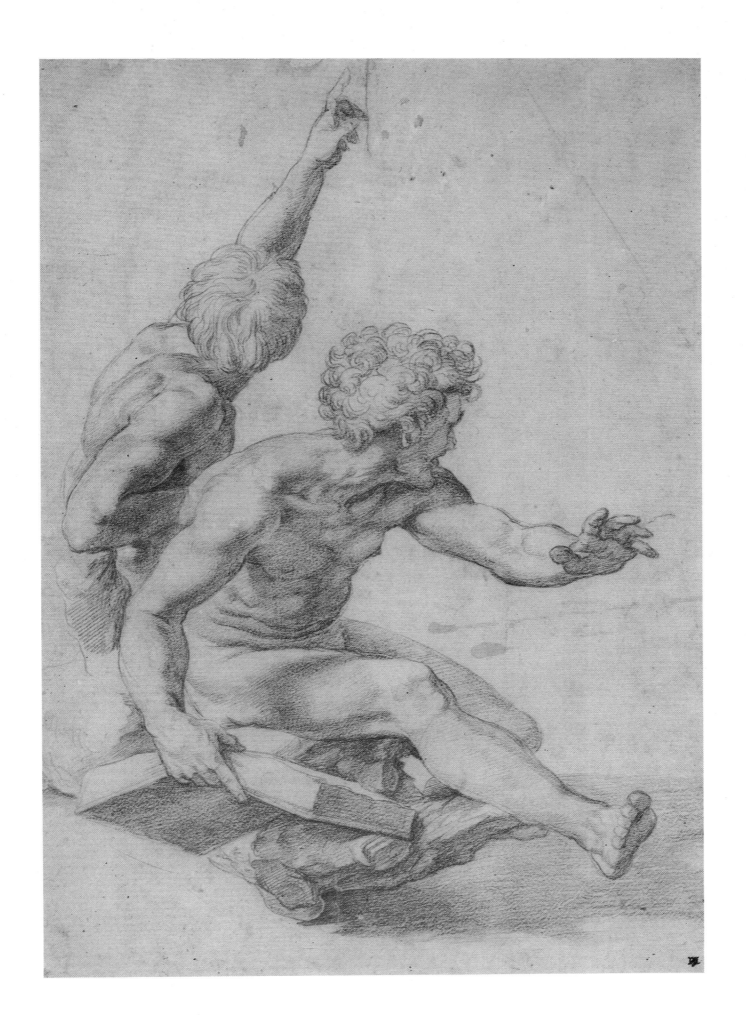

48. *St Peter and St John for the* Transfiguration

Oxford, Ashmolean 568
Black chalk and white heightening over pouncing
499 × 364 mm.

One of the auxiliary cartoons prepared by Raphael in 1520 in the later stages of work on the *Transfiguration* (D. pp. 52–5), providing all the information, except colour, that could possibly be needed. Interestingly, the change of position of St Peter's hands with respect to the pouncing marks was not carried through to the painting, where they remain in the original position.

Even in this sublime drawing the purist could point to weaknesses – the thick lines which do not fully define the position of St John's hands, for example, or the slightly awkward contour of his nose (cf. cat. 434), and it is significant that these can be found, for they emphasize the fact that almost nothing can escape a hypercritical examination of detail. But it would be tragic blindness to overlook the supreme visionary beauty of this sheet: the apostles' concern at the possessed boy's affliction mingled with their awe at his miraculous cure, for that is surely the moment portrayed. Tragedy is transfigured by revelation; youth and age overlap, contrast and unite in their reactions, and the compassion they extend is extended by the artist to them. The drawing hovers between Leonardo – whose command of expression in the *Last Supper* is equalled here (indeed, Raphael's St John is based upon Leonardo's, perhaps via the latter's preparatory drawings) – and Rembrandt, who might well have known it, and whose passion for representing the lines and wrinkles of age illuminated by love or faith, although verging on the obsessional, never surpassed what is recorded here. This drawing, as much as anything Raphael ever produced, is not only evidence of his supreme command of his art; it also reveals a depth of spirit and a sublimity of soul equal to anything in western painting. Whether or not it is true, the legend that Raphael's body was laid in state beneath the *Transfiguration* has a poetic rightness, for the painting and drawings for it like this, have the quality of a testament.

CAT. 437

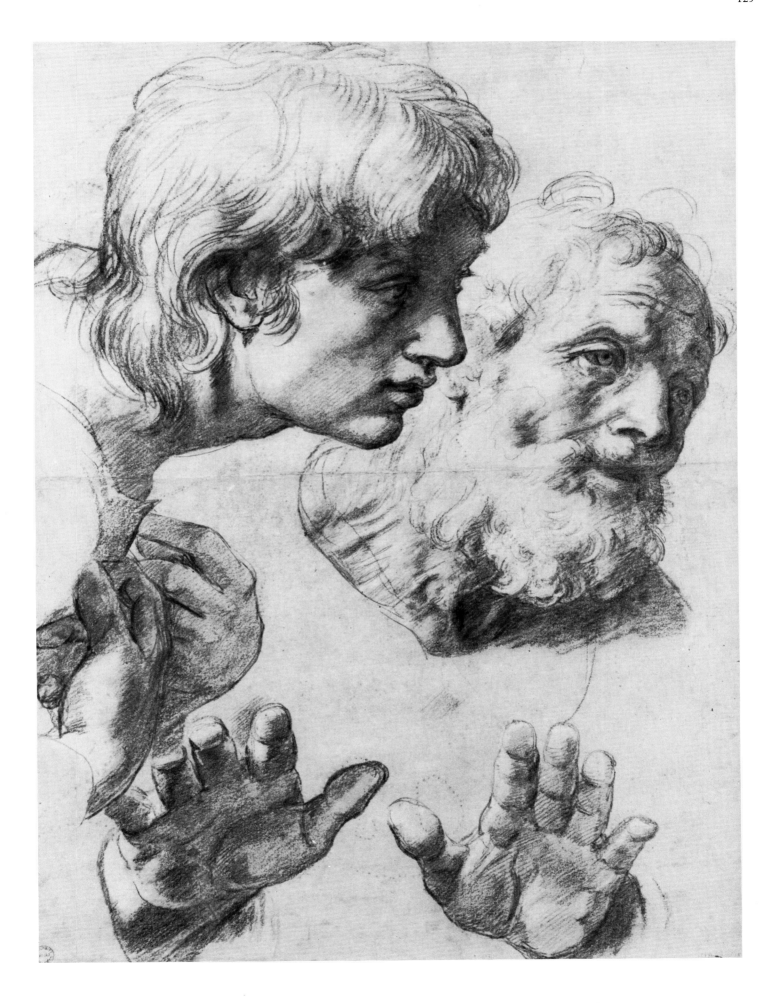

❧ CATALOGUE ❦

Catalogue

The following catalogue contains all the drawings known to me which I believe to be authentic (with a couple of unavoidable omissions); they are numbered as sheets, with rectos and versos reproduced side by side. All versos which contain drawings are reproduced, whether or not these are by Raphael, for the way in which sheets were used is also important. I have omitted drawings which I believe to be copies of lost drawings, despite their documentary value, except in a few instances where there seems room for doubt or where strong cases have recently been made for authenticity. On the other hand a considerable number of drawings which I believe to be by Raphael's pupils have been included, the principle of inclusion being that if a drawing by Raphael himself exists for a work, then all other creative drawings for that work are reproduced. If not, not. Thus all the drawings for the *Coronation of Charlemagne* are catalogued here, but neither of those for the *Oath of Leo* (although one of these is reproduced in the introduction). The organization is chronological, insofar as this can be established, subdivided according to Raphael's projects. Sequences of drawings for particular projects have not been interrupted, so the reader will sometimes find a later drawing catalogued before an earlier one. In addition, since rectos and versos are reproduced together, I have sometimes had to choose between competing alternatives: in these cases I have inserted the sheet in the sequence in which its presence seemed most significant. As a result, a few drawings for particular projects are separated from the others, but cross-referencing should enable the reader to find them rapidly.

By and large this catalogue is a work of compilation, and although there are one or two novelties, it cannot be said to mark a new departure, or to compete with the great multi-volume corpus begun by Oskar Fischel in 1913 and now being continued by Konrad Oberhuber. When completed that will be the definitive work, but the nine volumes that have so far appeared are unavailable outside specialist libraries and they are not easy to use. They also have the inconvenience of separating rectos and versos. This summary catalogue will, I hope, fill the gap between Fischel's great work, the fundamental collection catalogues of Parker and Pouncey and Gere, and the selections of

Raphael's drawings illustrated in more general books, of which that by Sir John Pope-Hennessy should be singled out.

My catalogue is on the whole expansionist. I have rejected very little that Fischel accepted, and some drawings that have not been attributed to Raphael for many years are here restored to him. In contrast it will be seen that I have given more of the late drawings to Raphael's pupils than has been common in some very recent scholarship. There has always been, and is always likely to be, dispute over the precise assignment of hands in Raphael's studio. In principle a deductive method, attributing drawings in accordance with a concept of Raphael's working procedure, might seem called for; however, my efforts to build up patterns in this way have invariably met with insurmountable obstacles and finally I have adopted an inductive approach, attempting to build up chains of resemblance proceeding from secure works to others less certain. This will be seen particularly in my reconstruction of the early work of Raphael's most important pupil, Giulio Romano. But I hope that enough material is presented here to permit different arrangements to be more readily composed.

In problems of attribution I have relied finally on my own judgement, for however much one respects the work of others, to repeat their views when one does not believe them is merely abdication of personal responsibility. I have tried to indicate briefly the reasons for my views on attribution and dating, usually in the form of comparison with other drawings, so the reader will find many cross-references in the catalogue. I have not hesitated to be hesitant, and the reader will also find frequent oscillation between the compass-points of uncertainty: presumably, probably, perhaps and possibly. On the other hand when I have made up my mind I have said so with a directness which I trust will not be mistaken for dogmatism – prolonged contact with Raphael, to say nothing of his major interpreters, is quite sufficient to cure one of that.

I have studied almost all the drawings discussed here within the last two years, in most cases not for the first time. Those which I know only from reproduction, and of which my judgement will be more than usually fallible, are marked with an asterisk.

PAUL JOANNIDES
September 1982

1497 Studies for two predella panels to the altarpiece of the *Madonna and Saints* in Santa Maria Nuova at Fano, by Perugino; signed and dated 1497 (D. p. 58) (cat. 1–2)

 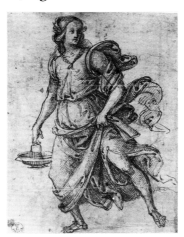

1r: Compositional sketch for the *Birth of the Virgin*
 Florence, Uffizi 366 (as Pinturicchio)
 Pen. 163 × 121 mm.

A long tradition links Raphael's name with this predella, and the recent discovery of this drawing by Sylvia Ferino Pagden supports the case for this involvement. The abbreviation of the figures and their internal movement are characteristic of early Raphael, as is the vitality and complexity of their actions. Above all, the psychological concentration exhibited in this tiny sketch seems alien to Perugino, the only other likely author.

1v: The woman on the right in the *Birth of the Virgin*
 Pen. Partially cut to isolate the recto composition and then rejoined.

The least obviously Raphaelesque of the drawings for the predella; an energetic and detailed study, which was considerably simplified in execution. The drawing shows the influence of Florentine forms, especially those of Filippino Lippi, in the thin, angular limbs and flowing drapery; perhaps signs of Raphael's training with his eclectic father, who was more interested than Perugino in depicting movement.

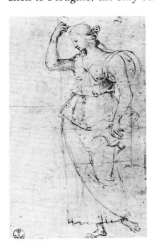

2r: The woman on the left in the *Birth of the Virgin*
 Florence, Uffizi 368 (as Pinturicchio)
 Pen. 165 × 125 mm., cut at top and left; the sheet has been partially cut to isolate the verso figures and then rejoined.

Reversed in execution; the jug held by the hips replaced by a staff. The geometrical formula for the features and the addition of perfunctory breasts to a male model of lay figure are closely similar to cat. 12.

2v: A suitor in the *Marriage of the Virgin*; urinating putto
 Pen.

See commentary to Plate 2.

All drawings are reproduced at a standard depth of 60 mm.

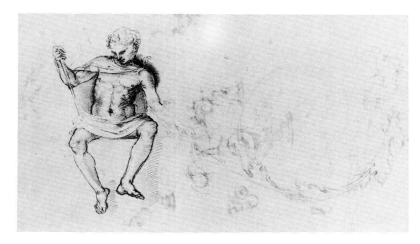

3r: Seated man; acanthus frame
 Oxford, Ashmolean 503
 Pen and dark brown ink (the man); black chalk (the frame). 219 × 337 mm.
The seated man was first lightly outlined and then worked over with a thicker pen.
The baton and cloak suggest a figure in an antique scene. The design apparently
remained unused until *c.* 1511, when it was painted on the keystone above the
Expulsion of Heliodorus. The heavy shading suggests that it was to stand against a
dark background.

3v: Four pediments, two putti supporting roundels; scroll; man
 seen from the rear; head of a unicorn
 Pen and dark brown ink over traces of black chalk.
Variant designs for the pediment of a tomb or plaque. The forms are
very similar to those designed by Filippino Lippi for works in Rome
and Spoleto as well as Florence, but the putti are unmistakably
Raphael's. The standing man is another copy of Signorelli's archer (cf.
cat. 11r).

4: Man carrying a bull (Milon of Crotona?); details repeated at upper right and lower left
 Oxford, Ashmolean 33 (as circle of Perugino)
 Pen and dark brown ink. 226 × 183 mm.
Usually denied to Raphael, but hardly separable from cat. 3r and probably drawn from the same model; the fine
hatching on the head and neck and the use of a thicker pen to reinforce the contours are virtually identical. The
advancing movement, derived from antique reliefs via Pollaiuolo, was of considerable interest to the young
Raphael (cf. cat. 8r). Cf. cat. 1v. I owe the early dating of cat. 3 and 4 to Nicholas Turner.

*5r: Youth in profile
 Cambridge, Mass., Fogg Art Museum 1936–120 (as Perugino)
 Black chalk. 290 × 201 mm.
Variously attributed to Raphael and Perugino, though Raphael's authorship is
supported by the alternation of hatched and spared areas at the front of the head,
which neatly define both volume and light; the lively suggestion, rather than
description, of the hair; the cap pulled low on the forehead (cf. cat. 7v); and the
economical indication of weight and texture. The study shows an inherent
geometrical organization (the parallel of cap and chin, the columnar neck)
combined with an extreme objectivity of characterization.

5v: Angel playing the viol da braccio
 Silverpoint on white ground, laid over black chalk.
Presumably by Perugino; used in modified form for his Vallombrosa *Assump-
tion,* signed and dated 1500, in which Raphael's participation has sometimes
been discerned (Florence, Accademia). In keeping with Perugino's style towards
1500, this drawing stresses surface pattern, linear elegance and above all shape,
rather than volume or drama.

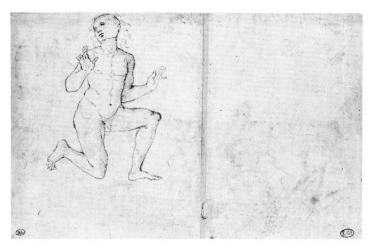

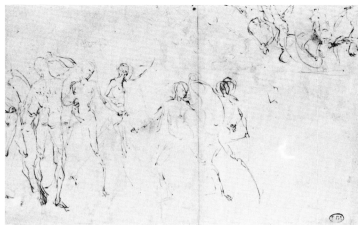

6r: Nude study for (or after) St John in the *Transfiguration* in the Cambio, Perugia

 Paris, Louvre, Coll. Gatteaux 000049

 Pen over stylus, traces of black chalk on right. 142 × 219 mm., the sheet has been bisected and rejoined

The upper part of the figure sketched again at the right, then erased. Perhaps a reiteration of Perugino's figure from a model posed nude, or conceivably part of the preparation of this complex figure, in which Raphael would have assisted Perugino. The elastic strength and sharp clarity of the contours compare well with cat. 20r.

6v: Group of soldiers; two fighting men

 Pen over stylus.

The abbreviations are similar to cat. 11v, with the sickle-like treatment of the limbs conveying rapid movement and taut muscles. The man seen from the back, with his head turned to convey internal tension, is related to cat. 7r.

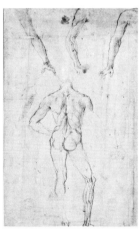

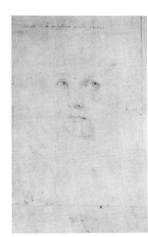

7r: Nude man seen from rear; studies of arms

 London, British Museum 1860-6-16-94

 Pen, the arm on the right in black chalk. 314 × 190 mm.

Perhaps from an *écorché* model. An exercise in muscular expressiveness and tense gesture. The turned head of the figure compares well with cat. 6v, and the execution of the arms, though more elaborated, with cat. 8r. Influenced by Pollaiuolo.

7v: Self-portrait aged about 15 (?)

 Black chalk over stylus.

An intense, almost sombre self-portrait, exploiting a mode that Perugino developed for portraits and devotional heads of saints towards 1500 (cf. also Fig. 3). The light rubbing around the eyes and nostril shows already a mastery of chalk technique. Preliminary indentation with the stylus persists throughout Raphael's career. The drawing may be preparatory for the disputed, but probably autograph, early self-portrait in the Royal Collection, Hampton Court (D. p. 60).

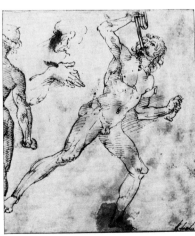

8r: Running man with bugle; man seen from rear; head in profile; right hand and wrist

 Bayonne, Musée Bonnat 1716 (as Florentine School)

 Pen over stylus. 215 × 178 mm., cut at top, bottom and left.

A lively study of movement, more raggedly drawn than usual; adapted, probably via a Pollaiuolesque source, from the Quirinal horse-tamers. Details of the knees and arms are close to cat. 7r. The short chin and expanded cheeks recur several years later in cat. 135v.

8v: Kneeling woman with attendant

 Silverpoint on grey ground, partly reworked in pen.

Very badly damaged. Probably by some associate of Raphael, perhaps copying Raphael's variant of a familiar Perugino composition, with the woman's hands folded across her breast rather than clasped in prayer. Presumably, but not certainly, a Virgin with accompanying angel.

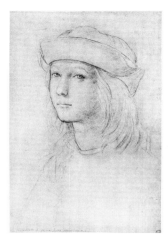

9: Self-portrait
 Oxford, Ashmolean 515
 Black chalk (the traces of oxidized white heightening lack logic, and may be offset from another drawing).
 380 × 260 mm.
A controversial drawing: traditionally a self-portrait of c. 1500, it has more recently been dated c. 1504 by comparison with cat. 67, and the identification denied. However, the sitter does look like Raphael, the formula is appropriate for a self-portrait (cf. Pinturicchio's self-portrait at Spello), and although the clearest analogies are later, there is nothing in the style which militates decisively against an early date.

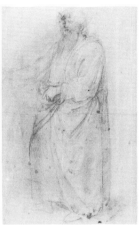

c. 1499 Studies for the Creation of Eve for the banner of the Confraternity of the Holy Trinity (Città di Castello, Pinacoteca; D. p. 3) (cat. 10–11)

10r: Study for God the Father
 London, British Museum 1895–9–15–618
 Black chalk, touches of white chalk. 377 × 224 mm.
Probably a preliminary idea for the Creation of Eve; God the Father is identified by His triangular halo. The broad blocking out of the figure and the abbreviation of the right hand suggest a knowledge of Signorelli's drawings. The position of the head has been changed. The solidity of the draperies probably reflects awareness of the late fifteenth-century Masacciesque revival in Florence.

10v: Standing male figure
 Black chalk.
A preliminary study for the recto. The head, originally turned outwards, has finally been drawn in profile. The very loose, soft handling of chalk demonstrates Raphael's precocious versatility in this medium, and often recurs in later years.

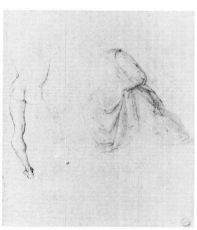

11r: God the Father kneeling; archer seen from rear
 Oxford, Ashmolean 501
 Black chalk, pen. 254 × 216 mm., cut down left, right and top.
See commentary to Plate 1.

11v: Three compositions of the Virgin, Child and St John; sketch of a
 castle
 Pen.
See commentary to Plate 2.

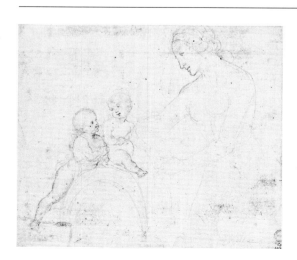

12: Virgin, Child and St John, with pack saddle
 Oxford, Ashmolean 502
 Silverpoint on lavender ground. 193 × 228 mm., cut at top and bottom.
Continues the scheme essayed at centre right in cat. 11v. A juxtaposition of two manners of drawing: volumetric for the children, diagrammatic for the Virgin. As in cat. 2r, breasts have been added to a male figure; the profiles are also very similar. The central plumb-line, and ruled horizontal on a level with the Virgin's eyes, demonstrate the geometrical basis of Raphael's compositional clarity even at this early stage.

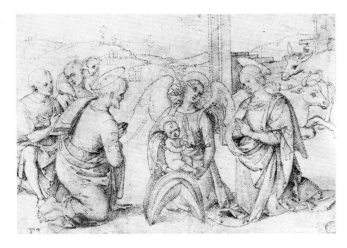

13: *The Adoration of the Shepherds*
 Oxford, Ashmolean 40 (as Pinturicchio)
 Pen over traces of black chalk, pricked for transfer. 183 × 202 mm.
For a predella panel, now in a private collection, painted by an Umbrian artist
c. 1500. The drawing follows cat. 12, though it is more conventionally Peruginesque
in the pose of the Virgin. The sequence of forms on the left side, and the pose of the
kneeling Joseph, unbalanced in adoration, are characteristic of Raphael (cf. *The
Miracle of St Cyril*, Lisbon; D. p. 9); less so are the vapid facial expressions and
animals. The hatching is frequently laborious (e.g. on the saddle, the Virgin and the
area behind her), and inadequately descriptive for so careful a drawing.
Conceivably by Raphael not at all at his best, but probably by a contemporary,
closely following, perhaps tracing, a lost drawing.

1500–1 Studies for the *Coronation of St Nicholas of Tolentino* (dismembered and scattered: fragments in Naples, Capodimonte; Brescia, Pinacoteca Tosio Martinengo; Paris, Louvre. D. pp. 1–3) (cat. 14–18)

14r: Compositional study
 Lille, Musée des Beaux-Arts 474/5
 Black chalk over stylus. 409 × 265 mm.
See commentary to Plate 3.

14v: Study of head; draperies; architecture; birds
 Black chalk, pen.
See commentary to Plate 4.

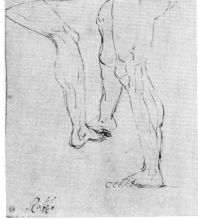

15r: Head of an angel; head and bust of the Virgin
 Bayonne, Musée Bonnat 1708 (as follower of Raphael)
 Probably lead point. 121 × 145 mm., irregular, originally
 joined to cat. 16r.
The angel's head was presumably drawn between cat. 14r
and cat. 17v, no longer looking up, but not yet focused on St
Nicholas. The head and neck of the Madonna are very close
to the *Madonna Diotalevi* (Berlin-Dahlem; D. p. 4), which
was probably begun *c.* 1500. These basic, rather scratchy
outlines were not taken further, but there is no reason to
dismiss them.

15v: Studies of legs
 Pen.
Studies of movement and musculature, very close in
handling to the legs of cat. 7r.

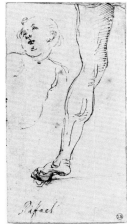

16r: Folded arms
 Bayonne, Musée Bonnat 1708 (as follower of Raphael)
 Probably lead point. 70 × 136 mm., originally joined to cat. 15.
Barely visible; the bust of the Virgin with arms folded across her breast.

16v: Study of a leg; reclining child
 Pen.
The left leg was originally joined to the right leg on the left side of cat. 15v.
The summary, but effective, volume-creating hatching may be compared
with cat. 6r. The child was presumably intended for an Adoration, or a
Holy Family and, although only a quick sketch, shows an effective
characterization and focused gaze.

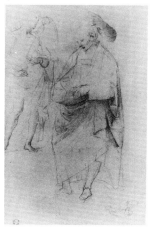

17r: Angel and St Augustine
 Oxford, Ashmolean 504
 Black chalk over traces of stylus. 379 × 245 mm., cut at top and left.
A full-length study from a model, although St Augustine is only shown at half-length in the final painting. The forms of the drapery, established with a framework of thin lines, are defined with hatching which determines the volume as well as shape of the folds. The angel's elongated S-pose is reminiscent of Perugino's Cambio figures, but is more complex, with the left shoulder thrown back. The leading edge of the wing frames the head, and the scroll enlivens the expanse of the chest.

17v: Studies of hands and a head
 Black chalk.
These close-up studies are openly but crisply hatched; the fingertips and nails, especially those of the hand holding the crown, are precisely delineated, as are the clasps on the book. The angel's gaze is now directed towards St Nicholas. The drawing demonstrates Raphael's sharp focusing of significant details.

18r: Head of Satan (?)
 Paris, Louvre 3870
 Black chalk over stylus. 191 × 82 mm., cut all round.
A rapid sketch, concerned with mass rather than line; perhaps drawn from the model who posed for St Augustine in cat. 17r, (ironically, if the traditional identification is correct).

18v: St John the Evangelist seated, after Donatello
 Pen.
Probably copied from a drawing by Perugino after Donatello's statue. The face has been given the characteristic Peruginesque features (e.g. the long divided beard), and the drapery adapted to his system of pot-hooks. An interesting example of the transmission and adaptation of motifs, and of Raphael's awareness of the play of personalities within a single image.

19: Seated Madonna and Child
 Frankfurt, Staedel 377 (as copy)
 Pen and dark brown ink over black chalk, the Child underdrawn in stylus.
 214 × 145 mm., cut all round (?).
Recently re-attributed to Raphael by Sylvia Ferino Pagden. The facial type is close to the *Diotalevi* (Berlin-Dahlem; D. p. 4) and to cat. 15r. The pose, although heavily indebted to Perugino, is more solidly conceived than in Perugino's work, and is similar to that of the *Solly Madonna* (Berlin-Dahlem; D. p. 4). The herring-bone hatching on the Virgin's right sleeve is not very effective here, but was used more forcefully later (cf. cat. 62). The vertical lines behind the Virgin indicate a throne, and this arrangement was re-employed a little later in an altarpiece design (cat. 37).

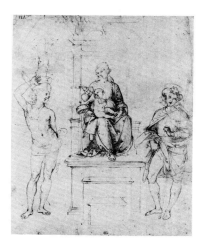
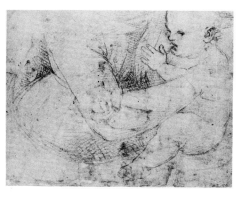

20r: Virgin and Child with Sts Sebastian and Roch
 Paris, Louvre RF 1395
 Pen, stylus line along right edge, compass intersection on left edge level with St Sebastian's head (there must have been an equivalent on the left side which has been cut away), compass hole on centre vertical line between two edges of tread of lower step. Stylus mark in centre, 108 mm. from right edge. 287 × 223 mm., irregular, made up to 225 mm.; the original dimensions of the composition perhaps c. 306 × 216 mm., cut all round.
Clearly for an altarpiece commemorating the cessation of the plague – perhaps that of 1499 – for which Raphael's banner (Città di Castello, Pinacoteca; D. p. 3) was probably painted. The clarity of the pen line, stressing contour without denying volume, is close to that of cat. 6r, but more masterly. The intimacy of the Madonna and Child contrasts with Perugino's more hieratic arrangements, and was adapted as a separate composition, cat. 22r. St Roch's hat and St Sebastian's tree witness a decorative exuberance which hardly emerges in the known early paintings.

20v: Virgin suckling Child
 Black chalk.
Presumably drawn before the recto, when the sheet was much larger. A mediocre drawing, less spatially effective than usual, with some weak forms.

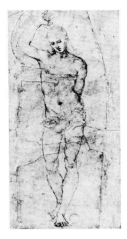

21: St Sebastian
Lille, Musée des Beaux-Arts 451
Pen. 257 × 102 mm., very irregular, made up to 257 × 130 mm.
A badly damaged sheet, but a figure of considerable power and elegance;
contemplative rather than demonstrative. Perhaps an alternative design for cat. 20r,
but the drawing could also represent a self-sufficient image. Broadly adapted from the
St Sebastian of Signorelli.

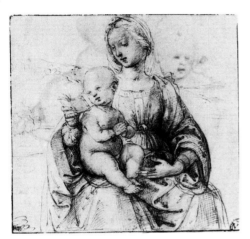

22r: Virgin and Child reading in a landscape
Paris, Louvre 3855
Pen over stylus. 123 × 122 mm., cut all round,
originally joined to cat. 23.
Developed into a half-length, square format group from
cat. 20r. The pen-work is very fine with subtle contour
hatching round the head and neck, cross-hatching on
the drapery and directional hatching in the folds. The
discrepancy between the extraordinarily high level of
execution, with effects of Leonardesque delicacy, and
the slightly *retardataire* pose of the Child, which lacks
Raphael's usual physical verisimilitude, is puzzling,
but probably indicates an earlier rather than a later
date.

22v: Studies of children
Pen over traces of lead point (?).
The hard contours and slight flatness of the modelling
suggest that these studies, whose attribution to
Raphael should not be doubted, were worked up to
pattern-book clarity from lost sketches.

23: Swinging putto holding a flambeau
Paris, Louvre 3881
Pen over stylus, traces of black chalk.
59 × 126 mm., originally joined to cat. 22.
The execution is of watchmaker's precision
but slight dullness. Sylvia Ferino Pagden notes
that this drawing was used in, and may have
been made for, the design for a decorative
panel in Princeton (Inv. 47–9), which may copy
a lost Raphael drawing. On the laid down verso
of this drawing is a reclining putto, the top of
whose head is visible at the bottom of cat. 22v.

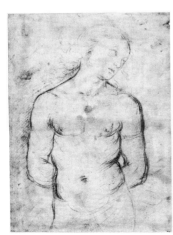

24: St Sebastian
Hamburg, Kunsthalle 21418
Black chalk, some re-working of contours but not necessarily by a later
hand. 260 × 186 mm.
Clearly related to the Sebastian of cat. 20r in pose. The format suggests a
bust-length devotional image, shown at a length slightly greater than
required, but the sideways gaze also indicates a role within a context,
conceivably that of the left panel of a diptych. The modelling of the neck and
left shoulder is extremely economical.

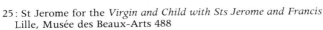

25: St Jerome for the *Virgin and Child with Sts Jerome and Francis*
Lille, Musée des Beaux-Arts 488
Black chalk. 150 × 109 mm.
Slightly worn and faded. Of feathery execution with only selected contours
receiving sharp emphasis. A painterly study of the different textures of hat,
face and beard, and a poignant analysis of reflective reverence, weakened in
the painting (Berlin-Dahlem; D. p. 4), for which it is the sole surviving study.

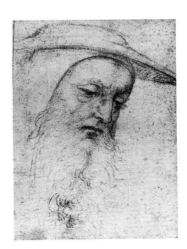

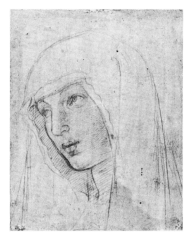

26: Head of the Virgin (Mater Dolorosa?)
 Lille, Musée des Beaux-Arts 466
 Silverpoint on white ground. 133 × 98 mm.
This drawing shows considerable dexterity in the use of silverpoints, with
a very fine point used to create a delicate half-tone modelling on the cheek;
a thicker point is used for the slightly heavier hatching on the nose; still
thicker, more forceful lines for the shadow of the wimple; and strong
duplicated lines for the contours of the face.

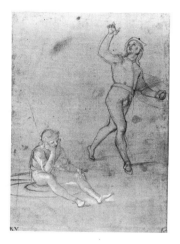

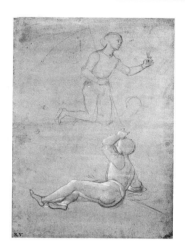

c. 1502 Studies connected with the *Resurrection* (São Paulo; D. p. 3) by a follower of Raphael (cat. 27–8)

27: Two guards
 Oxford, Ashmolean 505
 Silverpoint and white heightening on dark grey ground. 320 × 220 mm.
Studies from the model contrasting torpor and balletic action. The
exceptionally complex pose of the standing guard (cf. the left-hand angel in the
Mond Crucifixion (London, National Gallery; D. p. 8)) demonstrates the value
to Raphael of his earlier studies of stretching and twisting form, for it is
achieved with minimal pentimenti. The technique ranges from a thick
silverpoint on the contours, through a medium point on the legs, to the side of
the instrument for the inside of the shield; the application of white heightening
is similarly flexible (see cat. 28).

28: Guard; angel holding nails
 Oxford, Ashmolean 506
 Silverpoint and white heightening on grey ground. 327 × 236 mm.
The position of the angel's head sketched again on the right. The guard here
and the standing guard in cat. 27 were both employed in the *Resurrection*
(which was not painted by Raphael), but not the seated guard or the angel, and
it is unlikely that these drawings were prepared specially for it.

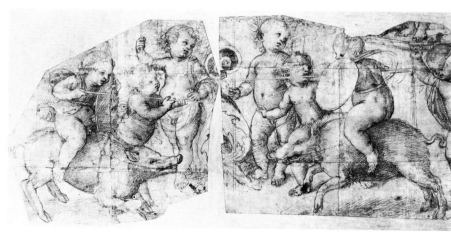

29: Jousting children on boars
 Chantilly, Musée Condé FR. IX, 42 bis
 Black chalk, charcoal, much stylus work under the
 left-hand boar and putto, pounced contours.
 525 × 1250 mm., fragmentary, on 12 sheets of
 paper.
A cartoon for a substantial but unknown decorative
scheme. The narrative derives from Boccaccio's
Uberto and Filomena; the boars are taken from Dürer's
Prodigal Son (1497). The pose of the third putto from
the right looks forward to the soldier in cat. 56; the
standing putti with lances, to the soldiers in cat. 58r.
The forms stress the surface and are slightly flattened
accordingly. The supporting putto at the right is
standing partly behind a dais (?).The central dividing
element, in front of which the joust takes place, is
perhaps a pseudo-antique altar, with lion's feet and
an acanthus frame.

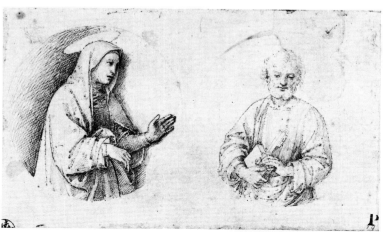

30: The Virgin as Mater Dolorosa and St Peter
 Berlin-Dahlem, Kupferstichkabinett 494
 Pen, over stylus in St Peter; pricked for transfer; possibly a slight
 reinforcement of some of the contours of the Virgin. 101 × 172 mm.
A cartoon, probably for figures in the arms of a crucifix. A virtuoso
drawing, where the technique and execution reinforce the theme. The
Virgin is set against a shadowed bowl, her drapery simplified to
concentrate attention on her face and gesture; St Peter, against an
undefined space, is less tragically characterized, and his drapery is
largely rendered in the long, thread-like lines of coarse but soft cloth.
His compact pose suggests his authority (cf. cat. 31 for the technique).

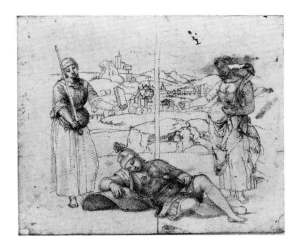

31: The Knight's Dream
 London, National Gallery No. 213a
 Pen over stylus, pricked for transfer. 168 × 202 mm.
The cartoon for the tiny painting (London, National Gallery; D. p. 6). The elaborate diamond patterned cross-hatching is used to indicate depths of shade rather than for modelling, and inside the shield it even disguises the shape. The handling of pen on the right-hand figure (Pleasure) is close to cat. 30; the pose of the left-hand figure (Virtue) is close to the Coronation types. Possible knowledge of Botticelli in the landscape need not entail an early trip to Florence or a later dating.

c. 1502–3 Studies for the *Madonna at Nones* (Pasadena, Norton Simon Museum of Art; D. p. 7) (cat. 32–5)

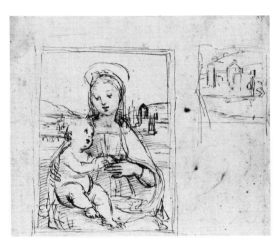

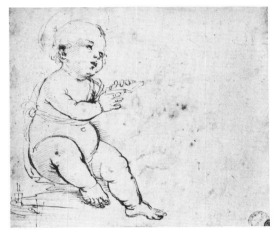

32r: Compositional study
 Oxford, Ashmolean 508a
 Pen over stylus. 114 × 129 mm., originally joined to 33 (?)
An incisive sketch, fixing from the start the final arrangement of the painting. The Child is enclosed within the pyramid of the Virgin; the responsive curves of her drapery and His back, and the subsidiary echo of His stomach and her sleeve are instantaneously grasped. The pen is handled with the greatest functional precision, evoking volume and gesture with only minimal reworking of contour. Raphael's deep concern with integrating figure and landscape is shown in the detail on the right.

32v: The Child alone
 Pen over stylus.
This study clarifies the Child's gesture with the book of hours (not finally adopted), the details of His reins, and the pressure, and therefore expressive effect, of the bend of His ankle. His stomach has been further rounded to increase weight and curvature.

33r: Virgin outlined against a landscape
 Oxford, Ashmolean 508b
 Pen over stylus. 116 × 132 mm., originally joined to cat. 32 (?).
The building has been moved to the left, to lighten the tone rather than to add compositional weight above the figure of Christ.

33v: Virgin outlined against a landscape
 Pen.
A clarification of the recto; the building studied in greater detail below.

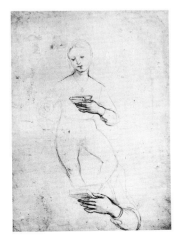

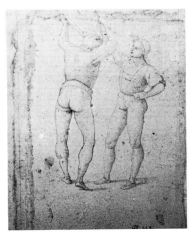

34r: *Garzone* study for the Madonna
 Lille, Musée des Beaux-Arts 442
 Silverpoint on white ground, the Virgin's necklace added in graphite. 263 × 189 mm.
The handling, despite the different medium, is similar to cat. 32r, though here, Raphael achieves a greater sense of volume. The important feature of the hand is taken up below. The Virgin's haloed head was tried again to the upper right but, subsequently erased, is now barely visible. A roundel in the lower left corner contains a head facing left, a design with a multitude of possible uses.

34v: Two crossbowmen
 Pen, touches of black chalk at lower left corner.
A careful and precise but stiff and weakly foreshortened copy by an associate of Raphael; perhaps after a lost drawing by Signorelli for his *Martyrdom of St Sebastian* (cf. cat. 3v, 11r), as John Gere has suggested.

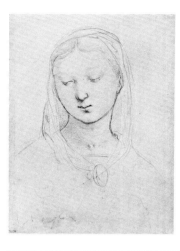
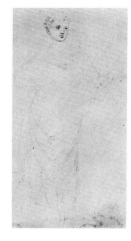

35r: Study for the head of the Virgin
 London, British Museum 1895–9–15–611
 Silverpoint on white ground. 258 × 191 mm.
This drawing communicates a splendid effect of volumetric purity and pearly clarity. Raphael has used a fine silverpoint impressionistically, to obtain delicate gradations of shade, and a thicker point for the contours. The scribbles may well be by a child.

35v: Standing young man
 Pen and lead point(?). Window mounted 225 × 114 mm.
Possibly a study for or after a composition of the Magi, in which this figure might be a young king. Not by Raphael.

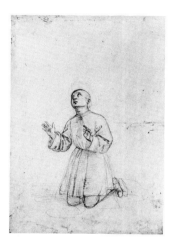

36: Saint kneeling in contemplation (the Magdalen?)
 Oxford, Ashmolean 509
 Silverpoint on white ground, later scribbles in black chalk. 265 × 184 mm.
The lightly sketched additional drapery suggests a female figure. The handling is very close to cat. 35r. The figure has a crystalline perfection that any adjustment would weaken. Below the left knee is a complex, partly erased, study for a decorative panel. The eyes sketched in silverpoint at top left are probably by Raphael; the black chalk head at bottom right certainly is not.

37: Virgin and Child enthroned with St Nicholas of Tolentino
 Frankfurt, Staedel 376
 Pen over stylus, black chalk under the figure of St Nicholas. 230 × 155 mm.
A study for an altarpiece which was apparently never executed. The pose of the Madonna was adopted from cat. 19, drawn a year or so earlier and the type of throne used a little later (*c.* 1504–5) in the Ansidei altarpiece (London, National Gallery; D.p. 13). The St Nicholas is not unlike the apostles in the *Coronation*; the crispness of the facial expressions is akin to cat. 36, the handling to cat. 32r.

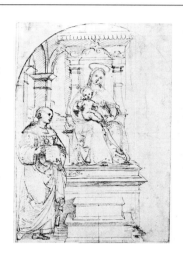

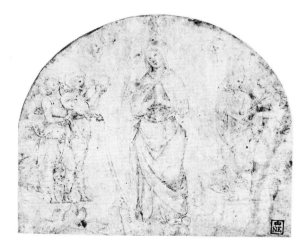

1503 Studies for the *Coronation of the Virgin* (Vatican; D.p. 10) (cat. 38–55, 61v)

38: The Assumption of the Virgin (upper half)
 Budapest, Museum of Fine Arts 1779
 Pen, stylus work, many compass pricks down central fold; the drawing of a leaf, lower left
 corner, in brush and reddish ink. 158 × 190 mm., perhaps originally joined to cat. 39.
A worn and faded drawing, but the precision modelling of the Virgin's drapery and the range of facial expressions of the angels are qualitatively consistent with Raphael's authorship. Taken with cat. 39 the drawing is of some importance as it is Raphael's earliest surviving *modello*, and also because it shows that he first conceived the *Coronation* as an Assumption and only subsequently combined the schemes, with some crowding in the upper section. The figure of the Virgin is taken from the Virgin in Perugino's frescoed altarpiece of the Assumption, then on the altar-wall of the Sistine Chapel.

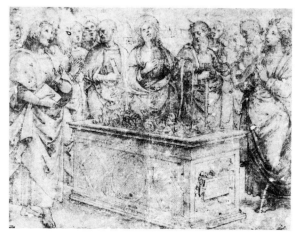

39: The Assumption/Coronation of the Virgin (lower half)
 Paris, Louvre 3970
 Pen over traces of stylus, compass holes down centre fold; some reworking.
 166 × 203 mm., perhaps originally joined to cat. 38.
Conceivably cut from cat. 38 by Raphael himself, to be attached to a new drawing of the upper section. The hatching is less solid than in cat. 38, but emphasizes texture more. In handling it comes closest to cat. 30, as Scholz, to whom the attribution is due, has noted.

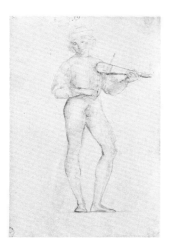

40: Angel playing a rebec
Oxford, Ashmolean 511a
Silverpoint and oxidized white heightening on grey ground. 191 × 127 mm.
The instrument shown on the left of cat. 38 has here been replaced by a smaller one to obtain a less obstructed view, but the pose of the figure remains the same.

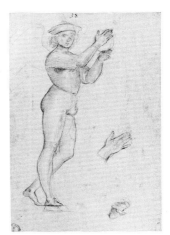

41: Angel playing the tambourine
Oxford, Ashmolean 511b
Silverpoint and oxidized white heightening on grey ground. 189 × 126 mm.
Here wings have been experimentally added and the hand positions re-studied. Although intended for the rear left angel in the Assumption (cat. 38), this figure was used with little change for the angel at front left in the *Coronation*.

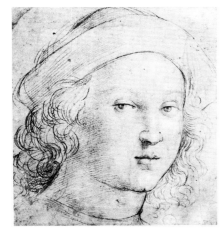

42: Head of a youth
Lille, Musée des Beaux-Arts 461
Black chalk and white heightening. 211 × 188 mm., cut all round.
A portrait study of the model of cat. 41, in approximately the same position. Perhaps in preparation for the painting, but conceivably an independent study. The bulk of the head and face, the curling vitality of the hair, the plump flesh created by the slight fanning-out of the hatching, constitute a vivid piece of portraiture.

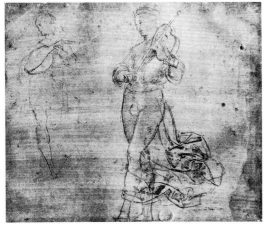

43r: Two angels, one playing the lute, the other the viol da braccio
Lille, Musée des Beaux-Arts 444/492
Silverpoint on grey ground. 210 × 230 mm.
Life studies: the nearer *garzone* has drapery added, probably sketched from a small piece of sized cloth since the fold patterns are out of scale with the figure. The poses of the figures are adapted from cat. 38; their placing suggests the composition was still an Assumption.

43v: Decorative designs
Pen, brush and wash, red chalk.
Probably for plasterwork frames for secular decorative frescoes, *c*, 1540. Perhaps by Perino del Vaga, who inherited many of Raphael's drawings. Under the left-hand drawing is a red chalk sketch of a profile which may be by some early associate of Raphael like the author of cat. 34v.

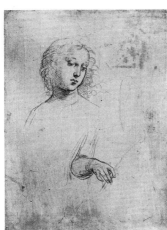

44: Head and right hand of an angel playing the viol da braccio; ruled lines
London, British Museum Pp. 1–67
Silverpoint on white ground. 276 × 196 mm.
See commentary to Plate 5. On the laid down and unphotographed verso of this sheet there is a series of ruled perspective lines in stylus converging on a vanishing point. This arrangement is not, apparently, connected with a known composition.

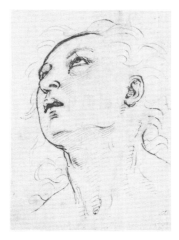

45r: The head of St James (?)
 Oxford, Ashmolean 512
 Pen over stylus, traces of black chalk. 89 × 62 mm., cut all round.
A small but precisely controlled sketch with a firm accent on the modelling of the neck. Copied in the Venice sketchbook (15r).

45v: Two legs
 Pen over black chalk.
A copy of an antique statue of Marsyas, itself copied in the Venice sketchbook (6v).

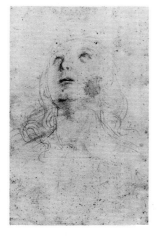

46r: Disciple looking upwards
 Lille, Musée des Beaux-Arts 482/3
 Black chalk. 363 × 207 mm.
The pose, not used in the finished painting, was possibly intended for a disciple behind St James. Presumably from the same model as cat. 47r.

46v: Drapery for St James; horse and rider
 Black chalk.
The drapery studies are drawn in powerful incisive strokes, with the chalk pressed hard; following the fall of the material, much more than in cat. 14v (Plate 4), they give the form a sculptural consistency. The small mounted rider, who appears to be spearing something on the ground, might be St George, but the action does not seem sufficiently violent. (Cf. the background figures in cat. 56 for this type of sketch).

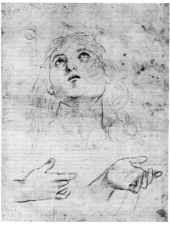 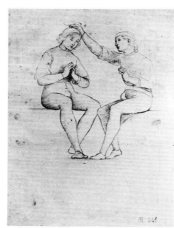

47r: Head of St Thomas; childish scribbles
 Lille, Musée des Beaux-Arts 440/1
 Silverpoint on white ground. 268 × 196 mm.
One of the boldest and most dynamic silverpoints of this period. The face is blocked out in angular contours and the right cheek and the underside of the chin are treated as two simple planes, set against the open left cheek to frame the yearning eyes and mouth. The slight clumsiness of the hands adds, if anything, to their poignancy. On the right is a crudely drawn standing figure seen from the back; just above is a head facing left.

47v: Christ crowning the Virgin
 Pen over stylus, traces of black chalk in stylus marks.
Whether or not the stylus work is by Raphael is impossible to say, but the pen lines certainly are not.

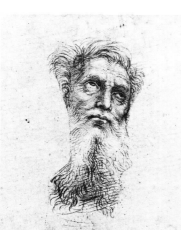

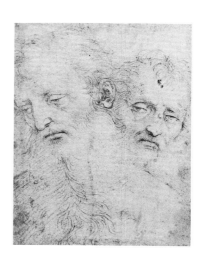

48: Auxiliary cartoon for the head of an apostle
 Lille, Musée des Beaux-Arts 470
 Black chalk over pouncing. 221 × 192 mm.
Drawn in a darker chalk than cat. 49, this background head is more plastic than those further forward, thus preserving the equality of emphasis. The darker tone also serves to accentuate the whites of the upturned eyes, the venerable moustache and the still Peruginesque beard. Raphael has carefully described the expressive features of the eye-sockets, nostrils and mouth.

49: Auxiliary cartoon for the heads of two apostles
 Windsor, Royal Collection 4370
 Black chalk over pouncing. 238 × 186 mm.
An indication of how carefully Raphael controlled the facial expressions in this important and complex early project. A faded drawing, but intentionally softer and less plastic than cat. 48. All three heads were probably drawn from the same model.

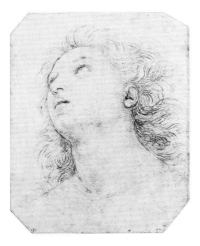

50: Auxiliary cartoon for the head of St James
 London, British Museum 1895–9–15–610
 Black chalk over pouncing. 274 × 216 mm., corners cut.
See commentary to Plate 6.

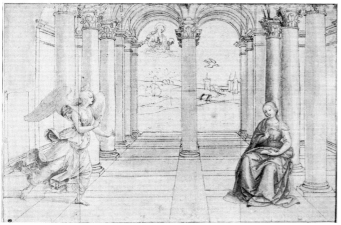

51: Cartoon for the *Annunciation*
 Paris, Louvre 3860
 Brush and brown wash, some pen and ink, traces of black
 chalk, stylus and compass work, pricked for transfer; a
 circle incised round top of central column. 284 × 422 mm.,
 on two pieces of paper, made up at upper left corner.
Drawn largely in wash, with pen employed to strengthen some
outlines and shadows. Raphael has here created a quiet drama of
light and shadow in a limpid interior. A slight solecism in the
placing of the central column has been half disguised by the
omission of the far side of the base.

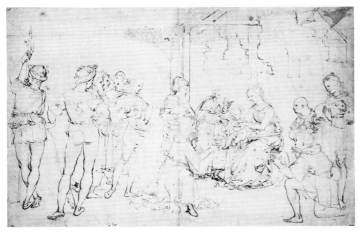

52: *The Adoration of the Shepherds*
 Stockholm, Nationalmuseum 296
 Pen over stylus and traces of black chalk. 272 × 419 mm.
See commentary to Plate 7.

53r Studies for the *Adoration*, the Virgin outlined
 against the stable and the stable repeated; piece of
 metalwork; (with the left edge as base) the frame of
 an escutcheon (?), decorated with two putti riding
 sea monsters (?); (with the sheet upside down) a
 statuette of David holding the head of Goliath; a
 candlestick (bisected)
 Florence, Uffizi 1476E
 Pen, traces of lead point. 242 × 231 mm.
The sketches connected with the *Adoration* are closely
comparable with cat. 33; the Pollaiuolesque statuette
confirms the stylistic inflection of the verso, and in
execution is very close to cat. 11v (Plate 2). The
escutcheon, with its tiny but richly rhythmical design,
shows a rare side of Raphael – his activity as a designer of
metalwork – and is drawn with great verve.

53v: Hercules and the centaurs
 Pen and brown ink, traces of lead point.
A drawing which anticipates some of Raphael's
Florentine interests in its relief-like arrangement and
portrayal of violent action. Probably derived from a
lost composition by Antonio Pollaiuolo. Cf. cat 94r.

54: *The Presentation in the Temple*
 Oxford, Ashmolean 513
 Pen and dark brown ink, the font in black chalk. 200 × 200 mm.
Developed from the panel of the *Circumcision* at Fano, but much more acute in characterization and
movement (e.g. the High Priest handing the Child back to the Virgin). Raphael has used black chalk to
stress the difference of texture of the font and to establish its tonal values; he undoubtedly studied it in
detail in a further drawing. The robes are treated with deliberately jagged folds to offset the
smoothness of the font (see also cat. 61v).

55r: Head of a young woman in profile; drapery
 London, British Museum 1947–10–11–19
 Pen over black chalk (the head); the drapery in black chalk.
 222 × 321 mm., cut on left and made up to 326 mm.
The line to the left of the main drapery study makes it clear that this
was for a swelling piece of drapery, perhaps for the woman on the
right of the *Presentation of Christ in the Temple*.

55v: Drapery of St Thomas (?)
 Black chalk, window mounted at 210 × 140 mm.
A light sketch, perhaps making use of a lay figure, and quite close to
the drapery of St Thomas in the main panel.

c. 1503 Studies for Pinturicchio's frescoes of the life of Pius II in the Piccolomini library, Siena, and for his *Coronation of the Virgin* (Vatican) (cat. 56–61)

56: *Modello* for the *Journey of Aeneas Silvius Piccolomini to Basle*
 Florence, Uffizi 520E
 Pen, brush and wash, white heightening over traces of black chalk and stylus, squared in pen at 27 mm. 705 × 415 mm.
 maximum (arched top).
See commentary to Plate 8.

57r: Sketch for *The Journey of Aeneas Silvius Piccolomini to Basle* (?)
Florence, Uffizi 537E
Pen over stylus (a complete horse drawn in stylus only at the right, noted by
Sylvia Ferino Pagden), re-touched slightly in grey ink. 272 × 400 mm.
Usually connected with cat. 56, with which there are certainly corres-
pondences, but not impossibly for another, unknown, project. A careful
attempt has been made to combine a diagonal alignment across the page with
the maximum of individual variation in riders and horses. The broad
execution has affinities with cat. 3r; the figure style with cat. 58r; the
Pollaiuolesque horses with cat. 62.

57v: A Griffon (?) face of a woman looking
 down to her left; head of a child
 looking up to his left; (with the sheet
 turned upside down) devil standing
 over a recumbent man (after Signor-
 elli); lightly sketched calf and foot
 Pen.
None of these sketches seems to be con-
nected with a known composition, except
the rough copy from Signorelli's fresco *The
Preaching and Fall of Antichrist*, at Orvieto.

58r: Four soldiers for the background of the
Coronation of Aeneas Piccolomini on the
Capitoline Hill
Oxford, Ashmolean 510
Silverpoint on blue ground. 213 × 221 mm.
See commentary to Plate 9.

58v: Putti holding shields
Pen, window mounted 75 × 129 mm.
Quick *concetti* for the putti who stand between the
arches. See also cat. 60v, 61v.

* 59: Meeting of Frederick II and Eleanor of Portugal
Private Collection (promised gift to the Pierpont Morgan Library, New
York)
Pen over stylus, brush and wash, heightened with white. 545 × 405 mm.
Although badly damaged, this *modello* still exhibits a brilliant combination
of detail and overall unity. The emotion of the main figures is not lost in the
crowd, and the composition anticipates Raphael's *Sposalizio* (Milan, Brera;
D. p. 10), completed the following year.

60r: Kneeling bishop facing right
Paris, Louvre RF 1870–28962 (as Francia)
Silverpoint and white heightening on dark grey ground. 171 × 104 mm., originally joined
to cat. 61 (?)
Until recently attributed to Francia but certainly by Raphael; probably made to assist
Pinturicchio in his *Coronation of the Virgin* (Vatican). The technique is very close to cat. 27
and 28, as is the colour of the ground.

60v: Putto with escutcheon; architectural sketches
Pen, the architectural sketches in black chalk.
The putto is for the Piccolomini library (cf. cat. 58v); his right leg is sketched again faintly
on the right. The architectural sketches of an arch and a spandrel relate to cat. 61v.

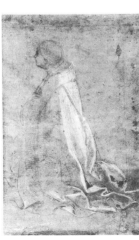

61r: Kneeling bishop facing left
Paris, Louvre RF 1870–28963 (as Francia)
Silverpoint and white heightening on dark grey ground. 176 × 107 mm., originally
joined to cat. 60 (?)
The companion to cat. 60r, also for Pinturicchio's *Coronation of the Virgin*.

61v: Sketch for the *Presentation in the Temple*
Pen and brown ink, black chalk, scribbles in red chalk.
The sketch of the *Presentation* must antedate cat. 54 because it shows a different altar,
closer to that of the Fano predella. The architecture is similar in both paintings. At the
lower right is the right foot of a putto, obviously for the Piccolomini library (cf. cat. 58v, 60v).

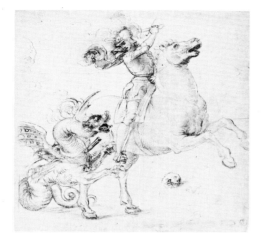

62: St George and the Dragon (cartoon for the Louvre
 painting)
 Florence, Uffizi 530E
 Pen over traces of black chalk, pricked for transfer.
 265 × 267 mm., cut at right.
St George's horse, based on one from the Quirinal (copied
again by Raphael in cat. 398), is somewhat stiffly rendered,
with a slight failure of junction between the powerful
modelling of the chest and the inflexible contour of the neck.
The scattered bones were substituted in the painting (Louvre;
D. p. 5) by fragments of the saint's lance, but in both the
perspective is insecure (cf. cat. 57r).

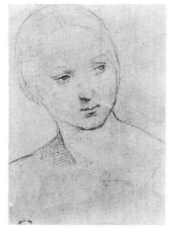

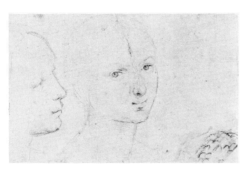

1503–4 Studies for the *Sposalizio*, signed and dated 1504 (Brera, Milan; D. p. 10) (cat. 63–4)

63r: Head of one of the Virgin's companions
 Oxford, Ashmolean 514
 Black chalk. 161 × 111 mm., cut down.
A rapid but solid study for the head fourth from left, deliberately
simplifying all but the expression of concentration.

63v: Heads of two of the Virgin's companions
 Black chalk.
For the heads first and third from left. An indecipherable
scribble at lower right. Both these heads, like that of the recto, are
blander in the completed painting.

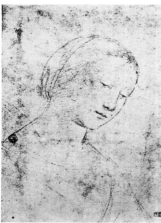

* 64: Head of the Virgin
 Formerly Paris, de Triqueti Collection (present whereabouts unknown)
 Black chalk. Dimensions unknown.
Similar to cat. 63 and probably drawn from the same model. The Virgin's
head is turned slightly more in profile in the finished painting. Here Raphael
has not reduced the coiffure to a geometric configuration, but has played its
texture against the smooth cheek and forehead.

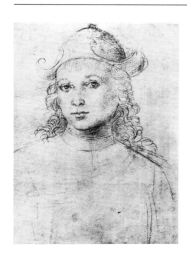

* 65: Head of a youth
 Formerly Rowfant, Locker-Lampson Collection (present whereabouts
 unkown)
 Black chalk. 255 × 185 mm.
Similar headgear appears in cat. 56 and in the *Sposalizio*, but Raphael was
capable of this sort of accomplishment from at least 1500 onwards, and the
drawing could be earlier. The curling brim seen in profile on the left and the
hair brought forward to frame the cheek achieve a delicate rhythmical
balance with the longer curls and deeply shadowed brim on the right.

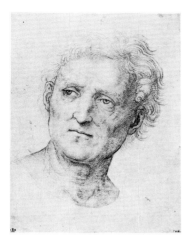

66: Head of a man
 London, British Museum 1895–9–15–619
 Black chalk over stylus. 411 × 260 mm.
Not connected with a known composition, though the facial type bears
some resemblance to St Peter in the *Pala Colonna* (New York, Metropolitan;
D. p. 14) and to the heads in the *Sposalizio*. The precision, detail and scale
suggest an auxiliary cartoon, but there is no pouncing. The chalk has been
used very densely, and in places has been carefully rubbed, suggesting that
the drawing was made for a project with a dark overall tone.

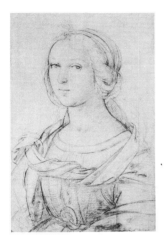

67: Female saint, bust length
 London, British Museum 1895–9–15–612
 Black chalk over stylus. 411 × 260 mm.
The size and self-contained composition suggest a cartoon for a devotional
painting, but the contours are neither pricked nor indented. The facial type is
similar to those in the *Sposalizio*, and the Peruginesque fold-system and hatching
are close to cat. 68; both are somewhat *retardataire*.

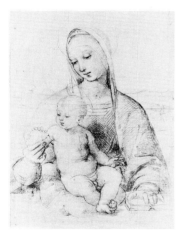

68: Virgin and Child with pomegranate
 Vienna, Albertina Bd. IV, 4879
 Black chalk. 412 × 294 mm.
A cartoon for a small Madonna (presumably unused, since it is unpricked and
unindented). The smaller-headed, longer-necked Child marks a move away
from the types of *c.* 1501–3, though the elongated proportions of the Virgin
are reminiscent of the *Diotalevi*, and the pot-hook folds of the drapery still
Peruginesque. But a new depth of characterization, and the extreme delicacy
of the hatching on the faces, suggest a date *c.* 1504, and a relation to the
elongated mode of the *Sposalizio* and the Ansidei altarpiece (London,
National Gallery; D. p. 13).

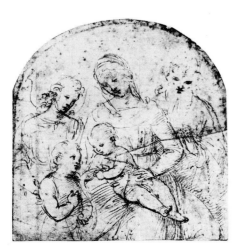

69: Virgin and Child with St John, St Joseph and an angel
 Lille, Musée des Beaux-Arts 431
 Pen over traces of black chalk. 168 × 159 mm., the lower right
 section is a restoration.
While the angel and St Joseph are Peruginesque both in
characterization and pose, the increased complexity and freedom
of the children's movements and the fast, lively hatching support a
late Umbrian date. The composition, though designed with an
arched top, could easily have been adapted to a tondo. Indeed the
Terranuova Madonna (Berlin-Dahlem; D. p. 16), perhaps Raphael's
earliest fully Florentine painting, represents a slightly later
development of the same idea.

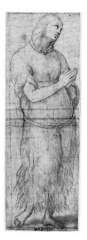

70: The Magdalen
 Berlin-Dahlem, Kupferstichkabinett 5172
 Brush and wash over traces of black chalk, pricked for transfer, squared in black chalk at
 47 mm., a red chalk line down the left side. 303 × 95 mm., irregular, cut at sides.
A cartoon for a small panel formerly in the Contini-Bonacossi Collection (D. p. 16). Pair to
cat. 71.

* 71: St Catherine
 Formerly Berlin, Habich Collection (present whereabouts unknown)
 Brush and wash over black chalk, heightened with white, pricked for transfer.
 285 × 155 mm., cut at bottom.
A pair to cat. 70, for a panel formerly in the Contini-Bonacossi Collection (D. p. 16); the two were
probably wings of a wider panel. This drawing is more plastic than the Magdalen, where the
contrasts of light are less strong. The effect is one of the Magdalen leading in, and St Catherine
closing.

72: Child holding a bird
 Lille, Musée des Beaux-Arts 480
 Lead-tin stylus (?) on white ground. 103 × 74 mm.
The line seems too soft for silverpoint. The pose of the Child, with a symbol
of His Passion, is close to cat. 32r, but the characterization is less
conventional and more vivaciously observed. Despite a temptation to date
it later, the pose seems to commit it to a late Umbrian–early Florentine date.

73r: St Jerome with a view of Perugia
 Oxford, Ashmolean 34 (as circle of Perugino)
 Pen, traces of black chalk. 244 × 203 mm., made up at bottom
 left and right corners.
The attribution to Raphael, long doubted, has been decisively
reaffirmed by Sylvia Ferino Pagden. The modified view of Perugia
was adapted from at least two earlier drawings, and the St Jerome
only partially integrated, which accounts for the unusual stiffness
and laboriousness.

73v: Landscape with cottages and a church; (upside down) Virgin
 suckling Child
The landscape recurs in the left background of the *Pala Colonna*
(*c.* 1504–5; D. p. 14), as noted by Sylvia Ferino Pagden. The
weakness of line in the little sketch of the Virgin is partly due to the
fact that it was formerly laid down.

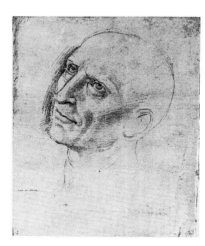

74: Head of St Jerome
 Lille, Musée des Beaux-Arts 435
 Silverpoint on green ground. 121 × 98 mm., irregular.
A study of expression for cat. 73r. The medium has been used densely
and strongly, with external hatching round the right cheek to
emphasize its gaunt profile.

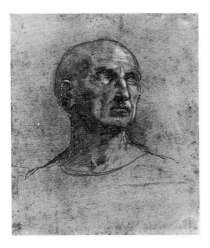

75 : Head of a man
 Lille, Musée des Beaux-Arts 434
 Silverpoint and white heightening on green ground. 128 × 105 mm.
Probably from the same model as cat. 74 but hatched even more densely
to create a sculpturesque solidity. The treatment of light and shade is
masterly, with the deeper shadow under the chin contrasting with the
lighter shadow on the neck. The repeated lines on the left of the neck
demonstrate Raphael's adjustment of the natural form for pattern, but
round the jaw-line they express the loosening of ageing flesh.

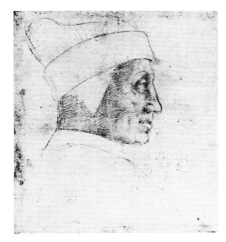

76 : Head of a man in profile wearing a Venetian bonnet
 Lille, Musée des Beaux-Arts 468
 Silverpoint on green ground. 122 × 103 mm.
An exercise in *contre-jour* modelling, where the dense hatching, by
sparing the coat and hat, suggests that the model was heavily tanned.
The hatching does not, however, obscure the relief of the cheek or
eliminate expression. Presumably from life rather than from a
painting; perhaps from a Venetian delegation to central Italy, though
it is not inconceivable that Raphael himself visited Venice.

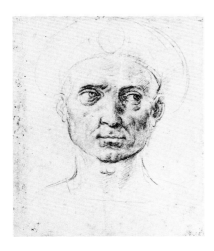

77 : Head of a soldier or attendant
 Lille, Musée des Beaux-Arts 429
 Lead-tin stylus (?) on green ground. 128 × 104 mm.
A rigorously objective portrait study, for which Raphael used a stylus
softer than silver. The hatching on the left cheek seems as soft as
stumped chalk. Perhaps a little later than the other drawings in this
'sketchbook', since none of the others shows this command of
atmosphere (cf. cat. 66 for the characterization).

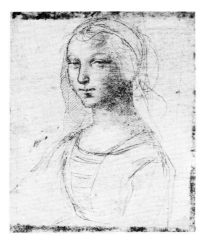

78 : Portrait of a girl
Lille, Musée des Beaux-Arts 469
 Silverpoint on green ground. 126 × 101 mm.
Probably showing a knowledge of Florentine, and specifically
Leonardesque, portraiture. The right side of the face is framed by the
flattened fall of the veil, the left side unconfined. The suggestion of
domestic intimacy is alien to Umbrian modes, though the cast of the
features is still slightly Umbrian.

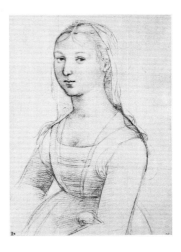

79 : Young woman seated, half length
 London, British Museum 1895–9–15–613
 Black chalk. 259 × 183 mm.
Very close in pose, expression and type to cat. 78, and presumably from
the same model dressed differently and veiled. The greater formality
suggests that Raphael was moving towards a painted portrait.

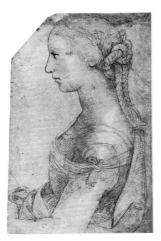

80r: Seated girl in profile
 Florence, Uffizi 57E
 Black chalk over stylus, pen-work on nose
 and eye, white heightening (badly rubbed)
 on neck, shoulder and arm. 256 × 160 mm.,
 irregular, cut all round.
An exercise in linear rhythms, additionally
emphasized by the pen-work. As intense as the
portraits of the Pollaiuoli, but perhaps in-
fluenced by the sculpted reliefs of Desiderio
da Settignano and his followers.

80v: Fragment of a profile
 Pen.
Traced against the light from the recto.

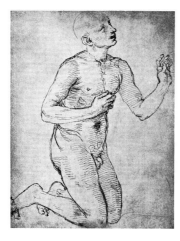

81: St Francis receiving the stigmata
 London, British Museum Pp. 1–64
 Pen, a touch of red chalk. 238 × 176 mm., cut at top and left.
Studied from the nude, probably in Florence. The formula of repeated
curving lines for the division of hips, torso and buttock becomes a recurring
feature. The hands are sharply described, but the pose – St Francis half rising
in ecstasy – is unconvincingly rendered. Although unprepossessing, there is
no reason to doubt the drawing's authenticity. It may have been conceived as
a companion to cat. 73r.

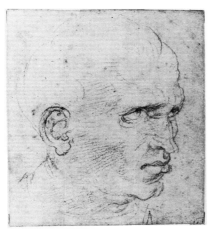

82: Head of a man
 Lille, Musée des Beaux-Arts 467
 Black chalk. 115 × 98 mm., cut down all round.
Despite the poor definition of the upper lip, the crumpled outline of
the forehead and the generally Teutonic appearance of this study,
Raphael's authorship cannot be categorically denied. The facial type is
similar to cat. 81 (cf. particularly the ear), and the hatching on the
cheeks and forehead, and the shading round the eyes, is not
uncharacteristic. However, the possibility that it is a later drawing by a
pupil (cf. cat. 376) is not to be excluded.

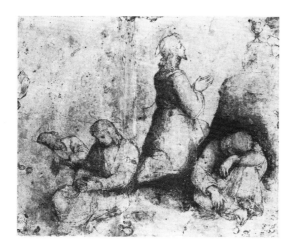

* 83: The Agony in the Garden
 New York, Pierpont Morgan Library I, 15
 Pen, brush and wash, pricked for transfer.
 220 × 265 mm., many losses.
A ruined cartoon for the left-hand predella panel
(D. pp. 15–16) to the *Pala Colonna* (New York, Metro-
politan Museum; D. p. 14), similar in execution to cat. 71.

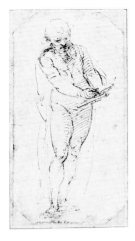

84r: Man writing in a book
 Oxford, Ashmolean 526
 Pen. 177 × 88 mm., corners made up, cut down.
Presumably a study for a standing saint in an altarpiece; there is a slight resemblance to St Peter in the *Pala Colonna* (D. p. 14). Perhaps developed into cat. 85r.

84v: Christ and a disciple (?)
 Pen.
A mutilated study for or after a painting of Christ demonstrating a point to a disciple (?). Christ's gesture is re-employed in the *Disputa* (cf. also cat. 235r).

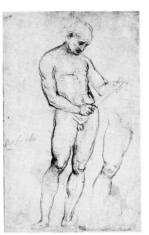

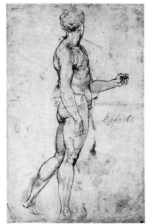

85r: Standing saint (Peter?); study of his right leg
 London, British Museum Pp. 1–65
 Pen 279 × 169 mm.
The identification is suggested by the cord (to hold keys?) that dangles from the saint's right hand. There is some relation to the St Peter of the *Pala Colonna* (D. p. 14) in pose. Presumably a companion to cat. 86.

85v: Nude man advancing to right
 Pen.
A study from the model in a pose adapted from Michelangelo's *David* (cf. cat. 87v, 97). Raphael seems to have been particularly interested in the adaptation of statuary at this moment (cf. cat. 87r, 88r).

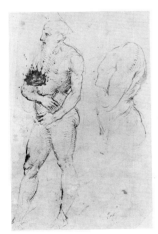

86: Standing bearded saint (Jerome? Paul?), nude; a torso in left profile
 Budapest, Museum of Fine Arts, 1936
 Pen and black ink, over stylus in torso at right. 238 × 147 mm. maximum, cut down at left and top.
The position of the feet and the raised forearm in the study suggest that this drawing served as a starting-point for the St Paul in the *Pala Colonna* (D. p. 14). Probably completed after Raphael's first experience of Florence, the saint is there depicted as a stocky figure, clad in the voluminous drapery this pose would seem to anticipate.

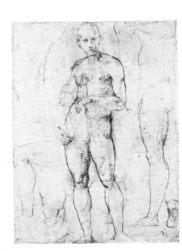

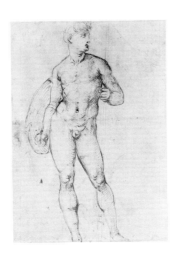

87r: Standing St Paul, nude; three studies of knees; bent leg; man in left profile, nude; foot seen from the rear
 Oxford, Ashmolean 522
 Pen. 265 × 187 mm.
St Paul, identifiable from his sword and book, is adapted from Donatello's *St George* (cf. cat. 88r) – an appropriate model for a militant saint. The hatching, finer than in cat. 85 and 86 (which are clearly contemporary) creates volume and texture in the thighs and torso. (Cf. cat. 99 for the ovoid head.) Adapted by Domenico Alfani for the right side of the Virgin's throne (see verso).

87v: Standing warrior
 Pen.
Adapted, wittily rather than weakly, from Michelangelo's *David*; employed by Domenico Alfani for a relief figure on the left side of the Virgin's throne in his *Virgin between St Gregory and St Nicholas of Bari*, s.d. 1518 (Perugia, Galleria Nazionale). (Cf. cat. 85v, 97.)

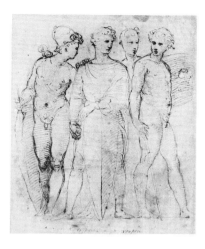

88r: Group of warriors
 Oxford, Ashmolean 523
 Pen. 271 × 216 mm.
The group centres on a variant of Donatello's *St George*, already known to Raphael in Perugino's studio; the nude figure at the right is taken from a Roman relief. This compact rectangle may have been prepared for a decorative scheme, possibly for a palace façade. The figure style suggests the early Florentine period.

88v: Standing nude man (upside down); torso and arm in
 right profile, twice; a knee; (with the right edge as the
 bottom) head in outline looking up
 Pen, the contours of the head pricked for transfer, the
 standing man in black chalk.
Apparently unconnected with known paintings or drawings. If by Raphael (and it is essentially unattributable) the head might be later, an auxiliary cartoon (?) of *c.* 1512 (?), since there is some resemblance to the head of Heliodorus.

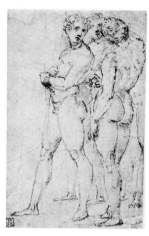

89: Three standing nude men and the legs of a fourth
 London, British Museum 1895–9–15–628
 Pen over traces of black chalk. 243 × 148 mm., cut at right.
Possibly for a group of soldiers. Perhaps related to cat. 91v. The pose of the left-hand man is similar to that of the right-hand figure in cat. 88r, in reverse.

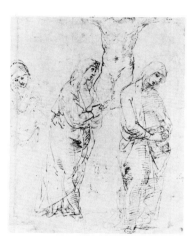

90: The Virgin at the Crucifixion
 Vienna, Albertina Bd. IV, 196
 Pen over stylus. 271 × 212 mm.
Three different expressions of grief, with hands and head successively lowered from left to right. The drapery is more angular than usual and adds weight to the poignancy of the poses. The body of Christ is left incomplete and placed rather lower in relation to the Virgin than was customary. Possibly connected with cat. 92.

91r: Standing male nude facing right; arm and shoulder
 Vienna, Albertina Bd. V, 250
 Pen over stylus. 244 × 163 mm.
A life study for the central figure in cat. 90. The contours of the right hip and thigh re-worked for a more rounded form. (Cf. cat. 94r, right-hand figure.)

91v: Two male nudes (for a battle scene or a baptism?); Eve taking the apple
 Pen, over black chalk for the left-hand figure; Eve in faint black chalk.
Probably influenced in theme by Michelangelo's *Battle of Cascina*, but not formally related to it (cf. cat. 89 for the figure style). Perhaps related to the commission recorded in cat. 94r, etc. The small sketch of Eve taking the apple may be a first idea for the composition developed in cat. 131v.

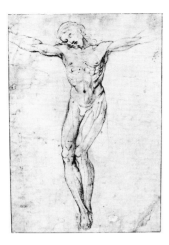

92: Christ on the Cross
 Florence, Marucelliana E.84
 Pen. 353 × 226 mm., cut at sides.
The proportions are close to those of the *Mond Crucifixion*
of *c.* 1502 (the frame dated 1503) (London, National Gallery;
D. p. 8), but this drawing can hardly be dated so early. It is
probably from the early Florentine phase, *c.* 1505, and is
perhaps connected with the project for which cat. 90 and
91r were drawn.

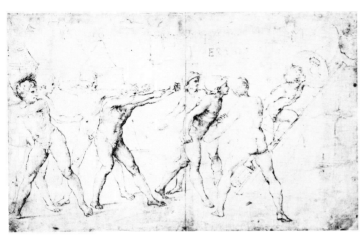

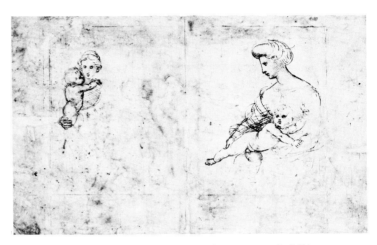

93r: *The Storming of Perugia*
 Paris, Louvre 3856
 Pen over stylus. 266 × 406 mm.
Certainly genuine, though faded. Two figures sketched lightly at the top:
left, a man with shoulders and neck turned slightly to his left; right, a nude
woman, breasts and hips partly visible. The *Storming* is presumably for an
unknown Perugian commission – a small rather than large painting judging
from the figure scale, maybe for a piece of furniture. The splayed-leg poses
suggest an early date in Raphael's Florentine phase and demonstrate the
continuing influence of Antonio Pollaiuolo. The three figures centre right
are studied in cat. 108v.

93v: Copy of Michelangelo's Taddei tondo; Virgin and Child
 Pen over stylus.
Another variant copy is on cat. 111v. The Virgin and Child are somewhat
reminiscent of the *Small Cowper Madonna* of *c.* 1505 (Washington, National
Gallery; D. p. 19).

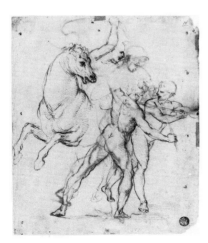

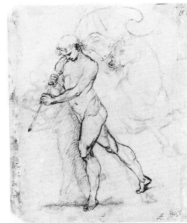

94r: Cavalryman and two infantrymen
 Venice, Accademia 16
 Pen over stylus, stylus plumb-line down central figure.
 258 × 209 mm.
Perhaps for the same commission as the *Storming of Perugia* (cat. 93r).
The poses look back to the *Journey of Aeneas Piccolomini to Basle*
(cat. 56). Perhaps prompted – but not noticeably influenced – by the
battle paintings of Leonardo and Michelangelo, which were
under way at this time in the Palazzo della Signoria, Florence.

94v: Standard-bearer
 Pen over stylus
Presumably for the same project as the recto. The pose, pointed
features and intermittently heavy contours are reminiscent of
cat. 4, but are more accomplished. The twisting outwards of both
legs and the movement of the stomach give the drawing the air of a
self-conscious demonstration of skill.

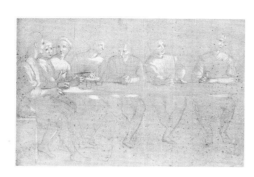

95r: The left-hand side of a composition of the Last Supper
 Oxford, Ashmolean 507
 Silverpoint and white heightening on buff ground, squared in
 silverpoint at 27 mm. 216 × 321 mm.
The second head from the left was taken up at the lower left. Studies
from posed models for an unknown project. Characteristically, there
is heavy use of white to suggest an interior. The slight weaknesses in
perspective are caused by using the same models in different
positions.

95v: Head of the Virgin
 Black chalk.
A feeble sketch, perhaps based on a lost drawing by Raphael for the
Madonna del Cardellino (Florence, Uffizi; D. p. 20).

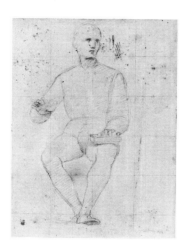

96r: Seated figure with book
 Oxford, Ashmolean 533
 Silverpoint on grey ground, a few strokes of red chalk, squared in silverpoint
 at 36 mm. 203 × 140 mm.
The angle of vision suggests that this figure was to be seen from below, but its
purpose is unknown.

96v: Sketches for the *Preaching of St John*
 Black chalk.
Usually ignored or dismissed, these loose chalk drawings were plausibly
identified by Sylvia Ferino Pagden (cf. cat. 158v) as sketches (mostly reversed) for
the single surviving predalla panel (Mersey Collection, on loan to the National
Gallery, London; D. p. 14) of the Ansidei altarpiece.

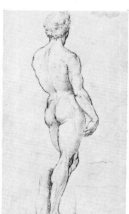

97: Copy after Michelangelo's *David*
 London, British Museum Pp. 1–68
 Pen over traces of black chalk. 393 × 219 mm.
The *David* is seen from an angle which was impossible in its original location. Raphael
may therefore have made this drawing from a plaster or wax model, or assembled it
from different studies. The *David* influenced Raphael's treatment of the male nude
from early in his Florentine phase, but the date of this drawing is not necessarily as
early as 1504–5. Raphael's tendency to arrange forms in patterns is clearly seen in the
rhyme of the right arm and the line of the back. The hatching is used to obtain a
marmoreal sheen.

98: Leda and the Swan after Leonardo
 Windsor, Royal Collection 12759
 Pen over stylus and traces of black chalk. 308 × 192 mm.
Perhaps after one of Leonardo's preparatory drawings for his standing *Leda* rather than
the finished painting, for the contour hatching shows a knowledge of Leonardo's
graphic technique, even if rendered in a simplified way. The elongated ovoid features
and outward gaze defuse the modesty, and to some extent the sensuality, of Leonardo's
design. Eroticism for Leonardo becomes rhythm for Raphael.

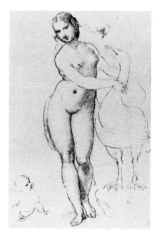

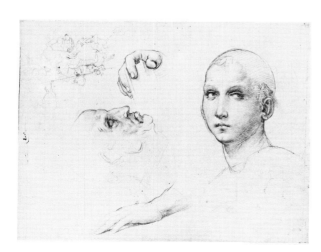

99: Heads of saints for the *Trinity* of San Severo;
 studies after Leonardo
 Oxford, Ashmolean 535
 Silverpoint and white heightening on white
 ground. 212 × 274 mm.
See commentary to Plate 10.

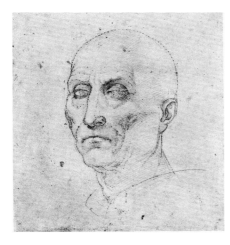

100: Head of an old man
 Lille, Musée des Beaux-Arts 477
 Silverpoint on light buff ground, pricked for transfer.
 205 × 187 mm.
Very close in style to cat. 99. Not for one of the heads in the
executed section of the San Severo *Trinity*, but perhaps for one of
the figures intended to stand below. The solidity and mastery of
this drawing and the clarity and sculpturesque precision of
Raphael's silverpoint are surpassed only by cat. 99.

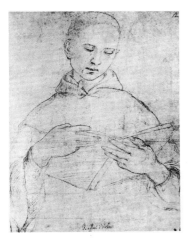

101: Young monk reading
 Chantilly, Musée Condé FR. IX, 42
 Black chalk, pricked for transfer. 459 × 345 mm.
Obviously close in type to cat. 100, but not for the San Severo *Trinity* since
the light falls from the right. Although self-sufficient in composition, it does
not seem to be a cartoon for a devotional panel, but might be for a panel in a
polyptych. Although it is badly foxed, nothing can disguise the crystalline
precision of this drawing.

102: Studies of hands
 Paris, Fondation Custodia 5083
 Silverpoint on grey-brown ground. 74 × 118 mm.
 and 133 × 95 mm. (two fragments from the same
 sheet).
Not connected with a known project, but close to cat. 101.

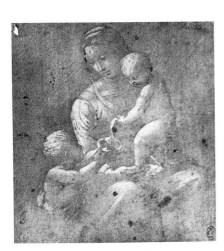

103: Virgin and Child with St John
 Windsor, Royal Collection 12743 (as Granacci)
 Silverpoint and white heightening on buff ground, inscribed within
 a circle. 139 × 120 mm.
Invariably denied to Raphael this century, but undoubtedly
autograph. The types of the Virgin and Child are identical with those
of the *Terranuova Madonna* (Berlin-Dahlem; D. p. 16). The complexity
and clarity of the composition speak for Raphael's invention, and the
precise focus of the gazes for his execution. Heavy white heightening
suggests the setting is an interior, and the scroll the Child accepts is
conceived entirely in terms of light. No other drawings of exactly this
type have survived, but for the use of white compare cat. 27.

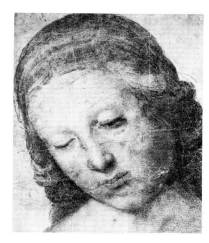

104: Head of the *Terranuova Madonna*
 Berlin-Dahlem, Kupferstichkabinett 11659
 Charcoal over stylus. 180 × 148 mm., everything below the mouth
 restoration.
A fragment of the cartoon for the *Terranuova Madonna* (Berlin-Dahlem;
D. p. 16). Since it is not pricked, transference must have been by
indentation, though this fragment is now so damaged that no traces
remain.

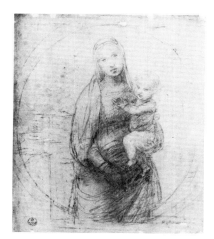

c. 1505 Studies for the *Madonna del Granduca* (Florence, Palazzo Pitti; D. p. 18) (cat. 105–6)

105: Compositional study
 Florence, Uffizi 505E
Black chalk over stylus, a stylus tondo outside the drawn one.
 213 × 184 mm.
A fairly rapid study, tried within circular, oval and rectangular frames.
The simpering divergence of the heads, and the dangerous lack of
support for the Child, were modified in the painting, where Raphael
brought the Virgin's right arm across her body to support the Child's
torso. The painting is much more sculptural than the drawing: Umbrian
pattern-making is superseded by Florentine plasticity. The landscape in
the painting was subsequently overpainted.

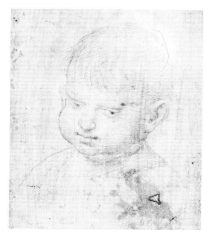

106: Head of a Child
 Frankfurt, Staedel 384
 Silverpoint on blue-grey ground, the contours of cheek, lips and
 eyes slightly reinforced, perhaps by the artist. 112 × 99 mm., cut
 all round.
The forelock brushed forward (a feature of Raphael's portrayal of the
Christ Child *c*. 1505–6) and the fluffing out of the hair over the ear
were rendered with only minimal changes in the painting, though the
relation of head and body are different.

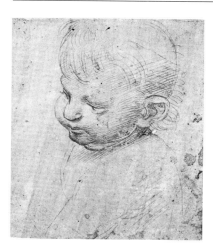

107: Head of a child
 Hamburg, Kunsthalle 21419c
 Silverpoint on grey-green ground, some reinforcement on ear and
 nose. 102 × 88 mm., cut all round.
A sharp study for the head of a child; similar in handling to cat. 106,
and quite close to, though probably not for, the Christ Child in the
Madonna of the Meadow (Vienna; D. p. 20).

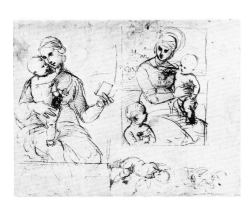

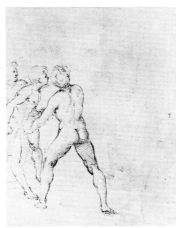

108r: Two Madonna compositions; (with the sheet turned so the bottom is the right edge) sketch of a Madonna and Child; a child
 Vienna, Albertina Bd. IV, 206
 Pen. 147 × 252 mm., cut at top.
The right-hand composition was developed from cat. 110r; it was probably the origin (in reverse) of the *Northbrook Madonna* (Worcester, Mass.; D.p. 61). Compare also cat. 93v. A livelier variant appears on the left, shown down to the calves but framed at the knees. The Virgin and Child lower right reflects Leonardo's *Virgin of the Yarn Winder* and anticipates the *Bridgewater Madonna* (Sutherland Collection, on loan to the National Gallery, Edinburgh; D.p. 23). For the sketches lower right cf. cat. 115r.

108v: Three nude figures for the *Storming of Perugia*
 Pen.
A study for cat. 93r; the Leonardesque characterization of the left-hand figure there post-dates this drawing.

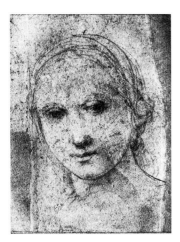

109: Head of a young woman
 Montpellier, Musée Fabre 3185
 Pen and silverpoint (?) on badly damaged pink ground (?) 135 × 98 mm., made up at lower left edge and right edge.
A sharp, sensitive portrait not quite comparable with any other drawing of the Florentine phase except possibly the San Severo studies (cat. 99). The angle of the head and gaze are identical with those of the *Northbrook Madonna* (Worcester, Mass.; D.p. 61) and the study was undoubtedly made for this picture, though the features were coarsened in execution (see also cat. 114v).

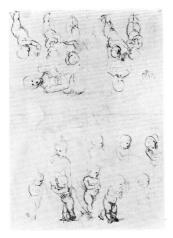

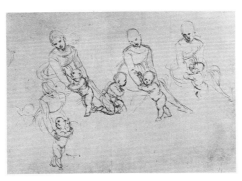

1505 Studies for the *Madonna of the Meadow* (Vienna; D.p. 20) (cat. 110–13)

110r: Compositional studies
 Vienna, Albertina Bd. IV, 207
 Pen over stylus. 362 × 245 mm., cut at right and bottom and perhaps left, a patched hole upper centre.
See commentary to Plate 11.

110v: Four compositional studies
 Pen over stylus
Developed from the recto with a series of different positions for the Child, and, upper centre, the Baptist kneeling.

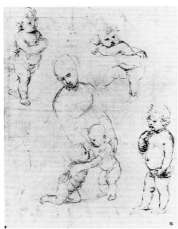

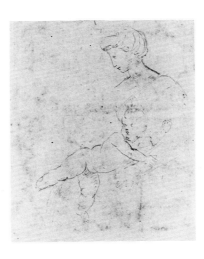

111r: Compositional study
 Chatsworth 783
 Pen. 250 × 194 mm.
A further development of the central group in cat. 110v. The relation of the children is now more closely defined and the action of Christ accepting the cross determined.

111v: Copy of Michelangelo's Taddei tondo
 Pen.
Since Michelangelo's tondo was later owned by Taddeo Taddei, to whom Raphael gave the *Madonna of the Meadow*, this drawing suggests that Michelangelo's unfinished sculpture was already in Taddei's house when Raphael was preparing his painting. Raphael has modified the position of the Child's right arm to make a regular curve (cf. cat. 93v).

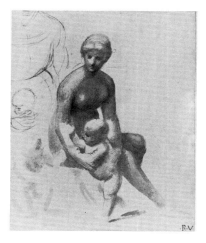

112: Compositional study
 Oxford, Ashmolean 518
 Brush and wash with white heightening (largely oxidized) over lead
 point (?) with red chalk. 218 × 180 mm., cut at left, squared at 57 mm.
 In red chalk.
See commentary to Plate 17.

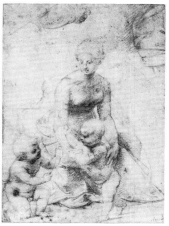
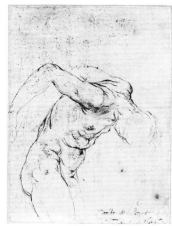

* 113r: Compositional study
 New York, Metropolitan Museum of Art, Rogers Fund 64–47
 Red chalk. 224 × 154 mm., cut all round (?)
St John's right arm taken up at top left; the Virgin's drapery top right.
Raphael's first known study in red chalk, lightly handled to maintain the
atmospheric unity created in cat. 112 while incorporating details of drapery
and expression. In the painting the Child's pose is more erect, and His head is
turned outward.

113v: Half-length nude figure for a Descent from the Cross
 Pen.
A study from the model, perhaps for the body of Christ, perhaps for one of the
thieves. Taken further on cat. 143r.

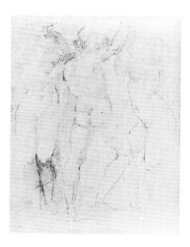

114r: Vintagers
 Oxford, Ashmolean 524
 Pen, plumb-lines for all three figures in lead point; very faded.
 278 × 203 mm.
Presumably *en suite* with cat. 135v for a decorative panel, perhaps
for a piece of furniture. The accent is very much on the contour
and the rhythmical relations of the figures. The nymph on the left
echoes Leda (cat. 98), the movement of that on the right the Child
in cat. 120. The faun in the centre is reminiscent of Signorelli's
Kingdom of Pan (formerly Berlin).

114v: Studies for the *Northbrook Madonna* (Worcester, Mass.;
 D. p. 61)
 Black chalk (laid down, visible only against the light)
Drawings for the Christ Child; His right and left arms studied
again to the right (see cat. 108r, 109).

c. 1506 Studies for the *Madonna del Cardellino* (Florence, Uffizi; D. p. 20) (cat. 115–16, see also cat. 95v)

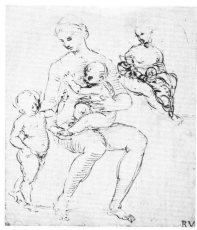

115r: Virgin, Child and St John; Virgin and Child in an arched frame
 Oxford, Ashmolean 516
 Pen and two shades of brown ink. 248 × 204 mm., irregular, made
 up at top.
The particularly Leonardesque sketch at top right, with the Virgin's
head in several different positions, has features in common with
cat. 108r. It was continued in a drawing now known only in a copy
(Ashmolean 634). The pose of the main group suggests the
increasingly sculpturesque ambitions which characterize the
Cardellino, though this drawing could easily have been developed
into a different composition.

115v: A chapel (?)
 Black chalk.
A sketch of or for a small chapel or transept arm: barrel vaulted, a
round window in the lunette, the main part of the wall composed in a
triumphal arch format with a large central niche, flanked by two
smaller ones, each of the latter surmounted by a rectangular panel; a
suspended *baldacchino* at left. The sketch cannot be connected with
any known project or building.

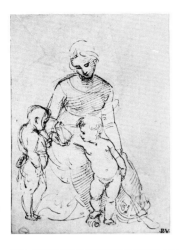

116r: Virgin, Child and St John
 Oxford, Ashmolean 517
 Pen over lead point. 229 × 163 mm., very irregular, made up on right side
 and upper left side.
The figures first sketched nude, then lightly draped. A sequence of forms
unbalanced towards the left and arrested by the solid pose of St John. The motif of
the Child's foot resting on the Virgin's was retained in the painting.

116v: Architectural sketches
 Black chalk (laid down and visible only against the light)
A small cruciform building with inset corner columns on the right margin; part-
plan of a basilical church (?) at lower edge. This drawing is important evidence of
Raphael's early architectural sophistication, especially in the use of corner
columns, which follows Francesco di Giorgio, and may reflect contemporary
experiments by Bramante; it also anticipates his own painted architecture in the
Expulsion of Heliodorus.

c. 1506 Studies for *St George and the Dragon* (Washington; D.p. 13) (cat. 117–19)

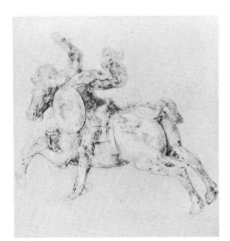

117: St George
 Oxford, Ashmolean 44 (as Signorelli)
 Silverpoint and white heightening, oxidized, on white ground.
 215 × 225 mm., maximum, silhouetted, mounted at too low an
 angle.
This badly damaged drawing was presumably Raphael's first scheme
for the painting, with St George armed with a sword, as in the Louvre
version (D.p. 5), and not in direct contact with the dragon. This
drawing has been independently re-attributed to Raphael by Dr
David Alan Brown.

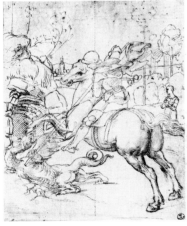

118: Cartoon (?)
 Florence, Uffizi 529E
 Pen over black chalk, pricked for transfer. 263 × 213 mm.
See commentary to Plate 12.

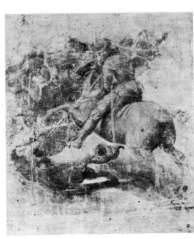

*119: *Modello*
 Washington, National Gallery of Art B.33, 667
 Brush and wash with white heightening over black chalk.
 246 × 202 mm.
This badly damaged drawing is very similar in handling to cat. 154. It
refines some of the detail of cat. 118, and was presumably prepared to
establish the distribution of light and shade in the underpainting of this
important picture.

1506–7 Studies for the *Belle Jardinière,* signed and dated 1507 (Paris, Louvre; D. p. 22) (cat. 120–3)

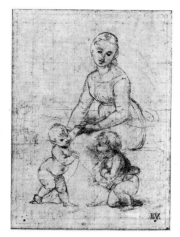

120: Compositional study
 Paris, Louvre RF 1066
 Pen over stylus, squared in red chalk at 27 mm., framed twice: first as a
 rectangle in black chalk over stylus (290 × 195 mm.), then arched in black
 chalk (272 × 178 mm.); compass intersections at lower right and lower
 left. 302 × 208 mm.
The figures were first drawn nude then partly clothed. The dense cross-
hatching of St John shows a knowledge of Michelangelo's pen drawings, and
his pose the influence of the Child in the Doni tondo. The compass work
demonstrates the geometrical calculation that underlay Raphael's com-
positions. The project may well have been under way for some time before the
painting was completed; here the arrangement is much more static than in the
painting.

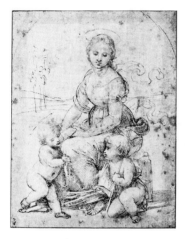

121: Compositional study
 Chantilly, Musée Condé FR. IX, 53
 Pen over stylus, incised central plumb-line, stylus marks along edges,
 compass holes, some contours strengthened, probably by the artist.
 230 × 166 mm.
Some changes were made in the expressions and poses of the children after
cat. 120. The execution is a little flat, although the lightly sketched trees in
the background are lively, but this is probably the result of too harsh
cleaning in the past. The variation of pen stroke seems too controlled, the
drama too precise, for this to be a facsimile of a lost drawing, as has sometimes
been suggested.

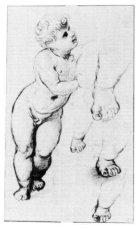

122r: The Christ Child; His left foot
 Oxford, Ashmolean 521
 Pen over lead point (the lavishly applied ink has corroded the paper somewhat).
 283 × 161 mm.
A bold study for the Child in the final version of the composition. The broad, Leonardesque
contour hatching round the Child's left thigh creates a powerful but smooth volume. The
studies of His left foot demonstrate Raphael's precision of detail, and the broad handling his
effort to attain greater vigour. The pose of the Child is a deliberate quotation from
Michelangelo's *Bruges Madonna*, inserted at a late stage in the development of the
composition.

122v: Seated anatomy
 Pen, a faint red chalk line down the back and across the seat.
One of Raphael's rare and not very successful attempts to analyse the skeleton.

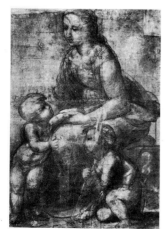

* 123: Cartoon
 Holkham Hall, Leicester Collection
 Black chalk. 940 × 668 mm.
Badly damaged, and partly reinforced. The Child's right leg can be seen bent to
the left in the underdrawing, which suggests that cat. 122r was drawn after the
initial laying out of this cartoon but before the final version. St John's garland
was omitted in the painting.

c. 1506–7 Studies for the *Entombment,* signed and dated 1507 (Rome, Galleria Borghese; D. p. 23) (cat. 124–42, 148v, 158v)

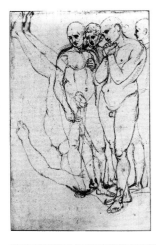

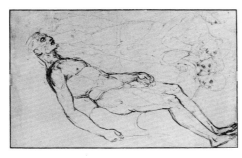

124r: Four standing male nudes
 Oxford, Ashmolean 530
 Pen over black chalk (under St John) and lead point; the contours pricked; two horizontal lead point lines drawn *c.* 16 mm. apart halfway up sheet, the lower pricked as a horizon line, on left for 10 mm. and on right for 50 mm. 322 × 198 mm.
St John pounced through to cat. 125. These figures are presumably the product of a still earlier stage of the design.

124v: The body of Christ
 Pen over stylus, compass intersection just above the right hand, on pricked line; the contours pricked for transfer.
The head is turned upward and the left hand brought across the thigh as in Michelangelo's St Peter's *Pietà.* The faint beginning of the Magdalen's legs beneath Christ's thighs and her torso above. Presumably preparatory to cat. 125.

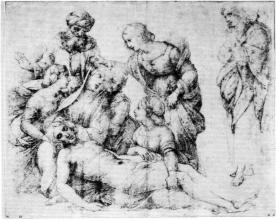

125: The Lamentation
 Paris, Louvre 3865
 Pen over stylus and black chalk, possibly a little re-working, framing lines some 3 mm. from either edge, compass intersection about 4 mm. above Christ's thigh and about 17 mm. above the Magdalen's head on centre line. 334 × 397 mm.
An elaborate drawing (much dulled through over-exposure) for presentation to a client. The dense cross-hatching is characteristic of Raphael's highly finished pen drawings *c.* 1506–7, partly under Michelangelo's influence. This conception follows Perugino's painting of *c.* 1495 (Florence, Pitti); it may not have been wasted, for a seventeenth-century copy of this composition by Sassoferrato (Berlin-Dahlem) shows so Raphaelesque a landscape that it may have been made from a lost painting rather than from this drawing. St John was pounced through from cat. 124r.
 Another head was started in black chalk between St John and the Magdalen.

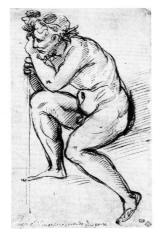

126r: Torso of Christ; the shoulder and neck repeated at left
 Paris, École des Beaux-Arts 318
Silverpoint on salmon-pink ground. 195 × 120 mm.
A study of detail, perhaps drawn after cat. 125 to create a more angular pose. Cat. 178 is on the same colour ground.

126v: Seated male nude
 Pen over traces of black chalk.
A loosely and rapidly drawn sketch for a bacchic (?) figure. For the facial type cf. cat. 186r, which is also similar in modelling. Cf. cat. 153 for the simplification and elongation of the right foot.

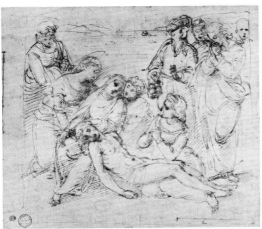

127: The Lamentation
 Oxford, Ashmolean 529
 Pen over stylus, traces of black chalk, central plumb-line in stylus, compass intersection on centre line just to right and above head of woman supporting Virgin on the right, incised small circle in lower centre, scale at lower right 60 mm. (in Roman *palmi*), at left *c.* 21–22 mm. 178 × 205 mm., made up at upper left.
The drawing was subsequently engraved by Marcantonio Raimondi. It attempts to clarify the composition by gaze and geometrical arrangement. The large open V in the centre focuses attention on the figure of Christ, whose body is set at the front, parallel to the line of women's heads, His head lying across the diagonal from the Virgin's left leg to the right shoulder of the turbanned man. The grief of the Virgin is strongly emphasized, as befits this painting commissioned by Atalanta Baglione, a grieving mother.

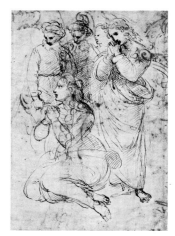

128: Mourning figures
 London, British Museum 1895–9–15–636
 Pen. 250 × 169, cut down.
A revision of the right-hand group in cat. 127. The draperies of both the Magdalen and St John are composed in more sweeping curves. The Magdalen's gaze is now focused on the Virgin; the bearded figure looking downwards (Joseph of Arimathea?) is drawn twice, both positions modifying the relation depicted in cat. 127.

On the laid down verso are unphotographed decorative motifs in pen, apparently studies of a scrolled bracket supporting a tabernacle (?); a scrolled bracket separately, twice; and a chain of ovals. Not considered to be by Raphael by those who have seen them.

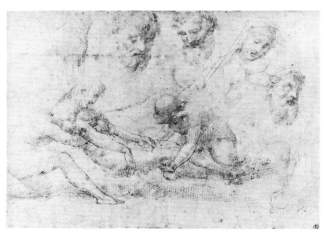

129: The Entombment; head and hand studies
 Oxford, Ashmolean 531
 Pen. 218 × 307 mm., cut at top and left.
This drawing presumably documents the moment when Raphael began to think of an active composition. The head of the Virgin is close to that of cat. 127; the bearded head to her right could well be for the Joseph of Arimathea in the same study; the bearded head to her left, with shoulders and left arm indicated, does not occur in other sheets, nor does the bearded head top centre, looking down to his left (though cf. cat. 125). This sheet seems to be the only surviving record of a considerably revised composition, with at least one, possibly two, male figures standing at the left. The creation of form by cross-hatching, with few contour lines, shows remarkable skill. A counterproof of cat. 120 can be discerned on this drawing.

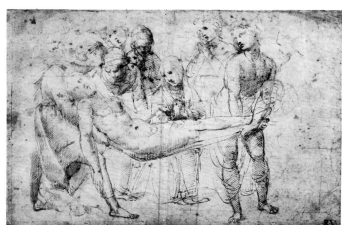

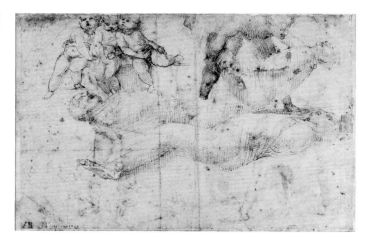

130r: The Entombment
 London, British Museum 1963–12–16–1
 Pen. 213 × 320 mm., cut at top
Although the lack of movement to left and right suggests that the action is still the lowering into the tomb, the seeds of the later development have been planted. Christ's body is supported well above the ground, the Marys are grouped in the centre and the Magdalen is roughly outlined again, bending over His feet; Christ's left hand is drawn in two different positions, first as in cat. 125, then being lifted. In handling, the drawing displays a virtuosity similar to cat. 129, if less extreme.

130v: Burial scene; three putti
 Pen.
This depiction of shrouded corpses being laid out is unlike anything else in Raphael's *oeuvre* and may be the result of studies in a mortuary, though the bearer is in a more complex pose than one would normally see in real life. The putti cannot be connected with any known composition (but cf. cat. 144r, etc.) The use of cross-hatching is again of great virtuosity.

131r: Kneeling Virgin (?); the Magdalen (?) rushing forward
 Chantilly, Musée Condé FR. VIII, 44
 Pen over black chalk and stylus. 166 × 118 mm., cut all round.
The identities of both figures are uncertain. The kneeling figure is presumably developed from cat. 130r and should be the Virgin, but in cat. 133r she has been replaced in the central position by the Magdalen. The head of the woman moving forward is probably the Magdalen, as in cat. 138 (and hence drawn after the main study) but it could also be a preliminary idea for the Virgin in cat. 133r.

131v: Head of the bearer
 Black chalk, white heightening.
An unusual drawing, generally ignored, and rather crude, especially round the eyes. But there seems no good reason to reject it and it is patently related to the central figure in cat. 134, as Sylvia Ferino Pagden has pointed out.

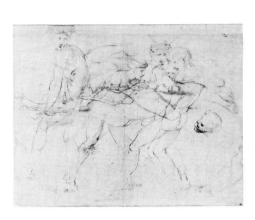

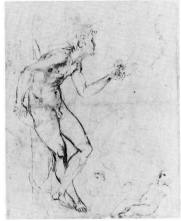

132r: The Death of Meleager
 Oxford, Ashmolean 539
 Pen. 265 × 330 mm., irregular.
Copy of an antique relief existing in several versions (though without the step, e.g. Perugia, Museo Archeologico). The relief perhaps gave Raphael the idea for the transporting of the body (though this occurs also in Michelangelo and Mantegna) and he continued to experiment with it. The arrangement of the body in cat. 130r, and the wrist position of the right-hand bearer and the Magdalen in cat. 137 are taken from this composition. The coincidence of names with Atalanta Baglione may also have had some significance.

132v: The Temptation of Adam; reclining Child, supported
 under the head and right arm.
 Pen over lead point; the figure of Eve in lead point only.
Perhaps a first design for the Segnatura vault, to be executed by Sodoma but subsequently replaced by Raphael with a different design, executed by himself (see cat. 250). The complete composition was later engraved by Marcantonio Raimondi. The sketch of a torso with the thigh bent outwards, which is probably a first idea for Eve, can be seen in the original near Adam's left knee. The Child is derived from Giovanni Bellini's *Madonna with Sleeping Child* (Boston, Gardner Museum), a motif known to and used by Giovanni Santi (*Virgin and Child*: London, National Gallery). Copied on cat. 260v.

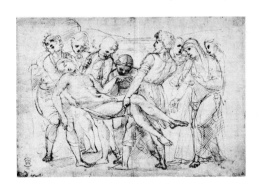

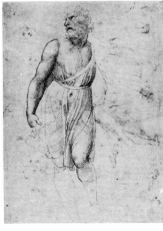

133r: The Entombment
 London, British Museum 1855–2–14–1
 Pen over black chalk; the head of the third bearer from the left
 drawn looking to the left in black chalk alone. 230 × 319 mm.
This drawing documents the moment at which Raphael began to consider a composition moving from right to left. The role of the central mourner is now definitely the Magdalen's and the Virgin and holy women form a separate group to the right. The composition is designed as a foreground relief. Christ's pose is once more taken from Michelangelo, and the Virgin's gesture looks to Michelangelo's *Entombment* (London, National Gallery).

133v: Standing bearded man
 Pen.
Based on Michelangelo's unfinished *St Matthew*; Raphael may have thought of employing this figure as a bearer, but in the event did not.

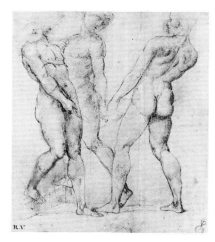

134: Three bearers, nude
 Oxford, Ashmolean 532
 Pen over rubbed black chalk, Christ's body in red chalk, the
 contours of the main figures pricked for transfer, pricked horizon
 line, some divider marks and indentations. 282 × 246 mm.,
 irregular.
The figures' positions are laterally compressed in a manner
reminiscent of Mantegna's *Bacchanal with Silenus*. It does not,
however, appear to represent a compositional revision. It may also
reflect some interest in Michelangelo's *Cascina*. The cross-hatching
and sharp contours deliberately emphasize the front plane relief
which is so important in the final painting. The position of the legs of
the left-hand bearer shows that this study comes after cat. 133r but
before cat. 135r.

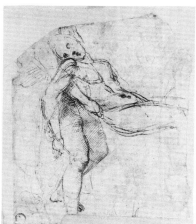

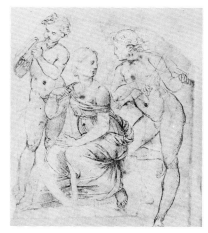

135r: The upper part of Christ's body and a bearer
 Oxford, Ashmolean 525
 Pen, pricked for transfer. 232 × 185 mm., irregular, cut down all
 round and made up.
A rapid but poignant study revising the position of the bearer's legs
in relation to Christ's body and His pendant arm.

135v: Three musicians playing (left to right) the horn, the harp, the
 viol da braccio
 Pen over traces of black chalk.
Presumably *en suite* with cat. 114r; perhaps for the decoration of a
musical instrument. The deliberate flattening by cross-hatching and
surface patterning by contour is here even more pronounced. For the
musician on the left cf. cat. 8r.

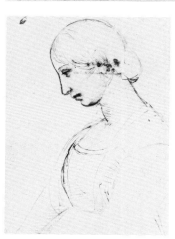

136: Profile of a girl
 Florence, Uffizi 1477E
 Pen, traces of black chalk. 262 × 189 mm., cut on right.
Probably a study for the head of the Magdalen in cat. 137.

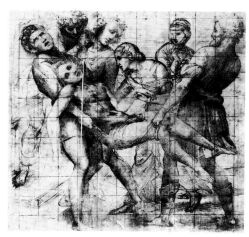

137: *Modello* for the main group
 Florence, Uffizi 538E
 Pen over traces of black chalk, squared in two grids in pen
 at 24 mm. and red chalk with some stylus at 27 mm.;
 head of left-hand bearer pricked for transfer.
 289 × 298 mm.
See commentary to Plate 13.

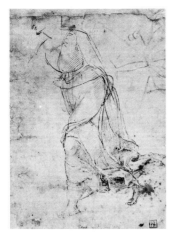

138r: The Magdalen running forwards; a palm-tree (?)
 Paris, Fondation Custodia I, 952
 Pen, the tree (?) in black chalk. 258 × 186 mm., made up to
 266 mm.; irregular, cut at top and right.
Developed from the maidservant pouring water in Ghirlandaio's
Birth of the Virgin, a figure which Raphael copied in a lost drawing,
itself now known only in a copy (Chatsworth 725). A pair of male
(?) legs is drawn lightly over the Magdalen's. The identification by
Mr Byam-Shaw of the forms upper right as a rough chalk sketch of a
palm-tree finds support in the verso.

138v: Sketch for the drapery of the *Holy Family with a Palm*;
 scribbles
 Black chalk.
Despite the damaged state of this study for the *Holy Family with a
Palm* (Sutherland Collection, on loan to the National Gallery,
Edinburgh; D. p. 23), the left profile of the Virgin's drapery is
clear: her right knee is pushed out beyond her left, and the material
falls in smooth curves. Postdates cat. 155.

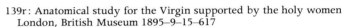

139r: Anatomical study for the Virgin supported by the holy women
 London, British Museum 1895–9–15–617
 Pen over black chalk, body and legs of kneeling woman in black chalk only.
 307 × 202 mm.
A weak attempt at anatomical analysis, an endeavour Raphael soon abandoned. The
head studies are deliberately simplified and rhetorical, drawn in a Leonardesque
manner. This drawing was followed by another which survives only in a copy
(British Museum 1895–9–15–616). See also cat. 122v.

139v: Standing figure
 Black chalk.
Too slight for any judgement to be made; it does not seem to connect with any
composition by Raphael.

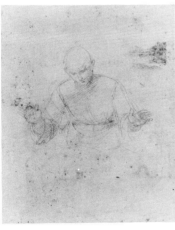

140r: God the Father
 Oxford, Ashmolean 534
 Silverpoint on grey ground. 233 × 180 mm.
Probably a first idea for the lunette of the *Entombment*, but
conceivably for the obliterated figure of God the Father in the San
Severo *Trinity*.

140v: A triumphal arch surmounted by a triangular pediment
 Pen over stylus.
Probably for a pictorial rather than an architectural composition,
since the barrel vault of the left passage can hardly rest on the
pillars seen on the left side of the main passage. The occasionally
mooted resemblance to the arch in the left background of
Signorelli's *Martyrdom of St Sebastian* is no more than generic.

141: God the Father blessing
 Lille, Musée des Beaux-Arts 465
 Pen, squared in black chalk at 22 mm., framed at top and twice at
 bottom. 114 × 101 mm., cut down.
The narrow, rectangular format is now determined. The position of
the right hand was modified in the painting by Domenico Alfani
(Perugia, Galleria Nazionale). A simple, powerful and surprisingly
volumetric sketch from the model.

142r: Charity with four children
 Vienna, Albertina Bd. IV, 245
 Pen and two shades of ink over lead point. 380 × 250 mm., patched at upper
 right corner, cut at top and left.
The shape of the tondo is lightly indicated lower left. The single surviving
drawing for the grisaille predella of the *Entombment*. A powerful drawing
which successfully combines broad, expressive outline and vigorous shading
in a tight, rhythmical composition based on Michelangelo's Pitti tondo.
Charity's face was strengthened by sharp strokes on the jaw, eyebrows and hair.
The child type is found repeatedly in drawings *c.* 1507–8, especially the *profil
perdu* of the suckling child.

142v: The Deposition
 Pen over black chalk,
In preparation for the composition subsequently engraved by Marcantonio
Raimondi, though probably drawn with a painting in view. The connection
with cat. 143r, v and 113v is evident, though the sinuous figure style of this
drawing suggests that it is a little later than those.

143r: Hanging body in a Deposition
 Paris, Louvre 3880
 Pen over black chalk. 360 × 238 mm.
Developed from cat. 113v, but much feebler. Raphael at his weakest or, more likely,
a copy. The figural proportions are comparable to cat. 188.

143v: Man straining under a weight
 Pen over black chalk.
Close in style to cat. 113v and also reminiscent of cat. 189v, with longer hatching lines
and a more sinuous contour. The hands, but not the foot, are omitted even in the under
drawing. Clearly for a figure lowering the body of Christ, but not found in this form
either in cat. 142v or in Marcantonio's engraving.

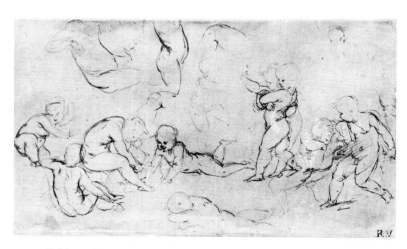

144r: Children playing with a lamb; additional studies of children
 Vienna, Albertina Bd. IV, 246
 Pen over black chalk. 217 × 365 mm., cut at top and bottom.
None of these light and fluid studies coincides with cat. 146r and 147, and the
close-up details at the top of the sheet are presumably related to another drawing
which does not survive. The child at the right was first drawn wrestling with
another child bent backwards, and only subsequently shown starting back. For
this figure cf. cat. 142r; for the child seen from the back on the left cf. cat. 173v.

144v: The Death of Meleager
 Black chalk, possibly impressed from another sheet by stylus.
A variant, not an offset, of cat. 132r. An opinion as to the authorship is hardly
possible.

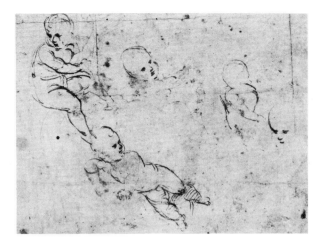

*145: Sketches of children
 Vatican, Lat. 13391
 Pen, 134 × 170 mm., cut all round (?)
The child on the left corresponds closely to the child on the left of cat. 144r, and this drawing presumably forms part of this series.

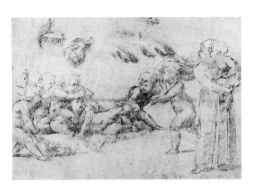

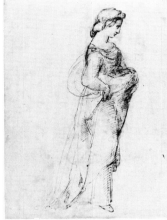

146r: Children playing with a lamb watched by a woman and
 child; studies of leaves
 Oxford, Ashmolean 528
 Pen, not re-worked. 273 × 194 mm., cut at left and right.
Closely cross-hatched in the pen style that Raphael developed under Michelangelo's influence. The fourth child from the left is based on the Virgin in the Doni tondo. The leaf at upper centre was probably copied from a broken Corinthian capital.

146v: Woman walking to the right
 Pen.
A slightly stiff figure, the left side turned forward to emphasize the plane. The single-line simplification of the profile and the cylindrical treatment of the head and neck compare with cat. 135v. Cannot be connected with a known composition.

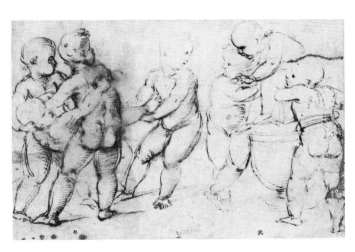

147: Seven putti playing judge and prisoner
 Oxford, Christ Church 0112
 Pen. 145 × 214 mm., cut at left and right.
Some resemblance in motif to the *Entombment*. Presumably *en suite* with cat. 144r and 146r in preparation for an unknown decorative commission.

c. 1507 Studies for the *Canigiani Holy Family* (Munich; D. p. 19) (cat. 148–50)

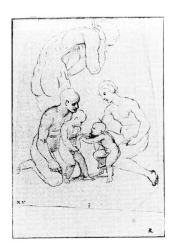

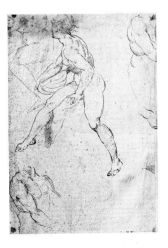

148r: Compositional study
 Chantilly, Musée Condé FR. VIII, 43
 Pen, contours heavily incised. 370 × 245 mm., maximum; irregular, made up at
 right and upper left.
The incised lines suggest that the drawing may have been traced through to another sheet. Though usually described as a copy of a lost drawing due to the hard, somewhat mechanical quality of the contours and hatching, it is not impossible that it is autograph and its disquieting features the result of the large scale and diagrammatic simplification. The figure style and child types come close to cat. 142r.

148v: Seated figure in left profile, upper left; turning man holding lute; two studies
 of a bearer for the *Entombment*, lower left and upper right
 Pen, traces of black chalk, some incising.
The studies for the bearer were presumably made between cat. 135r and 137; the outline drawing upper left compares with cat. 153; the man with the lute may be linked with cat. 135v. Like the recto, a borderline attribution.

149: Head of a child in right profile
 Hamburg, Kunsthalle 21419a
Lead point. 87 × 77 mm., a fragment from the same
 sheet as cat. 150.
A light, soft but delicately characterized study for
the cherub formerly at the top left corner of the
picture, but now over-painted.

150: Head of a child looking down to his left
 Hamburg, Kunsthalle 21419b
Lead point. 66 × 74 mm., a fragment from the same
 sheet as cat. 149.
For the upper right corner, now over-painted. In
common with cat. 149 it suggests that Raphael was
acquainted with Florentine quattrocento child por-
traiture, especially that of Desiderio da Settignano.

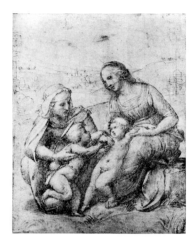

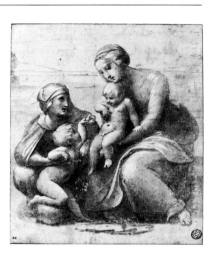

151: Virgin, St Elizabeth, Christ Child and St John
 Windsor, Royal Collection 12738
 Pen. 234 × 180 mm.
An example of Raphael's closely cross-hatched style of *c.* 1506–7.
Related in conception to the *Canigiani Holy Family,* and for a lost or
unexecuted painting of the same date.

152: Virgin and Child with St Elizabeth and St John
 Paris, Louvre 3949
 Pen, brush and wash, white heightening over black chalk.
 224 × 187 mm.
Usually thought to be a copy but conceivably a much faded original.
Though similar to the *Canigiani Holy Family,* the composition is more
closely akin to cat. 151, of which it is, in essence, a variant. A small
painting with this composition by Raphael presumably existed, for
several replicas are known.

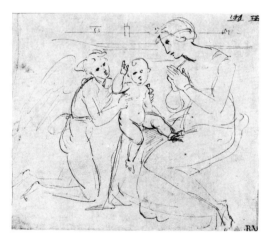

153: An angel presenting the Christ Child to the Virgin
 London, British Museum 1895–9–15–637
 Pen, framing lines at left and right edge. 206 × 227 mm.,
 cut all round.
A spare but expressive outline sketch for an otherwise
unknown composition, related in style to cat. 164v, etc.
and in subject and arrangement to cat. 151, 152. There is
perhaps some link between the Virgin's left leg and the left
leg at the top left of cat. 148v. A reprise of a Peruginesque
theme in an entirely Florentine manner.

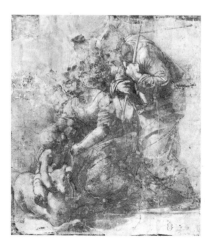

154: Cartoon for the *Holy Family with the Lamb*
 Oxford, Ashmolean 520
 Pen, brush and wash, white heightening, squared with stylus at
 22 mm., pricked for transfer. 275 × 227 mm., made up upper left.
Raphael's ruined cartoon for the *Holy Family with the Lamb* signed and
dated 1507 (Madrid, Prado; D. p. 11; the version dated 1504 (D. p. 11),
currently – 1981 – on loan at Cologne, is merely a copy). The pricking of
St Joseph's staff here corresponds to the Prado version (cf. cat. 119).

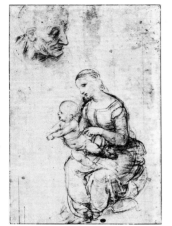

c. 1507 Studies for the *Holy Family with the Palm* (Sutherland Collection, on loan to the National Gallery, Edinburgh; D. p. 23) (cat. 155–7, see also cat. 138v)

155: Compositional study
 Paris, Louvre 3861
 Silverpoint on pink ground, the Virgin squared at 29 mm., compass
 intersections on horizontal line at hip level, one *c.* 4 mm. to the right, the
 other *c.* 18 mm. to the left, of the Child's arm. 226 × 153 mm.
A very broad use of silverpoint which, in reproduction, looks like fine red
chalk. The head of St Joseph is blocked out almost in caricatural fashion with
large ears and a square jaw. The Virgin's drapery is developed further on
cat. 138v.

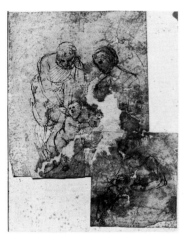

*156r: St Joseph leaning over the Virgin
 Vatican, Lat. 13391
 Pen. 240 × 177 mm., irregular, cut all round, badly damaged.
A study for cat. 155 (?); see cat. 157.

156v: The Christ Child
 Pen, the right side patched over.
A close-up study for the recto.

*157r: St Joseph bringing fruit to the Virgin
 Vatican, Lat. 13391
 Pen. 208 × 110 mm., irregular, cut down all round and badly damaged. Like
 cat. 156, probably a preliminary stage in the development of the *Holy
 Family with the Palm*, which describes the same action: St Joseph providing
 food (dates) on the flight into Egypt.

157v: Partial copy of Michelangelo's *Battle of Caseina*
 Pen.
A vital and dynamic study, drawn from below, of Michelangelo's cartoon, which
hung, still intact, in the Palazzo della Signoria. The pose of the seated figure was
referred to by Raphael in cat. 210r, and the complex turning soldier (also copied
by Timoteo Viti (Hamburg 21498), who probably knew it through Raphael) was
used much later in Raphael's design, now known only in copies, of the *Triumph
of Bacchus* for Alfonso d'Este.

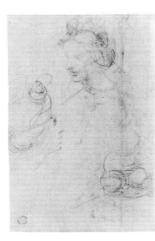

c. 1507–8 Studies for *St Catherine* (London, National Gallery; D. p. 25) (cat. 158–60)

158r: St Catherine
 Oxford, Ashmolean 527
 Pen. 259 × 170 mm., made up at top right.
Despite the lack of traditional attributes, this is almost certainly a study for *St
Catherine*. The format is reduced to three-quarter length in cat. 159r; the treatment of
head and neck finds analogies in cat. 173r. A further development of this drawing was
also copied on Chatsworth 725. Cf. cat. 139r.

158v: Two female heads; seated woman turning round
 Black chalk.
These loose sketches are clearly for the *Entombment*, drawn after cat. 139r. The
sketch lower right, based on Michelangelo's Doni tondo, with the legs tried to right and
to left, is for the woman supporting the Virgin from below, as is the head on the left.
The upper head is probably for the woman at the far right, behind the Virgin.

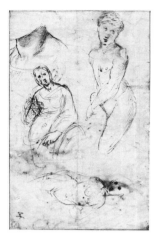

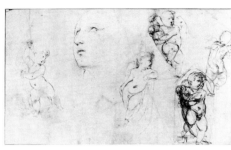
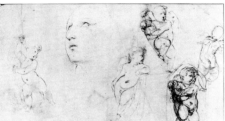

159r: Four studies
 Oxford, Ashmolean 536
 Pen over traces of black chalk. 279 × 170 mm., cut on left and right.
Variants developed from cat. 158r. The neck and shoulders upper left,
with fine cross-and directional hatching, show Raphael's concern with
the surface of the painting even at this early stage.

159v: Head of St Catherine; five studies of cupids
 Pen, over traces of lead point on right.
The head demonstrates the greatest refinement and solidity with light,
even pen-strokes used like silverpoint. The cupids cannot be linked
with a known composition: the one on the left and those at the top and
bottom right are attempting to string a bow; the cupid seen from the
rear may be attempting to do likewise. The standing cupid is close in
pose to the Child in cat. 122r.

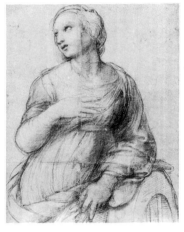

160: Cartoon
 Paris, Louvre 3871
 Black chalk and white heightening, pricked for transfer. 587 × 436 mm.
See commentary to Plate 14.

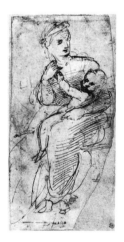

161r: Seated Virgin and Child
 Bayonne, Musée Bonnat 1714
 Pen. 170 × 95 mm., irregular, cut down.
A study in diagonals, with some resemblance to the *Colonna
Madonna* (Berlin-Dahlem; D. p. 25) of *c.* 1508, completed by
an associate of Raphael. A drawing which anticipates
Parmigianino.

161v: Seated veiled woman
 Pen on paper stained pink.
A life study of a woman (at the confessional?)

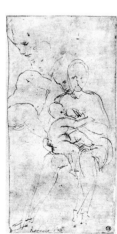

162r: Virgin suckling the Child; Virgin's head and Child
 Bayonne, Musée Bonnat 1713
 Pen over black chalk on paper stained pink. 161 × 78 mm.,
 irregular cut down.
The quick sketch of the Child upper left with the Virgin's face
partly overlapping His is quite close in arrangement to the
Virgin and Child with Beardless St Joseph (Leningrad; D. p. 22).
The main group, with the Virgin's head shown frontally and
then turned to the side, was developed in three different
ways, in cat. 163, 164–6, 167–8.

162v: Lion couchant
 Black chalk on paper stained pink.
A quick sketch, perhaps for a lion to accompany a St Jerome.

163: Virgin and Child in a tondo
 Florence, Uffizi 501E
 Pen over traces of black chalk. 157 × 91 mm., irregular, cut down.
The Virgin's left hand was tried grasping the Child's left leg, and holding the left foot. There is some resemblance both to the *Colonna Madonna* (Berlin-Dahlem) and to the *Large Cowper Madonna* (Washington) (D. pp. 25 and 26). Developed from cat. 162r.

164r: Seated Virgin suckling the Child
 Oxford, Christ Church 0113
 Pen on paper stained pink, scribbled heads in black chalk. 198 × 154 mm., cut down.
Studied twice, the subject is developed from cat. 162r, and approaches a Madonna of Humility pose. The style is more linear than usual, emphasizing surface pattern rather than plasticity.

164v: Seated Virgin and Child
 Pen on paper stained pink
Developed from the recto and taken further in cat. 165, 166.

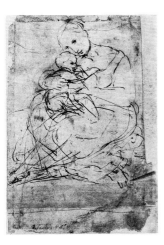

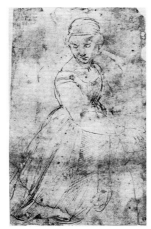

165r: The Virgin suckling the Child
 Bayonne, Musée Bonnat 1715
 Pen on paper stained pink. 212 × 133 mm., irregular, cut down.
Developed from cat. 164 with the Child's pose slightly changed and the Virgin now seated firmly in a Madonna of Humility pose. Developed further in cat. 166.

165v: Kneeling woman facing left, looking down to her right
 Pen on paper stained pink.
Perhaps a study from a female model in preparation for the unfinished *Esterházy Madonna*, of 1507–8 (Budapest; D. p. 21). Cf. 169.

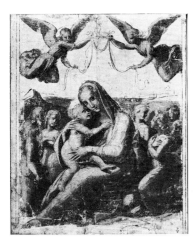

166: Virgin and Child with angels
 Chantilly, Musée Condé FR. X 56
 Pen over stylus, brush and wash, white heightening; (badly rubbed) central plumb-line in stylus framing, traces of squaring at 40 mm. 286 × 236 mm.
A *modello* or, conceivably, a cartoon developed from 165 etc. for a small painting now lost, but of which a version in reverse survives at Avignon, and an adaptation in the Casa di Raffaello. There is a red chalk copy of the Child, probably by Giulio Romano (*c.* 1518) in Dusseldorf (FP. 13v).

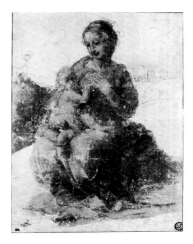

167: Virgin and Child in a landscape
 Paris, Louvre 3859
 Brush and wash, pen, white heightening (oxidized). 250 × 185 mm.
A *modello* for a lost painting, now known only through copies including
one by Ventura Salimbeni (Rome, Galleria Borghese). Very similar in
composition to cat. 168, and like it developed from cat. 162r.

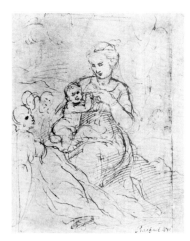

168: Virgin and Child in a landscape: the Virgin crowned by angels, with
 angels in attendance
 Vienna, Albertina Bd. IV, 202
 Pen and reddish-brown ink over traces of black chalk, framing lines at
 left and top. 176 × 127 mm., cut down to framing lines and made up
 and restored *c.* 10 mm. on right edge.
Developed from cat. 162r and linked to cat. 167 and 166, although the Virgin
is not here characterized as the Madonna of Humility. The drapery is
reminiscent of cat. 179r, the slightly pointed features of cat. 170.

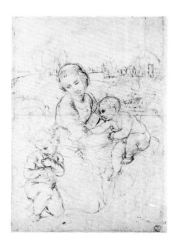

169: Cartoon for the *Esterházy Madonna*
 Florence, Uffizi 539E
 Pen over traces of black chalk, squared in stylus at 24 mm., pricked for
 transfer. 287 × 192 mm.
The pose of the Virgin in the cartoon for the *Esterházy Madonna* (Budapest;
D.p. 21) was probably developed from cat. 165v. The figure of St John is
loosely derived from the Christ Child in Michelangelo's Doni tondo. The
drawing style, confident and firm with bold re-working of St John's left arm
and the Virgin's head, reflects Raphael's interest in Leonardo's contour
hatching (cf. cat. 98). The increased liveliness of the Child is notable.

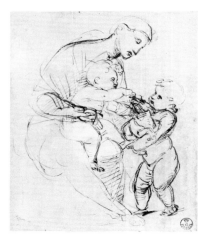

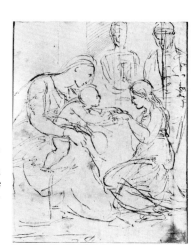

170: Virgin, Child and St John with Lamb
 Florence, Uffizi 515E
 Pen over lead point. 160 × 132 mm.
The movement of the Child is comparable to cat. 169. Raphael has
achieved a real sense of effort in the St John lifting the Lamb up to
Christ. The sweeping movement of the Virgin bending forward links to
cat. 173r, and cat. 263 is anticipated in the simplification of the Virgin's
face.

171: The Marriage of St Catherine
 Vienna, Albertina Bd. IV, 210
 Pen and dark brown ink over stylus for the Virgin but not St Catherine,
 framing lines at bottom, left and top. 179 × 135 mm.
The powerful drawing of the Virgin, especially of her face, connects with
cat. 138r, the pose of the kneeling St Catherine is similar to that of the
angels in cat. 166; the form of the Child may be compared with cat. 142r.
This composition is otherwise unknown.

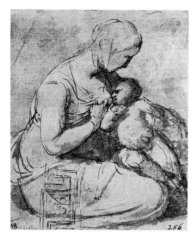

172: Virgin and Child
 Stockholm, Nationalmuseum 322
 Pen, brush and dark-grey wash, on paper stained pink. 146 × 113 mm.
A badly rubbed drawing, but nevertheless of great beauty. The domestic emphasis anticipates cat. 319, 320 and, through them, Parmigianino. The *profil perdu* of the Virgin is a motif found mainly in child studies. The compactness and rhythm of the design, and the heavier female type, are unexpected at this period, but there is no good reason for dating it later. Presumably once part of the same sketchbook as cat. 161–5.

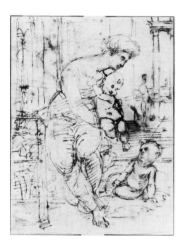

173r: Virgin, Child and St John in an interior
 Oxford, Ashmolean 519
 Pen. 163 × 118 mm., cut down to framing lines on all four sides.
Unusually, the group is set within a spacious chamber opening to a loggia with a large Serliana of the sort that Bramante was constructing in the Vatican at this time. As a study of movement and curving rhythm it comes close to the *Bridgewater Madonna* (Sutherland Collection, on loan to the National Gallery, Edinburgh; D. p. 23) and cat. 170; in composition, pen-work and characterization it shows a fusion of the influences of Leonardo and Michelangelo.

173v: Virgin seated on the ground with the Child and St John; female head; drapery
 Pen, the head and drapery in black chalk.
A composition which anticipates later Roman paintings such as the *Madonna of Divine Love* (Naples, Capodimonte; D. p. 49). There are copies of the composition before mutilation in the British Museum (1900–8–24–115) and elsewhere. For the infant St John seen from the back cf. cat. 144r.

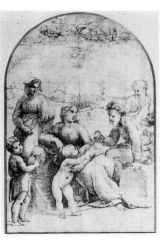

174r: *Modello* for the *Holy Family with a Pomegranate*
 Lille, Musée des Beaux-Arts 458/9
 Pen over traces of black chalk, stylus under putti; compass intersections at the base in the second squares from right and left, squared in red chalk at 24 mm., but only in the lower figurative section; a horizontal stylus line 9 mm. above top of square. 357 × 257 mm. maximum.
A *modello* for Raphael's associate Domenico Alfani, and deliberately simplified for Alfani's requirements. The painting based on it is dated 1511 (Perugia, Galleria Nazionale). Not reworked, as has sometimes been claimed.

174v: Letter to Alfani
 Pen.

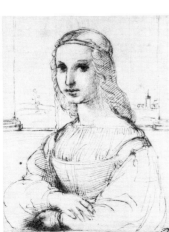

175: Portrait of a girl
 Paris, Louvre 3882
 Pen over traces of black chalk, brush and wash round hands.
 223 × 158 mm.
See commentary to Plate 15.

1507–8 Studies for the *Madonna del Baldacchino* (Florence, Pitti; D. p. 26) (cat. 176–9)

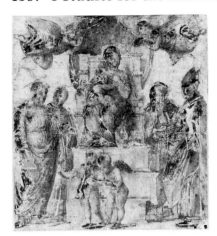

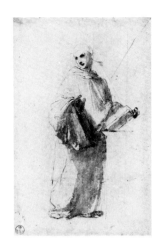

176: Preliminary *modello*
Chatsworth 733
Brush and wash over stylus, white heightening much oxidized, squared in
 stylus at 30 mm. 270 × 230 mm.
A study for the largest painting of Raphael's Florentine period. The
architectural setting has, however, not been included. The standing putti in
front of the throne are a typically Venetian formula already used by Perugino.

177: St Bruno
 Florence, Uffizi 1328F
Pen, brush and wash over stylus, white heightening, partly oxidized,
 background of rubbed black chalk (either by accident or design), stylus centre
 plumb-line, squared in black chalk at 32 mm., compass intersections at lower
 left and right. 217 × 133 mm.
The lightly handled contours and the broadly washed shadows were
undoubtedly influenced by Leonardo's proto-rococo pen-and-wash draw-
ings. Raphael is here interested in the play of shadow over a white robe. The
drawing has a curiously affecting Pierrot quality.

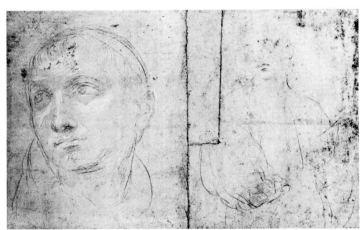

178: Studies for the head and head and chest of St Bruno
 Lille, Musée des Beaux-Arts 473
 Silverpoint and white heightening on salmon-pink ground. 123 × 191
 mm., apparently made up of two separate sheets or two fragments cut
 from the same sheet, a strip added in the centre (cf. cat. 179).
A crisp and clear exposition of expression and gesture; the comparative
lavishness of the white heightening suggests an interior setting. The same
colour ground as cat. 126r.

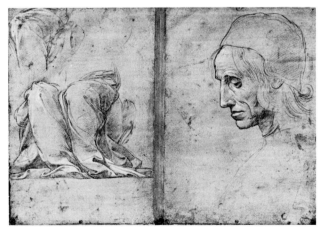

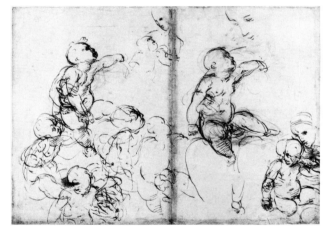

179r: The Virgin's drapery; male head
 Paris, École des Beaux-Arts 310
 Silverpoint and white heightening on buff ground. 223 × 312
 mm., bisected then rejoined (cf. cat. 178).
The drapery corresponds to cat. 174, and was considerably
modified in the painting. The use of silverpoint demonstrates the
precision that Raphael required for the Virgin's drapery, a
central feature of the painting. The portrait head is unusual in
Raphael's work and may be a copy of an earlier portrait, perhaps
by Lorenzo di Credi; it is loosely studied again lower right,
perhaps by a pupil.

179v: The Christ Child and the Virgin studied repeatedly
 Pen, over black chalk.
A vital pentimento drawing, full of energy. The Child links in type
 with cat. 142r.

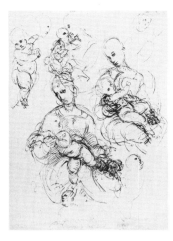

180: Studies for the *Bridgewater Madonna* (Sutherland Collection, on loan to the
National Gallery, Edinburgh; D.p. 23) and other Madonnas
London, British Museum Ff. 1–36
Pen, over traces of red chalk in centre. 254 × 184 mm., cut all round (?)
See commentary to Plate 19.

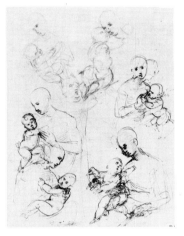
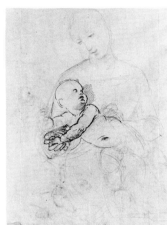

181r: Studies for the *Colonna* (Berlin-Dahlem; D.p. 25), *Large Cowper*
(Washington; D.p. 26) and other Madonnas
Vienna, Albertina Bd. IV, 209
Pen, red chalk. 260 × 192 mm.
Companion sheet to cat. 180 showing how Raphael generated a series of
paintings in a single creative burst. The sketch in red chalk top left relates to
the *Colonna Madonna*; that centre left to the *Large Cowper*, s.d. 1508; that
centre right perhaps to the lost *Madonna of the Carnation* (D.p. 63); the chalk
study upper right perhaps, in reverse, to the *Casa Tempi* (Munich; Alte
Pinakothek; D.p. 21); the larger chalk study of the head and right arm of the
Child reaching up in the centre was later developed into St John in the
Aldobrandini Madonna (London, National Gallery; D.p. 26).

181v: Study for the *Bridgewater Madonna* (Sutherland Collection, on loan to
the National Gallery, Edinburgh; D.p. 23)
Pen and dark-brown ink over silverpoint on discoloured pink ground.
A rather broad silverpoint study, sharpened with the pen; framed at bottom
right. The pose of the Child adapts that of Michelangelo's Taddei tondo (cf.
cat. 93v, 111v) and the composition looks back to Leonardo's *Madonna of the
Yarn Winder*, itself a source for Michelangelo.

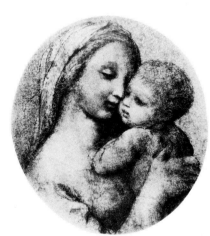

*182: Cartoon fragment for the *Casa Tempi Madonna*
Montpellier, Musée Fabre 3186
Black chalk, white heightening, cut to an oval. 420 × 380 mm. maximum,
on four pieces of paper (?)
The remains of what must have been one of Raphael's loveliest cartoons.
The Virgin's expression – especially the mouth and eyes – is even more
dreamily intense than in the completed painting, which must have been
one of Raphael's last Florentine works (Munich, Alte Pinakothek;
D.p. 21).

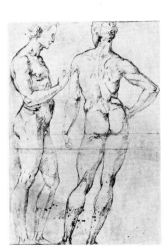
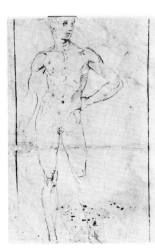

183r: Two nude men
Vienna, Albertina Bd. XII, 117 (as Bandinelli)
Pen over black chalk. 460 × 298 mm., cut at top and bottom.
Probably an anatomical study rather than for a painting. A forceful if bombastic
attempt to come to terms with the expressive nude, but lacking the complexity,
internal movement and balance of Michelangelo. This somewhat overstated manner
was to become common with Bandinelli and his circle, and it was to Bandinelli that it
was formerly attributed.

183v: Standing nude man
Pen.
A similar pose to that of the right-hand figure on the recto reversed, and slightly
closer to Michelangelo's *David*. Cf. cat. 87v.

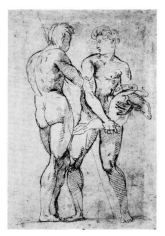

184: Two nude men and a lamb
 Bayonne, Musée Bonnat 1706
 Pen over traces of black chalk, stylus marks on head of right-hand figure.
 280 × 160 mm., made up to 308 × 200 mm., the lower part of the left leg of
 the right-hand figure, the ankle and foot of the left-hand figure and the
 head of the lamb are restoration.
Presumably shepherds for an Adoration, otherwise unknown. For the pose of
the left-hand figure see cat. 89. The fluidity of the poses and well-achieved
complexity of movement suggest a date *c.* 1507; cf. cat. 142v for the movement
of the right-hand figure and the schematic treatment of head and eyes.

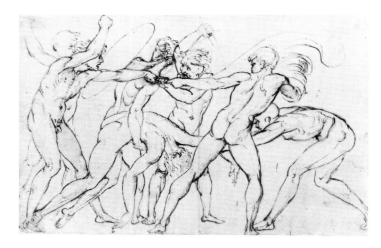

185: Nude warriors fighting for a standard
 Oxford, Ashmolean 537
 Pen over black chalk, pricked for transfer. 270 × 421 mm.
An extraordinarily rhythmical, undulating design, treated like a bas-relief
and possibly intended for sculpture or simulated sculpture. The actions
obviously refer in theme, though not in treatment, to Leonardo's *Battle of
Anghiari*. The awkwardness of some of the poses and the diminished sense of
volume, especially of the collapsed figure, find echoes in cat. 186. The pose of
the warrior on the left is close to cat. 188. This type of drawing strongly
influenced Perino del Vaga.

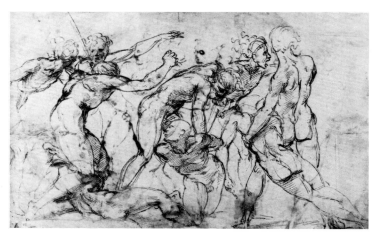

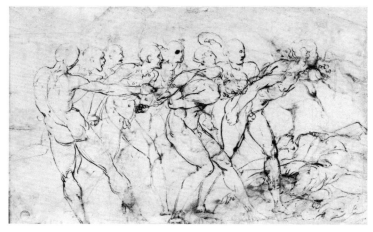

186r: Battle scene with prisoners
 Oxford, Ashmolean 538
 Pen over black chalk. 268 × 417 mm., cut at left, right and at bottom,
 made up upper right corner and bottom left edge.
Presumably *en suite* with cat. 185, with which it shares the motif of
the warrior supporting a wounded comrade. Here, however, the
contours have not been emphasized to produce a two-dimensional
effect. The proportions are sometimes ungainly (e.g. the warrior on the
left edge) and the foreshortening is intermittently weak (e.g. the
shoulders of the warrior at the right).

186v: Battle scene with prisoners
 Pen over black chalk.
See commentary to Plate 16.

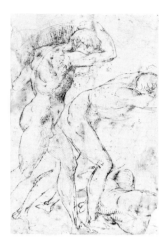

187r: Two nude men advancing to the right over the body of a third
 London, British Museum Pp. 1–75
 Pen over black chalk. 269 × 172 mm., cut all round.
Close to cat. 186 in action, though a little stiffer in style; presumably linked with this series rather than cat. 89.

187v: Nude man advancing to the right; right hand
 Pen, the hand in pen with brush and wash and white heightening.
The main figure is perhaps connected with cat. 186r. The attention given to the hand suggests that it was drawn at a fairly late stage in the preparation of a painting, but it cannot be linked to any surviving work.

188: Hercules and a centaur
 London, British Museum 1895–9–15–631
 Pen. 400 × 244 mm., cut at right.
This and the following drawings are designs for a sequence of the Labours of Hercules of which we have no further knowledge. The proportions are influenced by those of Michelangelo's *David*, and the twisting of the right leg to bring it parallel with the picture surface suggests that this, like the other drawings, was intended for a context where readability and surface pattern were paramount. Cf. the figure at the left of cat. 185 for the pose.

189r: Hercules and the Hydra
 Windsor, Royal Collection 12758
 Pen over black chalk. 340 × 274 mm., cut at top, bottom and left.
A forceful but rather coarse drawing, where the expressive musculature in the back and legs seems factitious and unsure. The stiffness of the pose and the awkwardness of the arm movements reveal Raphael's difficulties in trying to construct an heroic nude. Penni may have entered Raphael's studio at about this time, for his pen drawings are characterized by a similar type of cross-hatching (cf. cat. 366v).

189v: Hercules and the Nemean lion
 Pen. Window mounted at 270 × 270 mm.
More successful than the recto, perhaps because more closely based on pre-existing models (cf. cat. 143v for the hatching).

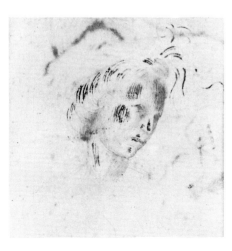

190r: Hercules and the Nemean lion
 Oxford, Ashmolean 540
 Pen over stylus. 262 × 262 mm.
A variant of cat. 189v, employing a different hatching system to obtain more rounded modelling and sharper contrasts of light and shade. Clearly designed for a square format, stressing the diagonals, and with a brilliantly arranged flying cloak. The lion was presumably to be studied separately.

190v: Head of a nymph
 Brush and wash, white heightening (oxidized) over
 lead point. Window mounted at 80 × 79 mm.
Not connected with any known composition.

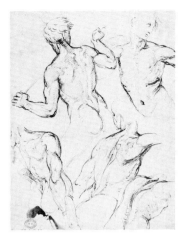

191r: Torsos of five nude men in action
 London, British Museum 1895–9–15–624
 Pen over lead point. 269 × 197 mm., cut all round.
More secure and proficient than cat. 185 etc., but presumably of approximately the same date. For the face upper right cf. cat. 170. The central lower figure recurs with little change in the *Massacre of the Innocents* (cf. cat. 287). The figure top left is developed from Michelangelo's *Cascina*. This study was probably made to clarify details in a composition which had already been determined.

191v: The Virgin adoring the Infant Christ
 Red chalk, the children outlined faintly in black chalk.
Not connected with a known painting, but there are some links with a *Holy Family* by Fra Bartolommeo (London, National Gallery). Probably, but not certainly, a late Florentine design for a tondo, the edge of which is indicated at lower right.

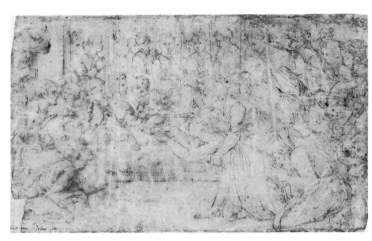

192: Funeral of a bishop
 Munich, Graphische Sammlung 2457
 Pen. 250 × 395 mm., irregular, cut down at right and left, made up left edge.
Very badly damaged but apparently autograph *c.* 1507; cf. cat. 184 for the facial shorthand. Heavily influenced by Donatello's relief of the *Miracle of the Miser's Heart* (Padua). The cripple was perhaps remembered in the *Healing of the Lame Man,* and the figural movement generally in the *Donation of Constantine* by Giulio Romano and Penni (D. pp. 102; 86–88).

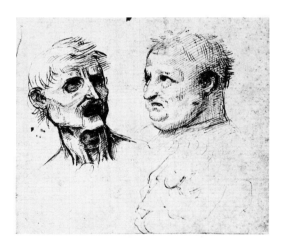

193: Two male heads; head of a lion
 Lille, Musée des Beaux-Arts 493
 Pen. 181 × 201 mm., cut down.
Unlike any other Raphael drawing. This little allegory of the fat and the thin presumably dates from *c.* 1507. On the laid down verso there is a small drawing of a right foot, seen from the rear, with the light falling from the left; not by Raphael.

194r: Head of a girl
 Cambridge, Mass., Fogg Museum 1932–354
 Black chalk. 154 × 250 mm., originally joined to cat. 195.
A study for a figure on the left of an elaborate *sacra conversazione* of late Florentine–early Roman date which is known only from a copy of a lost Raphael drawing in Stockholm.

194v: Bust of Venus
 Black chalk, originally joined to cat. 195.
Presumably the centre spread of a sketchbook, or simply a large page folded over, with the recto and the recto of cat. 195 drawn on the outer faces.

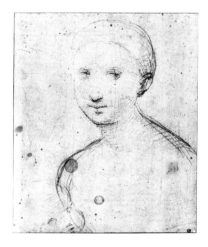

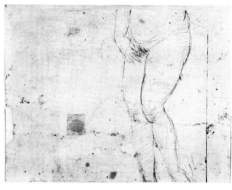

195r: Head of a woman and a child
 Bayonne, Musée Bonnat 1712
 Black chalk. 245 × 196 mm., originally joined to cat. 194.
Anticipating cat. 275.

195v: Lower half of Venus
 Black chalk. Originally joined to cat. 194.
A generalizing study from life of the late Florentine–early
Roman period, further pursued in cat. 202r.

196r: The interior of the Pantheon
 Florence, Uffizi 164A
 Pen. 277 × 407 mm.
A free-hand study of the Pantheon by Raphael which has been
completed at the right by another hand in order to show,
inaccurately, the entrance. The entrance may have been copied by
the second artist from a now lost second drawing by Raphael, and in
combining them he compressed them, omitting a fourth tabernacle
and a third column-screen, in order to obtain a (false) symmetry. This
two-handed drawing was copied by a third artist in the Codex
Escurialensis, which was in Spain as early as 1508. This sheet was
probably used by Raphael during an unrecorded Roman visit of 1506
or 1507, a date which corresponds well to the style (cf. cat. 121,
317v).

196v: The porch of the Pantheon; pilaster and entablature profiles;
 an antique relief
 Pen over stylus, many compass marks.
A drawing of great sharpness and clarity; a fair copy, made in the
studio, of a lost freehand (?) drawing made on the spot.

1508–14 Studies for the Stanza della Segnatura (Vatican; D. pp. 69–77) (cat. 197–259)

1. Studies for the *Disputa,* 1508–9 (?) (D. pp. 71–3) (cat. 197–226)

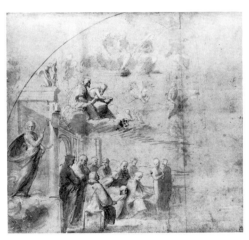

197: Half elevation
 Windsor, Royal Collection, 12732
 Brush and wash, white heightening, partly oxidized, over stylus, compass work, squared in black
 chalk at 26 mm. 280 × 285 mm.
The earliest surviving drawing for the project. The half elevation, like an architect's drawing, implies a
symmetrical arrangement. The space corresponding to the door which penetrates the right side of the
fresco field is occupied by a plinth and a cloud supporting an angelic presenter. He is framed in a
column and entablature which forms one wing of a high wall with a pedimented central arch. The main
figure-composition is confined to the central area. Christ, St John, the Virgin and four saints or
patriarchs are placed at a level above the other seated figures of the Evangelists, with St Peter and St
Paul in the centre. The apsidal arrangement of the fresco is not yet established and there is no central
altar. This drawing formed the basis for cat. 198 and 199.

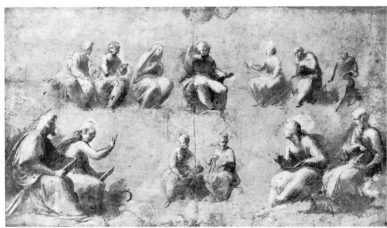

198: Compositional study for the upper level
 Oxford, Ashmolean 542
 Brush and wash, white heightening much rubbed, touches of pinkish
 wash, incised curve of a lunette upper right. 232 × 400 mm., made
 up upper right edge, possibly, but not certainly, originally joined
 to cat. 199.
A more detailed study developed from cat. 197; the use of dark wash
and white heightening suggests that Raphael may at first have
considered deeper overall tonality. Here it is the establishing of the basic
masses of light and shade that concerns him.

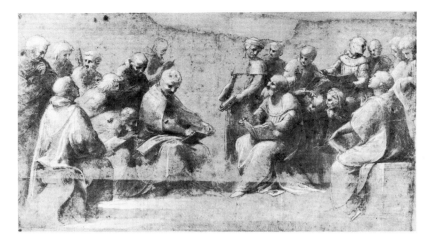

199: Compositional study for the lower level
 Chantilly, Musée Condé FR. VIII, 45
 Brush, dark-brown wash, white heightening, squared in black
 chalk at 22 mm.; an area of damage running horizontally across
 drawing at about quarter way up. 331 × 405 mm., irregular,
 made up upper right, and most of lower edge; possibly, but not
 certainly, originally joined to cat. 198.
This drawing shows more changes from cat. 197 than does cat. 198.
The figure group is tightened, the two figures in the centre
background are eliminated and a balancing group is added on the
right. The well-preserved application of white lead shows how badly
cat. 198 has suffered. The derivation of the left-hand group from
Leonardo's *Adoration* is even clearer here than in cat. 197. The scene
is clearly anchored on the four seated Doctors of the Church.

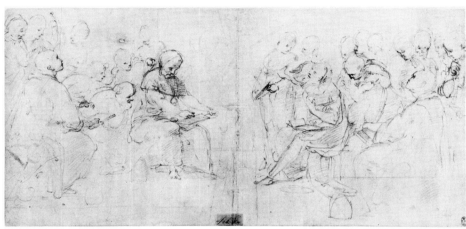

200: Compositional sketch for the lower section
 Windsor, Royal Collection 12733
 Black chalk. 202 × 408 mm.
Revising rather than preparing cat. 199. The attributes
of mitres, tiaras and Cardinals' hats can be seen on the
ground, and the gestures and movements are more
complex and differentiated. The balustrade from
cat. 197, omitted in cat. 199, is reinstated.

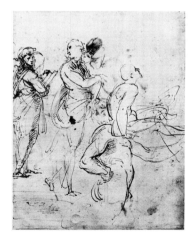
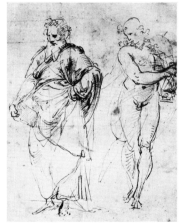

201r: Four figure studies
 Lille, Musée des Beaux-Arts 447/8
 Pen traces of black chalk lower right. 290 × 211 mm., irregular, cut
 at left and right.
The three main figures (the head of the central one sketched again to the
right) seem to be the seated St Gregory, looking upwards as in the final fresco
(although he is also drawn as though seated on the ground rather than on a
throne), and two acolytes (?) standing behind him. Raphael has not yet
determined the character and roles of the figures standing around the Doctors
of the Church. The Leonardesque central man was subsequently moved to
the outer left edge. The half-length gesturing figure lower right, studied from
below, is probably a first idea for an angel.

201v: Standing philosopher (?); standing nude youth (Apollo?)
 Pen over stylus, the philosopher partially squared in black chalk at
 25 mm.
It is difficult to be sure whether the two figures are separate studies or
designed to stand together; the nude young man, with the characteristics of
Apollo, might have been intended to be draped, and was first drawn in a
less self-contained pose with right arm and leg outstretched. The fact that
only the upper part of the bearded man is squared might suggest that he
was to stand behind the parapet (right foreground) in the *Disputa*.
Alternatively, he might have been intended, either with or without the
nude figure, for the *School of Athens*. The young man could also be a first
idea for the standing nude statue of Apollo in that fresco, though he seems
to be holding books rather than a lyre.

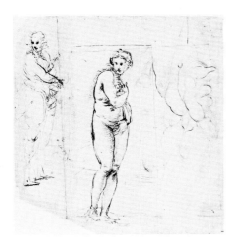

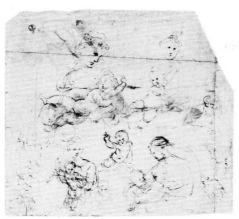

202r: Standing male figure; standing nude Venus; study of a back (from the antique?)
Florence, Uffizi 496E
Pen over black chalk. 245 × 269 mm., irregular, cut at lower left and upper left corners.

The standing male figure is another version of the central figure in cat. 201r. Venus is a development of the figure sketched on cat. 194v/195v. Although it is not inconceivable that a simulated statue of Venus was at one point intended to pair that of Apollo in the *School of Athens* (see cat. 286), this seems to be a design for a lost or unexecuted easel painting. The muscled back, adapted from an Apollo Sauroctonos, is close to the straining figure on the left of cat. 186v (see also cat. 264r, 265r). A weak outline chalk-sketch of a torso above and behind Venus.

202v: Studies of the Virgin and Child
Pen over black chalk; the head on the right margin in black chalk only, probably by a pupil.

The main study, upper left, is a development of the *Bridgewater Madonna* (Sutherland Collection, on loan to the National Gallery, Edinburgh; D. p. 23); the group upper right still shows the influence of the Taddei tondo in the Child's pose (cf. cat. 180), as does that below it, which is probably a first idea for the *Alba Madonna* (Washington; D. p. 35). At the left edge are two children playing – a motif derived from Leonardo and previously employed in the *Preaching of the Baptist* (Mersey Collection, on loan to the National Gallery, London; D. p. 14); below, the Child from the upper right is studied again; lower left, the Virgin supporting the Child blessing, with the young St John below right; centre, the Child blessing (continued on cat. 265r); far right the *Alba* group re-studied.

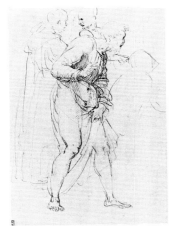

203r: Two monks(?) in discussion; standing man gesturing; seated Doctor
Wantage, Private Collection 116
Pen. 308 × 206 mm.

An attempt to articulate the area around the seated St Gregory. The central figure now gestures in surprise, or in conviction, at the sight of the Eucharist; although abandoned in subsequent stages, he was eventually to reappear as the philosopher (?) seen from the rear.

203v: Two studies of the main recto figure; pointing young man
Pen.

The recto figure is given a Socratic characterization top left, and a more collapsed pose; the young man is virtually identical with the one in cat. 202r.

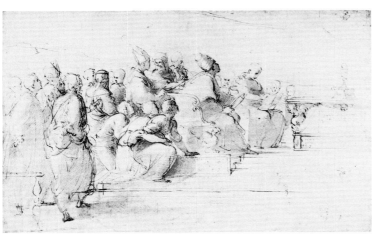

204: Compositional study for lower left section
London, British Museum 1900–8–24–108
Pen over stylus; the figure seen from the back on the left in brush and wash with white heightening. 247 × 401 mm.
See commentary to Plate 18.

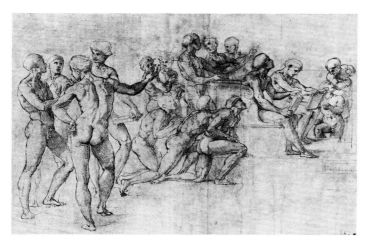

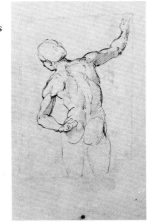

205: Nude study of lower left section
 Frankfurt, Staedel 379
 Pen, over traces of black chalk on right, stylus
 on left, pricked for transfer.
 280 × 416 mm., made up upper left corner
See commentary to Plate 20.

206: Nude man half length seen from behind
 London, British Museum 1948–11–18–39
 Pen over stylus. 146 × 95 mm., cut down.
A quick and forceful sketch for the third man
from the left in cat. 205. The analysis of the
physical structure is energetic and sure.

207r: Sketch for St Ambrose and accompanying figures; bearded head
 in profile; draft of a sonnet
 Vienna, Albertina Bd. IV, 205
 Pen over lead point. 193 × 152 mm., cut down all round to frame
 verso composition.
The vigorous gesture of the standing bishop was carried into the fresco,
where, however, Raphael changed the characterization by first incising,
and then omitting, his mitre. The kneeling figure at the left was
probably intended to frame the altar as a counterpart to the figure on
the right in cat. 205. The profile above was copied from the same
antique source as cat. 268.

207v: Virgin and Child in a landscape
 Pen over lead point
The influence of the Doni tondo is still present in the complex pose, and
the bend of the Virgin's left wrist is highly Michelangelesque, but
sources have been subsumed into a rhythmical balance of form and
action. Volumes are obtained by contour, without hatching. Probably
Raphael's most fluid variant of the Madonna of Humility theme.

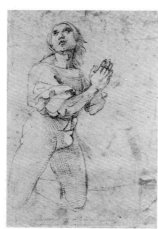

208r: St Ambrose
 Munich, Graphische Sammlung 2458
 Pen over black chalk and stylus. 244 × 161 mm., cut at left.
A study from the model developed from cat. 207r. The figure is given an overall
upward rhythm by the sweep of the drapery, the raised left hand and the lower
viewpoint. The contour is very tight, and the form powerfully plastic, reduced to
large volumes. The undulation of the embroidered cope shows a complete command
of perspective. The broad hatching is used to create powerful contrasts. In the fresco
the right hand was also raised.

208v: Praying youth
 Pen over black chalk and stylus.
For the kneeling acolyte to the right of the altar, developed from cat. 207r, but much
more tightly controlled. The hands thrown out to the figure's right while he looks
upwards to the left is an invention worthy of Michelangelo. The chiselled treatment
of the features demonstrates the hard-edged clarity that underlies this fresco. The
figure was abandoned in the final design.

209: Sketch of the right-hand side; draft of a sonnet
 London, British Museum Ff. 1–35
 Pen. 250 × 390 mm.
This swift outline drawing begins the blocking out of the right corner, and
was perhaps developed from an earlier, stiffer stage recorded in cat. 201v.
The draft is of the same sonnet as cat. 207r.

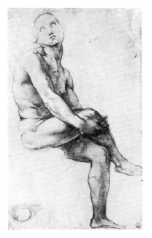
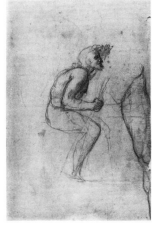

210r: Adam; sketch of the Segnatura ceiling (?)
 Florence, Uffizi 541E
 Black chalk. 357 × 210 mm., cut at sides and bottom.
The position of the head and neck, deriving from a figure in Michelangelo's *Battle of Cascina* (cf. cat. 157v), was changed in the fresco. Like the other studies for this level, this drawing was executed in soft black chalk (sharply hatched in places to bring out particular nodes of modelling), in order to obtain a generalizing effect. If the small sketch is for the Segnatura vault, the pentimento of square and circle suggests that it must have been drawn at the very beginning of Raphael's Roman period, when he re-planned the vault, rather than at the moment of his later re-painting of Sodoma's panels.

210v: Seated man in right profile, shading his eyes; male leg
 Black chalk, white heightening.
Presumably for figure in the circle of saints and patriarchs (Noah?) but not used. The leg may be a copy from the Apollo Belvedere. The hands are drawn with expressive economy.

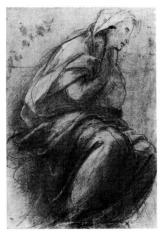

211r: The Virgin
 Milan, Ambrosiana Resta 45/2 p. 39
 Black chalk and white heightening. 308 × 199 mm., cut all round.
The Virgin's face first tried slightly higher and further forward. One of Raphael's softest chalk drawings.

211v: Outline drawing for the upper level
 Pen, gridded irregularly on the right in black chalk.
At first sight an oddly empty sketch, but presumably drawn after the plan of the upper section had been determined, and before the individual figure studies. The pen lines are made with great precision and create strongly volumetric forms. The irregular gridding is probably a proportional guide rather than squaring for transfer. The gesture of the Virgin's right arm was taken up in cat. 457.

212r: Christ
 Lille, Musée des Beaux-Arts 471/2
 Brush and wash over lead point, white heightening (oxidized), compass intersections at lower left and right level with second line of squaring horizontal, the figure inscribed in a circle in stylus centred in Christ's stomach; squared in black chalk at 27 mm., a pen line lower left. 410 × 265 mm.
A rich and fluid study, presumably prepared in mixed media to obtain a plasticity more precise and forceful than that of the saints and patriarchs. The handling of the white varies from the broad and luxurious to exquisite fineness. The lower part of the legs is thrown into deep shadow so that the bright light falling on the lap sets off Christ's torso. The stylus circle indicates the glory that surrounds Him.

212v: Sketch of patriarchs and saints
 Pen over lead point.
A preliminary idea for the seated figures at the right, similar to that adopted.

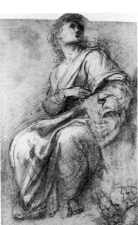

213: St Stephen, angels' heads
 Florence, Uffizi 1342F
 Black chalk, possibly charcoal, and white heightening on tinted (by the artist?) paper. 320 × 193 mm., cut all round.
One of the softest studies in this sequence. The treatment of the head is in the style of Fra Bartolommeo, whose black chalk drawings were certainly known to Raphael. Certain key points – the left hand and the contour of the left leg – are brought out by sharper lines. The angels' heads link with cat. 216r.

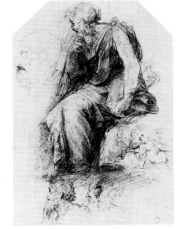

214: St Paul
 Oxford, Ashmolean 548
 Black chalk of two different shades, partly stumped, white heightening.
 387 × 265 mm., cut at top corners and probably at both sides and top.
See commentary to Plate 22.

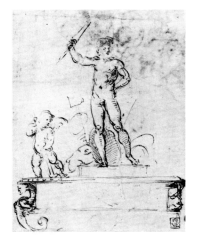

215r: Cherubs for the upper right
 Budapest, Museum of Fine Arts 1935
 Pen, darker ink for cherubs, lighter for angel. 199 × 153 mm., cut down
 to frame verso composition.
The short curving lines defining the cherubs and the flickering pen strokes are a perfect preparation for the soft, painterly treatment of these figures in the fresco. The slight but severe outline of the angel is designed in deliberate contrast, and was pursued on cat. 216r.

215v: Sculptural(?) ensemble with a standing figure of Mars
 Pen over stylus, traces of black chalk on the left.
An unusually doll-like figure for Raphael at this period. The putto with the inverted torch suggests a funeral monument, but the standing nude Mars hardly seems appropriate. Conceivably for a temporary decoration, and not impossibly later than the recto.

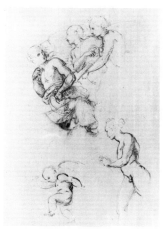
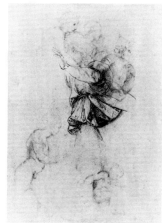

216r: Angels for the upper right
 Oxford, Ashmolean 549
 Pen. 254 × 176 mm.
The angel lower right was clearly developed from cat. 215r; the three above are vigorous and emphatically plastic. The little angel in a dancing movement was reversed and modified in cat. 247.

216v: Drapery study for an angel
 Pen.
A crisp, angular study, with sharp contours, played against the softer texture of the longer, thinner hatching lines in the drapery. Developed from cat. 217r.

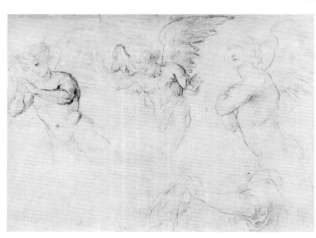

217r: Angels for the upper right
 London, British Museum 1895–9–15–621
 Black chalk. 263 × 357 mm.
These studies vary in handling from the sharp hatching on the right-hand figure to the blurred breadth of the central angel. The arm lower right was probably drawn before cat. 216v. None of these studies was used in the fresco.

217v: Sketches for angels
 Black chalk, a few touches of red chalk.
Loosely drawn but situated in perspective alignment with a subtle rhythmical interlinking.

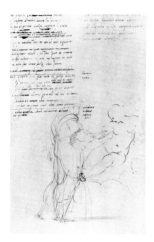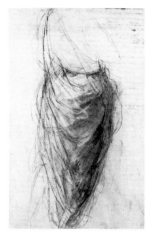

218r: Standing man; reclining woman; partial reclining form; sonnet fragment
 Oxford, Ashmolean 545
 Black chalk (standing man); pen (reclining woman and reclining form). 380 × 231 mm.,
 cut at top, left and right.
The man is a first idea for the scholar standing with his back turned, just to the right of St
Gregory's throne; a late addition to the left side, the figure acts as a counterpoint to the
flow to the altar. The kneeling acolyte is just visible to the left. The reclining woman is a
sketch for the muse to the left of Apollo in the first plan (now known only in a copy:
Oxford, Ashmolean 639; Fig. 21) for the *Parnassus*. The form below her may also be for the
Parnassus, but is difficult to interpret.

218v: Drapery study for standing scholar
 Black chalk, brownish chalks, white heightening.
The smooth transitions from light to shadow on the right are obtained partly by stumping.
A delicate study for the figure on the recto, where the pose was considerably modified. The
study was perhaps done in chalk rather than wash because the drapery was to be less
plastic than that of the foreground figure (cf. cat. 214).

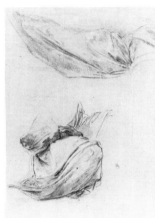

219: Drapery studies for the kneeling acolyte foremost beside St Gregory's
 throne, and for the standing philosopher
 Oxford, Ashmolean 543
 Black chalk and white heightening. 392 × 255 mm.
The drapery study for the standing philosopher shows him in a pose close to
that defined at the left side of cat. 218r. This must have been drawn between
cat. 218r and cat. 218v, where pose and drapery come closer to their final form.
The drapery of the kneeling acolyte was changed considerably in the fresco,
and his right hand, instead of holding his drapery (as here) was raised in a
gesture of revelation. These studies are sketchier and in a higher key than the
black chalk drawings for the upper level.

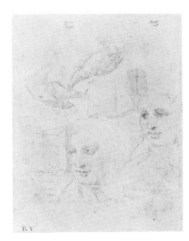

220r: The head of the figure to the right of the balustrade; flying angels with
 books
 Oxford, Ashmolean 547
 Silverpoint on green ground. 279 × 211 mm.
A sharply focused study for a particularly important head, and for the angels,
who, although situated much further in depth, needed to be drawn very
densely in preparation for their position in advance of the heavenly
semicircle. The curling pages and hanging clasps of the books demonstrate
once more Raphael's command of significant detail.

220v: Draft of a sonnet
 Pen.

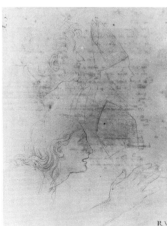

221r: Heads of acolytes and bishops
 Oxford, Ashmolean 546
 Silverpoint on green ground. 284 × 209 mm.
Studies for the kneeling and standing acolytes beside St Gregory, and for the
two bishops behind him. Drawn in a more open, less densely hatched style
than cat. 220r (which is *en suite*) because these figures required a less powerful
plasticity.

221v: Draft of a sonnet
 Pen.

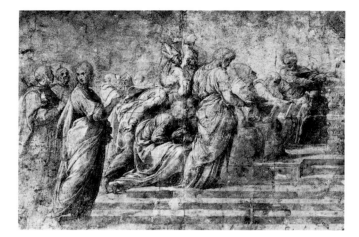

222: *Modello* for the lower left side
 Vienna, Albertina Bd. V, 224
 Brush, wash and white heightening over black chalk; squared in stylus at 37 mm.
 298 × 432 mm.
Virtually ruined. This drawing demonstrates how Raphael continued to make
changes after the *modello* stage: the pose and drapery of the standing philosopher
were altered, and the figures to the left of the pointing youth changed. Raphael has
not extended this *modello* to the left edge, allowing himself room for manoeuvre in
this area.

223r: Drapery study for the pointing figure
 Oxford, Ashmolean 544
 Brush and wash with white heightening over black chalk.
 405 × 262 mm.
Prepared for the Leonardesque man at the left pointing towards the
altar, but not seen in this form either in cat. 222, which it probably
postdates, or in the fresco. One of Raphael's richest and most brilliant
wash drawings, varying in touch from the broad washes used in the
shadow to miniaturist brush strokes in the half tones. Perhaps
studied from a draped lay figure, the material takes on a life and flow
of its own, as though the pleasure of execution superseded the
intended function.

223v: Reclining child
 Black chalk, window mounted at 75 × 137 mm.
A very slight sketch, as likely to be by Raphael as not.

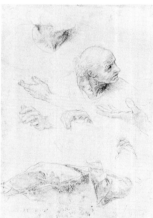

224: Studies for the left-hand group
 Paris, Louvre 3869
 Silverpoint on light-grey ground, some flaking. 412 × 277 mm.
For the outside groups in the *Disputa* Raphael allowed himself greater freedom
of movement and sharper plasticity of form (cf. cat. 225). These areas, defined
by the penetration of the door into the right of the fresco field, and the
corresponding space on the left, had been divided at first from the central area
(cf. cat. 197, 199); their subsequent inclusion permitted lively figural
arrangements. Here, in his treatment of the hands – the right rather simple and
diagrammatic, the left much more bony and prominent – Raphael adjusted the
focus according to the emphasis required. The solid treatment of the drapery
suggests that this was envisaged as fairly final, though in fact the revisions
were considerable.

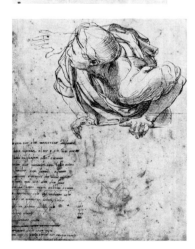

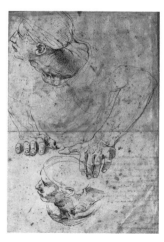

225r: Man on the right; small geometrical sketch; fragment of a sonnet
 Montpellier, Musée Fabre 3184
 Pen over traces of lead point; black chalk. 360 × 235 mm., cut at top, left and
 right.
This drawing, with its hard, relatively unvarying stroke, has a forcefulness
and energy which anticipates the next room. The right arm and hand were
raised, but then lowered again. The contours have the precision of an engraved
line; the hatching – parallel, contour and cross – as required – analyses the
forms like the planes of a polyhedron. The small black chalk sketch below is
difficult to decipher.

225v: Man on the right
 Pen and dark-brown ink over traces of lead point and stylus (?); possibly
 some later stylus indenting.
Even more self-consciously plastic than the recto, with particular emphasis
given to the hands. Minor changes have been made from the recto (the right
hand, for example, no longer holds the corner of the parapet). In the fresco the
left hand was raised and thrown back, as though the man had just moved
forward.

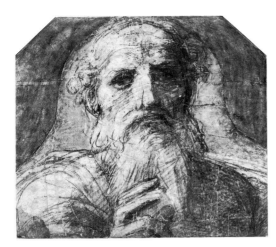

226: God the Father
 Paris, Louvre 3868
 Charcoal, pricked and indented for transfer, on three
 sheets of paper. 370 × 375 mm. maximum, irregular,
 silhouetted.
The single surviving cartoon fragment for the *Disputa*; of
the greatest power and boldness, simple in form and
eschewing detail.

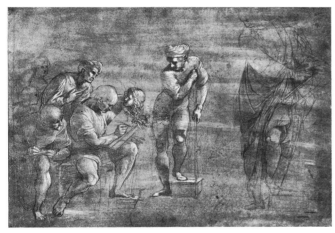

2. Studies for the *School of Athens, c.* 1509 (D. pp. 73–4) (cat. 227–34)

227: Study for left-hand group
 Vienna, Albertina Bd. V, 4883
 Silverpoint and white heightening on grey ground; a vertical line ruled on left, a
 horizontal line about halfway up the page. 289 × 397 mm.
Each of the three models – a sharp-featured bald man (see also cat. 224), a man
wearing a turban, and a long-haired youth – is studied twice. The initial pose of the
standing man is close to that of St Joseph in the *Canigiani Holy Family* (Munich, Alte
Pinakothek; D. p. 19). The pose studied again at right is much closer to that in the
fresco. The drawing style is a silverpoint equivalent of the pen style of cat. 225, with
sharp contours and a vigorous combination of cross- and parallel hatching. Berto di
Giovanni employed the pose of the seated figure in his *St John the Evangelist*
(Perugia, Galleria Nazionale). The emphatic white heightening and grey ground
approximate to the more patchy lighting and deeper shadow of this area of the
fresco.

228r: Euclid instructing his pupils
 Oxford, Ashmolean 553
 Silverpoint and white heightening (oxidized) on green ground, a vertical line about 20 mm. from right
 edge, a horizontal about halfway up sheet (cf. cat 227); a divider mark at the intersection of lines.
 247 × 326 mm., the sheet bisected to frame verso composition and then rejoined.
Once an extremely beautiful drawing, but now badly damaged. Denser in handling and more advanced
compositionally than cat. 227. The green ground was perhaps used to approximate to the slightly cooler hues
of this area. The model used for Euclid is the same as in cat. 224. The elongated standing figure on the left,
greatly simplified in comparison with the other figures, demonstrates Raphael's range within a single study.

228v: Compositional *concetto* for the Chigi Chapel in Santa Maria della Pace (D. pp. 93–5)
 Pen.
Probably Raphael's first idea for the scheme. Here he seems to intend showing only a single sibyl with an
angel at the lower level, and judging by the curvature of the central niche, an altarpiece may not at this
moment have been planned. Relatively few *concetti* survive, and this example compares with cat. 258. The
composition was taken further in a lost drawing of which a copy survives in Stockholm.

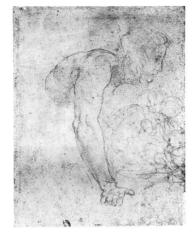

229: A pupil of Euclid; Virgin and Child with St John
 Lille, Musée des Beaux-Arts 479
 Silverpoint on pink ground. 155 × 118 mm.
A study in rather broad silverpoint for the basic masses of the shoulder and arm; the hair-style was changed in the fresco. The Virgin is related to cat. 269 etc.; her head is drawn in three different positions: left to right (1) looking down at the Child with her right arm bent at the elbow, level with the Child's shoulder; (2) looking backwards over her right shoulder; (3) leaning forward to the right over St John, her right arm now curving behind the Child. Cf. also cat. 280.

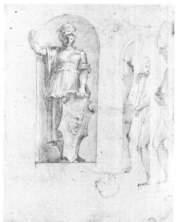

230: Minerva; statues in niches seen obliquely; (inverted) a man descending stairs
 Oxford, Ashmolean 551
 Silverpoint and white heightening on pink ground. 274 × 201 mm.
A deliberately simplified study for the statue at upper right; first hatched with long, regular strokes, and then cross-hatched according to the density of shadow required – greater on the left, less on the right. The man descending the stairs may be a preliminary idea for cat. 231; this figure is shown walking down and looking up to his left, rather than walking down looking down to his right.

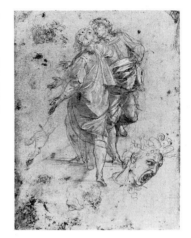

231: Two men on the stairs
 Oxford, Ashmolean 550
 Silverpoint and white heightening, partly oxidized, on pink ground.
 278 × 200 mm.
 See commentary to Plate 24.

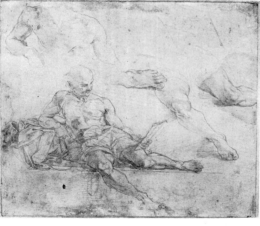

232: Diogenes
 Frankfurt, Staedel 380
 Silverpoint on pink ground. 244 × 284 mm., cut at bottom and right edge.
 See commentary to Plate 21.

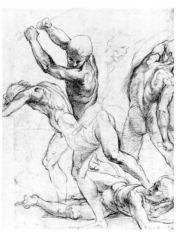

233r: The relief below Apollo
 Oxford, Ashmolean 552
 Red chalk over stylus. 379 × 281 mm., cut at left and right.
The development of this drawing from the fighting nudes (cat. 186 ff.) can be seen in the proportions and the not entirely convincing manner in which the internal modelling is mapped out, e.g. in the figure seen from the back on the right. The close cross-hatching with a sharp chalk shows that this was drawn under the influence of Raphael's contemporary pen and silverpoint style. This way of handling red chalk (used here because of its light tonality, appropriate to simulated sculpture) reached its apogee in the studies for the Chigi Chapel in the Pace (cat. 299 etc.). Cf. also cat. 282v.

233v: Crucified body facing left (left side); to right, torso and head seen from front; above right, two studies of a standing nude man with left arm outstretched; the head again upper right; lower centre: male torso and head (turned to his right) seen from front in a curved pose (perhaps leaning); lower right: lower part of male figure seen from back; upper right: drawn over thighs of standing man; a bearded and a helmeted head facing right in three-quarter profile
 Black chalk, pen, touches of red chalk.
It is difficult to say how many of these slight sketches are by Raphael; the crucified body on the left might date from the later Florentine period. The standing nude man was employed by Bandinelli in his *Massacre of the Innocents*.

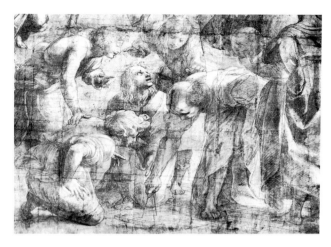

234: Detail of the cartoon
 Milan, Ambrosiana
 Charcoal, black chalk, white heightening
 pricked for transfer. 2800 × 8000 mm.
See commentary to Plate 25 and endpapers.

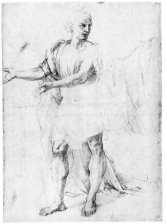
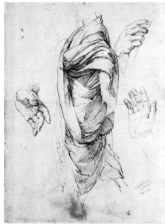

3. Studies for the *Parnassus, c.* 1509–10 (D. pp. 74–6) (cat. 235–45)

235r: Standing man; study of drapery
 London, British Museum Pp. 1–74
 Pen, squared in faint black chalk at 42 mm. 343 × 242 mm.
One of Raphael's hardest and sharpest drawings, stressing the sculptural clarity of form that characterizes this fresco. The drapery on the right arm has been altered with a thicker pen, and the drapery sketch top right probably re-plans the shoulder and upper arm. This figure corresponds to one of those on the right of the lost second design, of which there is a copy in Oxford (Ashmolean 639; Fig. 21). (The first is recorded in an engraving by Raimondi.) The pose is similar in reverse to a figure to the left of the altar in the *Disputa*; this may represent a re-use of the drawing, but it is not close enough to be certain (cf. also cat. 84v).

235v: Drapery of Horace (?); his two hands; the left hand of the fifth figure from the right
 Pen over black chalk
Very close to the fresco. Although less dramatic, the drawing style is close to cat. 225.

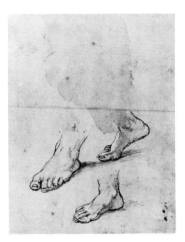
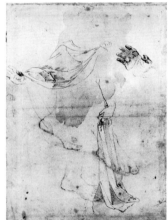

236r: Three feet
 Lille, Musée des Beaux-Arts 446/445
 Pen, the upper two feet over black chalk. 343 × 240 mm.
Obviously drawn immediately after cat. 235; the upper feet are those of Horace (cat. 235v), the lower is the right foot of the standing figure in cat. 235r.

236v: Drapery of Homer; his right hand
 Pen over traces of black chalk.
The sweep of the drapery was abandoned in the fresco and the hand lowered; the left arm and wrist, here reminiscent of Michelangelo's *David*, were also modified in the fresco, where they nevertheless retain a Michelangelesque expressiveness. Developed in cat. 237r.

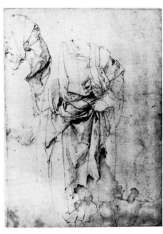
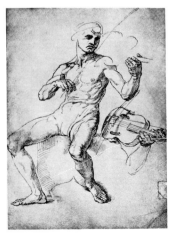

237r: Drapery of Homer
 Lille, Musée des Beaux-Arts 453/452
 Pen. 345 × 240 mm., cut at left and bottom; stained.
A revision of the drapery of cat. 236v.

237v: Apollo playing the viol da braccio
 Pen.
The angular and sinewy simplifications of the contours of the arm and the modelling of the left leg are close to silverpoint studies such as cat. 224, but more energetic. The divisions of the rib-cage and the musculature of the stomach owe a debt to the experiments of Raphael's late Florentine period (e.g. cat. 188 etc.), but the rigour and firmness of the contours mark a high point in his art. The sharp contrasts of light and shadow create an impression of heroic simplicity.

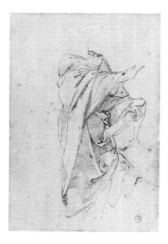 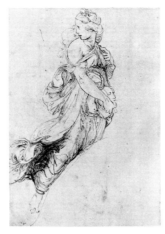

238r: Virgil
 Oxford, Ashmolean 541
 Pen over traces of black chalk. 330 × 219 mm., cut at top and right.
The body is mostly concealed in the fresco. Virgil's head is lightly drawn in black chalk, turned to his right. The crispness of the hatching is combined with a use of longer lines to suggest drapery texture.

238v: Melpomene
 Pen over traces of black chalk.
See commentary to Plate 26.

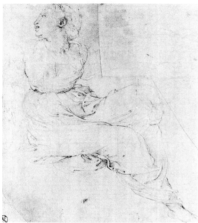

239: Erato
 Vienna, Albertina Bd. V, 220
 Pen. 245 × 215 mm., irregular, made up lower left and upper right
 section, cut all round.
A battered and badly faded drawing, less incisive than most in this series, but comparable in technique. The rhythm and figure type anticipate the Sibyls of the Pace Chapel; for the facial expression, but not the style, cf. cat. 355.

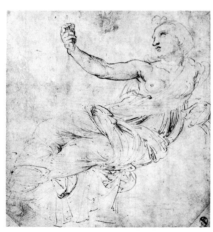 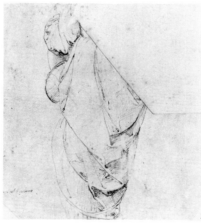

240r: Euterpe
 Vienna, Albertina Bd. V, 219
 Pen. 243 × 218 mm., cut all round, lower left and right
 corners made up.
Obviously *en suite* with cat. 239. A brilliant study in which vigour and energy have been modified in favour of elegance and lyricism. The upper part derives from Michelangelo's *Creation of Adam*, the drapery from the Vatican *Ariadne*, but Raphael has fused them into a new unity: the drapery is arranged in longer curves, and Michelangelo's angular emphases are suppressed.

240v: Muse seen from the rear
 Pen (patched over upper right).
A drapery study where the folds have been excavated only shallowly. A deliberately surface-stressing formulation. A copy of the drawing before it was cut down is in the Uffizi.

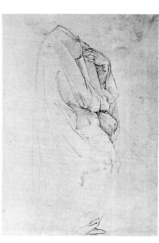 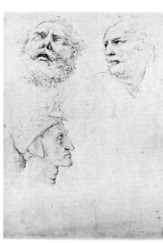

241r: Drapery study for Dante
 Windsor, Royal Collection 12760
 Pen. 271 × 186 mm., cut at top and bottom.
The sequence of planes in the chest is contrasted with the broken folds below the waist at the front in order to create a movement up to Dante's head. Closely followed in the fresco.

241v: Studies for the heads of Homer, Dante and another poet
 Pen.
The head of Homer is based on that of the Laocoon, a brilliant reinterpretation of a cry of pain as the moment of poetic inspiration; The head of Dante (whose austerity is emphasized by the regular hatching) is based on a traditional type; the bearded head was used for the figure fourth from left in the left foreground.

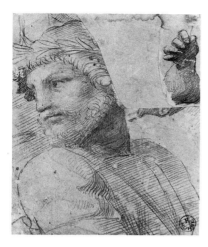

242: Head of a poet; right arm
 Florence, Horne Museum 5878
 Silverpoint on faded pink ground. 122 × 103 mm., very irregular, cut
 apart and patched together.
A detailed study of expression for the poet fourth from the left edge; the
arm belongs to the scribe immediately above him who is taking down
Homer's verse. A very broad and vigorous drawing, with contour
hatching used for the cheeks and shoulder. The thigh and part of the
drapery of the scribe can be seen above his head and on the right side.
The arm is simplified for its position in space, with the fingers
highlighted.

243: Sappho and poets
 London, British Museum Pp. 1–73
 Silverpoint on pink ground. 288 × 183 mm., damaged and made up centre of
 right edge.
The two main figures are studied in great detail, the others only lightly sketched.
Presumably drawn in silverpoint to determine precisely the left foreground
(probably, as in the *Disputa*, the last part to be finalized). Sappho, whose left arm
is raised higher in the fresco, derives both from the Virgin in the Doni tondo and
from the *ignudo* next to the *Creation of Adam* on the Sistine ceiling. The
execution is of engraver's precision.

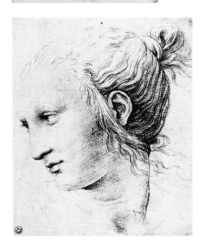

244: Head of the Muse immediately to the right of Apollo
 Florence, Horne Museum 5643
 Black chalk. 264 × 207 mm.
Apart from on the lips, nostrils and shadows in and around the ear and
under the chin, the chalk lines are kept separate, creating an effect akin to
silverpoint purity. No pounce marks are visible, and the extreme
certainty of the drawing might suggest a copy, but the dreamy expression
and the full but patterned treatment of the hair, deriving from the
antique, are beyond a copyist.

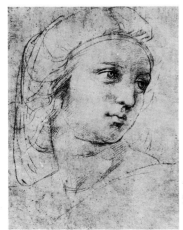

*245: Auxiliary cartoon for the head of a Muse
 London, Private Collection (1)
 Black chalk over pounce marks. 304 × 222 mm.
For the head of the third standing Muse to the right of Apollo. The broad
areas of light, the comparatively unstressed contours, and the restrained
shadow are determined by the high key that Raphael required for this
fresco (which had to compete with light from the window). The physical
type, strong and ripe, is closely linked with the Allegories on the Justice
wall, and with the Sibyls in the Chigi Chapel in Santa Maria della Pace
(D. p. 93).

4. The Vault, *c.* 1510 (D. pp. 70–1) (cat. 246–53)

246r: Theology
 Oxford, Ashmolean 554
 Pen over traces of lead point. 201 × 143 mm., cut all round, made up bottom
 edge.
A vital and energetic drawing. The first position of the left arm came close to that
of Astronomy; it was later modified, and was brought round to the book on the
left thigh. The right arm was brought in and the movement stilled in the fresco.
The fast hatching and the sweeping pentimenti connect with cat. 250.

246v: The Assumption of the Virgin for the Chigi Chapel in Santa Maria del
 Popolo (D. p. 95)
 Pen.
Presumably the initial *concetto*. The figure style and simplification of bodies and
heads are close to cat. 228v. The design was taken further in cat. 317r. In the
heads of the Apostles a considerable range of gesture and expression is already
adumbrated; psychological differentiation is present even at this stage.

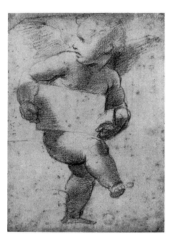

247: Angel to the right of Theology
 Lille, Musée des Beaux-Arts 433
 Black chalk, touches of white heightening; a stylus arc incised on left edge,
 crossing the right forearm. 226 × 159 mm. maximum, irregular, cut at top.
Quite close in style to the black chalk studies for the upper part of the *Disputa*,
but more vaporous in technique and simplified in form. There are slight
pentimenti on the left arm and hand, and some doubled contours to obtain the
child's swelling forms. A demonstration of Raphael's close attention to even minor
figures at this stage of his career. Faint traces of black chalk on the laid-down verso.

248: Poetry
 Windsor, Royal Collection 12734
 Black chalk and touches of charcoal over stylus; squared in black chalk at
 56 mm.; tondo indicated, lower left and right. 358 × 227 mm.
One of Raphael's loveliest drawings of this period. The delicate *sfumato*
modelling and the radiant expression make this study virtually a presentation
drawing.

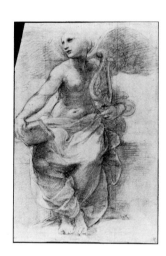

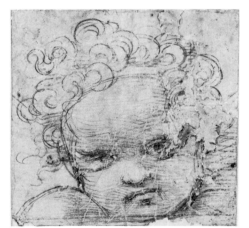

249: Cartoon fragment for the putto to the right of Poetry
 London, British Museum Pp. 1–76
 Black chalk, pricked. 234 × 232 mm., irregular, damaged.
The hatching is varied to register light rather than for modelling,
though the curves on the right side of the forehead provide a
strong sense of volume.

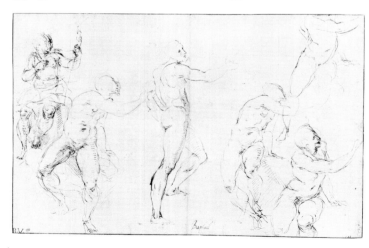

250: Study for Adam; St John (?)
 Paris, Louvre 3847
 Pen, red chalk underdrawing in second figure from right, some traces of
 black chalk. 285 × 433 mm.
A bold and vigorous pen study which it would be tempting to date later were
it not for the connection with the ceiling. The pose of Adam perhaps shows
knowledge of the last of Michelangelo's ancestors of Christ, but it could also
have been developed from the *Cascina* copy (cat. 157v). The St John in the
Wilderness (?) is presumably a first idea for a devotional painting
concentrating on a single figure of a saint, the sort of composition
subsequently produced in Raphael's school. The standing figure is perhaps
an idea for St John preaching. Cat. 132v may record Raphael's earlier design
for the vault, executed perhaps by Sodoma and subsequently replaced by the
present scheme by Raphael.

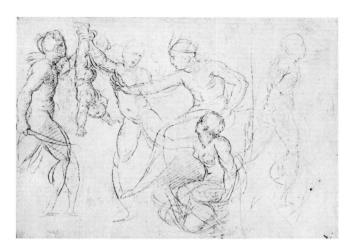

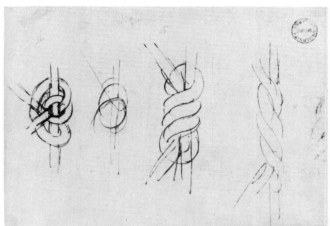

251r: The Judgement of Solomon
 Oxford, Ashmolean 555
 Silverpoint on green ground. 100 × 137 mm., cut all round.
The figures were drawn nude and drapery was then lightly indicated over them. An unusual example of a free composition study in silverpoint, with all the figures in action. The executioner is studied again on the right and taken further on cat. 252r.

251v: Studies of knots
 Pen.
Probably for some decorative purpose.

252r: Executioner for the *Judgement of Solomon*
 Vienna, Albertina Bd. IV, 189
 Black chalk. 264 × 290 mm., irregular, cut
 down and piece added top left (?)
Developed from cat. 251; clearly related in reverse to a figure on the right of Michelangelo's *Cascina*.

252v: Study for the *Judgement of Solomon*
 Pen over black chalk (study upper right
 added on).
The true mother is visible in a black-chalk underdrawing in the centre. The close cross-hatching on the executioner creates a bronze-like consistency. The clarity of the false mother's drapery, the use of light to draw attention to her hands, and the powerful twist of her head look forward to cat. 333v. The executioner was finally used in the *Massacre of the Innocents* (see cat. 253v, 288).

253r: Astronomy
 Vienna, Albertina Bd, IV, 188
 Pen over lead point. 235 × 410 mm., cut at top, left and bottom.
The figure of Astronomy, lightly drawn full length from the model, the spheres added, and the torso, head and arms more fully worked in a rhythmical, looping style.

253v: Studies for the *Massacre of the Innocents*
 Red chalk.
The executioner taken up from cat. 252v. Probably drawn after cat. 288r to study the expressive elements of shoulders, legs and drapery. The fact that red chalk is used in this broad, soft way suggests that the *Massacre* may have been intended initially for painting rather than engraving

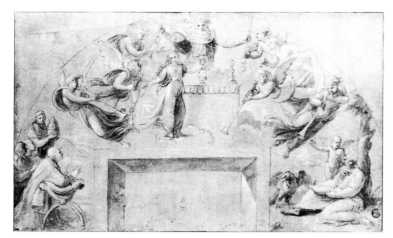

5. The Jurisprudence wall, 1511, and its window embrasure, *c.* 1514 (D. pp. 76–7) (cat. 254–7)

254: *Modello* for the Jurisprudence wall (?)
 Paris, Louvre 3866
 Pen, brush and wash, white heightening, some stylus indentation. 248 × 397 mm., irregular.
A puzzling drawing, probably recording a project of *c.* 1509 for the Jurisprudence wall, which underwent a late re-planning in 1511, but conceivably of *c.* 1511 (judging by the very vigorous poses of the angels), and for the *Bolsena* wall in the next room. The execution suggests a copy, but there is a pentimento in the right hand of the central angel at the right side. The treatment of the features has much in common with the later *modelli* ascribed to Penni. The laid-down verso is recorded as carrying studies for the *Mass of Bolsena*.

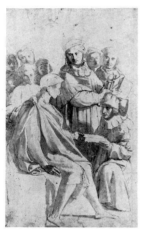 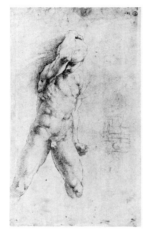

255r: Justinian receiving the Pandects from Trebonianus
 Frankfurt, Staedel 381
 Pen, brush and wash over black chalk; the head top left in black chalk. 371 × 215 mm.
Broad pen outlines, like those of the *Parnassus* studies, are combined with a silvery wash to register the fall of light. The high key establishes that of the fresco.

255v: Guard in the Pace *Resurrection* (copy); *concetto* for the Jurisprudence wall
 Pen and grey-brown ink; the architectural sketch in black chalk.
The architectural scheme of the Jurisprudence wall, rapidly sketched here, was a change of plan of around mid-1511, probably influenced in form by Michelangelo's design for the front face of the Julius Tomb. The pen drawing, extremely refined but more mechanical in hatching than any study by Raphael, copies a lost drawing for the right side of the *Resurrection* (see cat. 304, 307). It is attributable to Perino del Vaga by comparison with a drawing by him copying a lost Raphael study for the arms of the 1518 *St Michael* (Paris, Louvre; D. p. 47) in the H. Schickman Gallery, New York, in 1968 (*Old Master Drawings*, 1968, No. 23v).

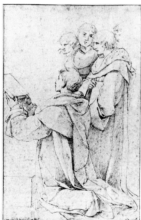

256: The Presentation of the Decretals
 Frankfurt, Staedel 382
 Pen over traces of black chalk and stylus. 372 × 222 mm.
A faded drawing, close in style to cat. 241r; slightly dull in appearance, but deliberately simplified and probably an original rather than a copy.

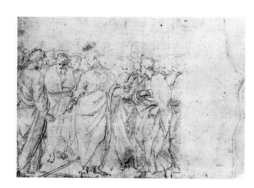 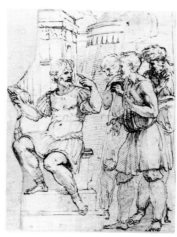

257r: The Doctrine of the Two Swords
 Windsor, Royal Collection 3720
 Red chalk. 262 × 363 mm., cut on right.
A sketch, probably not followed up by further drawings, for the window embrasure of the Jurisprudence wall. It is likely that, in common with cat. 258, 259, it is to be dated anything up to three years later than the completion of the main frescoes. The figure style and arrangement comes closest to the Tapestry cartoons.

257v: The Judgement of Zaleucus
 Pen over stylus.
A study, considerably more elaborated than the recto, for the opposite scene in the window embrasure. The pen style, although developed from drawings like cat. 235r, shows a more rounded, more emphatic contour, stressed musculature, and less modulation of line. It comes close in style to drawings like cat. 343, and probably dates from 1513/4. The language of gesture is again close to the Tapestry cartoons.

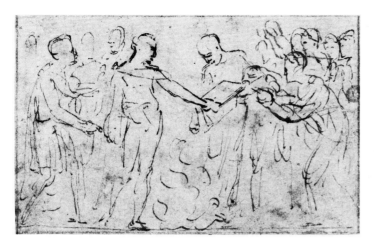

6. The Grisaille Panels below *Parnassus, c.* 1514 (D. pp. 76–7) (cat. 258–9)

258: Augustus prevents the burning of Virgil's books
 Haarlem, Teylers Museum A56[2]
 Pen. 62 × 94 mm., cut all round.
A *concetto* for the left-hand relief beneath *Parnassus*, which was added after the modification of the room under Leo X (*c.* 1513–14). Although calmer and more stately in composition and pen-stroke, the manner is recognizably that of cat. 246v.

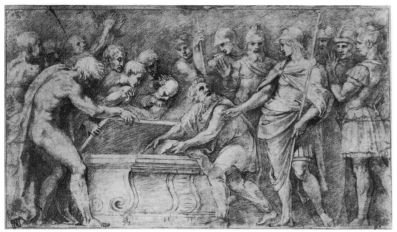

259: Alexander committing to safety the works of Homer
 Oxford, Ashmolean 570
 Dark-red chalk over stylus. 243 × 413 mm.
A controversial drawing for the right-hand relief beneath *Parnassus*. The considerable differences between the stylus and the red chalk confirm that this is a creative drawing, and parts – especially Alexander's face, his right arm, his left leg – are of great sensitivity and precision. But the uniformity of emphasis, the lack of analysis of facial expression and the comparative flabbiness of the modelling would support the attribution to a pupil, perhaps Penni (cf.cat. 373).

 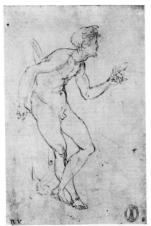

* 260r Landscape sketch
 Weimar, Graphische Sammlung KK8047
 Pen. 193 × 312 mm.
Probably of early Roman date, possibly representing the ruins of the forum of Nerva, with a bridge akin to that in the *Cardellino* (D. p. 20). The landscape treatment still retains a Florentine airiness, and the denser, moodier landscape of Raphael's Roman period has not yet made an appearance. It has been connected with the background of the Esterházy Madonna (Budapest, Museum of Fine Arts; D. p. 21), but the links are no more than generic.

260v: Adam
 Pen over lead point.
A pupil copy of cat. 132v, perhaps by Giulio Romano (cf. cat. 380v).

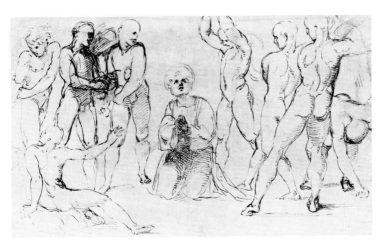

261: The Stoning of St Stephen
 Vienna, Albertina Bd. V, 211
 Pen. 267 × 420 mm., cut at top and right.
A puzzling drawing, usually connected with the representation of this episode in the Tapestries. The figure style, however, is closer to studies of *c.* 1507–8 (cf. cat. 188), although it is more substantially drawn with a thicker pen. For the facial type of the figure on the left cf. cat. 202v. It is probably of the early Roman period, perhaps for a predella panel.

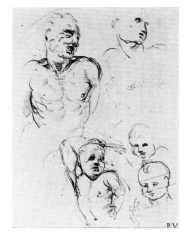

262: Torsos of two men and a child; two heads of children
Vienna, Albertina Bd. IV 260
Pen over black chalk. 234 × 171 mm., upper left corner made up.
The torso upper left may be for a St Sebastian or, less likely, a Marsyas. The lightly sketched figure top right, with his left arm stretched forward, might be connected with the right-hand side of the *Disputa*, as also might the torso and head of the putto bottom centre, seen from below, and the putto head above right. The cancelled head lower right is probably by a pupil. The connection with the *Disputa*, though speculative, can be supported stylistically by comparison with cat. 201r, 202r, especially the form of the head and neck of the central figure.

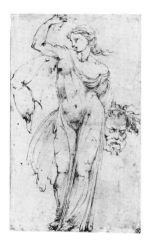

263: Judith and Holofernes
Vienna, Albertina Bd. IV, 179
Pen over stylus. 406 × 247 mm., probably cut all round.
Based on a Venus Genetrix. This drawing has been dated later, probably on account of the long, woodcut-like hatching lines which define the folds, and the bold energy of the forms. But a comparison of the treatment of the head and neck with that in cat. 262 suggests that this powerful but somewhat factitious design dates from the early Roman period, when Raphael briefly made use of this energetic but overstated manner. The voluptuous physical type links also with the female figures in *Parnassus*.

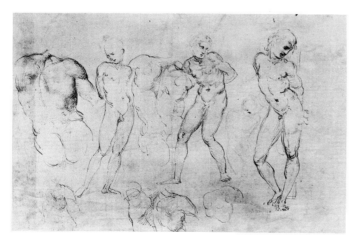

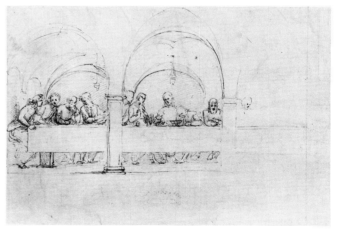

264r: Four studies of a pinioned figure; five studies of a torso
 seen from the rear
Vienna, Albertina Bd. IV, 195
Pen over black chalk; the smaller pinioned figure second
 from left in faint black chalk only. 263 × 376 mm., cut at
 bottom.
The headless torso, studied from slightly different angles (the head very lightly indicated top left), was copied from an antique Apollo Sauroctonos, though Raphael has made various additions and modifications; the statue was also the source for the left-hand figure in cat. 186v, 202r and 265r. The pinioned men have some relation to the prisoners in cat. 262 and cat. 186v, but seem to be for an isolated figure, perhaps a St Sebastian, a Marsyas, or (right) a Christ at the Column. The small prisoner sketched in black chalk may show a knowledge of Michelangelo's slave sketches for the Julius Tomb.

264v: The Last Supper
 Pen over black chalk; a geometrical drawing in stylus at
 right.
A slight *concetto* for the grouping in the lower centre. For an unknown fresco (?) commission, probably for a refectory, of the early Roman period. Heavily influenced by Leonardo, with Judas clearly characterized at the extreme right of the central arch. Gestures and expressions are close to those of the *Disputa*.

265r : Three studies of a torso from the rear; three studies of the Virgin holding the Child blessing; four studies of the
 Virgin, kneeling, presenting the child St. John to the Christ Child; sleeping male figure; the Child (?) studied
 left of the sleeping figure, and again, in the centre of the page in a Michelangelesque turning movement
 Vienna, Albertina Bd. V, 208
 Pen over lead point. 257 × 356 mm.
The torsos are developed from the same source as cat. 202r and cat. 264r. The hatching on the second from the left at
the top creates a pulpy quality which suggests that Raphael might have thought of adapting the form for a child. The
Virgin holding the Child blessing is developed from the sketch lower left centre on cat. 202v. The kneeling Virgin,
her arms in an umbrella position over the two children, was later developed into the studio painting of which there are
versions in the Westminster Collection and elsewhere.

265v : The Virgin and Child with a saint; two studies of saints (?); ointment pot; base of a candlestick
 Pen over lead point; the ointment pot and candlestick base in lead point only (?).
The main sketch may be for a marriage of St Catherine; the Virgin's right arm is shown in two different positions,
holding the Child, and holding up an object (?). In the latter case, if it is an object the Child is reaching for, the figure
on the left would be a saint bending forward in adoration or, conceivably, a Magus. The kneeling pose of the Virgin
links with the recto and with cat. 267. The two saints – the lower probably, the upper possibly, St Jerome – may or
may not be connected with the main group. Some of the elements were later re-used in the *Madonna del Pesce*
(Madrid, Prado; D. p. 38).

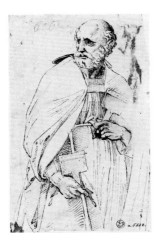

266 : St Blaise holding his instruments of martyrdom
 Florence, Horne Museum 5882
 Pen over traces of black chalk. 250 × 155 mm., irregular, cut all round.
Similar in style and technique to the pen drawings for *Parnassus*, though the
hatching is denser than in most of these. Not connected with a known commission,
but psychologically similar to the saints on cat. 265v.

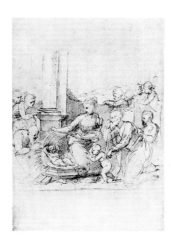

267 : The Adoration of the Shepherds with the infant Baptist
 Oxford, Ashmolean 564
 Pen, over traces of black chalk at right, over stylus at centre and right, a stylus
 horizontal for the top of the frame. 405 × 265 mm., the framed area
 c. 252 × 255 mm.
An adventurous and brilliant composition, related in the central motif to the
Madonna di Loreto (Chantilly; a copy D. p. 27) and the *Madonna of the Diadem* (Paris,
Louvre; D. p. 28). The characterization of the shepherd, left and St Joseph (?)
supporting the infant Baptist, right, are close to the lower saint on cat. 265v. The
figures upper right are close to the angels for the *Disputa*, and the movement of the
Virgin's head and neck is similar to that of one of the Muses for *Parnassus* (cf. cat.
244). Presumably for an unrecorded commission, *c.* 1509–10, and used by Tommaso
Vincidor in 1520 as the basis for a tapestry design (Paris, Louvre, 4269).

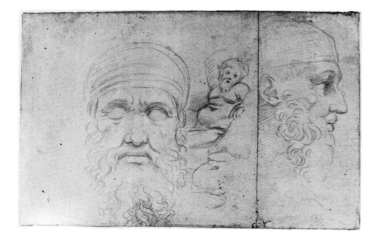

268: An antique head, full face and right profile; a reclining Silenus
 Lille, Musée des Beaux-Arts 484
 Silverpoint on pink ground. 109 × 168 mm.; the profile on the right
 incomplete – either cut from this sheet and reassembled incomplete, or
 from another sheet.
After the head of an antique Gaul; perhaps prepared in connection with studies
of expression for the Segnatura since the left profile occurs in schematic form on
cat. 207r. The reclining Silenus is also from the antique, and the stomach and
pendulous breasts are re-studied below.

c. 1509–11 Studies for the Madonnas *Aldobrandini* (London, National Gallery; D. p. 26), *Loreto* (Chantilly; a replica D. p. 27), *della Sedia* (Florence, Pitti; D. p. 35), *Alba* (Washington; D. p. 35), *Mackintosh* (London, National Gallery; D. p. 31) (cat. 269–80, see also cat. 202v)

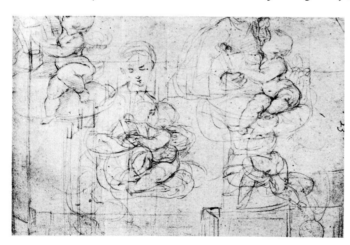
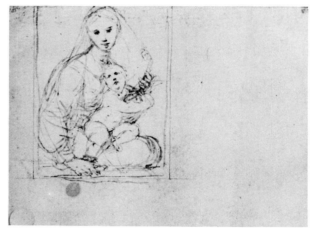

269r: Four studies of a Madonna and Child; the Child alone; studies of architecture
 Lille, Musée des Beaux-Arts 454/5
 Silverpoint on pink ground. 122 × 161 mm., cut all round.
An early idea for the *Aldobrandini Madonna*, before the inclusion of St John; the Child tried in a more vigorous
pose (cf. cat. 202v) lower right and lower left. The architectural drawing is difficult to interpret. With the right
edge as base: a complex and plastic entablature consisting of a stepped architrave, a frieze and an elaborate
cornice. Drawn over this, two pilasters (?) carrying a string course (?) surmounted by an arch (?) (cf. cat. 272
(?)). Lower right, further indecipherable architectural drawings. Perhaps for Sant' Eligio degli Orefici, rather
than, as has been suggested, the architecture of the *School of Athens*.

269v: Virgin and Child
 Brush and wash over traces of black chalk, framed by Raphael in wash and by another hand in black chalk.
The medium is unusual for a drawing of this type, normally it would be in pen. The pose of the Child links with
the *Aldobrandini Madonna* and the *Impannata* (Florence, Pitti; D. p. 38).

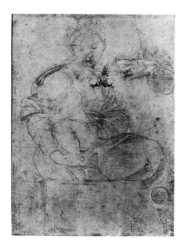

270: Study for the *Aldobrandini Madonna*
 Lille, Musée des Beaux-Arts 436
 Silverpoint on pink ground, squared at 25 mm. 162 × 113 mm.
Upper right, the Virgin's hand brought forward to hold the Child's left side.
The Child's attention is now focused to the left, which suggests a new element
in the composition – perhaps a saint leaning over from the left. A dense and
detailed drawing, moving towards a *modello*.

271: The Child for the *Madonna di Loreto*
 London, British Museum Pp. 1–72
 Silverpoint on pink ground. 168 × 119 mm.
A series of studies of great vitality for the Child. That on the upper right is taken up on the lower left of cat. 272. The central study was known to Domenico and Orazio Alfani, who used it in their *Nativity* of 1536 (Perugia, Galleria Nazionale).

272: The Child for the *Madonna di Loreto*; two figures in a lunette
 Lille, Musée des Beaux-Arts 438
 Silverpoint on pink ground. 167 × 118 mm.
A series of different ideas for the reclining Child; that at the top right was chosen for development in cat. 274. Like cat. 271, a page of great virtuosity, where silverpoint is handled with an extraordinary fluency and freedom, performing the role normally assigned to pen with a control and vivacity that equals Leonardo. The lunette composition (with the left edge as bottom), with a spandrel foreshortened above, might be for an unexecuted decorative project.

273: Studies for the *Madonna di Loreto*; nude study for the *Madonna della Sedia*
 Cleveland, The Cleveland Museum of Art, Purchase from the J. H. Wade Fund, CMA 78.37
 Silverpoint on pink ground, cut at top. 119 × 153 mm.
The left-hand Child seems to be a development of the Child second from the bottom on cat. 271. The others tend more in the direction of cat. 323, but can hardly be for it. The studies from the model are undoubtedly connected with the *Madonna della Sedia*, but this was probably painted a year or two later (see cat. 277, 319). The Child's head on the right (like Boltraffio in handling) cannot be connected with a known painting. Raphael presumably returned to cat. 271 after drawing the Child studies, below; this suggests that they were adjacent pages of a sketchbook.

274: Studies for the *Loreto*, *Aldobrandini* and another Madonna
 Lille, Musée des Beaux-Arts 437
 Silverpoint on pink ground. 117 × 144 mm.
Right edge (with left edge as base) a study very close to the Child in the *Madonna di Loreto*. Lower left, a composition study for the *Aldobrandini*, with the Virgin facing left and St John lower right (studied again on the right). The pose of the Child is virtually identical with that on cat. 229. Drawn over and above this is a Virgin and Child with St John handing the cross to Christ; the sketch is framed as a rectangle, but a structural arch (?) crosses the Virgin's head. In part this is a development of the *Holy Family with the Palm* (Sutherland Collection, on loan to the National Gallery, Edinburgh; D.p. 23). Essential features of the *Aldobrandini* and *Loreto* Madonnas crystallize on the same page.

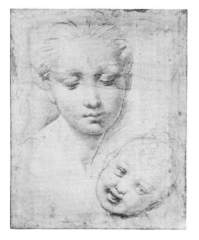

275: Facial studies of the Virgin and Child
 London, British Museum 1866–7–14–79
 Silverpoint on pink ground. 143 × 110 mm.
A particularly radiant study of the Virgin, with a most elegant play of the
line of the jaw against the neck. The features are constructed solely by
variations of shading without internal contours (save a single light vertical
to centre the nose); the effect is reminiscent of a bust by Desiderio da
Settignano. The Child's head, executed in a much broader, 'painterly'
silverpoint, is deliberately blurred to create an evanescent expression round
the mouth and eyes, and the broken contour allows a less emphatic volume.
The Virgin's head is close to cat. 269v. The Child is similar to the one in the
Mackintosh Madonna, in reverse (cf. cat. 277).

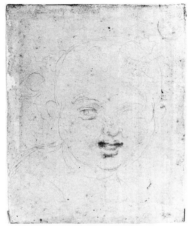

276: Head of a child
 Lille, Musée des Beaux-Arts 464
 Silverpoint on off-white ground. 103 × 78 mm., irregular, cut all
 round.
A quick life-sketch, probably in preparation for the *Mackintosh
Madonna*. Less attractive than cat. 275, but also of great skill in its
softness, immediacy and broken handling.

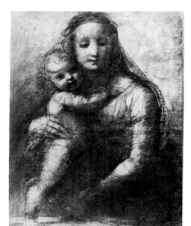

277: Cartoon for the *Mackintosh Madonna*
 London, British Museum 1894–7–21–1
 Black chalk with traces of white heightening, pricked and indented for
 transfer. 710 × 535 mm., made up at top; composed of two sheets of
 paper with a strip added on left.
The head of the Child is similar to the heads in cat. 275, 276; the type of the
Virgin has some links with cat. 202v. In the painting, the characterization
of both Madonna and Child is modified. Although at first sight a return to
Florentine simplicity, the solidity and architectural complexity of this
design look forward rather to the Madonnas of the mid-Roman period.

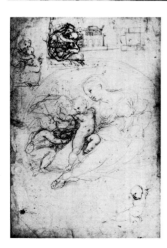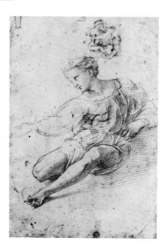

278r: Study for the *Alba Madonna*; studies for the *Madonna della Sedia* (?);
 architectural studies
 Lille, Musée des Beaux-Arts 456/7
 Red chalk (partly overworked in pen), pen, traces of black chalk. 421 × 271 mm.,
 cut at left and right.
The figure was first outlined nude. The pose exhibits the Michelangelesque ambitions
of the late Segnatura phase – the repeated Child lower right is once more derived from
the Taddei tondo. The powerful forms and sweeping movement, already anticipated
in the late Florentine work, here attain the most complex extension. The composition
was developed from the design in the lower right-hand corner of cat. 202v. Of the two
studies top left, both framed as rectangles, that on the right comes closest to the
Madonna della Sedia, but also shares features of the *Madonna della Tenda* (Munich;
D. p. 39); it was not, however, immediately preparatory for either. The architectural
elevation and plan are probably for the building under construction in the left
background of the *Disputa*.

278v: Life study for the *Alba Madonna*
 Red chalk.
Studied from a male model; the cross-hatched chalk derives from Raphael's practice
in pen and silverpoint, and can be seen in contemporary drawings like cat. 233r. This
style reaches its apogee in the studies for the Pace Chapel. The facial type relates
particularly to cat. 301.

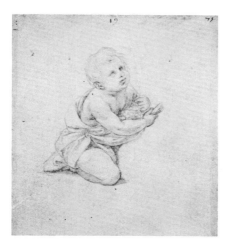

279: Kneeling St John for the *Alba Madonna*
 Rotterdam, Boymans-van Beuningen Museum I.110
 Silverpoint on off-white ground. 115 × 105 mm.
A detailed study, modified in the painting, especially in the position
of the head.

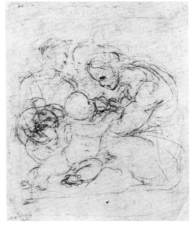

280: Virgin, Child, St John, St Joseph (?) and a saint
 Cambridge, Fitzwilliam Museum 3103
 Red chalk. 159 × 129 mm., made up at all four corners.
A head is lightly drawn immediately above that of the Virgin. Related in
motif to both the *Alba Madonna* and the *Madonna della Sedia*. Very much
the sort of composition admired by Correggio and Parmigianino. Perhaps
developed from cat. 229.

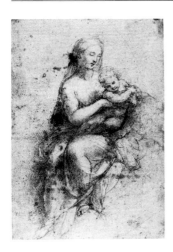

281: Study for the *Madonna di Foligno* (Vatican; D. p. 31)
 London, British Museum 1900–8–24–107
 Black chalk on blue paper, partly stumped, the Virgin's halo in stylus,
 squared in black chalk at 60 mm., a mandorla lightly sketched behind the
 Virgin. 402 × 268 mm.
The head of the Virgin has something of the sharp-featured quality seen in
cat. 263; her pose is derived from Leonardo's cartoon in the National Gallery,
London, as is that of the Child; the latter was changed in the painting to a pose
derived from the Child in the Doni tondo. The soft handling and delicate
gradation of shadow on, for example, the Virgin's left leg are close in subtlety
to cat. 248, with a slightly greater play of contour against interior. The wind-
swept hair of the Child was adopted for the *Sistine Madonna* (Dresden,
Gemäldegalerie; D. p. 36).

**Studies for the *Sistine Madonna*,
c. 1512 (Dresden; D. p. 36)
(cat. 282–3)**

282r: Compositional sketch; two arms
 Frankfurt, Staedel 4303
 Black chalk, pen over lead point. 248 × 375 mm.
A rapid compositional sketch, with features abandoned in the
painting (e.g. the putto accompanying the Virgin; cf. cat. 283). The
relation of Virgin and Child in the drawing takes up that of the
Mackintosh Madonna. The composition is framed as a rectangle,
with a circular glory lightly indicated behind the Madonna. At this
stage the saints may not have been envisaged, so the whole
altarpiece would have been unmediated in its visionary impact. A
small nude sketch clarifies the pose lower left. The final pose in the
painting was influenced by that of Michelangelo's Virgin for the
second version of the Julius Tomb. The raised right arm seems to be
a pupil study after a Michelangelesque drawing, perhaps one by
Raphael; for the sketch of the lowered right arm cf. cat. 88v.

282v: Figures on the right-hand side of the *School of Athens*
 Red chalk.
A copy of a lost drawing by Raphael, close in style to cat. 233r.

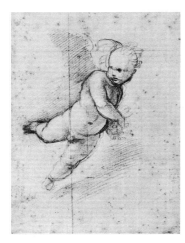

283: Putto scattering flowers
 Lille, Musée des Beaux-Arts 432
 Black chalk, partially squared at 55 mm., with central lines at 17 mm.
 237 × 174 mm.
A controversial drawing, sometimes given to Fra Bartolommeo because a
putto in a similar pose occurs in his *Coronation of the Virgin* (Stuttgart). But
the rhythm and vitality, the hatching on the wings (cf. cat. 247), the
doubled contour and the facial expression (cf. cat. 295) are unmistakably
those of Raphael. Probably for the putto accompanying the Virgin in
cat. 282.

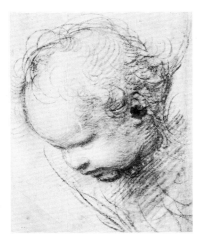

* 284: Head of a putto
 Hamburg, Kunsthalle 21592
 Charcoal (?). 300 × 287 mm.
A very broadly handled drawing. The type is close to that of the Child in
cat. 277. The purpose of this beautiful study is unknown, but comparable
cherubs occur in the *Foligno* and *Sistine* Madonnas.

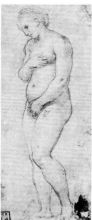
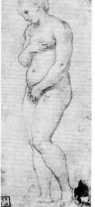

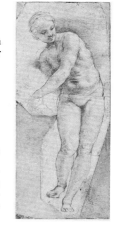

285: Female nude posed as Venus
 Budapest, Museum of Fine Arts 1934
 Silverpoint on buff ground. 188 × 75 mm., cut down.
Close to the pose of Venus in the *Judgement of Paris*, engraved by Marcantonio after a lost reconstruction of a
Roman relief made by Raphael at an uncertain date. This drawing, however, is probably not preparatory for
that, but simply an experiment in posing a model (perhaps the same as in cat. 273) as the Cnidian Venus.

286: Venus
 London, British Museum 1895–9–15–629
 Silverpoint on faded pink ground. 238 × 100 mm., irregular, on two pieces of paper, a new lower section
 added by Raphael.
Cupid's head and shoulders are visible, the rest of his body has been cut away. This figure was engraved by
Marcantonio as a pendant to his engraving of Apollo from the *School of Athens*. It remains a faint possibility that
Raphael initially intended to pair a celestial Venus with Apollo, and only subsequently replaced her by
Minerva. This drawing does not seem to be related to cat. 194v/195v and cat. 202r, which appear to be studies for
a painting. There may be some connection with cat. 285.

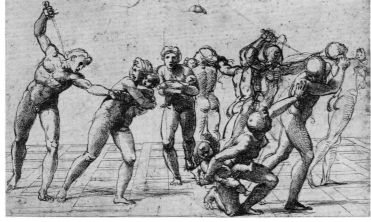

287: The Massacre of the Innocents; head of a dead child
 London, British Museum 1860–4–14–446
 Pen, over red chalk for two figures on right; all outlines pricked for
 transfer except these two figures; a vertical central line in pen, the
 pavement underdrawn in stylus, horizontal line of pricking about
 half-way up sheet on right-hand side coming in as far as the chest of
 the right-hand man; lines of vertical pricking top and bottom about 15
 mm. right of pen line, with compass intersections top and bottom and
 on left thigh of central figure. 232 × 377 mm., irregular, made up lower
 centre.
The densely hatched style creates rounded, simplified forms, a necessary
preparation for a complex nude composition with sculpturesque ambitions.
The vertical pen line presumably indicates the new half-way point after
Raphael had decided to extend the composition to the left. The executioner
on the left was taken from cat. 252v. The baby's head at the top was used in
the engraving, but does not occur in any subsequent drawing. The
unpricked group far right may have been derived from a relief by Jacopo
Sansovino (Victoria and Albert Museum). The dimensions of cat. 287 and
cat. 288 are virtually identical with Marcantonio's engraving, but the
composition may not have been designed expressly for it.

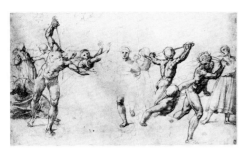

288r: The Massacre of the Innocents
 Windsor, Royal Collection 12737
 Red chalk over lead point, stylus and pouncing in black
 chalk. 232 × 377 mm., cut left, right and top.
Pounced through from cat. 287 (or a sheet pricked from that) as
can clearly be seen on the child held by the mother in the right
foreground (the head of the mother re-studied below). A
drawing intended to obtain subtleties of light and texture
excluded in cat. 287. There is a great variety of handling, from
the density of the rear executioner on the right to the broad,
lightly stumped style of the woman on the left. The chalk
moistened for some contours. Cat. 253v was drawn after this.

289v: Design for a salver
 Pen.
The motif of the sea-centaur pulling the hair of the female sea-
centaur on the far right is developed from the group on the right
of cat. 287. Raphael was designing dishes with flower patterns
for Agostino Chigi as early as 1510; see cat. 290.

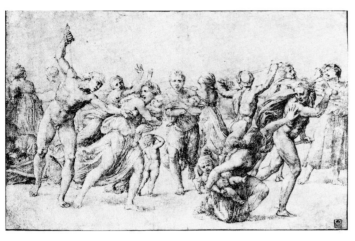

289: The Massacre of the Innocents
 Budapest, Museum of Fine Arts 2195
 Pen and two inks, light brown for the nudes, dark brown for
 the draped figures, on grey washed paper. 262 × 400 mm.,
 cut down left and right.
Identical with the engraving except for the omission of the two
dead children in the centre and left foregrounds (the former
prepared at the top of cat. 287). In detail, however, this
drawing, although heavily worked, is considerably more
sensitive to facial expression and texture than the engraving,
and it is probably Raphael's final design for it, rather than the
work of Marcantonio, the only likely alternative. The slight
reinforcements visible round some contours are not necessarily
later.

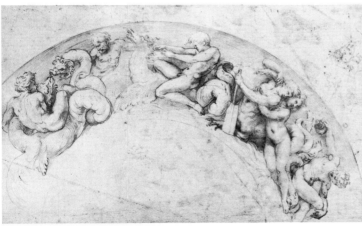

290: Design for a salver
 Oxford, Ashmolean 572
 Pen over stylus or faded lead point; red chalk sketches
 at right. 232 × 369 mm.
Closely related to cat. 288v and presumably developed
from it. Competently drawn, with difficult foreshorten-
ings accurately handled. Nevertheless, a slight dullness
and evenness in the execution suggests that it is by an
assistant (Penni?), though it is possible that Raphael
intervened in sharpening some of the contours, especially
on the right. The red chalk head with curling snake's
body, upper right, is close to Satan's head in the *Fall* in the
Loggia. Professor Shearman has noted a date of 152[?] in
the cartouche below it. If this is the date of the drawing, it
can only be a copy of a much earlier design, but it is
probably a later addition, for it lacks any apparent
connection with the main study.

291: Portrait head of Julius II
 Chatsworth 50
 Red chalk. 360 × 250 mm.
For the portrait in the National Gallery, London (1511; D.p. 29). See
commentary to Plate 23.

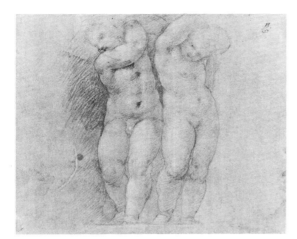

292: Copy of the two putti left of the Cumaean Sibyl by
 Michelangelo
 Oxford, Christ Church 1949
 Red chalk and white heightening on pink stained
 paper. 144 × 169 mm.
Despite a slight failure of rhythm in the legs, and the
slight slackness of the heads, the attribution to Raphael
may be correct, though the technique is unique for
him.

293: Two putti
 Frankfurt, Staedel 4301
 Red chalk, over stylus for lower putto, with touches of white
 heightening on lower putto. 180 × 57 mm., irregular, cut
 down all round.
The upper putto is clearly based, in reverse, on Michelangelo's
God Creating the Sun and Moon. The lower one is close in mood,
but not in pose, to the putti at the base of the *Sistine Madonna*.
Probably of *c.* 1512.

294r: Putto with sea monster (twice); putto (Ganymede?) with eagle
 (three times)
 Florence, Uffizi 1474E
 Pen; black chalk over stylus. Squared in stylus at 30 mm. on left, partial
 circles in stylus. 233 × 180 mm., irregular, a rectangle made up
 upper left, the lower right corner made up.
The putto with a sea monster is probably a design for a small fountain in
which the water would gush from the monster's mouth. The light
sketches of a putto and eagle may be for an exterior decorative painting;
they are taken up in cat. 295.

294v: Studies of a putto; ground plans and partial elevation of the Stalle
 Chigiane
 Pen, red chalk.
The elevation analyses a group of pilasters. The largest putto, right, seems
to be astride an urn (presumably an alternative fountain design). The
lowest putto on the right is reminiscent of the one in the foreground of the
Galatea (Rome, Farnesina; D.p. 99), of *c.* 1514. The larger figure was
developed from the sketch at lower left on cat. 202v. The Stalle Chigiane
were Raphael's first large architectural commission, and initiated a long
series of works for Agostino Chigi.

295: Putto with eagle (Ganymede and Jupiter?)
 London, British Museum 1868–8–8–3180
 Red chalk; the outlines indented with stylus, the verso blackened for transfer.
 120 × 142 mm., cut all round.
Ganymede is sketched again in a more active, Michelangelesque, pose on the right side of the
eagle, facing out to his right. The type of putto is similar to cat. 293. The handling of red chalk is
comparable with the Pace drawings (cat. 298 ff.)

296r: The entablature of the Pantheon
 London, R.I.B.A. XIII/IP
 Pen, traces of black chalk lower left. 238 × 186 mm.
A measured study of a detail of the Pantheon, which Raphael had
drawn some years earlier (cat. 196); perhaps a preparation for his own
architectural work.

296v: The window zone of the Pantheon
 Pen, red chalk.
A pictorial sketch, unlike the diagrammatic recto. The window is
drawn free-hand, and its cornice is studied again upper right. The use
of red chalk for the main cornice emphasizes its sculptural character
under a play of light and as seen from a distance – it is the general
effect that concerns Raphael here, not the precise detail.

c. 1511–12 Studies for the Chapel of Agostino Chigi in Santa Maria della Pace (D. pp. 93–5) (cat. 297–315, see also 228v, 255v, 333v)

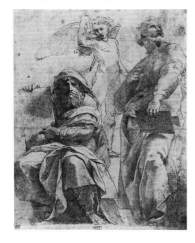

1. Prophets and Sibyls (cat. 297–303)

297: Hosea and Jonah
 Los Angeles, Hammer Foundation
 Pen, brush and wash, white heightening, squared under the figures in
 stylus, over in red chalk at 28 mm. 262 × 198 mm.
An unusual combination of techniques which reflects the influence of
Michelangelo's drawings for the *Cascina*. The seated Hosea is based on
Michelangelo's *Moses*.

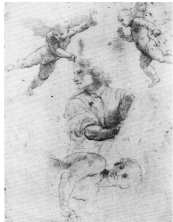

298: Daniel, the angel behind Daniel and David; the putto above them; the
 putto above Hosea and Jonah
 Florence, Uffizi 544E
 Red chalk. 332 × 239 mm.
Detailed studies employed with little change in the fresco. The handling
ranges from the soft, stumped shadows of the left-hand putto to the broad,
open hatching on the right-hand putto's legs. Raphael's final objective was
broad masses of fairly smooth modelling, heavier and less plastic in
individual parts than in the Sibyls below. The treatment of Daniel's
drapery, with thin, curving lines employed for the folds and a thin ridge of
light left between them and the shadow looks forward to Raphael's chalk
style of *c.* 1514.

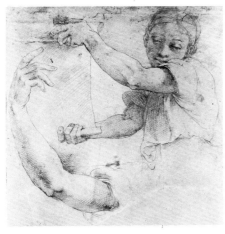

299: An angel; the right arm of the Cumaean (?) Sibyl
 Vienna, Albertina Bd. V, 17573
 Red chalk. 215 × 217 mm., cut down all round, made up lower
 left corner, lower right corner, upper edge. The top of the
 angel's head and part of the left thumb are restoration.
See commentary to Plate 27.

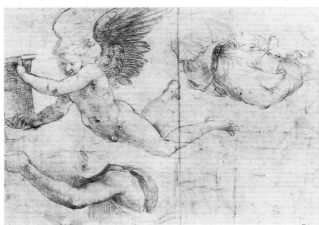

300: The angel above the Cumaean (?) Sibyl
 Vienna, Albertina Z. G. Bd. VII, 17574
 Red chalk over stylus; slightly worn.
 272 × 369 mm.
Less concerned with surface texture than
cat. 299, and more concerned with move-
ment and overall pose. The pattern of the
drapery still has affinities with cat. 216v, but
it is more complex and more richly rendered.

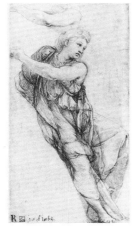

301: The Phrygian (?) Sibyl
 Oxford, Ashmolean 562
 Red chalk over stylus, corrections in black chalk
 on draperies; perhaps counterproofed.
 363 × 189 mm., cut down left and right.
The drawing of the left arm is close to that of cat. 299,
but the chalk style is less rigorous, modulating from
rubbed areas in the shadows on the left, to a
directional hatching of very light fine lines on the
face. Broad parallel or cross-hatching is used for areas
of flat shadow. The black chalk correction (cf.
cat. 326, 340) gives a sweeping curve to the draperies.
The head type is close to cat. 278.

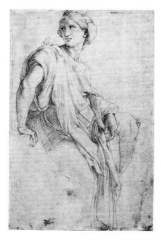

302r: The Phrygian (?) Sibyl
 London, British Museum 1953–10–10–1
 Red chalk over stylus. 262 × 167 mm., cut at
 right, top and bottom.
See commentary to Plate 28.

302v: Study of drapery
 Red chalk over stylus.
A very dense and rich study, voluptuous in its
treatment of the thick swags of drapery. The
modulation of form is observed with the
greatest precision. The positioning of the left
foot on a vase suggests strongly that this was
intended for an earlier version of the Tiburtine
(?) Sibyl. For this type of drapery cf.
cat. 319 ff.

303: The Tiburtine (?) Sibyl
 Vienna, Albertina Bd. V, 181
 Red chalk over stylus, a touch of ink (later?)
 round feet; possibly counterproofed.
 279 × 172 mm., cut down left and right.
A fast study of a complex pose, with the legs
elaborately crossed. Less densely worked than
cat. 302r, but comparable with the more open
parts of cat. 301. The vigorous diamond-pattern
hatching on the support on the left was to become
a frequent feature in later red chalk drawings by
Raphael and his school.

2. The Resurrection (cat. 304–11)

304r: The Resurrection
 Bayonne, Musée Bonnat 1707
 Pen, touches of red chalk, a faint semicircle at top.
 406 × 275 mm., cut left and right.
Presumably drawn after cat. 306v and before cat. 305r. A calmer
compositional draft, which must have been preceded by studies of
Christ and the surrounding angels, since their complex forms are
realized without pentimenti. Christ is on a larger scale than the
other figures, both because He is further from the eye and for
dramatic effect. His pose inspired that in the *Transfiguration* (the
transference of a motif from one iconographical scheme to another
is characteristic), and the motif of the angels pushing back the
clouds was used on the Eliodoro ceiling. Very similar in style to
cat. 317r for Santa Maria del Popolo.

304v: Studies of torsos; outline of a woman's head
 Pen over stylus; pouncing in black chalk.
The torso studies are probably teaching drawings; the head of a
woman (barely visible in the original) is made up of pounce marks
which were never connected; she is turning up to her right (our left),
and has a straight nose, turned up eyes and slightly protuberant lips
– a pose reminiscent, in reverse, of the head of the standing woman at
the left of the *Bolsena*.

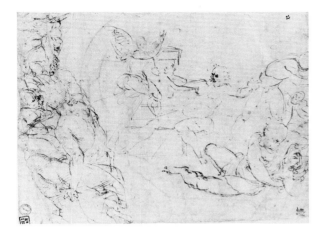

305r: Guards and an angel
 Oxford, Ashmolean 558
 Pen. 208 × 262 mm., cut all round, irregular, made up at bottom.
A development of cat. 306v and 304r, with the guards now in more formal, less naturalistic, poses. The reclining guard on the right was influenced by a figure in Michelangelo's *Cascina*; the seated guard on the left by one of his *ignudi*. Both were fully studied, as was the fleeing guard upper right, in cat. 309, 306r and 307. But this drawing certainly does not represent the final composition, since other figures, equally carefully studied (cat. 310, 311), do not occur here.

305v: Two octagons inscribed within two concentric circles; a semicircle.
 Pen, ruler and compass.

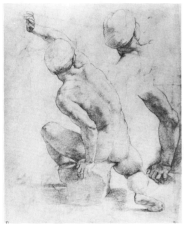
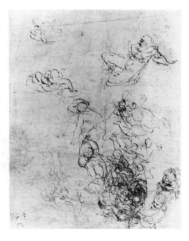

306r: Seated guard
 Oxford, Ashmolean 559
 Black chalk. 345 × 262 mm., cut at bottom, left and right, made up lower right edge.
The studies of the head and arm modify the dramatic focus of the main study; the guard now looks at Christ, the increased tension of the wrist stressing his involuntary recoil. The linear handling of black chalk in the main figure is designed to retain definition in the shadow, but creates a brittle effect when compared with cat. 310 or cat. 311, where the handling is richer. The main study demonstrates the difficulties of combining precise modelling and atmospheric continuity.

306v: Compositional studies
 Pen over stylus and traces of black chalk.
See commentary to Plate 29.

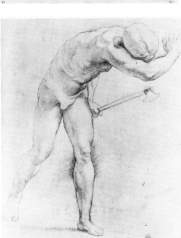

307r: Fleeing guard
 Windsor, Royal Collection 12735
 Black chalk, touches of charcoal. 321 × 256 mm., cut at bottom and right.
For the guard top right in cat. 304r and cat. 305r; subsequently used, in reverse, in the *Release of St Peter*. There are numerous pentimenti: the left leg was outlined further forward and the chest was initially lower; faint lines to the left may indicate the (reclining?) guard who appears on the right margin of cat. 305r. Despite the beauty of this study, the anatomy of the hips and abdomen has obviously given Raphael trouble. This figure may have been replaced by the original of cat. 255v. It is interesting to note that the figure casts a shadow to the left, indicating that Christ was not the sole source of light.

307v: Cows in a field
 Pen.
A unique example of a bucolic study: light and incisive in touch, combining solid structure and lively outline characterization. A prefiguring of the Campagna drawings of classicizing painters of the next century.

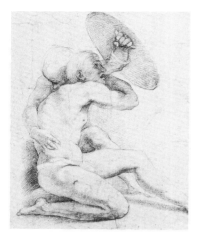

308: Two guards
 Windsor, Royal Collection 12736
 Black chalk, touches of charcoal. 266 × 224 mm. maximum,
 irregular, cut at top and right.
More contour hatching is employed here than in most of the drawings
in this series, and there is a particularly sensitive modulation of the
shadows, despite the difficulty in keeping them sufficiently light. A
study for the group just visible at the left of cat. 304r and cat. 305r.
The rear guard was adapted, in reverse, for the soldier immediately to
the right of Heliodorus. The external hatching to set off the figures is
much more extensive than in most Raphael drawings, and was later
taken up by Giulio.

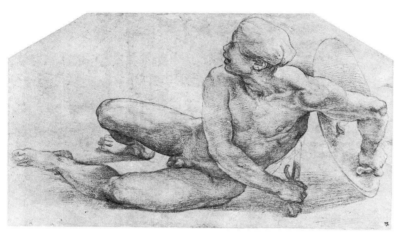

309: Recumbent guard
 Oxford, Ashmolean 560
 Black chalk. 185 × 315 mm., upper corners cut.
For the guard on the right in cat. 305r; one of the most plastic and rich
drawings of the first phase. The facial expression is close to that of the
woman in cat. 333v. Here Raphael has created less dramatic contrasts
and a more continuous tonal range with the subtlest variations. The
figure, employed with some changes for that of Heliodorus, derives
from the reclining soldier on the right of the *Cascina*.

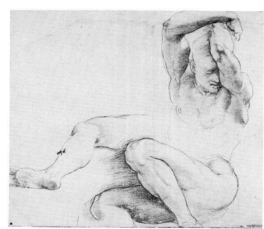

310: Guard
 London, British Museum 1854–5–13–11
 Black chalk. 293 × 327 mm., cut all round, made up upper
 and lower left corners, top edge; the upper right
 forearm is restoration.
See commentary to Plate 30.

311: Three guards
 Chatsworth 20
 Black chalk. 234 × 365 mm.
Like cat. 310, for the second phase of the *Resurrection* design. Used in reverse
for an engraving of a Bacchanal by Master H. F. E. (together with cat. 310, not
reversed). The engraving also includes a reference to cat. 233r, or a
development of it. The handling of chalk is richer and more lustrous than in
the drawings of the first phase, though it is not far from cat. 309, which
suggests a slightly, but only slightly, later date. These figures were finally
used in the *Resurrection* in the Loggia dado. The richness and suppleness of
these studies accounts for their former ascription to Michelangelo, whose
sensuous handling of the nude they echo.

3. The Roundels (cat. 312–15)

312r: Doubting Thomas
 Cambridge, Fitzwilliam Museum PD 125–1961
 Pen. 231 × 377 mm., cut all round.
A compositional sketch for the roundel intended to be placed to the right of
the *Resurrection*, sculpted in bronze by Lorenzetto and now at Chiaravalle.
The composition has affinities with cat. 257r and with the Tapestry cartoons,
which suggests a slightly later date for the roundels than for the rest of the
scheme. Although arranged as a frieze, the draperies are conceived for the
circular format, which is lightly sketched at lower left.

312v: Classical scene (?)
 Pen.
Obviously related in lack of rhythm, agitated gesticulation and weakness of
foreshortening to the Battle drawings of 1507–8, but also foreshadowing
elements of the *Ostia*. The range of poses and the individually studied groups
create a melodramatic dumb show without the dramatic coherence of the
earlier drawings. A puzzling drawing, whose subject, date and function
have yet to be elucidated. Although Raphael is usually credited with the
invention, there is no agreement about the authorship of the drawing.
However, the possibility that it is by Giulio Romano (*c.* 1515) should not be
excluded. It seems to be by the same hand as cat. 390.

313: Doubting Thomas
 Frankfurt, Staedel 4302
 Silverpoint on faded pink ground; some reinforcement with ink (?); contours indented; compass
 point in centre. 203 × 197 mm., corners trimmed and cut all round.
A very battered and worn sheet, but those parts which are legible, especially at the upper right, seem to
be by Raphael's hand. Developed from cat. 312r; probably the *modello* for Lorenzetto.

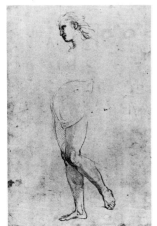

314: Study for Christ in the Descent into Limbo
 Lille, Musée des Beaux-Arts 439
 Pen over stylus, the arms in stylus only, the right bent up, the left stretched
 forward. 401 × 261 mm.
A hard, dynamic study drawn on soft paper, intended as a guide to the sculptor
for the effects desired in chiselling. More potent than the final design (cat. 315),
which was modified in the interests of clarity. The handling of the pen has some
links with cat. 343 and cat. 355.

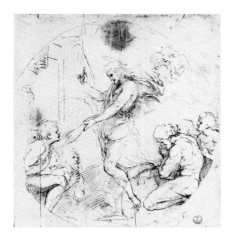

315r: The Descent into Limbo
 Florence, Uffizi 1475E
 Pen, the tondo in stylus. 209 × 205 mm., cut at left
 and bottom.
Christ forms the central vertical but simultaneously
echoes the curving frame with different parts of His
body and drapery. Some contours have been rein-
forced, probably by the artist. The staff and flag are
lightly sketched behind Christ, and the shadowed areas
are deliberately flattened. Probably the *modello* for
Lorenzetto.

315v: The Apollo Belvedere
 Pen over lead point.
A dynamic copy in which, perhaps under the influence
of Michelangelo, the neck is thickened and made more
powerful; the scale-like outlining of the muscles over
the ribs is a formula that is here used with potent effect.

1512–16 The Chigi Chapel in Santa Maria del Popolo (D. pp. 95–6) (cat. 316–17, 246v; see also 386–8)

316: Ground plan
 Florence, Uffizi A.165
 Pen, brush and wash, stylus and compass work, on squared paper.
 315 × 270 mm.
Presumably drawn at the beginning of work, *c.* 1512. The attribution
rests more on the handwriting and on the fact that it is clearly
preparatory rather than a fair copy by an assistant, than on drawing
style. But the dense application of wash is characteristic of *modelli* of
this period.

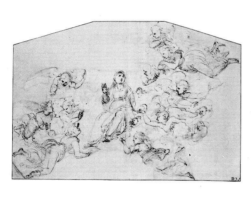 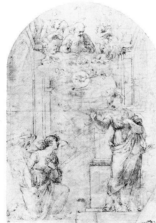

317r: The Assumption of the Virgin
 Stockholm, Nationalmuseum 291/2
 Pen over black chalk. 433 × 276 mm., cut down to frame verso
 composition, patched extensively at upper left, lower left, right
 edge and lower corner.
Developed from cat. 246v for the altarpiece. The similarity with
cat. 304r in the treatment of the angels is particularly close, and both
projects were probably initiated at the same time.

317v: The Annunciation
 Pen over black chalk.
A rare instance of Raphael using the recto and verso of a sheet some
years apart. This drawing dates from *c.* 1506–7 and may have been
for the same project as the painting by Albertinelli (Florence,
Accademia; s.d. 1510), with which it has many similarities. Certainly
the careful if rather dull detailing and the systematic treatment of the
shadows suggest a drawing for presentation to a prospective client.

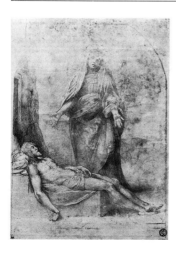

318: Pietà
 Paris, Louvre 3858
 Brush and grey-brown wash, white
 heightening over black chalk, compass
 marks 304 × 215 mm.
Engraved by Raimondi, but presumably
designed for an unknown and probably
unexecuted painted commission. The st-
rength of the composition, which was very
influential, looks forward to the style of the
Tapestry cartoons; this design, however, is
probably earlier. The drawing is often given
to Penni, but seems plastic enough to be by
Raphael.

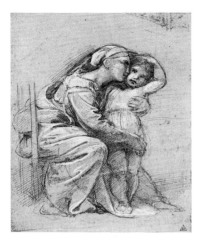

319: Mother and child
 Oxford, Ashmolean 561
 Silverpoint and white heightening on grey ground. 161 × 128 mm.
A companion piece to cat. 320; both were engraved by Raimondi, and were
perhaps executed in silverpoint for that purpose. It is essentially domestic
and realistic in its emphasis, and neither figure is haloed. The design is of
extraordinary compactness, creating a cameo-like effect. The grey ground
evokes an interior setting, and the thick white heightening a sharp,
contrasting fall of light. The child type links with *Bolsena*, the composition
and drapery with the *Madonna della Sedia* (Florence, Pitti; D. p. 36). The
composition is a good example of interlocked form suggesting interlocked
emotion.

320: Mother reading with child
 Chatsworth 728
 Silverpoint and white heightening on grey ground. 190 × 140 mm.
Identical in character to cat. 319, with a rather more freely drawn child.
Although hardly a life drawing, the scene presents a distillation of domestic
intimacy. A type of design which greatly influenced Parmigianino.

321: Virgin, Child and St Joseph
 Florence, Uffizi 499E
 Silverpoint and white heightening on grey ground. 123 × 101 mm.,
 cut all round.
The domestic mood is now transferred to the open. The movement,
combining that of the *Holy Family with the Lamb* (Madrid, Prado)
and the Doni tondo, is from upper left to lower right and from rear to
front. The Campagna head-dress of the Virgin was to prove
enormously popular. The Child is close to cat. 319; His toes turned
together and His concentrated attention evince the most careful study
of life. The emphasis of this moment suggests a renewed acquaintance
with children. The white heightening, although rubbed, was more
lavishly applied than in cat. 319, 320, in order to indicate bright
afternoon sunlight.

322: The Virgin kneeling
 Florence, Uffizi 500E
 Silverpoint on grey ground. 83 × 74 mm. maximum; irregular, cut
 down all round.
As in cat. 321, silverpoints of different thicknesses have been used.
This drawing also suggests a reconsideration of Raphael's late
Florentine ideas, especially in the Virgin's gesture. Clearly a study for
cat. 323.

323: Virgin, Child and St Joseph
Florence, Uffizi 502E
Silverpoint and white heightening on grey ground, pricked for transfer and scaled at bottom and sides at 16 mm., framed in red chalk. 172 × 129 mm., cut down to framing lines.

Alternatively framed as a tondo and with an arched top. In part a reconsideration of Florentine forms, with the Child probably based on a Botticelli design. The motif connects with the *Madonna di Loreto* (Chantilly, Musée Condé) and the *Madonna of the Diadem* (Paris, Louvre; D. p. 28). The St Joseph resembles the man on the right of cat. 257v. The relative simplicity of the detailing (the slightly wooden hands and arms of the Virgin) suggest that this might have been intended for pupil execution.

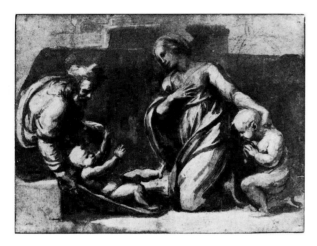

324: Holy Family
Oxford, Ashmolean 571
Brush and dark-brown wash and white heightening over black chalk; the tondo in stylus, a stylus centre plumb-line, a right-angled intersection in stylus in the left corner. 197 × 249 mm.

This damaged *modello* for a painted tondo at Cava dei Tirreni, traditionally ascribed to Penni, seems to have been drawn with less imagination than one would expect from Raphael, although it comes close to his style and has been ascribed to him. The application of wash in two tones, and the excessive use of white with little gradation, smacks of a personality preferring the routine to the difficult, and the contours of the Child's leg lack decisiveness. The concentration of attention, however, is very well caught (the Virgin is surely more convincing than in cat. 323), even if psychological differentiation is lacking: probably by Penni *c.* 1514–15 (cf. cat. 352).

c. 1512 Studies for the *Madonna dell'Impannata* (Florence, Pitti; D. p. 38) (cat. 325–6)

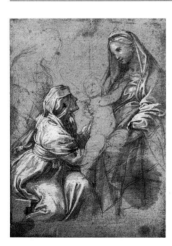

325: Compositional study
Windsor, Royal Collection 12742
Silverpoint and partly oxidized white heightening on faded buff-grey ground; a central plumb-line. 210 × 145 mm., cut at right and left.

The use of white is closely comparable to cat. 319 and cat. 320, also for interior scenes. St Elizabeth is reminiscent of the Tiburtine (?) Sibyl (cat. 303), the Child of that in the *Aldobrandini Madonna*. This composition corresponds to the underpainting of the picture, which was subsequently completed in a different form. However, the change must have been decided upon soon after the painting was begun since cat. 326 can hardly be much later.

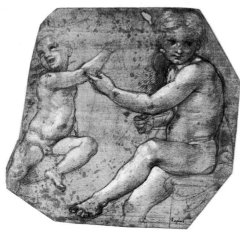

326: The Child and St John
Berlin-Dahlem, Kupferstichkabinett 2231
Silverpoint and white heightening on grey ground, black chalk correction of the arms of St John and overworking in ink (by Raphael?) 210 × 208 mm. maximum, irregular, cut down all round.

The application of white is broader than in cat. 325, presumably because it is on a larger scale. It anticipates the highly contrasted manner of the completed painting, though not its coarseness. The technique and characterization suggest that the addition of St John was decided upon very soon after cat. 325 and the beginning of the painting, although the painting was completed considerably later.

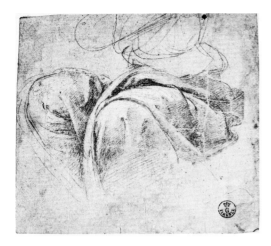

327: Drapery study
 Florence, Uffizi 1325F
 Silverpoint on grey ground. 108 × 119 mm. maximum,
 irregular, cut at top, bottom and left.
Close in the drapery forms (and pose, in reverse) to St
Elizabeth in cat. 325. Cf. also the Pace Sibyls.

328r: The Coronation of the Virgin surrounded by putti; male figure
 Bayonne, Musée Bonnat 1718
 Pen, paler ink for the Coronation group, darker for the putti; in
 very poor condition. 323 × 269 mm., cut on all sides, made up
 upper right, lower right, lower left.
In the centre, a light outline sketch of Christ crowning the Virgin,
seated on a throne. The lively putti encircling them are difficult to
account for: they do appear to form a connected group, but their
poses and attitudes seem more suited to a pagan than to a sacred
composition, and they were added after the central group; they may
represent no more than a *jeu d'esprit* on Raphael's part. A figure in
outline (with the left edge as base) is close in pose to the executioner
in the first version of the *Judgement of Solomon* (cf. cat. 252r).

328v: The Coronation of the Virgin
 Pen, over stylus in central group.
Very difficult to read in the original. The basic composition is
sketched twice: (above) the Coronation takes place on a round-
topped throne within two round arches, one encompassing the
angels top left, the other, considerably wider, including the standing
saints left and right, making a composition almost as wide as it is
high; (below) a Coronation under a *baldacchino* (taking up Raphael's
late Florentine altarpiece and anticipating the niched popes in the
Sala di Costantino), with angels left and right. The throne is similar to
the sanctuary wall in the *Bolsena*; the system of arches is that of the
Segnatura – early Eliodoro phase.

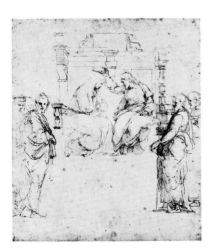

329: The Coronation of the Virgin with Sts Peter, Paul, Jerome and
 Francis Oxford, Ashmolean 565
 Pen over stylus, stylus lines at bottom and top. 353 × 288 mm.
See commentary to Plate 33.

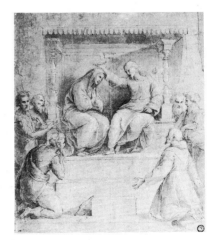

330: The Coronation of the Virgin with Sts Peter, Paul, Francis,
 Jerome, John the Baptist and another saint
 Paris, Louvre 3883
 Pen, brush and wash and white heightening over black chalk;
 stylus under kneeling figures. 319 × 271 mm.
See commentary to Plate 33.

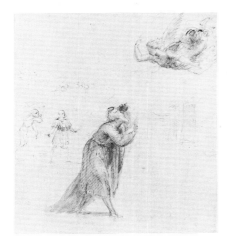

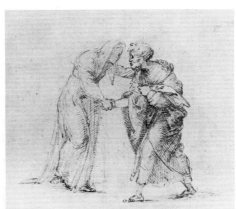

331r: The angel appearing to Joachim
 Oxford, Ashmolean 563
 Pen, brush and wash, with white heightening over
 black chalk. 314 × 276 mm., cut at left and right.
The pose and drapery of the angel link with the angels
for the Pace Chapel; the looping execution of the
background figure far left is reminiscent of the sleeping
figure in cat. 265r. The use of wash and white heighten-
ing over thick chalk looks forward to the *modelli* for the
Loggia, but similarity is one of function rather than
date. Perhaps a design for a predella panel for the
altarpiece (?) prepared in cat. 329, 330.

331v: The meeting of Joachim and St Anne
 Pen over black chalk. Window mounted,
 160 × 184 mm.
A slightly caricatural drawing, again suitable for a legible
narrative design for a predella panel. For the execution of
Joachim cf. cat. 190r. Like the recto, more homely and
anecdotal in characterization than is usual for Raphael,
though elegant and complex in pose. The figures are
adapted in the border of the *Sacrifice at Lystra* (Vatican
D. p. 103).

1511–14 Studies for the Stanza d'Eliodoro (D. p. 78–82) (cat. 332–47)

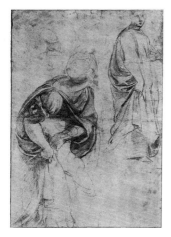

1. The Expulsion of Heliodorus, *c*. 1511–12 (cat. 332–6)

332: Woman and child; standing man
 Zurich, Kunsthaus N.56 III
 Black chalk. 400 × 260 mm., cut at top, bottom and right.
The pose was changed to a kneeling one in cat. 333v. The man was probably a
first idea for the figure on the left of the fresco. The combination of fairly solid
lines and broad shading on the man looks forward to the evocative black chalk
style of Raphael's last years. The precise detail of the woman's complex sleeve,
set against the broad sweep of her cloak, acts as a reinforcement of her protective
gesture.

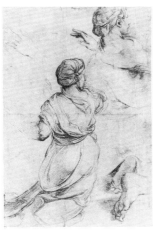

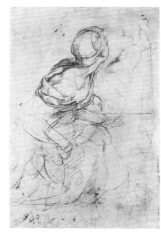

333r: Frightened woman
 Oxford, Ashmolean 557
 Black chalk. 395 × 258 mm., cut slightly all
 round.
See commentary to Plate 31.

333v: Woman and two children; sketches for
 prophets in Santa Maria della Pace
 Black chalk.
See commentary to Plate 32.

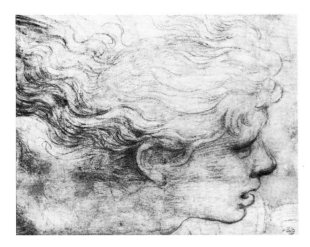

334: Head of an angel
 Paris, Louvre 3852
 Black chalk, pricked for transfer. 277 × 341 mm.,
 on two sheets of paper; made up upper right
 edge; the upper lip restoration, repairs else-
 where.
A cartoon fragment, combining clarity, firmness
and dynamic rhythm. The sweeping lines of the hair
and the darkened brows convey speed and con-
centration. The handling is broad and of extreme
confidence; the jaw is modelled rapidly with a few
strokes of the chalk.

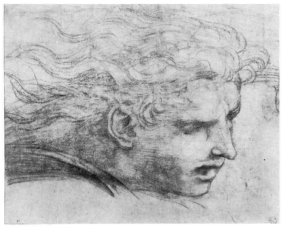

335: Head of an angel
 Paris, Louvre 3853
 Black chalk, pricked for transfer. 268 × 329 mm.,
 irregular, on three pieces of paper; lower right
 edge made up; the whole lower section rising
 from below the chin on the right to the level of
 the mouth on the left edge is restoration, pricked
 for conformity.
Characterized differently from cat. 334, with a longer
pointed nose. The streamlined effect has here been
enhanced by the cloak. The tip of the switch is visible
upper right. The modelling of the jaw has been
achieved by a fanning out of the strokes of the chalk.

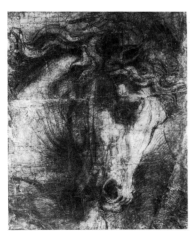

336: Head of a horse
 Oxford, Ashmolean 556
 Black chalk, pricked for transfer. 682 × 553 mm., on eight (?) pieces of
 paper; areas of damage.
Clearly influenced by Leonardo, especially by the horses in the *Anghiari*.
The shape of the head was also influenced by ancient models. The
stylization of the eye and the oval of the nostril are also seen in cat. 340.
These cartoon fragments represent a high point of energy in Raphael's
drawings.

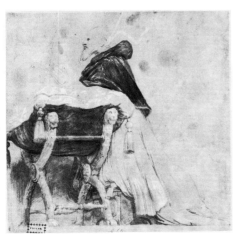

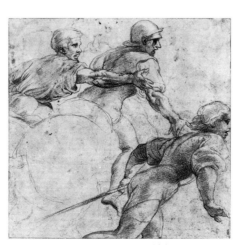

2. The *Mass of Bolsena, c.* 1511–12 (cat. 337)

337r: Pope Julius II kneeling in prayer
 Haarlem, Teylers Museum A.78
 Brush and grey wash, white heightening over lead
 point. 247 × 242 mm., cut all round (?)
Extremely close in pose and position to the figure in
the fresco, though with a more emaciated characteri-
zation of the Pope. A lack of vivacity in the wash and
an absence of described texture suggest that this is a
copy of a lost drawing, rather than an original.

337v: Three soldiers for the *Conversion of Saul*
 Red chalk.
A copy of cat. 362, made before it was cut down.

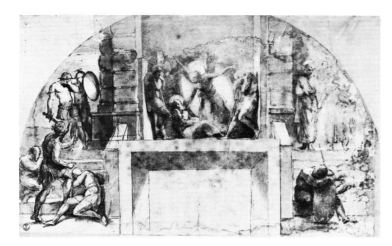

3. The *Release of St Peter*, c. 1512–13 (cat. 338)

338: The Release of St Peter
 Florence, Uffizi 536E
 Pen, brush and wash, white heightening (partly oxidized) on tinted
 paper. 257 × 415 mm. maximum, made up right edge and top centre,
 many areas of damage.
Drawn before Raphael had decided to employ the figure devised for the
Resurrection (cat. 307r) and before the inclusion of the grille. An exercise in
the drama of light, with a relatively loose description of form. There is
considerable variation between the black chalk underdrawing and the
wash layer, especially on the left, and a great variety and subtlety of
gradation in the wash. Cf. cat. 324 for differences and cat. 349 for
similarities. The guard top left is similar in stance and physique to Pope
Leo's groom in the *Repulse of Attila*.

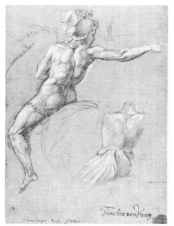

4. The *Repulse of Attila, c.* 1513–14 (cat. 339–41)

339: Rider
 Frankfurt, Staedel 1797
 Silverpoint and white heightening on grey ground. 197 × 145 mm.
The rider was first drawn with very close-fitting armour, then with a less
anatomical cuirass and skirt. The fast and confident handling, and the white
applied almost as if for an interior, are an indication that Raphael was here
aiming at more polished surface effects. The outline of the left arm and side
was sketched again between the two main drawings. The use of silverpoint
suggests that Raphael intended to abandon the painterly style of the other
frescoes in this room, and the lack of interest in three-dimensional modelling
prepares the silhouette-emphasizing style of this fresco and those in the
Incendio. This drawing was made for the first project (recorded in a copy in
the Ashmolean (P 645)).

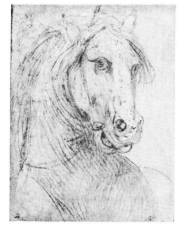

340: Horse seen from the front
 New York, Woodner Collection
 Silverpoint and white heightening (partly oxidized) on grey ground; re-
 worked in black chalk to lower the hindquarters. 144 × 106 mm.
For the type of the head, cf. cat. 336; for the re-working of a sharp medium in
soft black chalk, cf. cat. 301 and cat. 326. Perhaps drawn as a study for the
lost first design (copy in the Ashmolean (P 645)) then modified for the left-
hand horse in the central group in cat. 341. The great vitality and plastic
precision in this quick drawing, with very little hatching except under the
left eye, shows the sharpness of Raphael's command of form. For the short,
regular hatching strokes, cf. cat. 346r. I am grateful to Noël Annesley and
Nicholas Turner for bringing this drawing to my attention.

341: The Repulse of Attila
 Paris, Louvre 3873
 Silverpoint, brush and wash, white heightening on parchment; the
 lunette inscribed in stylus; badly worn. 361 × 590 mm.
Believed to be by Raphael as early as 1530, but probably a copy of a
modello for the second project. The enlargement of the composition to a
rectangle and the subsequent inscription of the lunette would be
pointless for a working *modello*, and the unique use of parchment
suggests a presentation drawing. The authorship should be Raphael's,
but the insipidity of the characterization, especially on the right, the
comparative stiffness of the gestures, the weaknesses of the perspective,
and the delicate but lifeless vegetation drawn in white on the left
suggest a pupil, probably Penni (cf. Stockholm No. 350). Although
Raphael certainly wanted a slight flatness in the forms (cf. cat. 339), it is
difficult to believe he could have been fully responsible for the
ungainliness and lack of substance of many of the figures here. Quite
possibly drawn later than c. 1513.

5. The Vault, 1514 (cat. 342–5)

342r: Study for God the Father appearing to Moses; St Helen (later
 inscribed Danae); St Peter's
 Florence, Uffizi 1973F
 Pen, brush and wash (on St Helen), traces of black chalk.
 264 × 365 mm., cut all round, made up upper left corner.
Lively studies for the angels accompanying God the Father,
developed from cat. 304r and cat. 317r, where the motif of pulling
back the clouds was also used. Here the strip-like clouds derive from
Dürer. St Helen, later engraved by Raimondi, has qualities of the
Madonna drawings cat. 319, 320, and the very broad use of wash for
shadow rather than modelling corresponds to the tonal use of the
grey ground. The architectural study lower right is undoubtedly for
St Peter's of which Raphael became architect in 1514. This, pre-
sumably, was also the date of the re-planning of the Eliodoro ceiling.

342v: Studies in vault construction; column bases; geometrical
 forms; the Eliodoro ceiling
 Pen, black chalk for the Eliodoro ceiling.
The architectural and geometrical sketches are presumably all
connected with St Peter's; the sketch lower right shows the Eliodoro
ceiling with the stud of the central rib removed (though the line of
the rib is still present), documenting the process of reducing eight
fields to four, to provide areas large enough for painted narratives.

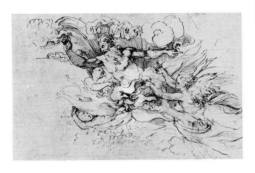

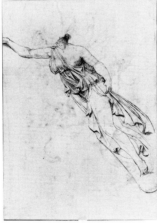

343r: God the Father appearing to Moses
 Oxford, Ashmolean 462
 Pen over traces of black chalk, squared in black chalk at 30 mm.
 271 × 401 mm., cut at top, bottom and right.
See commentary to Plate 34.

343v: Sculpted spandrel figure of Victory
 Pen.
Copied from the Arch of Titus. The drawing shows many of the same
characteristics as the recto, and has the clarity of printed line.
Probably by Raphael himself.

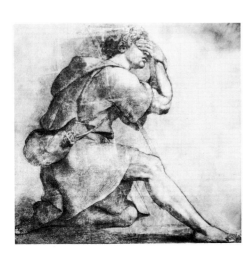

344: Moses
 Naples, Capodimonte 86653
 Black chalk and white heightening, pricked for transfer.
 1380 × 1400 mm., irregular, made up left and right; on
 fourteen (?) pieces of paper.
The combination of hard contour, areas of spared paper, and
dense, hard-edged shadow corresponds on a large scale to the
pen technique of cat. 343, as does the use of long strokes
following the movement of the drapery. The rubbed chalk is
treated rather like wash, spreading in flattish areas. The manner
is conditioned both by the grisaille technique and by the need
for legibility, but it also exemplifies the dark polished style
with which Raphael was experimenting at this period.

345: Putto carrying the Medici
Ring and Feathers
Haarlem, Teylers Museum A.57
Black chalk and white heighten-
ing. 339 × 186 mm.
See commentary to Plate 41.

6. The Dado, 1514 (cat. 346–7)

346r: A caryatid
Oxford, Ashmolean 569B
Silverpoint on faded pink ground. 146 × 98 mm., cut down all
round (?)
Almost certainly designed for the *dado* of the Stanza d'Eliodoro, but
not included there; employed instead in a modified form in the
tapestry of the *Conversion of the Proconsul* (Vatican; D. p. 103).

346v: A herm urinating
Pen, some splashes of wash.
A unique example of visual wit, perhaps intended for a temporary
secular display. One of Raphael's lightest sketches, unrecognizable
as his without the recto.

347: Caryatid at far right under the *Release of St Peter*
Paris, Louvre 3877
Red chalk over stylus, probably counterproofed. 259 × 131 mm.
A controversial drawing. The elegance of the conception must be set against the
comparative weakness of the contour of the left arm, the insubstantiality and
unconvincing placement of the legs, the poor definition of the wallet behind the back
(cf. cat. 344) and the unincisive hatching. The treatment of the light is planned for
grisaille, but the application of chalk is routine and ignores local felicities of shape; the
edge of the drapery, for example, is particularly dull compared with cat. 346r. Either by
Raphael at his weakest or by a pupil (Penni?) at his strongest. Cf. also cat. 354.

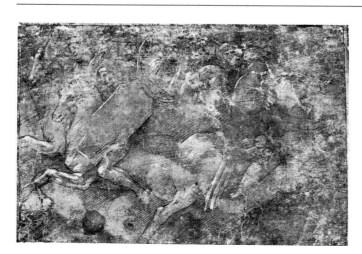

348: Battle relief from the Arch of Constantine
Munich, Graphische Sammlung 2460
Silverpoint and white heightening on grey ground. 150 × 214 mm.
A copy with many changes, demonstrating Raphael's interest in repeated forms and
spatial compression at this moment. The head of the foremost cavalryman on the
left is facing forward rather than turned round as in the relief. Perhaps part of the
preparation of the *Repulse of Attila*.

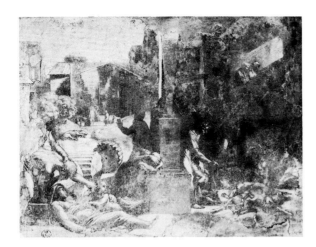

349: The *Morbetto*
 Florence, Uffizi 525E
 Brush and wash with white heightening over black chalk and stylus. 200 × 249 mm., made up on all four sides, many losses.
A ruined drawing, close in style, figure types and architecture to cat. 338. Raphael brilliantly contrasts the dark interior with the light exterior, yet so balances the emphases with powerful localized lights on the right and subtle *contre-jour* effects on the left that the composition does not split in two. Given the technique, this drawing was probably not intended for Marcantonio, though the composition was later engraved by him.

350: Landscape study for the *Morbetto*
 Windsor, Royal Collection 0117
 Silverpoint and white heightening on buff ground. 210 × 141 mm.
Anticipating classical landscapes of the seventeenth century in its solidity and clarity of structure, though probably a fairly accurate rendering of a corner of Trajan's forum. The technique is unusual for a landscape, but the ground provides a dark tone against which the white flares like sunlit patches in the late afternoon. The treatment of white was obviously a source for drawings by Penni (?), e.g. cat. 341. The delicacy is such that even shrubs growing from the ruins are depicted.

c. 1514 Studies for the *Madonna del Pesce* (Madrid, Prado; D. p. 38) (cat. 351–2)

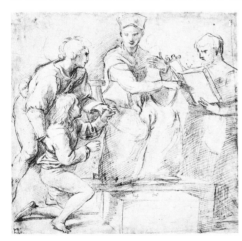

351: Compositional study
 Florence, Uffizi 524E
 Red chalk, traces of black chalk, touches of white, framed in stylus on left, in red chalk on right. 268 × 264 mm., cut down at top, right and (?) left.
A fast, incisive drawing, identical in range of touch to cat. 358, with dense, expressive modelling for the face and body of the angel on the left and diagrammatic blocking-out and cross-hatching for St Jerome on the right. The Virgin and Child are studied from a model holding a bolster; the Virgin's head-dress is characterized as the Campagna bonnet seen in cat. 321. The fish held by Tobias is lightly indicated, the oblique setting already defined.

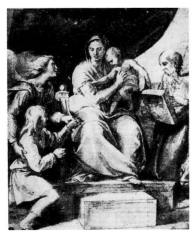

*352: *Modello* for the *Madonna del Pesce*
 London, Private Collection (2)
 Brush and wash over black chalk, squared in black chalk. 258 × 213 mm.
The painting was executed by pupils, with the exception of the Virgin's head, which was executed by Raphael. This drawing is usually given to Raphael, but is not impossibly by Penni (cf. cat. 324).

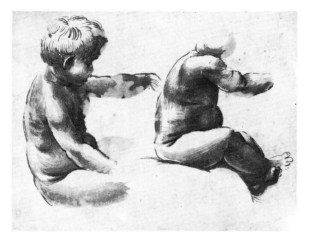

353: Studies for the *Madonna dei Candelabri*
 Oxford, Ashmolean 576
 Brush and wash. 160 × 203 mm.
The right-hand study was used with little alteration in the *Madonna dei Candelabri* (Baltimore, Walters Art Gallery; D. p. 56), executed by Raphael (the Virgin's face) and his assistants *c.* 1515. The application of two different tones of wash and the rather heavy contour are very close to cat. 324, although cat. 353 is of a higher quality and is in better condition. It is painstaking rather than spontaneous and lacks the incisiveness one would expect from Raphael. A borderline case, but more probably by a pupil (Penni?) than the master.

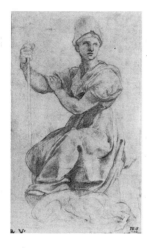

354: Female allegorical figure
 Oxford, Ashmolean 569A
 Red chalk (some restoration under right knee); probably counterproofed.
 267 × 154 mm.
Usually connected with the allegorical figures in the Sala di Costantino (the only surviving red chalk drawing for this scheme if this interpretation is correct). But so similar to cat. 344 in the way that the hatching curves to excavate the drapery, to cat. 347 in the facial type, and to cat. 343r in the hatching on the left arm, that it is virtually certainly of *c.* 1514–15, for an unknown project. The range of chalk handling is great, from rubbed areas of deep shadow to lighter, carefully modelled areas in the drapery, thin, silky lines round the sleeve, and parallel and contour hatching on the arms. It is this drawing in particular which casts doubt upon cat. 347.

c. 1514–16 Studies for the cartoons for tapestries of the Lives of Sts Peter and Paul, to be hung in the Sistine Chapel (D. pp. 101–8; the cartoons in the Royal Collection, on loan to the Victoria and Albert Museum, London; the tapestries in the Vatican) (cat. 355–66)

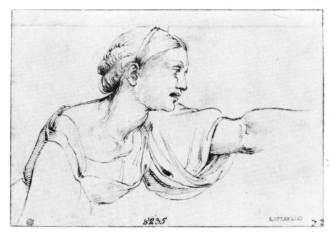

1. The Miraculous Draught of Fishes (cat. 355–7)

355: Study for the first version
 Munich, Graphische Sammlung 8235
 Pen over traces of black chalk. 100 × 138 mm., cut down all round.
A study for 356r, but, as Richard Harprath has pointed out, tenser in form and more intense in expression. The even, regular pen-strokes have led to an attribution to Giulio Romano or its dismissal as a copy, but the neo-woodcut style is congruent with cat. 343r, as is the technique of hard lines on soft paper. The flattening of form is intended to stress surface pattern, the basis of the relief style with which Raphael was experimenting at this time. The attribution to Raphael, while not certain, is more likely than the alternatives.

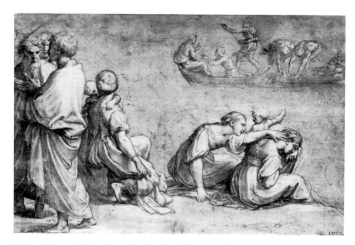

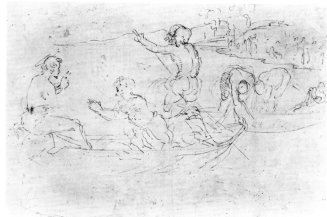

356r: Compositional study for the first version
 Vienna, Albertina Bd. VI, 192·
 Pen, brush and wash, white heightening over black chalk.
 228 × 327 mm.
Usually attributed to Giulio Romano, but almost certainly one of the
strongest surviving drawings by Penni, as attested by the technique, the
characterization and the other drawings for this scheme (cat. 357 and
cat. 368). There are many differences from the underdrawing, which may
have been traced from a sheet by Raphael, and the individual figures
certainly depend on Raphael drawings. At this stage the main event was
relegated to the background, as in the *Incendio*, suggesting that this must
have been one of the earliest projects of the series, executed before
Raphael determined the Masacciesque style.

356v: Compositional sketch for the final version
 Pen over black chalk.
Like the recto usually given to Giulio Romano, but surely by Raphael: a
brilliant sketch which documents the moment when Raphael saw that the
background group on the recto could be enlarged to form the whole
composition, and that the telephoto effect of a distant group transposed
to the foreground would enhance the surface pattern of the final tapestry.
One of Raphael's largest *concetti*, intensely vigorous and acutely
characterized. The third apostle from the left was shown gazing forward
in the chalk underdrawing and, at first, in pen; this was then cancelled
and he was shown facing the second boat. The psychological inventive-
ness is quintessentially Raphaelesque. For the handling, cf. cat. 258 (on a
smaller scale) and cat. 250.

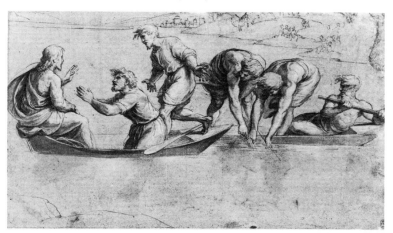

357: Compositional study for the final version
 Windsor, Royal Collection 12749
 Pen, brush and wash and white heightening, over black chalk; a
 horizontal line in red chalk upper left, horizontals in stylus 35 mm.
 and 80 mm. from the top on left, tilting down to *c.* 38 mm. and
 80 mm. on right. 201 × 339 mm., cut at top left and right; made up
 upper right corner.
A less fully finished *modello* by Penni; faded and perhaps over-cleaned.
There are pentimenti (though fewer than in cat. 356r) in Christ's back and
in the advancing St Andrew, especially in the drapery round the knee.

2. The *Pasce Oves* (cat. 358–60)

358: Christ; heads of three apostles; heads of five apostles
 Paris, Louvre 3854; Lexington, Kentucky, Private Collection
 Red chalk over stylus; counterproofed by Raphael. 256 × 133 mm.,
 irregular; 82 × 117 mm., irregular; 67 × 115 mm., irregular.
For these three fragments of a compositional study for the *Pasce Oves* see
cat. 359.

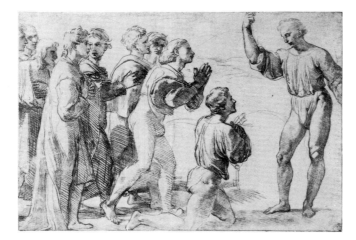

359: Compositional study (counterproof of cat. 358)
 Windsor, Royal Collection 12751
 Red chalk. 258 × 371 mm.
A counterproof made by Raphael to test the direction of the composition as in the tapestry. This drawing displays a great variety of handling from the smoothly finished heads and torsos of Christ and St Peter, to the rapid parallel hatching on the central group of apostles, and to the cross-hatched figure on the left. The contour lines may have been made in part with a moistened chalk. The same model was used for the fourth and sixth figures from the left. This drawing is very close in style to cat. 351.

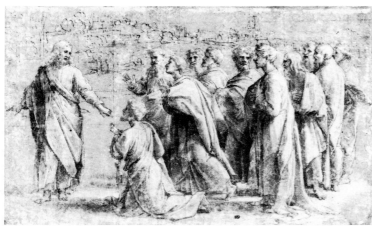

360: *Modello*
 Paris, Louvre 3863
 Pen, brush and wash, white heightening, over black chalk, on grey washed paper squared in black chalk at *c.* 33 mm. 221 × 354 mm.
See commentary to Plate 35.

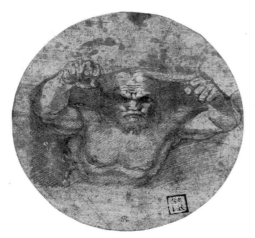

3. The Release of St Peter (cat. 361)

*361: Personification of an earthquake
 New York, The Pierpont Morgan Library 1977.45
 Silverpoint and white heightening on grey ground. Cut down to a tondo, diameter 114 mm.
A forceful study, presumably drawn in silverpoint because a powerful and clear relief was required for this foreground figure.

4. The Conversion of Saul (cat. 362)

362: Three soldiers
 Chatsworth 905
 Red chalk over stylus. 313 × 241 mm., cut down on all sides, made up upper left and lower left and right corners.
Copied on cat. 337v. Several changes were made between the stylus underdrawing and the chalk. A solid and dense study, with the chalk used to stress the basic masses of the bodies rather than the detailed excavation of drapery; the figures are slightly simplified so as not to detract from the central group. The open mouths were to become very much the dramatic trademark of Giulio Romano.

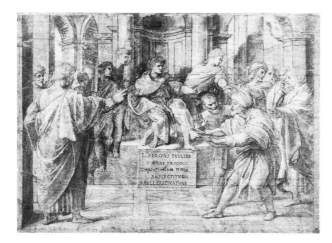

5. The Conversion of the Proconsul (cat. 363)

363: *Modello*
 Windsor, Royal Collection 12750
 Silverpoint heightened with white on grey ground, pen, brush and wash, a large
 number of construction lines; a horizontal through the main heads, the vanishing-
 point just above the pro-consul's right hand. 270 × 355 mm., made up top centre.
Presumably drawn in silverpoint, unlike the other surviving *modelli*, because of the
complex nature of the perspectival setting, which required a very precise definition of
the figures. The grey ground provides a mid-tone for this interior scene. Cat. 346r was
used for the statue at right in the tapestry.

6. The Sacrifice at Lystra (cat. 364)

364: St Paul tearing his garments
 Chatsworth 730
 Silverpoint and white heightening on blue-grey
 ground. 228 × 103 mm.
Drawn in silverpoint to sharpen the figure of St Paul in this
composition. With cat. 361 and cat. 363 one of Raphael's
latest surviving silverpoint drawings, capturing perfectly
the high emotional pitch of the action.

7. St Paul Preaching at Athens (cat. 365–6)

365: Compositional study
 Florence, Uffizi 540E
Red chalk over stylus (except for central figures in the middle
 ground). 278 × 419 mm.
Somewhat faded and worn. The same model was used for St Paul,
for the man on the right and perhaps for the seated figure. A
comparatively soft drawing, establishing the basic masses and
patterns of light and shade. The different responses are already
established, but the characterizations not yet precisely focused.
Not dissimilar in handling to cat. 372v and cat. 385, partaking of
the properties of black chalk as well as red. The use of flaring light
in the hair was to become a cliché with Raphael's pupils. Despite
the breadth of the drawing, the details of the drapery folds are
punctiliously established.

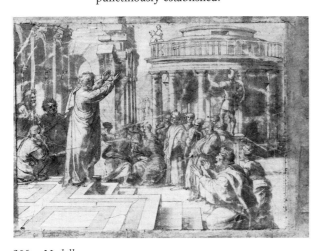

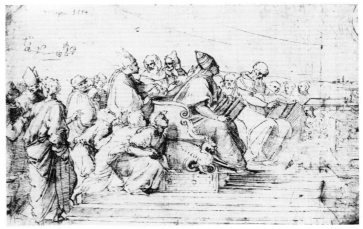

366r: *Modello*
 Paris, Louvre 3884
 Pen, brush and wash, white heightening, over black chalk, squared in black
 chalk at 15 mm.; perhaps some reinforcement of both pen lines and white;
 minute scaling at right-hand edge. 270 × 400 mm., framed section
 250 × 320 mm.
A damaged and unprepossessing drawing, but clearly functional and
undoubtedly by Penni. The central figures on cat. 365 are here placed closer
together, and the mistake (?) in the leftmost column of the round temple is
present here as in the cartoon. Harsher in its contrasts than most drawings by
Penni, and harder edged.

366v: Copy of a lost drawing for the *Disputa*
 Pen.
See commentary to Plate 18.

1514–17 Studies for the Stanza dell'Incendio (D. pp. 82–6) (cat. 367–79)

1. The Fire in the Borgo, *c.* 1514–15 (?) (cat. 367–70)

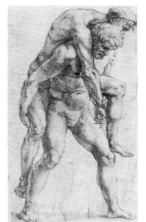

367: 'Aeneas and Anchises'
 Vienna, Albertina Bd. V, 4881
 Red chalk. 300 × 170 mm., irregular, cut at top, bottom and right.
See commentary to Plate 36.

368: Young man hanging from a wall
 Vienna, Albertina Bd. VIII, 4882
 Red chalk over stylus, silhouetted in grey wash (by the artist?) Stylus horizonals at
 breast and middle of thigh, stylus vertical in shadow on wall. 365 × 161 mm., cut at
 sides and top.
Sometimes attributed to Raphael's school, which, given the hardness of the contours, the slight
stiffness of the pose, and the exaggerated expression, is understandable. But the style is appropriate to
the disjunctive, theatrical mode of this fresco, and the slightly laborious hatching in the shadow is
comparable with, if not so sensitive as cat. 371. The drawing is an attempt to combine the precision of
silverpoint with the continuity of chalk, and the style is deliberately harder here than in the foreground
figures.

369: Two women
 Vienna, Albertina Z. G. Bd. VII, 4878
 Red chalk over traces of black chalk (perhaps counterproofed).
 326 × 250 mm.
The kneeling woman demonstrates the slight spatial compression seen
earlier in cat. 125 (cf. especially the left hand). The hatching is somewhat
laborious in the shadows and lacks the decisiveness and vitality one would
have expected; but the use of a spared ridge of paper for the highlight is
characteristic of this type of chalk drawing (cf. cat. 365). The foreground
child is sketched in a similar way to the one in cat. 332, and the woman at
the rear is also comparable to the woman in the same drawing. She is
derived ultimately from a Niobe in a sarcophagus relief. It should be noted
that the angle of her head has been altered. Despite a slight dullness, which
may be due to over-cleaning in the past, the integration of the two forms is
so effective – for example, the linking of the folds in the rear garment to
those in the foreground – that the ascription to Raphael must be
maintained.

370: Pleading woman
 Paris, Louvre 4008
 Red chalk over stylus and traces of black chalk. 340 × 216 mm.
A worn and foxed drawing. Clearly preparatory with numerous pentimenti. The
figure differs in several respects from the fresco, especially in the drapery over the
back, and in the hair. The stiffness of the arms and shoulders, and the flat
treatment of the folds over the buttocks and thighs (much cruder than in cat. 369)
are unparalleled in Raphael. Although the foreshortening of the feet is acute, and
the expressiveness of the toes shows a mind alert to emotional detail, it is difficult
to believe that this drawing is by Raphael. If it could be dated *c.* 1516 it would
be tempting to give it to the young Giulio Romano, by analogy with cat. 404.

2. The Victory at Ostia, *c.*1515 (cat. 371)

371: Two men
 Vienna, Albertina Bd. V, 17575
 Red chalk over stylus, Dürer's inscription in pen
 403 × 281 mm., cut at right.
See commentary to Plate 37.

3. The Coronation of Charlemagne, 1516 (cat. 372–6)

372r: Eight seated bishops
 Düsseldorf, Graphische Sammlung FP 11
 Red chalk over stylus, faint traces of black chalk at
 right. 261 × 318 mm.
A life drawing of two or three models posed successively
on a bench – which probably accounts for the per-
spectival awkwardness of the second bishop in the front
row. A fast drawing, similar to, but more accomplished
than, cat. 365, conveying character, texture and even
embroidery. The bearded model is probably the same as in
cat. 365; for the diamond cross-hatching in the shadow
see cat. 303; for the scooped drapery of the left
foreground figure, whose eyes shine with intelligence,
cf. cat. 354.

372v: A seated bishop, two deacons
 Red chalk. Window mounted.
Even more secure and vital than the recto. Clearly a life
study drawn with great speed to define texture and
atmosphere. The composition of the seated figure is
achieved effortlessly as a series of upright and inverted
triangles; the deacons are located in space with
complete security and economy.

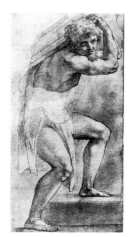

373: Porter
 Chantilly, Musée Condé FR. IX 48 bis.
 Red chalk; silhouetted in pink wash by a later hand.
 322 × 162 mm.
See commentary to Plate 36.

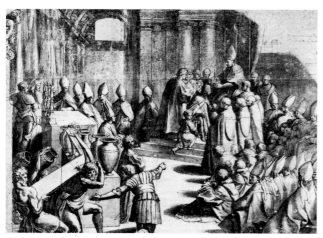

374: *Modello*
 Venice, Querini Stampalia 547
 Pen, brush and wash, white heightening over black chalk. 394 × 576 mm., on four
 sheets of paper.
This *modello* by Penni incorporates the preceding drawings and was revised by
cat. 375. The pen hatching in the underdrawing is different from that in the earlier
modelli by Penni, though the contrasts of light and shade come close to cat. 360, as
does the stronger outline. The anatomical weaknesses and the confusion of
perspective in cat. 374, maintained in the fresco, suggest that Raphael allotted the
overall responsibility to Penni, helping him only in the details. Although of a slightly
higher quality, the *modello* for the *Oath of Leo* (Fig. 7) is clearly by the same hand.

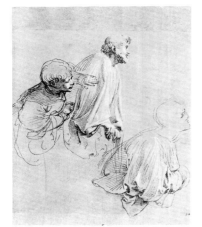

375: Three choristers
 Vienna, Albertina Z. G. Bd. VII, 227
 Pen and dark-brown ink on grey washed paper, white heightening,
 stylus curve in lower right corner. 194 × 183 mm., made up to
 236 × 183 mm., cut down left, right and bottom.
An unusual combination of media, obviously designed to approximate to
the technique of cat. 374, whose upper left corner it revises. Very powerful
and decisive in its hatching, and related in solidity of line to cat. 343r.
Usually considered a copy, but the hardness of the line is intentional,
and the drawing is an original of high quality.

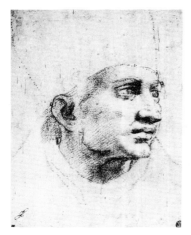

376: Head of a bishop
 Paris, Louvre 3983
 Black chalk and touches of white heightening over pounce marks;
 Overworked on left eye and nostril, right eye, right ear, the outline of
 the jaw and the lips. 287 × 214 mm.
The comparative flaccidity of this auxiliary cartoon for the seated bishop
immediately left of the deacons (adumbrated in cat. 372v) is in part due to
the heavy re-working, but also to the comparative flaccidity of the subject's
features, for it is clearly a portrait. The re-working makes this drawing,
disputed between Raphael, Giulio and Penni, difficult to judge, but it seems
more likely to be by a pupil than the master.

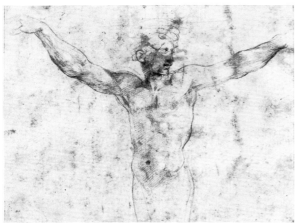

4. The Dado, 1517 (?) (cat. 377–9)

377: Herm left of Astulphas
 Haarlem, Teylers Museum A.64
 Red chalk over traces of black chalk. 162 × 212 mm., cut at left and
 bottom.
A fast drawing from the model for a simplified grisaille figure. A hard, finely
sharpened chalk was used to bring out the plasticity of the form without
deep shadow. The contour of the model's left side, rendered as a relatively
unchanging line, has probably been reinforced. The rhythm of the arms
and shoulders is greatly superior to cat. 378, and the vivacity of the gaze is
wholly Raphaelesque.

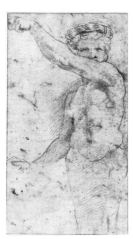

378: Herm right of Astulphas
 Haarlem, Teylers Museum A.65
 Red chalk. 194 × 103 mm., cut down all round (?)
A companion to cat. 377 but of lesser quality. The hardness of the contours of the
model's left side and arm and the right forearm is probably also due to re-working.
The plasticity of the raised arm, obtained by a rather dull cross-hatching, and the
poorly realized outline of the right breast and the stomach, where a scratchy exterior
shadow has had to be provided to set it off, is characteristic of Giulio Romano. If this
attribution is correct, then cat. 379 must be somewhat earlier.

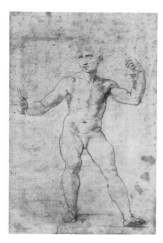

379: King Lothair
 Lille, Musée des Beaux-Arts 481
 Red chalk, 405 × 263 mm.
The dado is attributed to Giulio Romano by Vasari, and this drawing is certainly by him (cf. Figs. 11 and 12 for the eyes and mouth). But its weaknesses of foreshortening and modelling are so great as to constitute ineptitude, and Giulio was much more competent c. 1516–17 than this, as a comparison with the drawings for the Apostle series at Chatsworth, or with cat. 378, testify. This must have been drawn earlier in the work, c. 1515 (?)

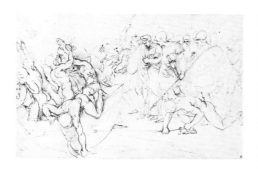

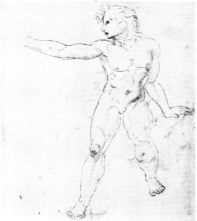

380r: Neoptolemus carrying off Andromache after the Fall
 of Troy
 Chatsworth 903
 Pen, brush and wash, over stylus. 262 × 356 mm., cut all
 round.
While the weak foreshortening and repeated contours of the figures in the boat are close to Penni's *Division of the Lands* (Windsor 12728), the dynamism of the drawing and the cogency of characterization support – but not unquestionably – the attribution to Raphael. The subject, identified by Professor Hugh Lloyd-Jones, was kindly communicated to me by John Gere, who also suggests that the scene may have been planned for engraving, a pendant to the *Rape of Helen*.

380v: Seated figure
 Pen. Window mounted, 257 × 213 mm.
Perhaps by Giulio Romano, c. 1514–15, for the dado of the Stanza dell'Incendio.

Studies for the *St Cecilia, c.* 1515–16 (Bologna; D. p. 39) (cat. 381–2)

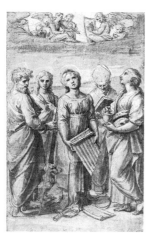

381: Compositional study
 Paris, Petit Palais, Dutuit 980
 Pen, brush and wash, white heightening over black chalk, stylus framing.
 268 × 163 mm.
Presumably the first design for the altarpiece, worked up by Penni from a lost sketch by Raphael. This drawing probably dates from the moment of the commission, c. 1514(?); it was later engraved by Marcantonio. Raphael greatly revised the design, as cat. 382 demonstrates, before the execution of the painting c. 1516–17.

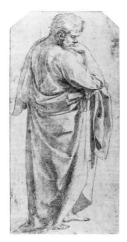

382: St Paul
 Haarlem, Teylers Museum I 26
 Red chalk over traces of black chalk; perhaps counterproofed. 316 × 152 mm., cut all round, the
 upper corners bevelled.
A slight laboriousness characterizes this drawing, but it is supremely efficient in the provision of information; the figure was used almost unchanged in the painting, probably completed in 1517. It is close in style to cat. 372r but rather more substantial, and was undoubtedly drawn from the same model as cat. 371, c. 1515–16. Sometimes doubted, it shows a variety of hatching that no pupil could equal, even if the final result is less than exciting.

382v: Drapery study
 Red chalk.
Clearly a sketch of the drapery of the recto figure. The use of bounding lines to structure the folds and the organization of the hatching to indicate three intensities of shadow are very apparent, and are very close to cat. 384r.

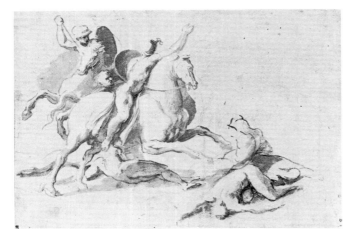

383: Battle scene
 Chatsworth 57
 Brush and wash, white heightening over
 black chalk. 197 × 249 mm.
A study for a battle scene engraved by
Marco da Ravenna, and re-engraved in 1522.
A difficult drawing to date. The use of wash
is similar to cat. 197, but despite the rapidity
of the drawing the forms are convincingly
modelled in three dimensions. The forms of
the bodies at the right are similar to the
guards of the *Resurrection*, but the propor-
tions and musculature of the central rider
link with cat. 415. Probably for an un-
known project *c.* 1515.

c. 1515–16 Studies for the *Spasimo* (Madrid, Prado; D. p. 44) (cat. 384–5)

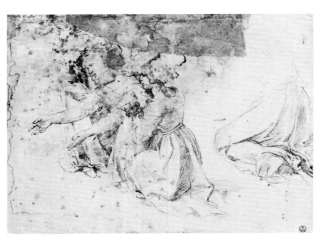

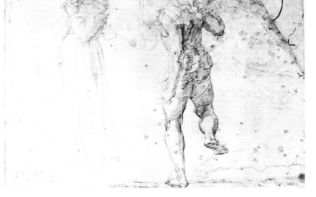

384r: Grieving women, the right-hand figure studied again on the right
 Florence, Uffizi 543E
 Red chalk over stylus. 270 × 360 mm., irregular, damaged and repaired at
 top.
Angular both in structure and stroke; more open in hatching than is
customary at this period to prepare the high key of the painting. The drawing
style and slight exaggeration of the gestures are related to cat. 370, but both
are here more precisely controlled. The hatching tends to flatten the form,
another example of Raphael's recurring experiments with a surface-stressing
manner. The handling of the chalk is in parts reminiscent of silverpoint. The
pose on the right was that finally adopted.

384v: Grieving woman; executioner
 Red chalk over stylus.
Only the head and shoulders of the woman are depicted in detail as they are
all that is visible in the painting. The pose of the executioner, here of extreme
complexity, was changed in the painting to one closer to the executioner in
the *Judgement of Solomon*. The great density of the chalk creates a sense of
weight and solidity which is akin to cat. 288r, a drawing where the emotional
range is comparable.

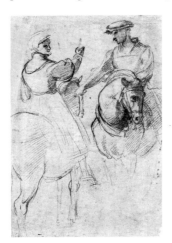

385: Riders
 Vienna, Albertina Bd. V, 234
 Red chalk over stylus. 273 × 198 mm. maximum, irregular, made up 286 × 203 mm. at top and left; the top of the right-
 hand rider's hat is restoration.
Rapid life sketches to establish the poses of the riders left and right. The treatment of the clothes (changed to armour in the
painting) is broad and soft. The simplification of the arms into broad masses of light and shade and the summary treatment
of faces were pursued in Raphael's later black chalk drawings (cf. cat. 390, 391).

c. 1515–16 Studies for the Cupola Mosaics in the Chigi Chapel, Santa Maria del Popolo, s.d. 1516 (D. pp. 95–6) (cat. 386–8, see also cat. 246v, 316, 317r)

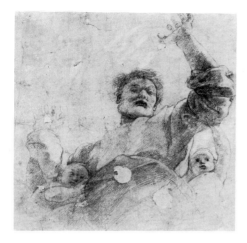 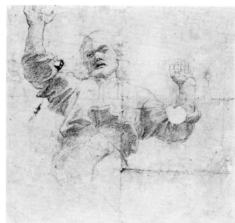

386r: God the Father
 Oxford, Ashmolean 566
 Red chalk over stylus (probably counterproofed).
 214 × 209 mm., cut at top and right, several
 holes patched
See commentary to Plate 38.

386v: Study from the model for God the Father
 Red chalk over stylus.
See commentary to Plate 38.

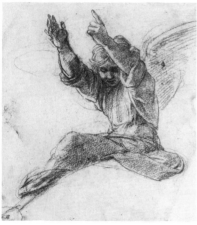

387: Angel above Jupiter
 Oxford, Ashmolean 567
 Red chalk over stylus. 199 × 168 mm., made up upper left and lower
 right corners, patched at left edge and right edge.
See commentary to Plate 39.

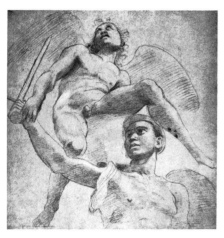

388: The planet Mars and an angel
 Lille, Musée des Beaux-Arts 428
 Red chalk, touches of white heightening on right arm of Mars and
 right hip of angel. 255 × 236 mm., irregular.
Physically unconvincing in gesture, modelling and anatomy; some
of the contours and hatching are reminiscent of cat. 301, but very
much lower in quality. Usually accepted as by Raphael, but
inconceivable as his. Since the weaknesses are of conception as well
as execution, and since they are reflected in the mosaic, this is
probably a creative drawing by a pupil (perhaps Giulio Romano), of
c. 1515–16, rather than a copy of a lost Raphael; cf. especially
cat. 312v.

c. 1516–17 Studies for the Vatican Loggia (D. pp. 88–92) (cat. 389–90)

389: Moses receiving the Tablets of the Law
 Paris, Louvre 3849
 Brush and wash and white heightening over black chalk;
 squared in black chalk at 30 mm. 255 × 279 mm.
The only surviving *modello* by Raphael for one of the scenes
in the Loggia vault. The arrangement of light and shade is
exceptionally dramatic, acknowledging depth but main-
taining a strong diagonal surface arrangement. The re-
ceiving of the Tablets of the Law has been rapidly but
acutely tried in three different positions, fully demon-
strating Raphael's vitality of thought.

390: David and Goliath
 Vienna, Albertina Bd. VII, 178
 Black chalk. 243 × 321 mm., cut at right.
See commentary to Plate 40.

391: Apostles for the *Monteluce Coronation*
 Berlin-Dahlem, Kupferstichkabinett 5123
 Black chalk of two shades, white heightening, indecipherable
 pouncing. 268 × 220 mm.
A study for the apostles on the left-hand side of the *Monteluce Coronation*
(Vatican; D. p. 55). A study in the drama of light and shade, simultan-
eously describing gestures and expressions. An example, together with
cat. 390, of the softest sketching style of Raphael's later black chalk
drawings, which suggests rather than delineates, and where broad
patches of shadow are played against thin, even contours.

392r: Architectural design for a Medici patron
 Oxford, Ashmolean 579
 Pen, brush and wash, over stylus; compass intersections on centre
 lines of side arches, plumb-lines through all three arches;
 damaged by over-cleaning. 250 × 362 mm. maximum; silhou-
 etted upper right and upper left.
This seems to be a project for the modernization of a villa on the site of
the Villa Madama, subsequently abandoned for the much expanded
final scheme. Raphael has regularized the quattrocento (?) building
with a heavy, balustraded, three-arched loggia, centred on a
tabernacle with a segmental pediment in powerful relief, which
frames a protruding, curved balcony, supported on consoles.
Surmounting the loggia is a balustraded balcony, and the two wings
of the building are linked by a large exedra fronted by a column-
screen. The modernization was clearly planned for a hillside
location, like the Villa Lante, also designed in Raphael's late Roman
years, and suggests his interest in panoramic views and landscape
gardening, both important concerns of the final scheme.

392v: A *casino* with a Serliana loggia and a tower, in elevation and
 plan
 Pen.
The elevation shows a small, daringly asymmetrical building with,
to the left, a Serliana loggia closed to about waist height and, to the
right, a closed bay with a window. This corresponds to the central
plan, which shows that the loggia looked out on to a semicircular
fish-pond, with a round central fountain, excavated into a hillside.
The larger plan superimposed upon this repeats it in essentials, but
with a modified arrangement of rooms and the insertion of a
staircase. The two plans upper left are probably the earliest ideas for
the scheme; the cancelled one also has a displaced loggia, and it has
an entrance hall and a door framed by two columns in the lower
centre.

Studies for the *Holy Family of Francis I,* s.d. 1518 (Paris, Louvre; D.p. 48) (cat. 393–6)

393: Seated woman
 Paris, Louvre 3862
 Red chalk. 173 × 119 mm., cut down at right and left.
Clearly a life study, antedating cat. 394, drawn with fine red chalk. A disputed drawing, whose attribution to Raphael is denied by the simultaneously laborious and weak contour of the left arm, the awkward pattern of hatching used to model the left forearm, the flattening of the left calf, which is dragged across the plane, the lack of focus in the model's expression, and the heavy-handed shadow. A vivacious drawing nevertheless, especially in the drapery, and undoubtedly by Giulio Romano (cf. Fig. 11 and cat. 402).

394: The Virgin and Child
 Florence, Uffizi 535E
 Dark red chalk over stylus, a
 tear made up at lower right
 side. 336 × 214 mm.
See commentary to Plate 42.

395: The Christ Child
 Florence, Uffizi 534E
 Red chalk over stylus. 270 × 209 mm.
Rather broadly handled, with certain features – the hip, left knee, right shoulder – picked out in thinner lines, but with much more rapidity and precision than in cat. 393. The balance achieved by Raphael between the silhouette and mass of the Child's stomach is remarkable and was weakened in the painting.

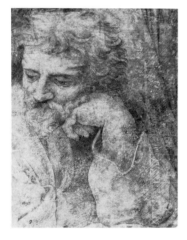

396: Head of St Joseph
 Bayonne, Musée Bonnat 1705
 Black chalk, heavily re-worked in graphite at a later date; indented (?)
 495 × 356 mm., fragmentary on four sheets of paper.
Extremely badly damaged and largely obscured by re-working; despite the absence of pricking this was probably part of the cartoon, and may originally have been by Raphael. The fragment now in Melbourne, so far as can be judged from a photograph, appears always to have been of lower quality, and may have been made for a replica.

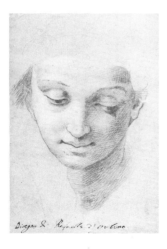

397: Study for the head of St Michael
 Formerly London, Sotheby's
 Red chalk and white heightening. 169 × 112 mm., cut down.
A preparatory study for *St Michael*, s.d. 1518 (Paris, Louvre; D.p. 47). Despite the slight overstatement in the accentuation of the mouth and eyes, and the odd S-curve of the neck, the drawing is probably by Raphael rather than Giulio Romano. For the angel's refined, ivory features Raphael returns to a cross-hatched technique which equals the clarity and smoothness of silverpoint. Unique in Raphael's late graphic *oeuvre*, but to some extent comparable with Giulio's drawing (Fig. 12), which represents a derivation of this manner.

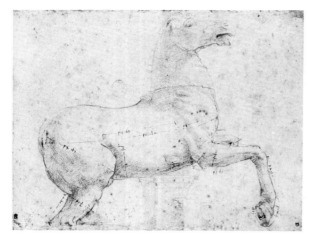

398: Sketch of a Quirinal horse
 Chatsworth 657
 Red chalk over stylus, measurements in pen.
 218 × 272 mm.
The use of red chalk enables Raphael to combine
detail, mass and surface texture. The dense but
completely controlled handling suggests a date
c. 1516–17. Raphael had of course known the horse
for many years, having used it in his first *St George*
(Paris, Louvre; D. p. 5); see cat. 62.

c. 1518 Studies for the Psyche Loggia in the Villa Farnesina (D. pp. 96–9) (cat. 399–421)

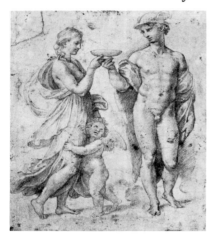

1. The Council of the Gods (cat. 399–400)

399: Mercury handing Psyche the cup of immortality
 Chatsworth 55
 Red chalk over stylus. 269 × 227 mm.
Disputed between Raphael, Giulio Romano and Penni. Less plastic than
one would have expected of Giulio, but the forms are so close to other
drawings attributable to him (compare the leg of Psyche with that of
cat. 415; the head of Mercury with the Chatsworth *Apostles*
(Nos. 70–81); the head of Cupid with that of St John in Fig. 13), that an
attribution to him rather than to Penni seems preferable. Only
Raphael's authorship can be securely excluded.

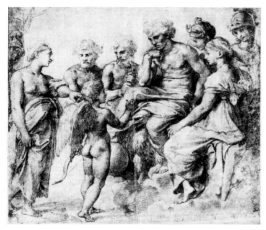

400: Psyche before Jupiter
 Paris, Fondation Custodia 1031g
 Two shades of red chalk over stylus. 218 × 244 mm., irregular; made up bottom
 right, patched at left edge and upper right.
The range of emotion is too dull and the rhythm too lumpy for Raphael, and the
handling, while quite sophisticated, lacks his vitality. The forms of the arms and
hands are very close to cat. 399 and this drawing is probably also by Giulio
Romano, though Penni remains a possibility, in view of the unbalanced figure of
Cupid.

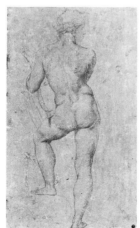

2. The Wedding Feast of Cupid and Psyche (cat. 401–9)

401: Apollo
 Vienna, Albertina Bd. VII, 218
 Red chalk, on grey washed paper. 334 × 187 mm.
The figure is partially draped in the fresco. A clear and precise drawing kept in a
deliberately high key. Very close to Raphael, but unincisive overall, with the
hatching carefully but hesitantly applied, and the contours of an unwavering and
inexpressive thinness. This rests on the borderline between Raphael and Penni and,
if by the latter, it is one of his best drawings.

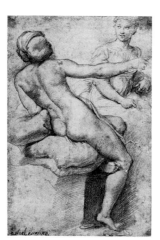

402: Omphale
 Haarlem, Teylers Museum A.62
 Red chalk over stylus. 256 × 164 mm.
One of Giulio Romano's loveliest drawings, often given to Raphael. The handling of the subsidiary figure is very close to cat. 393 in the treatment of the drapery, and to Fig. 11 in the drawing of the arm. The modelling of Omphale, employing thin contour hatching (cf. cat. 393), is extremely refined, but the unvarying outline, the awkward relation of head to shoulders, and the muffled contour of the right leg (cf. cat. 404) speak against Raphael's authorship and for Giulio's inherent bias toward linear pattern.

403: Pluto
 Berlin-Dahlem, Kupferstichkabinett 18152
 Red chalk over stylus. 146 × 90 mm., cut down all round (?)
The treatment of the hands, the contours of the arms and the somewhat inflated modelling strongly support Giulio Romano's authorship and help to confirm cat. 405, presumably drawn from the same model, as his.

404: Ganymede
 Paris, Louvre 4019
 Red chalk over stylus. 283 × 219 mm.
A lively and well-foreshortened drawing, with the left foot particularly well drawn (cf. cat. 370) but the left leg lost above the knee. The fold pattern is monotonous and was modified in the fresco, and the drapery on the leg is poorly achieved. There is some re-working: the external hatching round the legs (cf. cat. 402, 410) was clearly applied in three stages. Undoubtedly by Giulio Romano.

405: Bacchus pouring wine
 Milan, Ambrosiana F.272, INF.6
 Red chalk over stylus. 323 × 195 mm.
A precisely drawn study for a prominent fore-ground figure, designed to stand in sculpturesque relief. Too stiff and laborious for Raphael (cf. cat. 367) but extremely fine in detail, if lacking unity as a whole. The inflation of form, the lumpy treatment of wrists and hands, and the outline of the left breast all suggest Giulio Romano, who uses his fullest range of techniques in this drawing; cf. cat. 403.

406: Cupid and Psyche
 Vienna, Albertina Z. G. Bd. III, 90
 Pen over traces of stylus. 172 × 271 mm., cut at top, left and right.
A puzzling drawing which may be an example of Raphael's late figure style in pen. The hatching has the regularity and clarity of woodcut; the short, regular hatching lines on Cupid's left knee and Psyche's hip are close to those of cat. 343r, but the details of gesture are less expressive than one might expect, and the angular drapery is mechanical. Further discoveries might confirm or deny the attribution to Raphael of this distinctive study, the technique of which looks forward to the Carracci.

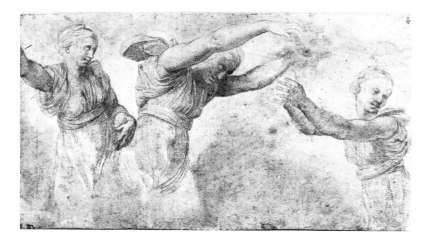

407 : Three Hours
 Chantilly, Musée Condé FR.IX 48
 Red chalk over stylus under left- and right-hand figures, white
 heightening added by a later hand and a pink wash applied
 round the figures. 195 × 330 mm.
The graphic components – the sharp lines registering the folds, the
scooping hatching on the stomach of the central figure, the rubbed
chalk in the shadows – clearly are very close to Raphael, and are
handled with considerable skill. But the lumpiness of the rhythms,
the equality of emphasis, the dull expressions and lack of luminosity
in the shadows confirm that it is by a pupil, perhaps Penni but not
impossibly Giulio.

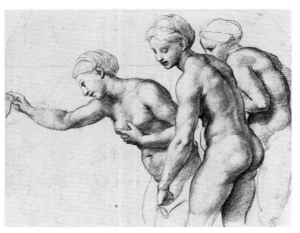

408 : The Three Graces
 Windsor, Royal Collection 12754
 Red chalk over stylus; counter-
 proofed on cat. 409. 203 × 260 mm.,
 cut at lower left and right corners
 and below after counterproofing.
See commentary to Plate 43.

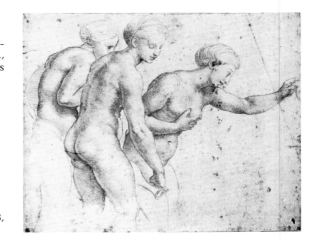

409 : The Three Graces (counterproof)
 Chatsworth 52
 Red chalk. 226 × 270 mm.
A re-worked counterproof of cat. 408,
before it was cut down.

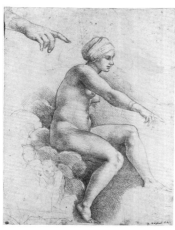

3. The Pendentives (cat. 410–16)

410 : Venus pointing out Psyche to Cupid (counterproof)
 Paris, Louvre 4017
 Red chalk over traces of black chalk. 311 × 229 mm., slightly irregular.
In the fresco the putti supporting Venus's seat (cf. cat.386r) have been
eliminated, Cupid's head is less inclined, and the changed position of
Venus's hand upper left, which is feeble and inexpressive, is not followed.
Lower left, a slight sketch of an arrangement of pendentives with the top
half of an octagon. Usually – and rightly – given to Giulio Romano, as the
treatment of contour confirms.

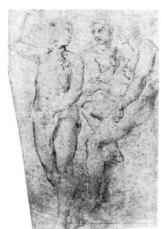

411 : Venus, Ceres and Juno
 Lille, Musée des Beaux-Arts 2150
 Red chalk over traces of stylus. 275 × 191 mm., irregular, cut all round.
The rather sharp contours and use of light cross-hatching under the raised arm of
Venus are akin to cat. 378. The drawing, clearly from the model, has none of the
rhythm of the fresco and the design must have been considerably revised by
Raphael. It is probably by Giulio Romano, and shows the limited facial
expressions characteristic of his preliminary drawings. Giulio also made a highly
finished drawing adapting this composition for engraving by Raimondi
(Albertina Sc. R.83).

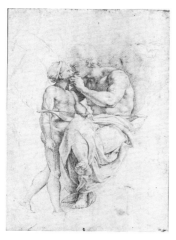
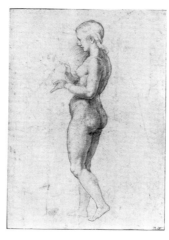

412r: Jupiter and Cupid
 Paris, Louvre M. J. 1120
 Red chalk, probably counterproofed, on hard shiny paper. 362 × 252 mm.
The handling of chalk approaches silverpoint in sharpness, and in some ways this drawing marks a reappraisal of the red chalk style of 1511–12 (but cf. cat. 397, 420). This study from the model is highly controversial. Disputed between Raphael and Giulio Romano, it is often considered to be a copy after one or the other. The thin contour hatching of Cupid comes close to some drawings by Giulio, but it is more roundly modelled than drawings which might seem comparable. The hardness of the technique does suggest a copy, but an unusually accomplished one. A special case about which no decision seems possible.

412v: Standing female nude
 Red chalk over traces of stylus.
The model is perhaps the same as in cat. 399. The contours may have been re-worked. Features like the forearm are indecisively drawn but the level of observation is high, and this drawing is as problematical as the recto. Probably for an unexecuted fresco of Psyche and her maidservants, the composition of which may be preserved in an engraving by Bonasone.

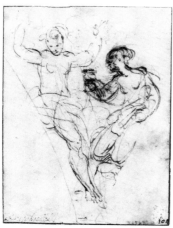

413: Psyche and Venus
 Oxford, Ashmolean 655
 Pen over red chalk. 104 × 78 mm., cut all
 round.
A *concetto* by Raphael with many pentimenti in the position of Psyche's head and in the pose of Venus.

414: Psyche and Venus
 Paris, Louvre 3875
 Red chalk over stylus (under Venus only). 264 × 197 mm.
The pose of Venus, with only slight turns of the body, is drawn in Raphael's most solid manner. It demonstrates how the dense, sculpturesque style of the figures demanded very careful drawing, which, when imitated by his pupils, could easily become dull. The exaggeration of Venus's facial expression helps to create that slightly burlesque mood which characterizes the scheme as a whole. Psyche, drawn with a fluency and ease which compares with cat. 408, is of an extraordinary beauty and grace.

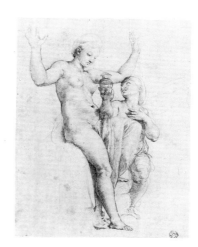

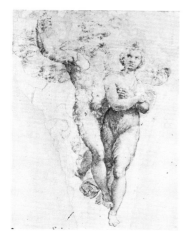

415: Mercury carrying Psyche to heaven
 Chatsworth 54
 Red chalk. 308 × 230 mm. maximum, cut to pendentive form, made up
 upper right corner and along top; in very poor condition.
Very clearly by Giulio Romano by analogy with Fig. 13. It probably served both for the fresco and for Raimondi's engraving of the composition.

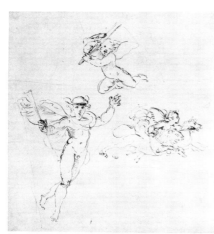

416: Mercury; putto with the tools of Vulcan; putto with lion and
 sea-horse
 Cologne, Wallraf-Richartz Museum Z. 1984
 Pen over stylus. 189 × 172 mm.
The figures are more doll-like than in cat. 413, and come very close to those in drawings attributed to Penni, but the vitality of the contours and gestures proclaims Raphael's authorship. The position of the upper putto's legs has been changed twice from the underdrawing, and Mercury's left arm has been modified. Raphael's energy can be seen in the way the contour breaks into a zigzag round the upper putto's left thigh, and the difficult arrangement of the putto with animals is handled with supreme confidence.

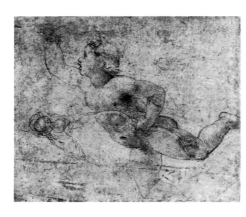

4. The Spandrels
(cat. 417–8)

*417r: Putto with Neptune's triden.
 Dresden, Staatliche Kunstsammlung W.189/190
 Red chalk over stylus. 209 × 172 mm.
A broad, open sketch with the precise position of the head left undecided and major pentimenti round the right leg. The light contour renders perfectly the swelling of the putto's body, and the hatching, mostly parallel but with some thin contour strokes on the ribs, conveys the solidity of flesh and the sheen of skin. This would presumably have been followed by a more complete drawing by a pupil, such as cat. 418.

417v: Putto with Cupid's bow; *concetto* for putto with
 Minerva's shield (?)
 Red chalk.
The left forearm was originally extended to the rear and the position of the right hand modified. The quiver is visible on the back and the wings are outlined behind and in front of the head. Although of lower quality than the recto, with sharper, less volume-creating outlines and less instinctively confident hatching – the changes of direction are slightly laboured – there seems no good reason to deny it to Raphael, and the light sketch left, perhaps a *concetto* for the putto carrying Minerva's shield, is completely convincing as autograph.

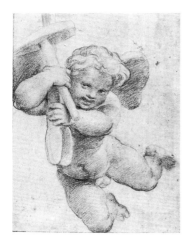

418: Putto with the tools of Vulcan
 Haarlem, Teylers Museum A.76
 Red chalk over stylus. 155 × 114 mm., cut all round (?)
A soft, and for the most part (save the right arm) well foreshortened drawing, with pentimenti in the head of the hammer and the flanges of the support. Of extremely refined rhythmical organization, and presumably closely based on a lost Raphael study drawn after cat. 416. The attribution to Giulio Romano is based on the similarity to the Child of Fig. 12.

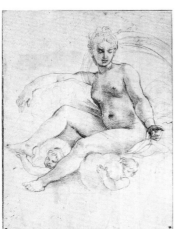

5. The Lunettes and Walls (cat. 419–21)

419: Psyche carried through the air (counterproof)
 Chatsworth 53
 Red chalk. 330 × 246 mm.
A design for one of the unexecuted lunettes. The light, almost rococo mood of the drawing and composition, unlike any other drawing for the Farnesina, suggests Raphael's inventiveness; however, the clumsy contour of the left breast, the dull device of the bracelet to aid the foreshortening of the arm, the rubbery contour and the poorly articulated right leg all point to Giulio Romano, as does the external hatching.

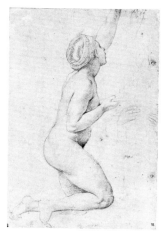

420: Kneeling nude woman; partial outline of a woman holding a platter
 Chatsworth 56
 Red chalk. 278 × 186 mm, cut at top.
Presumably for a scene either in a lunette or on a wall, (perhaps Psyche and her maidservants; cf. cat. 412v). The fluidity of the stroke and clarity of contour leave no doubt about Raphael's authorship.

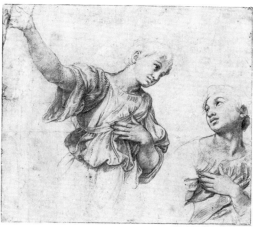

421: Two female figures
 Haarlem, Teylers Museum A.68
 Red chalk over traces of stylus. 202 × 234 mm., cut down all round (?)
Perhaps connected with an unexecuted section of the Psyche Loggia, though equally possibly for an Annunciation. The rhyming of the hands and the firm diagonal arrangement were expressive qualities taken up in the *Transfiguration*. The handling of chalk is uniquely brilliant, stretching even to a detailed description of the texture of the draperies. The hatching is subtly modified according to function – very finely rubbed in the shadows; flat and regular on the hands and wrists to set them against the costume; curving to match the movements of the drapery; moistened touches, like a Watteau, in the angel's (?) sleeve; and solid but variegated on the arms. The image of what cat. 407 should have been.

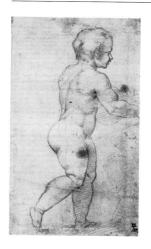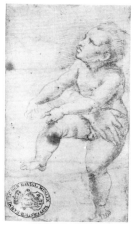

422r: The young St John for the *Perla*
 Berlin-Dahlem, Kupferstichkabinett 21551
 Red chalk; the contours reinforced by another hand. 173 × 97 mm., cut down all round (?)
The slight stiffness of this drawing for the *Perla* (Madrid, Prado; D. p. 51) is due to the clumsy reinforcement of the contours, which deadens both the movement and the vitality of the forms. The complex foreshortening of the turning back is precisely seized, as is the difficult angle of the feet. Modelling is evoked with the minimum of effort, and the texture of the hair comes close to Raphael's late black chalk drawings. An attribution to Raphael, perhaps re-worked by Giulio Romano, should not be discounted.

422v: The Christ Child for the *Perla*
 Red chalk over stylus, squared in stylus at 28 mm.
The flattening of the forms, the comparative weakness of the foreshortening and the beak-like mouth all suggest Giulio Romano, as does the Virgin's hand (cf. cat. 403). It is not surprising to find an assistant participating in the production of a painting which is largely autograph Raphael, but this drawing is coarse for Giulio, *c.* 1519, and the figure much inferior to that in the painting. A cartoon fragment in Lille (Musée des Beaux-Arts 487) is so weak that it must have been made for a later repetition, not for the original painting.

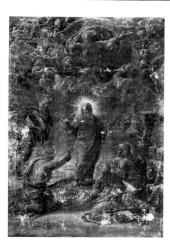

c. 1519–20 Studies for the *Transfiguration* (Vatican; D. p. 52) (cat. 423–38)

423: First design
 Vienna, Albertina Z. G. Bd. VI, 193
 Brush and wash, white heightening, on dark-grey washed paper. 398 × 268 mm.
In this first scheme Raphael did not include the Healing of the Possessed Boy, and concentrated on the Transfiguration itself. The large figure of Christ and the three gesticulating disciples before Him are closer to the manner of Sebastiano del Piombo's *Lazarus* than is the final version, where Raphael aimed at complexity rather than magnitude. The authorship of this badly worn drawing is uncertain but it may be by Penni, or even a copy after him. The technique is not unlike chiaroscuro woodcut.

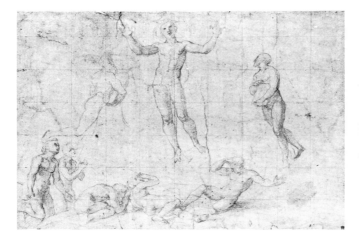

424: Christ, Moses, Elijah, three apostles and two onlookers
 Chatsworth 904
 Red chalk over stylus, squared at 37 mm. 246 × 350 mm.
A similar drawing at a later stage was probably codified by the nude *modello* (cat. 430). A purely compositional drawing in which, despite the deliberate elongation of the forms, there is a strong sense of physical solidity and expressive movement. Slight though the drawing is, it clearly represents the distillation of much work and thought.

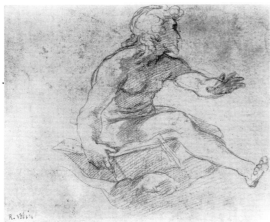

425: St Andrew
 Vienna, Albertina Bd. VII, 237
 Red chalk over traces of black chalk and stylus squaring at 23 mm.
 126 × 144 mm.
The preliminary stylus squaring suggests that this figure was to be fitted into a pre-existing grid. Raphael's authorship has sometimes been doubted, but the rapid hatching on the chest and legs, which conveys a strong sense of light without losing form, is economical and sure; the difficult foreshortening of the left arm is accurate and the drawing breathes energy.

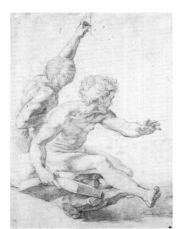

426: St Andrew and another apostle
 Chatsworth 51
 Red chalk over stylus. 328 × 232 mm., irregular.
See commentary to Plate 47.

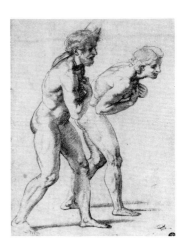

427: St John and another apostle
 Paris, Louvre 3864
 Red chalk over stylus, traces of black chalk on left-hand figure; perhaps
 counterproofed. 341 × 223 mm.
Probably preceding the nude *modello* (cat. 430), but possibly revising it. The left leg of the left-hand figure attaches poorly to the hip; the legs of St John are rather squarely modelled; and there is a certain amount of pedantic hatching to bring out the forms of the shoulder of the one and the thigh of the other. Yet the quality of expression and characterization and the intense spirituality of the movements of the heads and faces remove any doubts and remind one that Raphael even at his greatest produced effects that were less than perfect.

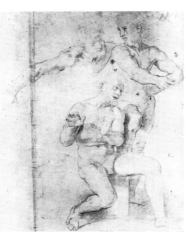

428: St Peter and two apostles
 Vienna, Albertina Bd. V, 4880
 Red chalk over stylus. 320 × 271 mm.
Clumsily foreshortened, weakly modelled and vapid in expression, this study from a single (?) model (who also posed for the left-hand figure in cat. 427) is weak in contrast and lacks any poetic compensation for its anatomical inadequacies. Probably by Giulio Romano, but surprisingly poor for him.

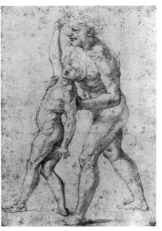

429: Father and his possessed son
 Milan, Ambrosiana F273 INF 36
 Red chalk over stylus (under the father). 282 × 193 mm.
The father was perhaps drawn from the same model as cat. 427, 428. The description of the thighs and chest is similar to cat. 405, but less solid; the boy, although in a contorted pose, is nevertheless clumsily drawn, and the study lacks unity of rhythm and lighting. Probably by Giulio Romano but, like cat. 428, poor for him.

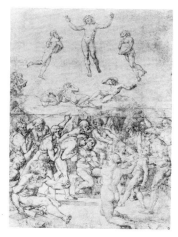

430: Nude *modello*
 Vienna, Albertina Z. G. Supp. Bd. IV, 17544
 Pen, over stylus and black chalk in the upper section. 534 × 376 mm. (on
 two sheets of paper).
Presumably based on a chalk drawing by Raphael of the type of cat. 424, but
making use of the detailed descriptions of the individual nude studies, with
some changes (cf. cat. 427). The drawing style is close to that of *modelli* which
are presumably by Penni (cf. cat. 374), but it is so coarse, particularly in the
lower section, that it may well be a copy after him rather than an original.

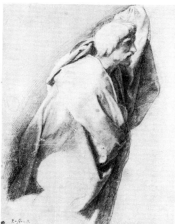

431: Drapery study for the fifth apostle from the left
 Paris, Louvre 4118
 Black chalk in two shades and white heightening. 264 × 198 mm.
The head was originally drawn higher up, the cloak further out. The
hatching follows the folds of the cloak, with long lines drawn across the
upper part of the falling section; but this like many of Raphael's late black
chalk drawings, is essentially a study in the evocation rather than the
description of form and texture. The shading on the face is extraordinarily
subtle, giving form to the moustache with minimal means.

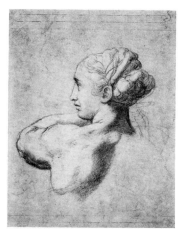

432: Head of the kneeling woman; above and below fragments of an
 entablature
 Amsterdam, Rijksmuseum 1971:51
 Black and white chalk, indecipherable pouncing. 330 × 242 mm.
A luminous and powerful study, no doubt in preparation for the cartoon,
but approaching closely the detail of the auxiliary cartoons. The drawing is
composed in masses rather than lines, and the splendour of the forms is
increased by the broad, soft contours. For the pouncing, which does not
correspond to the drawing, cf. cat. 391.

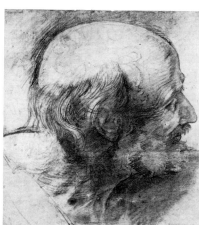

433: Head of St Andrew
 London, British Museum 1860–6–16–96
 Black chalk and charcoal (?) over pouncing. 399 × 350 mm.
An auxiliary cartoon for a head whose position caused Raphael
some difficulty; even this position was changed in the painting. The
crisp hatching under the ear and in the beard is probably Raphael's
revision rather than a re-working by another hand, since a deeper
shadow was required here to throw the front of the face into relief.
Structure and characterization are inseparable in this worn but
magnificent drawing.

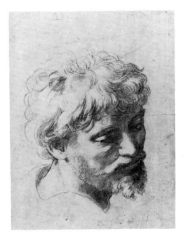

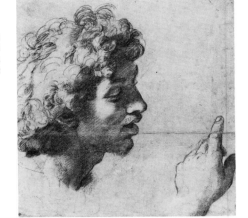

434: Head of the apostle at the left edge
 Chatsworth 67
 Black and white chalk over pouncing. 375 × 278 mm.
The combination of breadth and precision, relief and texture is
incomparable in this auxiliary cartoon; the hair, as in cat. 437, acts as a
metaphoric halo. Cf. cat. 431, on a much smaller scale, for the way in which
the moustache is drained of detail by the fall of light while retaining plastic
form.

435: Head of the fifth apostle from the left; his left hand
 Chatsworth 66
 Black chalk over pouncing. 363 × 346 mm.
The broad hatching on the cheek has been stumped to create an
overall sheen, and next to this, in the curls over the ear, short,
stabbing hatching has been laid on to give the hair body and
movement.

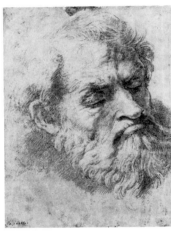

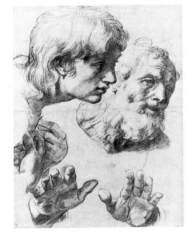

436: Head of the apostle (left) above St
 Peter
 London, British Museum 1895–9–15–634
 Black chalk over pouncing.
 265 × 198 mm.
Based on a head in Leonardo's *Adoration*; a
late tribute by Raphael to the artist who,
more than any other, provided the in-
spiration for the *Transfiguration*.

437: St Peter and St John
 Oxford, Ashmolean 568
 Black chalk and white
 heightening over
 pounced outlines.
 499 × 364 mm.
See commentary to Plate
48.

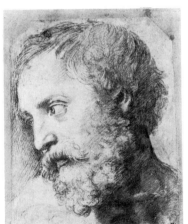

438: Head of the apostle (right) above St Peter
 Vienna, Albertina Bd. V, 242
 Black and white chalk over pouncing; the pupils indented (later?), also
 the contours of the neck. 240 × 182 mm., very irregular, cut left and
 right and top left and right corners.
The only surviving auxiliary cartoon for an apostle facing the light. Here
the problem was setting smaller patches of shadow against broadly lit
areas, and the slightest shadows are exploited to bring the face into relief,
e.g. the fringes of the moustache, the eye-sockets and the convexities of
the cheek and forehead.

c. 1519–20 Studies for the Sala di Costantino (D. pp. 86–8) (cat. 439–55)

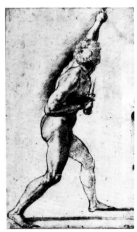

1. The Battle of the Milvian Bridge (cat. 439–43)

439: Fighting infantryman
 Paris, Louvre RF. 1870–1071
 Black chalk in two shades, white heightening. 364 × 204 mm.
Closely comparable in figure style with cat. 427, and in drawing style – thick
contours, broad evocation of light and shade – with cat. 431. The pose is based on
some derivative of the Borghese *Gladiator*, and the position of the head and arms is
similar to that of the apostle at the left edge of the *Transfiguration*. Like cat. 440 and
cat. 441, a nude study preparatory to cat. 442.

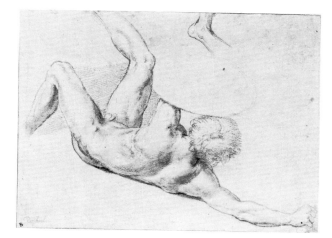

440: Fallen cavalryman
 Chatsworth 59
 Black chalk. 221 × 302 mm.
Close in technique and modelling to cat. 441, but much weaker in the realization of the right shoulder, the joint of the right thigh, and the left buttock. Since this is a life study from a particularly difficult pose and which could not have been held long, these weaknesses would not necessarily indicate pupil work were it not for the unintelligent hatching on the thighs which comes so close to Fig. 12 as to render the attribution to Giulio Romano virtually certain.

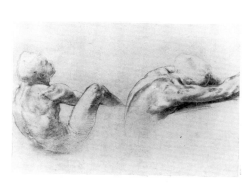
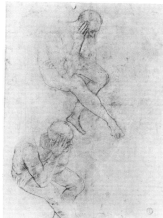

441r: Two soldiers climbing into a boat
 Oxford, Ashmolean 569
 Black chalk and white heightening, partly oxidized, over stylus.
 257 × 362 mm., cut at right.
See commentary to Plate 44.

441v: Two studies of an old man
 Black chalk.
Life studies of the same man asleep and looking up. The arrangement of the limbs demonstrates the geometrical basis of Raphael's late figure style, where elaborate contrapposto gives way to a demonstrative clarity and where the rhetorical emphasis of *c.* 1514–16 is disciplined into more deeply characterized individual reaction. The figure here might have been intended for a St Joseph.

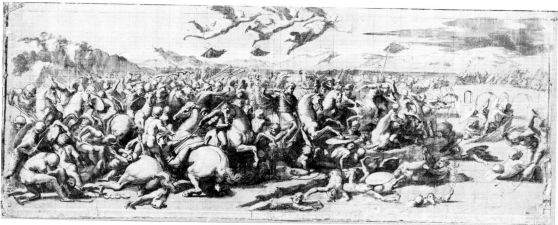

442: *Modello*
 Paris, Louvre 3872
 Pen, brush and wash, white heightening over black chalk (on the left side); squared in black chalk at 20 mm. 376 × 851 mm., on two pieces of paper; fragments of caryatids and allegories on either side, which show that *modelli*, such as cat. 450, for the series of popes and accompanying figures must once have been pasted on to this drawing.
A bland drawing by Penni, concerned to describe the full complement of figures and the basic distribution of light and shade. Despite the effort made to convey facial expression and physical tension, it is unimaginative and repetitive in detail. Many changes were made in the fresco.

443: Cartoon fragment
 Milan, Ambrosiana
 Black chalk, white heightening; incised. 805 × 2494 mm., very
 irregular.
Although the drawing is damaged and difficult to read, the
attribution to Giulio Romano has never been doubted. To be
compared with cat. 455, which is clearly by a superior hand.

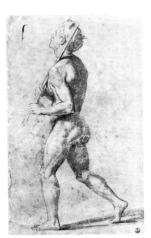

2. The Adlocutio (cat. 444–6)

444r: Advancing soldier
 Florence, Uffizi 542E
 Black chalk in two shades with white heightening over stylus. 356 × 215 mm.
More detailed and highly worked than the comparable studies for the *Battle of the Milvian
Bridge* (e.g. cat. 439, 441r) partly because the brighter lighting on this wall demanded more
elaborated figures.

444v: Profile of a caryatid
 Black chalk.
This very light sketch is scarcely attributable, but there seems no good reason to deny it to
Raphael: an outline of a figure he never took further.

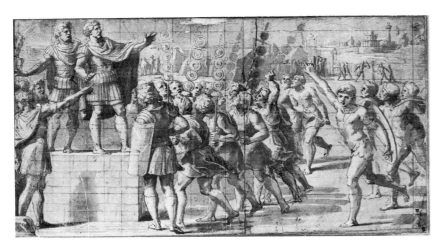

445: Compositional study
 Chatsworth 175
 Pen, brush and wash, white heightening over black chalk;
 squared on the left half only at 18 mm. 232 × 415 mm., cut
 left and right (?)
Very similar in technique to cat. 442 but rather broader;
undoubtedly by Penni. The fact that the drawing is on a smaller
scale than cat. 442 and cat. 450 suggests that it represents a less
developed stage. In the fresco the right-hand group was placed
in the background, and many other changes and insertions
were made which clearly demonstrate how quickly Raphael's
School diverged from his conceptions after his death.

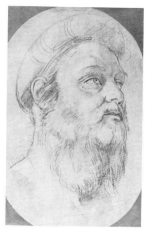

446: Head of Constantine's companion
 London, British Museum 1949–2–12–3
 Black chalk in two shades, over pouncing. 393 × 241 mm. maximum
In comparison with Raphael's auxiliary cartoons, the treatment here is more linear
and less substantial, especially in the beard. The short, vigorous hatching lines on
the beard and cheek are derived from Raphael's example in drawings like cat. 433.
The attribution to Giulio Romano is probably correct, but comparable authenticated
drawings are lacking. Vasari used this drawing for his portrait of Penni, so Giulio
presumably took his associate as his model.

3. The Donation of Constantine (cat. 447–9)

*447: Pope Sylvester I in a *sedia gestatoria*
 Boston, Isabella Stewart Gardner Museum 24093
 Black, red, yellow and white chalks, brush and wash;
 squared in black chalk twice, at 32 mm. under the whole
 drawing and at 27 mm. over the central group. 398 × 404
 mm.
See commentary to Plate 45.

448: Compositional study
 Paris, Louvre 3874; Stockholm, Nationalmuseum 329
 Pen. 418 × 287 mm.; 415 × 285 mm.; originally joined.
A rapid pen drawing by Giulio Romano for the whole composition.
The left-hand side is obviously based on cat. 447 and preparatory
to cat. 449.

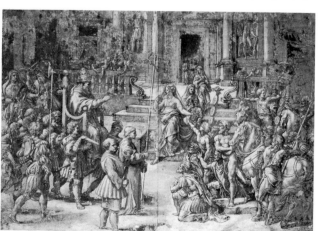

449: *Modello*
 Amsterdam, Rijksmuseum 1948–368
 Pen, brush and wash, white heightening, some stylus.
 395 × 549 mm.
See commentary to Plate 45.

4. The Popes and Allegories (cat. 450–5)

450: Niched pope with caryatids and allegories
Paris, Louvre 4304
Pen, brush and wash, white heightening over black chalk (especially under the head of the right-hand candelabra-bearing angel and the *baldacchino*), and stylus. 376 × 280 mm., a strip of 15 mm. added on the right edge.
A *modello* by Penni. Judging by the parts of the caryatid and allegory missing on the right, this must originally have been attached to another *modello* (but not cat. 442, although it is the same height). The pope's tiara was originally a mitre so he is probably Sylvester I. The inset panels in the pillars are an invention that influenced Michelangelo in the Laurentian library. The proportions were considerably altered in execution, undoubtedly under Raphael's supervision, and this must date from an early stage in the project.

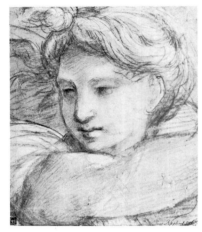

451: Head of a candelabra-bearing angel
Budapest, Museum of Fine Arts 1943
Black chalk and white heightening; the contours indented. 307 × 253 mm., cut down all round.
A vibrant and lively if worn and rubbed enlargement of the right-hand angel in cat. 450; perhaps a fragment of the cartoon. Although on a larger scale and more loosely drawn, it is comparable in style with cat. 453 and cat. 454.

452: Caryatid on left side of Urban I
Frankfurt, Staedel 421
Black chalk. 330 × 144 mm., made up to 347 × 172 mm., cut all round; the feet restored. Badly rubbed and worn, but nevertheless one of Raphael's most evanescent and graceful late drawings. The model seems to be the same as in cat. 453 and as the Virgin in Giulio Romano's drawing (Fig. 13). The delicacy of handling, with the forms breathed onto the paper, is inseparable from cat. 441r and cat. 453. The drapery, caressing the body and discreetly emphasizing breast and crutch, attests to a refined and lyrical sensuality.

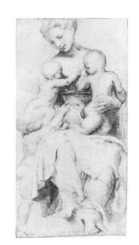

453: Charity
Oxford, Ashmolean 665
Black chalk and touches of white heightening. 311 × 154 mm., irregular, cut all round.
See commentary to Plate 46.

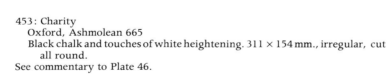

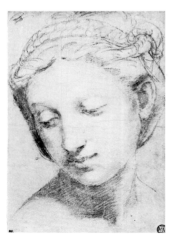

454: Head of Charity
Paris, Louvre 10958
Black chalk and white heightening; the contours indented. 230 × 160 mm. Although close to the head of the Madonna in the *Perla* (Madrid, Prado; D. p. 51), the light falling from the right confirms it as the head of Charity. More solid in relief than cat. 451, less so than cat. 455, it is carefully graded for the figure's subsidiary but important position. The characterization balances queenly refinement and maternal emotion. The execution combines spontaneity and faultlessness with a divine ease.

455: Head of Leo X for the fresco of Clement I
Chatsworth 38
Black chalk and white heightening; incised. 337 × 268 mm., irregular, made up to 480 × 299 mm.; all margins damaged.
A fragment of the cartoon for the fresco of Clement I. One of the most powerful of all Raphael's drawings. The characterization is comparable with, but intentionally more emphatic than, the portrait of Leo of 1518 (Florence, Uffizi; D. p. 46). The control of plasticity in the cheek, the grading of shadow round the mouth and eyes, and the magisterial disregard of modelling of the neck show the mind of a great master in an uninhibited moment.

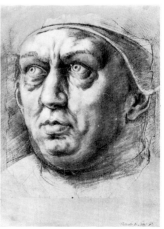

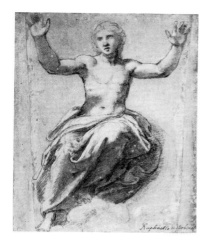

456: Christ
 Malibu, Paul Getty Museum
 Black chalk and white heightening on paper in part washed grey.
 223 × 177 mm.
Comparable in style to cat. 432 and cat. 458. Judging by the grey-washed
paper (cf. cat. 375 and the series of apostles at Chatsworth, Inv. 70–81)
this powerful and simplified image of an adolescent Christ was intended
for a dark setting, where Christ's narrow torso and large hands would
glow. While clearly related to that of Christ in the *Transfiguration*, the
pose is a re-working of the pose of Christ in the *Disputa*, another
indication of Raphael's late reconsideration of his early Roman work.
Here, however, the right forearm is slightly enlarged and flattened to create
an effect which is both hieratic and dramatic. The characterization was
conventionalized and weakened in cat. 457, and it may not have been
designed for it.

457: Christ, St John, the Virgin, St Peter and St Catherine
 Paris, Louvre 3867
 Pen, brush and wash, traces of black chalk in clouds below Christ.
 416 × 291 mm.
A badly damaged *modello* by or after Penni for Giulio's painting in the Galleria
Nazionale in Parma. Perhaps designed by Raphael, from whom the figure of
Christ is taken (cat. 456), but more probably a pastiche, done after Raphael's
death, of elements from the master. The types of the Virgin and St John are close
to those of the *Disputa* (cf. also cat. 211v); that of St Paul to the Apostle series of
1516. St Catherine's pose was used for the Magdalen in the Giulio
Romano/Penni *Noli Me Tangere* (Madrid, Prado).

458: Virgin and Child
 Chatsworth 902
 Black chalk. 410 × 223 mm., cut down
One of the most forceful and compelling of Raphael's late black chalk drawings,
entirely transcending in breadth and solidity of execution and ponderous energy of
movement the *Sistine Madonna* (Dresden, Gemäldegalerie; D.p. 36), with which it is
often connected. The forms are evoked virtually without line, and the treatment of
masses suggests an experiment with painterly chiaroscuro even more advanced than
the *Transfiguration*.

*459: Head of an unknown cardinal
 Salisbury, Wilton House
 Black and red chalks, the latter mixed with white heightening on the
 cheeks. 300 × 239 mm.
A portrait study probably dating from very late in Raphael's life. The
realistic emphasis on the slightly puffy flesh is similar to the *Leo X with
Two Cardinals* of 1518 (Florence, Uffizi; D.p. 46). Apart from cat. 447,
this is the only known drawing by Raphael in which he uses black, red
and white chalks together.

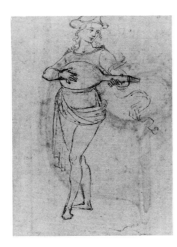

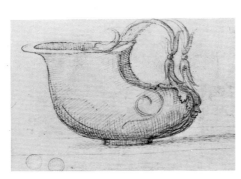

Supplement

5b (r): Lute player
 Oxford, Ashmolean 30 (as Perugino)
 Pen over black chalk, 149 × 104 mm., cut down.
A springy and full-bodied figure, economically captured in a compact and rhythmical stance. The traditional attribution to Raphael has been convincingly re-affirmed by Nicholas Turner, to whom I am indebted for its ultimate inclusion.

5b (v): Two-handled *askos*
 Pen over black chalk.
An untypically clumsy drawing, but very close in handling to the vessel held by the woman in cat. 1v, as Nicholas Turner has noted.

Select Bibliography

Documents

GOLZIO, V., *Raffaello nei Documenti*, Vatican City, 1936 (2nd edn. with additions, Farnborough, 1971)

Monographs

CROWE. J. A., and CAVALCASELLE, G. B., *Raphael: his Life and Works*, 2 vols., London, 1882
(D.) DUSSLER, L., *Raphael, a Critical Catalogue*, London, 1971
(1948) FISCHEL, O., *Raphael*, London, 1948 (2nd edn. revised, Berlin, 1962)
FREEDBERG, S., *Painting of the High Renaissance in Rome and Florence*, Harvard, 1961
PASSAVANT, J. D., *Raphael d'Urbin*, 2 vols., Paris, 1860
P.-H. POPE-HENNESSY, J., *Raphael*, London, 1970

Studies of Drawings

FISCHEL, O., *Raphaels Zeichnungen. Versuch einer Kritik*, Strasburg, 1898
——, *Raphaels Zeichnungen*, 8 vols, Berlin, 1913–41, continued by OBERHUBER (f)
(1917) ——, *Die Zeichnungen der Umbrer*, Berlin, 1917
VENTURI, A., *Choix de cinquante dessins de Raffaello Santi*, Paris, 1927
MIDDELDORF, U., *Raphael's Drawings*, New York, 1945
COCKE, R., *The Drawings of Raphael*, London, 1969
FORLANI-TEMPESTI, A., 'The Drawings', in *The Complete Works of Raphael*, ed. M. Salmi, New York, 1969

Studies of particular subjects

(Da) DACOS, N., *Le Logge di Raffaello*, Rome, 1977
DACOS, N., Review of Oberhuber, *Raphael's Zeichnungen*, in *Prospettiva*, 8, 1977, p. 68
(S.F.P.1) FERINO PAGDEN, S., 'Raphael's Activity in Perugia as Reflected in a Drawing in the Ashmolean Museum, Oxford', *Mitteilungen des Kunsthistorischen Institutes in Florenz*, XXV, 1981, no. 2, p. 231
(S.F.P.2) FERINO PAGDEN, S., 'Un disegno giovanile di Raffaello, originale o copia', *Prospettiva*, 27, 1981, p. 72
(Gere) GERE, J., Review of Parker's Ashmolean catalogue, *Burlington Magazine*, XCI, 1957, p. 159
GOULD, C., 'Raphael versus Giulio Romano: the Swing Back', *Burlington Magazine*, CXXIV, 1982, p. 479
(H.) HARTT, F., *Giulio Romano*, Yale, 1959
HIRST, M., 'The Chigi Chapel in S. M. della Pace', *Journal of the Warburg and Courtauld Institutes*, XXIV, 1961, p. 161
(Jaffé) JAFFÉ, M., Review of *Dessins italiens dans les collections hollandaises*, in *Burlington Magazine*, CIV, 1962, p. 231
(a) OBERHUBER, K., 'Die Fresken der Stanza dell'Incendio im Werk Raffaels', *Jahrbuch der Kunsthistorischen Sammlungen in Wien*, N.F. XXII, 1962, p. 23
(b) OBERHUBER, K., 'Vorzeichnungen zu Raffaels "Transfiguration"', *Jahrbuch der Berliner Museen*, IV, 1962, p. 116
(c) OBERHUBER, K., Review of Pouncey and Gere, *Raphael and his Circle*, in *Master Drawings*, I, 1963, p. 44
(d) OBERHUBER, K., 'A Drawing by Raphael Mistakenly Attributed to Bandinelli', *Master Drawings*, II, 1964, p. 398
(e) OBERHUBER, K., 'Eine unbekannte Zeichnung Raffaels in den Uffizien', *Mitteilungen des Kunsthistorischen Institutes in Florenz*, XII, 1966, p. 225
(f) OBERHUBER, K., *Raphaels Zeichnungen*, vol. 9 (continuation of Fischel), Berlin, 1972
(g) OBERHUBER, K., and VITALI, L., *Il Cartone per la Scuola d'Atene*, Milan, 1972
(h) OBERHUBER, K., 'The Colonna Altarpiece and Problems of the Early Style of Raphael', *Metropolitan Museum Journal*, 12, 1978, p. 55
POPHAM, A. E., 'An Unknown Drawing by Raphael', *Festschrift Friedrich Winkler*, Berlin, 1959, p. 239
PUTSCHER, M., *Raphaels Sixtinische Madonna*, Tübingen, 1955
QUEDNAU, R., Review of Oberhuber, *Raphaels Zeichnungen*, IX in *Kunstchronik*, 27, 1974, p. 66

QUEDNAU, R., *Die Sala di Costantino im Vatikanischen Palast*, Hildesheim, 1979

(a) SHEARMAN, J., Review of Hartt, *Giulio Romano*, in *Burlington Magazine*, CI, 1959, p. 456

(b) SHEARMAN, J., 'The Chigi Chapel in S. M. del Popolo', *Journal of the Warburg and Courtauld Institutes*, XXIV, 1961, p. 129

(c) SHEARMAN, J., 'Die Loggia di Psyche in der Villa Farnesina und die Probleme der letzten Phase von Raffaels graphischem Stil', *Jahrbuch der Kunsthistorischen Sammlungen in Wien*, XXIV, 1964, p. 59

(d) SHEARMAN, J., 'Raphael's Unexecuted Projects for the Stanze', *Walter Friedlander zum 90 Geburtstag*, Berlin 1965, p. 158

(e) SHEARMAN, J., Review of Pouncey and Gere, *Raphael and his Circle*, in *Burlington Magazine*, CVII, 1965, p. 34

(f) SHEARMAN, J., 'Le Seizième Siècle européen', *Burlington Magazine*, CVIII, 1966, p. 67.

(g) SHEARMAN, J., 'Raphael "Fa il Bramante"', *Studies in Renaissance and Baroque Art Presented to Anthony Blunt*, London, 1967, p. 12

SHEARMAN, J., 'Raphael as Architect', Journal of the Royal Society of Arts, 1968, p. 388

(h) SHEARMAN, J., 'Raphael at the Court of Urbino', *Burlington Magazine*, CXII, 1970, p. 72

(i) SHEARMAN, J., 'The Vatican Stanze; Functions and Decoration', *Proceedings of the British Academy*, LVII, 1971

(j) SHEARMAN, J., *Raphael's Cartoons in the Royal Collection*, London, 1972

(k) SHEARMAN, J., 'Raphael, Rome and the Codex Escurialensis', *Master Drawings*, XV, 1977, p. 107

TURNER, N., Review of Ferino Pagden, *Disegni Umbri . . .*, in *Burlington Magazine*, CXXV, February 1983

ZENTAI, R., 'Contribution à la période ombrienne de Raphael', *Bulletin du Musée Hongrois des Beaux-Arts*, 50, 1979, p. 69

Collection and Exhibition Catalogues (by location)

Austria

Viennna, Albertina: STIX, A., and FRÖLICH BUM, S., *Beschreibender Katalog der Handzeichnungen in der Graphischen Sammlung Albertina*, vol. III, *die Zeichnungen der toskanischen, umbrischen und römischen Schulen*, Vienna, 1932

France

Bayonne, Musée Bonnat: BEAN, J., *Dessins italiens*, Paris, 1960

Lille, Musée Wicar: MAUROIS, P., *Dessins de Raphael*, Lille, 1961

CHATELET, A., *Dessins italiens du Musée de Lille*, Lille, etc., 1968

(Rouchès) Paris, Louvre: ROUCHÈS, G., *Les Dessins de Raphael, Musée du Louvre*, Paris, 1948

(Cab.) OBERHUBER, K., and VIATTE, F., *Le Cabinet d'un grand amateur, P. J. Mariette*, Paris, 1967

(Cart.) BACOU, R., *Cartons d'artistes*, Paris, 1974

(N.Y.) BACOU, R., and VIATTE, F., *Italian Renaissance Drawings from the Musée du Louvre*, New York, 1974–5

(L.XIV) VIATTE, F., *Les Collections de Louis XIV*, Paris, 1977–8

(Chic.) MONBEIG GOGUEL, C., and VIATTE, F., *Roman Drawings of the 16th Century from the Musée du Louvre*, Chicago 1979–80

Germany

Berlin-Dahlem, Kupferstichkabinett: WINNER, M., *Vom Späten Mittelalter bis zu Jacques Louis David*, Berlin, 1973

Cologne, Wallraf-Richartz Museum: ROBELS, H., *Katalog Ausgewählter Handzeichnungen und Aquarelle*, Cologne, 1967

Düsseldorf, Kunstmuseum: BUDDE, I., *Beschreibender Katalog der Handzeichnungen in der Staatlichen Kunstakademie*, Düsseldorf, 1930

Frankfurt, Städelsches Kunstinstitut: MALKE, L., *Italienische Zeichnungen des 15. und 16. Jahrhunderts*, Frankfurt, 1980

Munich, Graphische Sammlung: HARPRATH, R., *Italienische Zeichnungen*, Munich, 1977

Great Britain

Chatsworth: POPHAM, A. E., *Old Master Drawings from Chatsworth*, Washington, etc., 1962–3

BYAM SHAW, J., *Old Master Drawings from Chatsworth*, London, 1973

(P. & G.) London, British Museum: POUNCEY, P., and GERE, J., *Raphael and His Circle*, London, 1962

London, National Gallery: GOULD, C., *The Sixteenth Century Italian Schools*, London, 1975

Oxford, Ashmolean Museum: ROBINSON, J. C., *The Drawings by Michelangelo and Raffaello in the University Galleries, Oxford*, Oxford, 1870

PARKER, K. T., *Catalogue of the Collection of Drawings in the Ashmolean Museum*, vol. 2, *Italian Schools*, Oxford, 1956

MACANDREW, H., *Catalogue of the Collection of Drawings in the Ashmolean Museum*, vol. 3, *Italian Schools, Supplement*, Oxford, 1981

Oxford, Christ Church: BYAM SHAW, J., *Drawings by Old Masters at Christ Church*, Oxford, 1976

(P. & W.) Windsor Castle, Royal Collection: POPHAM, A. E. and WILDE, J., *Italian Drawings of the Fifteenth and Sixteenth Centuries in the Collection of H. M. The King at Windsor Castle*, London, 1949

Holland

LUGT, F., and REGTEREN ALTENA, J. Q., *Les Dessins italiens dans les collections hollandaises*, Paris, etc., 1962
Haarlem, Teylers Museum: REGTEREN ALTENA, J. Q., *Cent dessins du Musée Teyler*, Paris, 1972
WARD-JACKSON, P., *Drawings from the Teylers Museum*, London, 1970
Amsterdam, Rijksmuseum: FRERICHS, L. C. J., *Italiannse Tekenengen II, de 15de en 16de Eeuw*, Amsterdam, 1981

Italy

(S.F.P.3) Florence, Uffizi: FERINO PAGDEN, S., *Disegni umbri del Rinascimento da Perugino a Raffaello*, Florence, 1982

U.S.A.

BROWN, D. A., *Raphael and America*, Washington, 1983
Boston, Isabella Stewart Gardner Museum: HADLEY, R. VAN N., *Drawings, Isabella Stewart Gardner Museum*, Boston, 1968
Cambridge, Mass., The Fogg Art Museum: MONGAN, A., and SACHS, P., *Drawings in the Fogg Museum of Art*, Cambridge, Mass., 1940
New York, Metropolitan Museum: BEAN, J., and STAMPFLE, F., *Drawings from New York Collections*, vol. I, *The Italian Renaissance*, New York, 1965

CONCORDANCE

Note to the Concordance

This Concordance, based on that in Frederick Hartt's *The Drawings of Michelangelo*, serves a triple function. Firstly, it provides an index of collections with the drawings in each listed in inventory sequence; secondly, it enables the reader to see at a glance the attributions of drawings by Raphael and his school made by those scholars whose contribution to this field of study has been the most signficant; thirdly, it supplements the Catalogue and acts as a guide to the Bibliography in drawing the reader's attention to some of the most revealing literature on individual drawings. Since scholarly references have been intentionally omitted from the Catalogue in order to concentrate attention on the drawings themselves, the Concordance provides a brief bibliography for every sheet. I have, in addition, occasionally provided references to particularly interesting or controversial drawings which I have not felt able to include in the Catalogue, but whose status seems to me to demand further discussion.

The Concordance includes the major large-scale works on Raphael which discuss his drawings, but excludes those volumes of selections published by Venturi, Middeldorf and Cock which, on the whole, deal with drawings about which there is little dispute. On the other hand the books and articles of Professors Oberhuber and Shearman have been included, for these seem to me to represent, in many cases, the best that has been written upon a large number of the drawings catalogued here. References which I believe to be particularly valuable in other recent writings have been entered in the column marked 'Additions'. I have provided page references to books, but not to articles, on the grounds that attributions in the latter are generally made within a closely woven argument which should be read in full. Abbreviations are provided in the Select Bibliography but should in any case be self-evident (R = Raphael, etc.).

Concordance

	Passavant	Crowe and Cavalcaselle	Fischel	Forlani—Tempesti	Oberhuber	Shearman	Additions	Joannides catalogue	
AMSTERDAM,									
Rijksmuseum	*Frerichs*								
1948:368	77 Giulio	—	—	—	—	(f) p. 28 Giulio	—	H.369 Giulio and Penni	449
1971:51	130 R	II p. 536(u) feeble	—	—	—	(b) R	—	H.30 Giulio	432
BAYONNE,									
Musée Bonnat	*Bean*								
(AI 146) NI 1705	133 R?	—	—	378(b) Giulio	—	—	—	—	396
(AI 681) NI 1706	130 R	—	—	199	99(a) R	—	—	—	184
(AI 683) NI 1707r	132r R	II p. 537 (bb) pupil	II p. 542 school	387 R	151(a) R	—	—	—	304r
NI 1707v	132v R	—	—	—	151(a) school	—	—	—	304v
(AI 684(a)) NI 1708(a)r	141 pupil	—	—	—	—	—	—	—	15r
NI 1708(a)v	—	—	—	—	—	—	—	—	15v
(AI 684(b)) NI 1708(b)r	142r pupil	—	—	—	—	—	—	—	16r
NI 1708(b)v	142v pupil	—	—	—	—	—	—	—	16v
(AI 1282) NI 1712r	126r R	—	—	141 R	—	—	—	—	195r
NI 1712v	126v R	—	—	141a R	—	—	—	—	195v
(AI 1283) NI 1713r	128r R	—	—	155 R	—	—	—	—	162r
NI 1713v	128v R	—	—	155a R	—	—	—	—	162v
(AI 1284) NI 1714r	129r R	—	—	151 R	—	—	—	—	161r
NI 1714v	129v R	—	—	152 R	—	—	—	—	161v
(AI 1285) NI 1715r	127r R	—	—	153 R	—	—	—	—	165r
NI 1715v	127v R	—	—	154 R	—	—	—	—	165v
(AI 1286) NI 1716r	195 Florentine school	—	—	—	—	—	—	—	8r
NI 1716v	—	—	—	—	—	—	—	—	8v
(AI 1288) NI 1718r	131r R	—	—	382 R	—	—	(b) R	—	328r
NI 1718v	131v R	—	—	383 R	—	—	(b) R	—	328v
BERLIN-DAHLEM,									
Kupferstichkabinett	*Winner*								
494	—	247 R	—	39 R	—	—	—	—	30
2231	—	—	—	374 R	—	—	—	—	326
5123	—	—	—	—	—	(f) p. 72 R?	—	—	391
5172	—	—	—	56a R	61 R	—	—	—	70
11659	—	—	—	104 R	—	—	—	—	104
18152	42 R or Giulio	—	—	—	—	(f) p. 68 R?	—	—	403
21551r	—	246 R	II p. 473 copy	—	—	(f) p. 29 Giulio	—	—	422r
21551v	—	246 R	II p. 473 copy	—	—	(f) p. 29 Giulio	—	—	422v
Formerly BERLIN, Habish Collection	—	—	—	56 R	61 R	—	—	—	71
BOSTON,									
Gardner Museum	*Hadley*								
24093	8 R?	—	II p. 140	—	—	(f) 490 R?	—	—	447
BUDAPEST,									
Museum of Fine Arts									
1779	—	240 R	I p. 144 R	(1917) 141 not R	—	—	—	S.F.P.3, p. 110	38
1934	—	—	—	(1948) p. 324 R	—	(f) p. 63 R	—	—	285
1935r	—	—	—	302 R	—	—	—	—	215r
1935v	—	—	—	301 R	—	—	—	—	215v
1936	—	242 R	—	86 R	—	—	—	—	86
1943	—	244 R	—	—	—	—	—	—	451
2195	—	—	II p. 120 copy	—	—	(f) p. 24 R?	—	—	289
CAMBRIDGE,									
Fitzwilliam Museum									
3103	—	—	—	357 R	—	—	—	—	280
PD 125–1961r	—	—	—	(1948) p. 182 R	—	(f) p. 56 R	—	P.-H. p. 225 R	312r
1961v	—	—	—	—	—	—	—	—	312v

	Passavant	Crowe and Cavalcaselle	Fischel	Forlani— Tempesti	Oberhuber	Shearman	Additions	Joannides catalogue	
CAMBRIDGE, MASS., Fogg Museum	*Mongan Sachs*								
1932 – 354r	152r R	—	—	141b R	—	—	—	—	194r
354v	152v R	—	—	141c R	—	—	—	—	194v
1936 – 120r	29r Perugino	—	—	(1917) 95 Perugino —		—	—	—	5r
120v	29v Perugino	—	—	—	—	—	—	—	5v
CHANTILLY, Musée Condé									
FR. VIII, 43r	—	354 R	I p. 298 R	132 R?	97(a) copy	—	—	—	148r
43v	—	354 R	I p. 314 R	—	—	—	—	—	148v
FR. VIII, 44r	—	358 R	—	186 R	—	—	—	—	131r
44v	—	—	—	—	—	—	—	—	131v
FR. VIII, 45	—	356	II p. 33 R	260 R	112 R	—	—	—	199
FR. IX, 42	—	353 R	—	212 R	—	—	—	—	101
FR. IX, 42 *bis*	—	360 R	—	42 R	—	—	—	—	29
FR. IX, 48	—	357 R	II p. 418 R	—	159 copy	(f) p. 69 R	(c) Penni	—	407
FR. IX, 48 *bis*	—	364 R	—	—	—	(f) 429 R	(d) Penni	—	373
FR. IX, 53	—	360a Viti	—	119 R?	—	—	—	—	121
FR. X, 56	—	—	—	159 R	—	—	—	—	166
CHATSWORTH, Devonshire Collection	*Popham/ Byam Shaw*								
(754) 20	P.55 R	—	—	394 R	—	—	—	—	311
(853) 38	P.69 Sebastiano?	—	—	—	—	(f) 482 Giulio	(j) p. 60 R	H.39 Giulio	455
(757) 50	—	—	II p. 103 not R	257 R	128 R	—	—	—	291
(758) 51	—	—	II p. 488 copy by Penni	(1948) p. 367 Penni	—	(f) p. 73 R	—	P.-H. p. 75 R	426
(759) 52	—	—	II p. 418 R counterproof	—	—	—	(c) R counterproof	—	409
(760) 53	P.61 R?	—	—	—	170(a) R	—	(c) R counterproof	—	419
(761) 54	—	—	II p. 423 Giulio	—	—	—	(c) Giulio	—	415
(762) 55	B.-S. 55 R	—	II p. 421 Giulio	—	—	(f) p. 35 Giulio	(c) Penni	—	399
(763) 56	P.62 R?	—	II p. 262 R	(1948) p. 104 R	170(b) R	—	(c) R	—	420
(764) 57	—	—	—	—	—	(f) p. 61 R	—	—	383
(767) 59	—	—	II p. 455 copy	—	—	(f) 486 R	(d) Giulio	—	440
(772) 66	P.56 R	—	II p. 489 R	(1948) p. 367 Penni	173 R	(b) R	—	—	435
(774) 67	—	—	—	(1948) p. 367 Penni	173 R	(b) R	—	—	434
(718) 175	B.-S. 59 Penni	571?	—	—	—	(f) 483 Penni	—	P.&G. p. 51 Penni	445
(729) 559	—	—	—	—	—	(f) p. 64 R	—	—	R??
(750) 657	B.-S. 56 R	—	—	—	—	—	—	—	398
(793) 728	P.57 R	566 R	—	375 R	155 R	—	—	—	320
(794) 730	P.58 R	563 R	II p. 306 R	(1948) p. 365 R	166 R	449 R	(j) p. 103 R	—	364
(797) 733	—	—	I p. 373 R	143 R	98 R	—	—	—	176
(723A) 783r	B.-S. 57 R	564 R	I p. 263 R	117 R	79(b) R	—	—	—	111r
(723A) 783v	B.-S. 57 R	—	—	117 copy	—	—	—	—	111v
(798) 902	P.59 R	—	—	369 R	134 R	(f) p. 69 R	?	—	458
(367A) 903r	—	569 R	II p.548 R?	—	—	(f) p. 56 R	—	H. 42 Giulio	380r
(367B) 903v	—	—	—	—	—	—	—	—	380v
(799) 904	B.-S. 58 R	—	—	(1948) p. 367 Penni	171 R	(b) R	—	—	424
(800) 905	P.60 R	—	II p. 281 R	—	—	(f) 447 R	(j) p. 101 R	—	362
CLEVELAND, Museum of Art									
CMA 78.37	—	161R	—	354 R	—	—	—	—	273
COLOGNE, Wallraf-Richartz	*Robels*								
Z. 1984	p. 89 R	—	—	—	—	(f) p. 58 R	(c) R	—	416
DRESDEN, Kupferstichkabinett									
W. 189r	—	—	—	—	—	—	(c) R	H. 26 Giulio	417r
W. 190v	—	—	—	—	—	—	(c) R	H. 27 Giulio	417v
DÜSSELDORF, Kuntsmuseum	*Budde*								
FP 11r	R	286 R	II p. 362 R	—	—	(f) 427 R	(d) Penni	—	372r
11v	R	286 R	II p. 362 R	—	—	(f) 428 R	(d) Penni	—	372v
FP 13r	—	288 R	—	—	—	—	—	—	Giulio
13v	—	—	—	—	—	—	—	—	Giulio
FLORENCE, Horne Museum									
5547	—	—	—	(1948) p. 365 Penni	—	(f) 432 Penni	—	P. & G. p. 51 Penni	Fig. 7
5548	—	—	—	—	—	(f) 481(c) Giulio	—	—	Giulio
5643	—	—	—	254 R	127 R	—	—	—	244
5878	—	—	—	—	—	—	—	—	242
5882	—	—	—	214 R	—	—	—	—	266

	Passavant	Crowe and Cavalcaselle	Fischel	Forlani—Tempesti	Oberhuber	Shearman	Additions	Joannides catalogue	
FLORENCE, Marucelliana E. 84	Popham R	—	—	—	80 R	—	—	—	92
FLORENCE, Uffizi									
57Er	—	—	—	32 R	48 R	—	—	S.F.P. 3, 55 R	80r
57Ev	—	—	—	—	—	—	—	S.F.P. 3, 55 R	80v
366Er	—	—	—	(1917) 114 R?	—	—	—	S.F.P. 3, 47 Perugino?	1v
366Ev	—	—	—	—	—	—	—	S.F.P. 3, 47 Perugino?	1r
368Er	—	—	—	(1917) 115 R?	—	—	—	S.F.P. 3, 48 Perugino?	2r
368Ev	—	—	—	—	—	—	—	S.F.P. 3, 48 Perugino?	2v
496Er	—	119 R	I p. 349 R	264 R	109(a) R	—	—	—	202r
496Ev	—	132 R	I p. 349 R	358 R	109(a) R	—	—	—	202v
499E	—	122 R	—	VIII, p. 370?	—	—	—	—	321
500E	—	124 R	—	VIII, p. 370?	—	—	—	—	322
501E	—	118 R	—	140 R	—	—	—	—	163
502E	—	123 R	—	356 R	—	—	—	—	323
505E	—	—	I p. 249 R	105 R	77 R	—	—	S.F.P. 3, 61 R	105
515E	—	117 R	I p. 339 R	127 R	—	—	—	—	170
520E	—	135 R	I p, 180 R	62 R	34 R	—	—	S.F.P. 3, 57 R	56
524E	—	120 not R	II p. 226 R	371 R	157 R	—	—	—	351
525E	—	136 R?	—	—	156 workshop	—	—	—	349
529E	—	126 R	I p. 279 R	78 R	76 R	—	—	S.F.P. 3, 60 R	118
530E	—	125 R	I p. 207 R	57 R	67 R	—	—	S.F.P. 3, 59 R	62
534E	—	113 R	II p. 400 R	378 Giulio	158 Giulio	—	—	H. 19 Giulio	395
535E	—	112 R	II p. 400 R	377 R	158 Giulio	—	—	H. 18 Giulio	394
536E	—	129 R	II p. 142 not R	(1948) p. 362 R	141	(f) 408 R	(d) R	P.-H. p. 115 R	338
537Er	—	—	I p. 182 R	60 R	36 R	—	—	S.F.P. 3, 58 R	57r
537Ev	—	—	I p. 182 R	61 R	36 R	—	—	S.F.P. 3, 58 R	57v
538E	—	108 R	I p. 312 R	175 R	96 R	—	—	S.F.P. 3, 63 R	137
539E	—	114 R	I p. 368 R	126 R	82 R	—	—	—	169
540E	—	111 R	II p. 310 Penni	—	163 R	(f) 451 R	(j) p. 105 R	—	365
541Er	—	—	—	293 R	118(a) R	—	—	—	210r
541Ev	—	—	—	294 R	118(a) R	—	—	—	210v
542Er	—	—	—	—	—	(f) 484 R	—	H. 38a Giulio	444r
542Ev	—	—	—	—	—	(f) 484a Giulio	—	—	444v
543Er	—	107 R	II p. 390 R	—	—	(f) p. 66 R	—	H. 15 Giulio	384r
543Ev	—	107 R	II p. 390 R	—	—	(f) p. 66 R	—	H. 16 Giulio	384v
544E	—	105 R	II p. 215 R	(1948) p. 165 R	—	(f) p. 64 R	—	—	298
1222E	—	—	—	—	—	(f) 462 school	—	P.&G. p. 51 Penni	Penni?
1325F	—	137 R	—	385 R	—	—	—	—	327
1328F	—	—	—	148 R	98R	—	—	—	177
1342F	—	—	—	295 R	118(b) R	—	—	—	213
1474Er	—	133 R	—	—	136 R	(c) R	—	—	294r
1474Ev	—	133 R	—	—	136 R	(c) R	(g) R	—	294v
1475Er	—	110 R	—	(1948) p. 182 R	149 R	(f) p. 56 R	—	H. 22 Giulio	315r
1475Ev	—	—	—	—	149 R	(f) p. 56 R	—	—	315v
1476Er	—	131 R	—	58 R	—	—	—	S.F.P. 3, 56 R	53r
1476Ev	—	131 not R	—	59 R	—	—	—	S.F.P. 3, 56 R	53v
1477E	—	138 R	—	176 R	88 R	—	—	S.F.P. 3, 62 R	136
1973Fr	—	—	—	—	143 R	(e) R	(g) R	—	342r
1973Fv	—	—	—	—	143 R	(e) R	—	—	342v
14794F	—	—	—	—	—	(f) p. 91 R	—	—	Penni?
164Ar	—	—	—	216 R	—	—	(k) R reworked	—	196r
164Av	—	—	—	217 R	—	—	(k) R	—	196v
165 A	—	140 R	—	—	—	—	(g) R	—	316
FRANKFURT, Städelsches kunstinstitut	Malke								
376	73 R	276 R	I p. 226 R	52 R	52 R	—	—	—	37
377	74 copy	277 R	—	—	—	—	—	S.F.P. 2, R	19
379	76 R	280 R	II p. 36 R	269 R	114(b) R	—	—	—	205
380	77 R	281 R	II p. 68 R	306 R	120(a) R	(g) p. 13 R	—	—	232
381r	—	282 R	II p. 95 R?	255 R	128 not R	(g) p. 37 R	—	P.-H. p. 106 R S.F.P. 2, R	255r
381v	—	—	—	395a copy	—	(g) p. 37 R (in part)	—	—	255v
382	—	283 R	II p. 95 pupil	256 R	128 R	—	—	S.F.P. 2, R	256
383	—	284 R	—	—	—	—	—	—	Giulio
384	—	278 R	I p. 251 not R	—	—	—	—	S.F.P. 2, R	106
421	79 workshop	II p. 307 Penni	—	—	—	(f) 481 Penni or R	(d) Giulio?	—	452
1797	—	—	—	(1948) p. 363 R	155 R	(f) 406 R	(d) R	—	339
4301	—	—	—	—	—	—	—	—	293
4302	—	—	—	—	—	—	—	—	313
4303r	75 R	—	—	368 R	134 R	—	—	—	282r
4303v	75 copy	II p. 541 aaa copy	—	310 copy	—	(g) p. 14 copy	—	—	282v

	Passavant	Crowe and Cavalcaselle	Fischel	Forlani—Tempesti	Oberhuber	Shearman	Additions	Joannides catalogue
GENEVA, Bodmer Foundation								
—	Sotheby's 9 Dec. 1936, No. 47 R	II p. 535 R school	—	—	—	—	P.&W. 858 R?	R??
HAARLEM, Teylers Museum	*Regteren Altena/Ward-Jackson*							
A14	(b) 11 R?	297 R	—	—	—	—	—	not R
A56²	—	—	255 school	—	416 R	—	—	258
A57	—	300 R	(1948) p. 363 R	—	412 R	(d) R	Jaffé R	345
A62	(b) 12 R	—	—	—	(f) p. 35 R	(c) Giulio	Jaffé Giulio H. 25 Giulio	402
A63	(a) 64 R	—	—	—	(f) p. 58 R	—	—	Penni
A64	(b) 14 R	301 R	—	—	(f) 434 R	(d) R	Jaffé R H. 11 Giulio	377
A65	(b) 14 R	—	—	—	(f) 435 R	(d) Giulio	H. 12 Giulio	378
A68	W.-J. 78 R	—	—	—	—	(c) R	Jaffé R	421
A76	—	303 R	—	—	—	—	—	418
A78r	W.-J. 77R	—	—	—	(f) 404 copy	(j) p. 102 R	Jaffé R	337r
A78v	W.-J. 77 R	299 R	II p. 281 copy	—	(f) 404 copy	(j) p. 102 copy	Jaffé R	337v
B37	(b) 14 R	—	—	—	(f) 436 R	—	—	not R
I 26r	(a) 63 R	302 R	II p. 379 copy (1948) p. 364 copy	—	(f) p. 66 R	—	Jaffé R	382r
I 26v	—	—	—	—	—	—	—	382v
HAMBURG, Kunsthalle								
21418	—	—	12 R	—	—	—	—	24
21419a	—	—	II Fig. 132 R	—	—	—	—	149
21419b	—	—	II Fig. 140	—	—	—	—	150
21419c	—	—	II Fig. 142	—	—	—	—	107
21592	—	—	367 R	—	—	—	—	284
HOLKHAM, Leicester Collection								
—	—	II p. 69 R	I p. 365 not seen	123 R	—	—	—	123
LEXINGTON, KENTUCKY, Private Collection								
—	—	—	—	—	(f) 443/4 R	(j) p. 96 R	—	358
LILLE, Musée des Beaux-Arts	*Maurois*							
428	52 R	397 R	II p. 340 R (1948) p. 153 R	161(a) R	(f) p. 65 R	(f) copy	—	388
429	20 R	409 R	69 R	—	—	—	—	77
430	49 R	395 R	222 R	—	—	—	—	copy
431	16 R	377 R	I p. 230 R 54 R	64 R	—	—	—	69
432	38 R	399 R	II p. 216 R 227 R	104 R	—	—	—	283
433	39 R	391 R	II p. 24 R 226 R	104 R	—	—	—	247
434	23 R	406 R	I p. 121 R 77 R	—	—	—	—	75
435	24 R	406 R	74 R	—	—	—	—	74
436	29 R	380 R	II p. 131 R 348 R	—	—	—	—	270
437	30 R	380 R	II p. 110 R 352 R	—	—	—	—	274
438	31 R	380 R	II p. 110 R 351 R	—	—	—	—	272
439	53 R	402 R	I p. 228 R	—	—	—	—	314
440r	9r R	384 R	I p. 147 R 16 R	41 R	—	—	—	47r
441v	10v R reworked	384 R	I p. 145 R reworked 15 R reworked	41 R reworked	—	—	—	47v
442r	17r R	375 R	I p. 226 R 50 R	53(a) R	—	—	—	34r
443v	18v not R	375 not R	I p. 118 R?	53(a)	—	—	—	34v
444r	14r R	383 R	I p. 146 R 21 R	44(b) R	—	—	—	43r
492v	14v not R	—	I p. 146	—	—	—	—	43v
445r	46r R	394 R	243 R	—	—	—	—	236r
446v	47v R	394 R	II p. 79 R 242 R	—	—	—	—	236v
447r	42v R	396 R	II p. 71 R? 266 R	109(b) R	(g) p. 11 R	—	—	201r
448v	41r R	396 R	II p. 71 R? 265 R	109(b) R	—	—	—	201v
449r	51r ?	413 R retouched	—	—	—	—	—	not R
450v	51v ?	413	—	—	—	—	—	not R
451	4 R	387 R	I p. 63 R 13 R	—	—	—	—	21
452r	44r R	393 R	II p. 85 R 245 R	—	—	—	—	237v
453v	45v R	393 R	II p. 85 R 244 R	135 R	—	—	—	237r
454r	35r R	379 R	II p. 164 R 346 R	135 R	(g) p. 37 R	—	—	269r
455v	36v R	379 R	347 R	—	—	—	—	269v
456r	33r R	376 R	II p. 127 R 364 R	—	—	—	—	278r
457v	34v R	376 R	II p. 128 R 365 R	—	—	—	—	278v
458r	32r R	378 R	I p. 379 R 161 R	97(b) R	—	—	—	174r
459v	32v R	378 R	I p. 379 R 162 R	97(b) R	—	—	—	174v
460	58 Eusebio	—	—	—	—	—	—	not R
461	15 R	377 R	20 R	49 R	—	—	—	42
462	61 R Giulio	374 R?	II p. 543 R?	—	(f) p. 35 Giulio	—	—	—
463	19?	405 R	—	—	—	—	—	not R
464	28 R	403 R	I p. 359 R 72 R	—	—	—	—	276
465	25 R	373 R	I p. 323 R 180 R	—	—	—	—	141
466	2 R	382 R	71 R	—	—	—	—	26
467	8 R	—	—	—	—	—	—	82
468	21 R	408 R	76 R	—	—	—	—	76
469	22 R	411 R	75 R	—	—	—	—	78
470	13 R	—	25 R	43 R	—	—	—	48

	Passavant	Crowe and Cavalcaselle	Fischel	Forlani—Tempesti	Oberhuber	Shearman	Additions	Joannides catalogue	
continued									
471r	40r R	390 R	II p. 46 R	289 R	—	—	—	—	212r
472v	40v R	390 R	II p. 46 R	290 R	—	—	—	—	212v
473	27 R	389 R	I p. 374 R	147 R	98 R	—	—	—	178
474	5 R	386 R	I p. 140 R	5 R	28 R	—	—	—	14
475	6 R	386 R	I p. 140 R	6 R	28 R	—	—	—	14
476	—	—	—	—	—	—	—	—	not R
477	26 R	410 R	—	211 R	—	—	—	—	100
478	56 Eusebio	II p. 487(d) follower	—	70 R reworked	—	—	—	—	not R
479	43 R	392 R	II p. 67 R	353 R	131 doubtful	(g) p. 13 R	—	—	229
480	3 R	II p. 487(b) follower	—	68 R	—	—	—	—	72
481	59 Giulio	401 R	II p. 484 R	—	—	(f) 437 Giulio	(c) Giulio	H. 10 Giulio	379
482r	11r R	385 R	I p. 147 R?	26 R	42 R	—	—	—	46r
483v	12v R	385 R	I p. 147 R?	27 R	42 R	—	—	—	46v
484	37 R	404 R	II p. 26 R	345 R	—	—	—	—	268
485	48 R	398 R	—	—	—	—	—	—	Giulio
486	1?	II p. 486 follower of Perugino	—	—	—	—	—	—	not R
487	54 copy	—	II p. 473 not R	379 copy	—	—	—	—	copy
488	7 R	388 R	I p. 110 not R	44 R	—	—	—	—	25
489	58 Eusebio	II p. 487 follower	—	—	—	—	—	—	not R
490	50?	414 R	—	188 R	—	—	—	—	copy
491	—	—	—	—	—	—	—	—	not R
492 (444v)	—	—	—	—	—	—	—	—	43v
493	55 circle of R	II p. 487f follower	—	103 R	—	—	—	—	193
2150	—	—	—	—	(f) p. 35 Giulio	(c) Penni	—	411	
LONDON, British Museum	*Pouncey & Gere*								
Ff. 1–35	32 R	449 R	II p. 51 R	286 R	115(a) R	—	—	—	209
Ff. 1–36	19 R	—	I p. 272 R	109 R	84(b) R	—	—	—	180
Pp. 1–64	7 R	446 R	—	55 R	—	—	—	—	81
Pp. 1–65r	14r R	444 R	—	85 R	—	—	(e) R	—	85r
Pp. 1–65v	14v R	444 R	—	84 R	—	—	—	—	85v
Pp. 1–67	4r R	440 R	I p. 146 R	22 R	45 R	—	—	—	44
Pp. 1–68	15 R	452 R	—	187 R	—	—	(e) R	—	97
Pp. 1–69	60 copy	448 R	II p. 485 not R	223 R	—	—	—	—	copy
Pp. 1–72	23 R	445 R	II p. 110 copy?	350 R	131 R	—	—	—	271
Pp. 1–73	44 R	442 R	II p. 87 copy	—	124 R	(c) R	—	—	243
Pp. 1–74r	29r R	443 R	II p. 79 R	240 R	125(a) R	—	—	—	235r
Pp. 1–74v	29v R	443 R	II p. 79 R	241 R	125(a) R	—	—	—	235v
Pp. 1–75r	17r R	447 R	II p. 75 R	197 R	—	—	—	—	187r
Pp. 1–75v	17v R	447 R	II p. 75 R	198 R	—	—	—	—	187v
Pp. 1–76	28 R	—	II p. 374 Sodoma	229 R	—	—	—	—	249
1854–5–13–11	34 R	—	—	395 R	153 R	—	—	—	310
1855–2–14–1r	12r R	458 R	I p. 309 R	171 R	—	—	—	—	133r
1855–2–14–1v	12v R	—	I p. 309 R	172 R	94(b) R	—	(e) R	—	133v
1860–4–14–446	21 R	562 R	II p. 119 R	233 R reworked	—	—	(e) R	—	287
1860–6–16–94r	1r R	—	—	4 R	23 R	(c) R	(e) R	—	7r
1860–6–16–94v	1v R	II p. 542 kkk R	I p. 282 R	38 R	—	(c) R?	(e) R	—	7v
1860–6–16–96	37 R	II p. 294f R p. 536t R	II p. 488 R	(1948) p. 285 R	173 not R?	(b) R	—	—	433
1866–7–14–79	24 R	159 R	I p. 359 R	349 R	132 R	—	—	—	275
1868–8–8–3180	35 R	—	—	(1948) p. 163 R	—	(c) R	—	—	295
1894–7–21–1	26 R	164 R	II p. 133 R	362 R	133 R	—	—	—	277
1895–9–15–610	5 R	II p. 539 mm R	—	23 R	42 R	—	—	—	50
1895–9–15–611r	3r R	II p. 538 gg R	II p. 227 R	51 R	53(b) R	—	—	—	35r
1895–9–15–611v	3v not R	II p. 538 gg	II p. 227	51 not R	—	—	—	—	35v
1895–9–15–612	9 R	II p. 542 lll R	—	34 R	56 R	—	—	—	67
1895–9–15–613	13 R	II p. 542 mmm R	—	33 R	73 R	(c) R	—	—	79
1895–9–15–617r	11r R	306 R / II p. 536 X R	I p. 314 R	178 R	92 R?	—	—	—	139r
1895–9–15–617v	11v ?	—	—	—	23 R	—	—	—	139v
1895–9–15–618r	2r R	—	—	11 R	—	(c) R	—	—	10r
1895–9–15–618v	2v R	—	—	—	—	(c) R	—	—	10v
1895–9–15–619	8 R	II p. 543 ttt R	—	37 R	57 R	—	—	—	66
1895–9–15–621r	31r R	—	II p. 44 R	298 R	115(a) R	—	(e) R	—	217r
1895–9–15–621v	31v R	—	—	297 R	115(a) R	—	—	—	217v
1895–9–15–624r	20r R	—	—	91 R	99(b) R	(c) R	—	—	191r
1895–9–15–624v	20v R	—	—	92 R	99(b) R	—	—	—	191v
1895–9–15–628	16 R	—	—	90 R	—	(c) R	—	—	89
1895–9–15–629	27 R	—	—	vol 7. p. 328 R	—	(g) p. 14 R	—	—	286
1895–9–15–631	22 R	—	—	189 R	—	(c) R	—	—	188
1895–9–15–634	38 R	II p.536 s R	II p. 489	—	173 not R	—	—	—	436
1895–9–15–636	10 R	475 R	I p. 304 R	165 R	93(b) R	—	—	—	128
1895–9–15–637	18 R	—	—	134 R	—	—	—	—	153
1900–8–24–107	25 R	II p. 538 hh copy?	II p. 167 copy	370 R	134 R	(c) R	—	—	281
1900–8–24–108	33 R	—	—	267 R	114(a) R	—	—	—	204
1947–10–11–19r	6r R	369 R	—	31 R	—	—	—	—	55r
1947–10–11–19v	6v R	369 R	—	31 R	—	—	—	—	55v

	Passavant	Crowe and Cavalcaselle	Fischel	Forlani—Tempesti	Oberhuber	Shearman	Additions	Joannides catalogue	
continued									
1948–11–18–39	30 R	—	—	—	—	—	—	206	
1949–2–12–3	72 Giulio	II p. 543 rrr	—	—	(f) 484b Giulio	—	—	446	
1953–10–10–1r	36r R	—	—	148(a) R	(c) R	—	—	302r	
1953–10–10–1v	36v R	—	—	—	—	—	—	302v	
1963–12–16–1r	—	453 R	I p. 310 R	170 R	94(a) R	—	—	130r	
1963–12–16–1v	—	—	I p. 310 R	—	94(a) R	—	—	130v	
LONDON, National Gallery									
213A	Gould R	II p. 17 R	I p. 202 R	40 R	—	—	—	31	
LONDON, Private Collection									
1	—	II p. 540 xx R	II p. 87 R	253 R	127 R	—	—	245	
2	—	120 not R	—	372 R	157 studio	(f) p. 61 R	—	—	352
LONDON, R.I.B.A.									
XIII–1Pr	—	—	—	—	—	—	(k) R	—	296r
XIII–Pv	—	—	—	—	—	—	(k) R	—	296v
Formerly LONDON, Sotheby's									
10th May 1963, No. 36A R	—	—	—	—	—	(f) p. 118 R	—	—	397
LOS ANGELES, Hammer Foundation									
—	—	—	—	(1948) p. 364 Giulio	—	—	—	297	
MALIBU, Getty Museum	Christie's 9 Dec. 1982, No. 17 R	II p. 536 R	—	(1898) 362 Giulio	—	(b) R?	—	—	456
MILAN, Ambrosiana									
Resta 45/2 p. 39r	—	148 R	—	291 R	—	—	—	—	211r
p. 39v	—	149 R	—	292 not R	—	—	—	—	211v
F.272, INF.6	—	—	II p. 422?	—	—	(f) p. 68 R	(c) Giulio	—	405
F.272, INF.36	—	—	—	—	—	(b) Giulio	(c) Giulio	H. 31 Giulio	429
School of Athens	—	145 R	II p. 65 R	313 R	122 R	—	—	—	234
Battle of the Milvian Bridge	—	146 R	II p. 457 Giulio	—	—	(f) 489a Giulio	—	H. 36 Giulio	443
MONTPELLIER, Musée Fabre									
3184r	—	416 R	II p. 51 R	287 R	115(b) R	—	—	—	225r
3184v	—	416 R	—	288 R	115(b) R	—	—	—	225v
3185	—	417 R	—	73 R	—	—	—	—	109
3186	—	415 R	I p. 272 copy?	106 R	—	—	—	—	182
MUNICH, Graphische Sammlung	*Harprath*								
2457	73 R	270 R	—	213 R	—	—	—	—	192
2458r	74r R	271 R	—	284 R	—	—	—	—	208r
2458v	74v R	272 R	—	285 R	—	—	—	—	208v
2460	75 R	273 R	—	(1948) p. 194 R	155 R	(f) p. 91 R	(j) p. 120 R	—	348
8235	76 R	—	—	—	—	(f) p. 125 Giulio	(j) p. 95 copy	—	355
NAPLES, Capodimonte									
86653	—	151 R	II p. 138 R	—	145 R	(f) 411 R	(d) R	—	344
NEW YORK, Metropolitan Museum	*Bean and Stampfle*								
Rogers Fund 64.47r	49r R	454 R	I p. 264 R	—	80 R	—	—	—	113r
64.47v	49v R	—	I p. 264 R	—	80 R	—	—	—	113v
NEW YORK, Pierpont Morgan Library	*Bean and Stampfle*								
I, 15	48 R	—	—	66 R	60 R	—	—	—	83
promised gift (anon.)	—	157 R	I p. 183 R	65 R	34 R	(h) R	—	P.-H. p. 88 R S.F.P. 3, p. 93 R	59
1977–45	50 R	II p. 204	II p. 311	—	—	(f) 450 R	(j) p. 105 R	—	361
NEW YORK, Woodner Collection									
—	Christie's 6 July 1982, No. 21 R	—	—	—	—	—	—	—	340
OXFORD, Ashmolean Museum	*Parker*								
30r	30r Perugino?	536R?	I p. 64 R?	(1917) 80 Perugino	—	—	—	—	5b (r)
30v	30v Perugino?	—	—	(1917) 81 Perugino	—	—	—	—	5b (v)
33	33 circle of Perugino	529d not R	—	(1917) 72 not R	—	—	—	—	4

	Passavant	Crowe and Cavalcaselle	Fischel	Forlani—Tempesti	Oberhuber	Shearman	Additions	Joannides catalogue	
continued									
34r	34r circle of Perugino	496 R	I p. 119 R	(1917) 76 Perugino w/shop	—	—	—	S.F.P. 1 R	73r
34v	34v R invention	—	I p. 119 R	(1917) 76 Perugino w/shop	—	—	—	S.F.P. 1 R	73v
40	40 Pinturicchio?	455 R	I p. 117 R	(1917) 78	—	—	—	—	13
44	44 Signorelli?	498 R	I p. 279 R	—	—	—	—	S.F.P. 3, p. 105 R?	117
248	248 Giulio?	—	—	—	—	(f) p. 28 Giulio and Penni	—	Gere: Giulio and Penni	Fig. 10
462r	462r Peruzzi	516 R	II p. 138 Giulio	—	143?	(f) 410 R	—	—	343r
462v	462v Peruzzi	—	II p. 138	—	—	(f) 410 school	—	—	343v
501r	501r R	491 R	I p. 118 R	2 R	30 R	—	—	—	11r
501v	501v R	491 R	I p. 116 R	3 R	30 R	—	—	—	11v
502	502 R	484 R	I p. 117 R	(1917) 67 Perugino	—	—	—	S.F.P. 3, p. 77 R	12
503r	503r R	—	—	(1917) No. 73 indeterminate	—	—	—	—	3r
503v	503v R	—	—	(1917) No. 73 indeterminate	—	—	—	—	3v
504r	504r R	—	I p. 139 R	8 R	29 R	—	—	—	17r
504v	504v R	—	I p. 139 R	7 R	29 R	—	—	—	17v
505	505r R	479 R	I p. 90 R	(1917) 74 R or Perugino	38 R	—	—	S.F.P. 3, p. 126 R	27
506	506v R	534 R	I p. 90 R	(1917) 75 R or Perugino	38 R	—	—	S.F.P. 3, p. 126 R	28
507r	507r R	539 R	II p. 528 R	vol II p. 92 Perugino?	—	—	—	—	95r
507v	507v not R	—	—	—	—	—	—	—	95v
508(a)r	508r R	486 R	I p. 227 R	46 R	53(c) R	—	—	—	32r
508(a)r	508v R	486 R	I p. 227 R	47 R	53(c) R	—	—	—	32v
508(b)r	508(b)r R	487 R	I p. 228 R	48 R	53(c) R	—	—	—	33r
508(b)v	508(b)v R	—	—	49 R	53(c) R	—	—	—	33v
509	509 R	497 R	I p. 138 R	41 R	50 R	—	—	—	36
510r	510r R	530 R	I p. 184 R	63 R	33 R	—	—	S.F.P. 3, p. 93 R	58r
510v	510v R	—	—	64 R	33 R	—	—	—	58v
511(a)	511(a) R	493 R	I p. 145 R	18 R	44(a) R	—	—	—	40
511(b)	511(b) R	493 R	I p. 145 R	19 R	44(a) R	—	—	—	41
512r	512r R	555 R	I p. 147 R	24 R	42 R	—	—	P.&G. p. 6 R	45r
512v	512v not R?	—	—	—	—	—	—	S.F.P. 3, p. 176 R	45v
513	513 R	456 R	I p. 155 R	30 R	47 R	—	—	—	54
514r	514r R	—	—	35 R	55 R	—	—	—	63r
514v	514v R	—	—	36 R	55 R	—	—	—	63v
515	515 R	459 R	I p. 282 R	1 R	58 R	—	—	P.&G. p. 3 R	9
516r	516r R	483 R	I p. 262 R	112 R	78 R	—	—	—	115r
516v	516v	—	—	—	—	—	(g) R	—	115v
517r	517r R	485 R	I p. 262 R	114 R	78 R	—	—	—	116r
517v	517v	—	—	—	—	—	(g) R	—	116v
518	518 R	481 R	I p. 264 R	118 R	—	—	—	—	112
519r	519r R	482 R	I p. 339 R	128 R	—	—	—	—	173r
519v	519v R	—	I p. 339 R	129 R	—	—	—	—	173v
520	520 R	—	—	—	—	—	—	—	154
521r	521r R	457 R	I p. 364 R	121 R	87 R	—	—	—	122r
521v	521v R	—	I p. 364 R	122 R	87 R	—	—	—	122v
522r	522r R	535 R	—	82 R	—	—	—	P.&G. p. 12 R	87r
522v	522v R	535 R	—	83 R	—	—	—	—	87v
523r	523r R	541 R	I p. 273 R	87 R	75 R	—	(k) R	—	88r
523v	523v not R	—	—	vol II Fig. 105 R?	75	—	—	—	88v
524r	524r R	543 R	II p. 75 R	88 R	70 R	—	—	—	114r
524v	524v R	—	—	—	—	—	—	—	114v
525r	525r R	542 R	I p. 309 R	89 R	95(a) R	—	—	P.&G. p. 11 R	135r
525v	525v R	542 R	I p. 309 R	174 R	95(a) R	—	—	—	135v
526r	526r R	540 R	—	310(a) R	—	—	—	—	84r
526v	526v R	—	—	—	—	—	—	—	84v
527r	527v R	544 R	—	99 R	89(b) R	—	—	—	158r
527v	527v R	—	—	vol III p. 149 R	—	—	—	—	158v
528 r	528r R	550 R	II p. 547 R	100 R	89(a) R	—	—	—	146r
528v	528v R	550 R	II p. 547 R	101 R	89(a) R	—	—	—	146v
529	529 R	475 R	I p. 304 R	164 R	93(a) R	—	—	—	127
530r	530r R	476 R	I p. 304 R	166 R	93 (b) R	—	—	—	124r
530v	530v R	476 R	—	167 R	93 (b) R	—	—	—	124v
531	531 R	477(l) not R	I p. 306 R	169 R	95(a) R	—	—	—	129
532	532 R	477 R	I p. 315 R	173 R	—	—	—	—	134
533r	533r R	537 R	I p. 229 R I p. 329 R	67 R	—	—	—	—	96r
533v	533v not R	—	—	—	—	—	—	—	96v
534r	534r R	547 R	I p. 228 R	149 R	—	—	—	—	140r
534v	534v R	—	I p. 228	vol. III p. 169 R	—	—	—	—	140v
535	535 R	532 R	I p. 329 R	210 R	74 R	—	—	—	99
536r	536r R	499 R	I p. 342 R	205 R	90 R	—	—	—	159r
536v	536v R	499 R	I p. 342 R	204 R	90 R	—	—	—	159v
537	537 R	533 R	II p. 265 R	193 R	—	—	—	P.&G. p. 14 R	185
538r	538r R	517 R	II p. 266 R	194 R	99(c) R	—	(a) R	P.&G. p. 14 R	186r
538v	538v R	517 R	II p. 266 R	195 R	99(c) R	—	(a) R	—	186v
539r	539r R	462 R	I p. 316 R	200 R	100 R	—	—	—	132r

	Passavant	Crowe and Cavalcaselle	Fischel	Forlani—Tempesti	Oberhuber	Shearman	Additions	Joannides catalogue	
continued									
539v	539v R	462 R	I p. 317 R	201 R	100 R	—	—	—	132v
540r	540r R	467 R	II p. 266 R	191 R	—	—	—	—	190r
540v	540v R	—	II p. 266 R	vol IV p. 194 R	—	—	—	—	190v
541r	541r R	511 R	II p. 86 R	249 R	126(a) R	—	—	—	238r
541v	541v R	—	II p. 86 R	248 R	126(a) R	—	—	—	238v
542	542 R	501 R	II p. 30 R	259 R	112 R	—	—	—	198
543	543 R	554 R	II p. 50 R	274 R	—	—	—	—	219
544r	544r R	553 R (retouched)	II p. 50 R	275 R	—	—	—	—	223r
544v	544v ?	—	—	—	—	—	—	—	223v
545r	545r R	—	II p. 50 R	281 R	—	—	—	—	218r
545v	545v R	—	II p. 50 R	280 R	—	—	—	—	218v
546r	546r R	504(a) R	II p. 50 R	278 R	—	—	—	—	221r
546v	546v R	504(a) R	II p. 52 R	279 R	—	—	—	—	221v
547r	547r R	504(b) R	II p. 47 R	276 R	—	—	—	—	220r
547v	547v R	504(b) R	II p. 47 R	277 R	—	—	—	—	220v
548	548 R	502 R	II p. 34 R	296 R	—	—	—	—	214
549r	549r R	503 R	II p. 44 R	299 R	—	—	—	—	216r
549v	549v R	—	II p. 44 R	300 R	—	—	—	—	216v
550	550 R	505 R	II p. 68 R	307 R	120(b) R	(g) p. 13 R	—	—	231
551	551 R	509 R	II p. 72 R	308	120(c) R	(g) p. 13 R	—	—	230
552r	552r R	508 R	II p. 73 R	309 R	121 R	—	—	—	233r
552v	552v	—	—	—	—	—	—	—	233v
553r	553r R	506 R	II p. 67 R	311 R	147 R	(g) p. 12 R	—	—	228r
553v	553v	—	—	—	147 R	—	—	—	228v
554r	554r R	548 R	II p. 24 R	225 R	103 R	(g) p. 15 R	—	—	246r
554v	554v R	—	II p. 24 R	380 R	103 R	—	—	—	246v
555r	555r R	470 R	II p. 20 R	230 R	106 R	—	—	—	251r
555v	555v R	—	—	—	106 R	—	—	—	251v
556	556 R	513	II p. 140 R	(1948) p. 362 R	140 R	(f) 402 R	—	—	336
557r	557r R	512 R	II p. 140 R	(1948) p. 103 R	138 R	(f) 398 R	—	—	333 r
557v	557v R	512 R	II p. 140 R	(1948) p. 103 R	138 R	(f) 399 R	—	—	333v
558r	558r R	II p. 513 t school	II p. 542 school	388 R	151(c) R	—	—	—	305r
558v	558v R	—	—	—	—	—	—	—	305v
559r	559r R	520 R	II p. 542 R	390 R	151(b) R	—	—	—	306r
559v	559v R	—	—	389 R	151(b) R	—	—	—	306v
560	560 R	521 R	II p. 542 R	391 R	—	—	—	—	309
561	561 R	489 R	—	376 R	155 R	—	—	—	319
562	562 R	500 R	II p. 218 R	(1948) p. 178 R	148(a) R	(f) p. 64 R	—	—	301
563r	563r R	II p. 513 ii school	—	386 R	—	—	—	—	331r
563v	563v R	II p. 513 ii school	—	vol. VIII Fig. 308 R	—	—	—	—	331v
564	564 R	II p. 513 cc school	I p. 354 R	361 R	—	—	—	—	267
565	565 R	492 R	II p. 462 R	384 R	—	—	—	—	329
566r	566r R	460 R	II p. 339 R	(1948) p. 153 R	161(b) R	(f) p. 65 R	—	—	386r
566v	566v R	—	II p. 339 R	—	161(b) R	(f) p. 65 R	—	—	386v
567	567 R	461 R	II p. 340 R	(1948) p. 153 R	161(b) R	(f) p. 65 R	—	—	387
568	568 R	473 R	II p. 489 R	(1948) p. 285 R	173 R	(f) p. 70 R	—	—	437
569r	569r R	519 R	II p. 455 R	—	—	(f) 487 R	(d) R	H 38 Giulio	441r
569v	569v	—	—	—	—	(f) 488 R(?)	—	—	441v
569 A	Macandrew 569 A R	—	—	—	—	(f) 478 R	(d) R	—	354
569 Br	Macandrew 569 Br R	—	—	—	—	(f) 413 R	(j) p. 103 R	—	346r
569 Bv	Macandrew 569 Bv R	—	—	—	—	(f) 414 R	(j) p. 103 R	—	346v
570	570 Penni?	II p. 541 yy	—	—	—	(f) 417 R	—	P.&G. p. 51 Penni	259
571	571 Penni?	II p. 538 cc school	—	vol. VIII p. 367 Penni?	—	(f) p. 61 R	—	P.&G. p. 51 Penni	324
572	572 Penni?	522 R	II p. 354 Penni?	(1948) p. 177 R and school	108 Raphaelesque	—	—	—	290
576	576 school	—	—	—	—	—	—	—	353
579r	579r school	560 R	—	—	—	—	(g) R	—	392r
579v	579v school	560 R	—	—	—	—	(g) R	—	392v
583	583 indeterminate	—	—	—	143 not R	—	(d) R	—	Penni?
638	638 indeterminate	527 R	II p. 548 R	—	—	—	—	—	Giulio
655	655 copy	555 not R	II p. 419 R	(1948) p. 184 R	169 R	(f) p. 58 R	(c) R	Gere R	413
665	665 copy	II p. 512 o Penni	II p. 535 Penni	—	—	(f) 479 R	(d) Giulio	—	453
OXFORD,									
Christ Church	*Byam Shaw*								
0112	362 R	561 R	II p. 547 R	102 R	70 R	—	—	—	147
0113r	363r R	—	—	157 R	—	—	—	—	164r
0113v	363v R	—	—	158 R	—	—	—	—	164v
1949	67 R?	—	—	—	—	—	—	—	292
PARIS,									
École des Beaux-Arts									
310r	—	361 R	—	145 R	98 R	—	—	—	179r
310v	—	361 R	—	146 R	98 R	—	—	—	179v

	Passavant	Crowe and Cavalcaselle	Fischel	Forlani—Tempesti	Oberhuber	Shearman	Additions	Joannides catalogue	
continued									
318r	—	—	—	—	—	—	—	126r	
318v	—	—	—	—	—	—	—	126v	
PARIS, Fondation Custodia	*Regteren Altena*								
I 952r	62 R	—	—	177 R	95(b) R	—	—	Jaffé R	138r
I 952v	—	—	—	—	—	—	—	—	138v
1031 g	—	—	—	—	—	(f) p. 35 Giulio	(c) Giulio?	Jaffé R	400
5083 (2)	—	—	—	208–209 R	74 R	—	—	Jaffé R	102
PARIS, Louvre	*Exhibition Catalogues*								
3460	—	—	—	—	—	(f) p. 47 Penni	—	—	Fig. 14
3607	Chic. 25 Giulio	—	—	—	—	(f) p. 30 Giulio	—	—	Fig. 11
3847	N.Y. 63R	351 R	II p. 21 R	224 R	102 R	—	(k) R	—	250
3849	—	319 R	II p. 518 R or Giulio	—	—	(f) 465 R	—	Da.IX.1 R	389
3852	Cab. 120 R	346 R	II p. 140 Giulio	(1948) p. 362 R	140 R	(f) 400 R	—	—	334
3853	Cab. 121 R	346 R	II p. 140 Giulio	(1948) p. 362 R	140 R	(f) 401 R	—	—	335
3854 (+ Lexington, Kentucky, Private Collection)	L.XIV 19 R	350 R	II p. 289 R	(1948) p. 256 R and pupil	165(a) R	(f) 442 R	(j) p. 96 R	H. 1 Giulio	358
3855r	Rouchès 2 R	325 R	I p. 108 R	43 R	—	—	—	—	22r
3855v	—	325 R	I p. 108 R	43 R?	—	—	—	S.F.P. 3, p. 58 R	22v
3856r	Rouchès 11 R	327 Viti	I p. 43 Viti	96 copy	—	—	(k) R	—	93r
3856v	—	327 R	—	108 R	—	—	—	—	93v
3858	—	330 R	—	—	—	(f) p. 60 R	—	—	318
3859	Rouchès 7 R	326 R	I p. 372 R	144 R	—	—	—	—	167
3860	Cart. 3 R	320 R	I p. 153 R	28 R	46 R	—	—	—	51
3861	N.Y. 61 R	328 R	I p. 288 R	139 R	83 R	—	—	—	155
3862	Chic. p. 66 R	329 R	II p. 400 R	378a Giulio	—	—	(c) Giulio	H. 17 Giulio	393
3863	Chic. 48 R	322 R reworked	II p. 290 Penni	(1948) p. 365 studio	—	(f) 445 R	(j) p. 97 R	H. 2 Giulio	360
3864	Rouchès 27 R	321 R	II p. 489 R	(1948) p. 286 R?	172 R?	(b) R	—	H. 28 Giulio	427
3865	Cab. 119 R	II p. 537 aa R	I p. 303 R	168 R	93(a) R?	—	—	—	125
3866	—	324 R and pupil	II p. 192 not R	—	—	(f) 402a school	(d) copy	—	254
3867	Rouchès 30	332 R reworked	II p. 554 Giulio and Penni	—	—	(b) Giulio?	—	H. 6 Giulio	457
3868	Cart. 5 R	331 R	II p. 46 R	303 R	—	—	—	—	226
3869	Rouchès 14 R	345 R	II p. 50 R	282 R	117 R	—	—	—	224
3870r	Rouchès 1 R	333 R	I p. 329 R	9 R	—	—	—	—	18r
3870v	—	333 R	—	10 R	—	—	—	—	18v
3871	Cart. 4 R	335 R	I p. 340 R	207 R	91 R	—	—	—	160
3872	Rouchès 29	343 R	II p. 457 Polidoro	—	—	(f) 485 Penni	—	P.&G. p. 51 Penni	442
3873	L.XIV. 20 R	342 R	II p. 142 school	(1948) p. 363 workshop		407 R and workshop	(d) not R	P.-H. p. 115 copy	341
3874 + Stockholm 329	Rouchès 17 R	344 Raphaelesque	II p. 140 not R	—	137 not R	(f) p. 28 Giulio	—	H. 32 Giulio	448
3875	Cab. 124 R	336 R	II p. 419 R	(1948) p. 360 Giulio corrected by R	169 R	(f) p. 68 R	(c) R	H. 23 Giulio	414
3877	Chic. 47 R	341 R	II p. 195 R	—	—	(f) 415 R	(d) Penni	—	347
3880r	—	—	—	183 R	80 copy	—	—	—	143r
3880v	—	—	—	184 R	—	—	—	—	143v
3881	—	339 R	—	IV p. 179 school	—	—	—	—	23
3882	L.XIV. 17 R	347	I p. 266 R	80 R	72 R	—	(k) R	—	175
3883	—	—	—	—	—	—	—	P.&G. p. 51 Penni	330
3884r	—	II p. 475 No. 573	II p. 310 copy	—	—	(f) 452 copy	(j) p. 106 Penni	H. 4 Giulio	366r
3884v	—	—	—	—	—	(f) 452 copy	(j) p. 106 R copied by Penni	—	366v
3949	—	—	—	131 copy	—	—	—	—	152
3954	—	—	—	—	—	(f) p. 48 Penni	—	—	Fig. 9
3970	—	334 Viti	—	—	—	—	—	S.F.P. 3, p. 110	39
3983	Cart. 8 R reworked	—	—	—	—	(f) 432 R reworked	—	—	376
4008	—	II p. 531, No. 10	—	—	—	(f) 424 R or pupil	—	H. 8a Giulio	370
4017	—	—	—	—	—	(f) p. 35 R	(c) Giulio	H. 23c Giulio	410
4019	—	—	—	—	—	(f) p. 35 Giulio	(c) Giulio	H. 24 Giulio	404
4118	—	—	—	—	172 late copy	(b) R	—	—	431
4261	—	—	—	—	—	(f) 474 Penni	—	—	Penni
4304	—	—	—	—	—	(f) 477 Penni	(d) Penni	P.&G. p. 51 Penni	450
10958	—	—	—	—	—	(f) 480 R?	—	—	454
MJ 1120r	—	372 R	II p. 417 Giulio	—	168 copy	(f) p. 68 copy	(c) R	—	412r
1120v	—	—	II p. 417	—	170(b) R	(f) p. 68 copy	(c) R	—	412v
RF 1066	Cab. 118 R	II p. 537 dd R	I p. 361 R	120 R	86 R	—	—	—	120
RF 1870–1071	—	—	—	—	—	(f) 489 R	—	H. 37 Giulio	439
RF 1870–1395r	Rouchès 3 R	—	—	45 R	39 R	—	—	—	20r
1870–1395v	—	—	—	45?	39	—	—	S.F.P. 1 R	20v
RF 1870–28954	—	—	—	—	—	(f) 476 Penni	—	P.&G. p. 51 Penni	Penni

	Passavant	Crowe and Cavalcaselle	Fischel	Forlani—Tempesti	Oberhuber	Shearman	Additions	Joannides catalogue	
continued									
RF 28962r	—	—	—	—	(h) R	—	S.F.P. 3, p. 93 R	60r	
RF 28962v	—	—	—	—	(h) R	—	S.F.P. 3, p. 93 R	60v	
RF 28963r	—	—	—	—	(h) R	—	S.F.P. 3, p. 93 R	61r	
RF 28963v	—	—	—	—	(h) R	—	S.F.P. 3, p. 93 R	61v	
Coll. Gatteaux 000049r	—	—	—	I Fig. 35 R?	—	—	—	6r	
000049v	—	—	—	I Fig. 36 R?	—	—	—	6v	
PARIS,									
Petit Palais									
Dutuit 980	—	II p. 150 not R	—			(f) p. 49 Penni	—	—	381
Formerly PARIS,									
de Triqueti Collection									
—	—	367 R	—	17 R	—	—	—	64	
ROTTERDAM,	*Regteren*								
Boymans-van Beuningen	*Altena*								
Museum									
J 110	(a) 61	161 R	—	355 R	131 forgery	—	—	Jaffé R	279
Formerly ROWFANT,									
Locker-Lampson									
—	—	—	I p. 170 not R	14 R	—	—	—	65	
SALISBURY,									
Wilton House	*Wilton cat.*								
—	D. 26 R	—	—	—	—	(f) p. 74 R	—	—	459
STOCKHOLM,									
Nationalmuseum									
291r	—	316(a) R?	—	215 R	—	—	(k) R	—	317r
291v	—	316(a) R?	—	381 R	146 R	—	—	—	317v
296	—	311 R	I p. 162 R	29 R	—	(h) R	—	—	52
322	—	—	—	156 R	—	—	—	—	172
329 + Louvre 3874	—	—	—	—	—	(f) Giulio	—	H. 33 Giulio	448
VATICAN									
Lat. 13391r	—	370 R	—	81 R	70 R	—	—	—	157v
13391v	—	370 R	—	135 R	—	—	—	—	157r
13391r	—	370 R	—	137	—	—	—	—	156r
13391v	—	370 R	—	138	—	—	—	—	156v
13391v	—	370 R	—	136	—	—	—	—	145
VENICE,									
Accademia									
16r	—	—	I p. 274 R	97	68 R	—	—	—	94r
16v	—	—	I p. 275 R	98	68 R	—	—	—	94v
105	—	99 R	—	—	—	—	—	—	copy
VENICE,									
Querini Stampalia									
547	—	—	—	—	—	(f) 430 Penni	(d) Penni	—	374
VIENNA,									
Graphische sammlung	*Stix and*								
Albertina	*Frolich Bum*								
Bd.IV, 188/Sc.R 220r	58 R	—	—	221 R	—	—	(c) R	—	263
Bd.IV, 188/Sc.R 220r	63r R	171 R	II p. 120 R	236 R	107(a) R	—	—	—	253r
220v	63v R	205 R	II p. 114 R	237 R	107(a) R	—	—	—	253v
Bd.IV, 189–Sc.R 221r	64r R	172 R	II p. 114 R	231 R	107(b) R	—	—	—	252r
221v	64v R	172 R	II p. 114 R	232 R	107(b) R	—	—	—	252v
Bd.IV, 195/Sc.R 229r	62r R	193 R	II p. 528	219 R	—	—	(k) R	—	264r
229v	62v R	178 R	—	220 R	—	—	—	—	264v
Bd.IV, 196/Sc.R 230 R	59 R	180 R	—	185 R	81(b) R	—	—	—	90
Bd.IV, 202/Sc.R 242	54 R	192 Viti?	—	150 R	—	—	—	—	168
Bd.IV, 205/Sc.R 245r	56r R	200 R	II p. 51 R	283 R	130 R	—	—	—	207r
245v	56v R	187 R	—	366 R	—	—	—	—	207v
Bd.IV, 206/Sc.R 246r	52r R	223 R	I p. 351	95 R	—	—	—	—	108r
246v	52v R	188 R	I p. 350	107 R	—	—	—	—	108v
Bd.IV, 207/Sc.R 248r	50r R	189 R	I p. 263 R	115 R	79(a) R	—	—	—	110r
248v	50v R	189 R	I p. 263 R	116 R	79(a) R	—	—	—	110v
Bd.IV, 209/Sc.R 250r	53r R	191 R	I p. 347 R	110 R	84(a) R	—	—	—	181r
250v	53v R	191 R	I p. 272 R	111 R	84(a) R	—	—	—	181v
Bd.IV, 210/Sc.R 251	55 R	—	—	160 R	—	—	—	—	171
Bd.IV, 245/Sc.R 301r	51r R	217 R	I p. 322 R	181 R	80 R	—	—	—	142r
301v	51v R	232 R	I p. 322 R	182 R	80 R	—	—	—	142v
Bd.IV, 246/Sc.R 302r	60r R	231 R	—	202 R	—	—	—	—	144r
302v	60v not R	231 not R	—	—	—	—	—	—	144v
Bd.IV, 260/Sc.R 311	61 R	229 R	—	218 R	—	—	—	—	262
Bd.IV, 4879/Sc.R 238	49 R	183 R	I p. 174 R	53 R	63 R	—	—	—	68
Bd.V, 181/Sc.R 219	72 R	196 R	II p. 217 R	(1948) p. 364 R	148(b) R	—	—	—	303
Bd.V, 208/Sc.R 249r	71r R	190 R	II p. 225 R	360 R	—	—	—	—	265r
249v	71v R	190 R	—	359 R	—	—	—	—	265v
Bd.V, 211/Sc.R 252	76 R	179 R	II p. 292 R	—	—	(f) 446 R	(g) p. 100 R	—	261

	Passavant	Crowe and Cavalcaselle	Fischel	Forlani-Tempesti	Oberhuber	Shearman	Additions	Joannides catalogue	
continued									
Bd.V, 219/Sc.R 262r	65r R	202 R	II p. 87 R	251 R	126(b) R	—	—	—	240r
262v	65v R	202 R	II p. 87 R	252 R	126(b) R	—	—	—	240v
Bd.V, 220/Sc.R 263	66 R	203 R	II p. 86 R	250 R	126(c) R	—	—	—	239
Bd.V, 224/Sc.R 270	69 R	199 R	II p. 50 R	273 R	—	—	—	—	222
Bd.V, 234/Sc.R 284	77 R	226 R	II p. 390 R	—	—	(f) p. 66 R	—	—	385
Bd.V, 242/Sc.R 294	79 R	—	—	(1948) p. 367 pupil	—	(b) R	—	—	438
Bd.V, 250/Sc.R 190r	67r R	228 R	—	94 R	81(a) R	—	—	—	91r
190v	67v R	228 R	—	93 R	81(a) R	—	—	—	91v
Bd.V, 4880/Sc.R 222	78 R?	174 R	II p. 489 R	—	—	(b) Giulio	—	H. 29 Giulio	428
Bd.V, 4881/Sc.R 283	75 R	209 R	II p. 258 R	(1948) p. 365 Giulio	159 not R	(f) 422 R	(a) R	H. 7 Giulio	367
Bd.V, 4883/Sc.R 267	68 R	201 R	II p. 67 R	305 R	—	(g) p. 11 R	—	—	227
Bd.V, 17573/Sc.R 256	73 R	197 R	II p. 216 R	—	—	(f) p. 64 R	—	—	299
Bd.V, 17575/Sc.R 282	74 R	225 R	II p. 264 R	—	160 R	(f) 426 R	(a) R	H. 9 Giulio	371
Bd.VI, 192/Sc.R 226r	85r	173 R	II p. 275 R	—	164 Giulio	(f) 438 Giulio	(g) p. 94 Giulio	H. 3 Giulio	356r
226v	85v	173 not R	II p. 275 R	—	164?	(f) 439 Giulio	(g) p. 94 Giulio	H. 3 Giulio	356v
Bd.VII, 178/Sc.R 216	114 Penni	169 R	II p. 522 R	—	—	(f) 468 R	—	Da.XI. 2 R	390
Bd.VII, 218/Sc.R 261	113 Penni	211 R	II p. 418 R	—	—	(f) p. 68 R	(c) Penni	—	401
Bd.VII, 235/Sc.R 285	117 Penni	—	—	378c Penni?	—	—	—	—	Penni?
Bd. VII, 237/Sc.R 287	116 Penni	176 R	II p. 488 R	—	172 R?	(b) R?	—	—	425
Bd.VII, 17634/Sc.R 266	118 Penni	219 R	II p. 545 R	—	—	Cab. 123 R	—	P.&W. 809 not R	Penni?
Bd.VIII, 4882/Sc.R 275	—	208 R	II p. 258 R	(1948) p. 365 Giulio	—	(f) 423 R	—	—	368
Bd.XII, 117/Sc.R 165r	214r Bandinelli	—	—	—	—	(d) R	—	—	183r
165v	214v Bandinelli	—	—	—	—	(d) R	—	—	183v
Z.G. Bd.III, 90/Sc.R 122	—	—	—	—	168 Later derivative	—	(c) R?	—	406
Z.G. Bd.III, 17635	Pordenone	—	—	—	—	(f) p. 37 Giulio	—	—	Penni?
Z.G. Bd.VI, 193/Sc.R 211	—	—	—	—	—	(b) Penni	—	—	423
Z.G. Bd.VII, 227/Sc.R 273	—	210 R	II p. 363 R	—	—	(f) 431 copy	(c) R	P.-H. p. 71 copy	375
Z.G. Bd.VII, 4878/Sc.R 274	—	207 R	II p. 262 R	(1948) p. 365 Giulio	—	(f) 425 R	(a) Giulio	H. 8 Giulio	369
Z.G. Bd.VII, 17574	—	198 R	II p. 217 replica	(1948) p. 178 R	—	(f) p. 68 R	—	—	300
Z.G. Supp. Bd.IV, 17544/ Sc.R 293	—	177 copy	II p. 489 Giulio	—	—	(b) Penni	—	—	430
WANTAGE, Private Collection									
116r	—	—	—	270 R	—	—	—	—	203r
116v	—	—	—	271 R	—	—	—	—	203v
WASHINGTON, National Gallery of Art									
B.33, 667	—	—	—	—	—	—	—	—	119
WEIMAR, Graphische Sammlung									
KK 8047r	—	—	—	203 R	—	—	—	—	260r
8047v	—	—	—	203 copy	—	—	—	—	260v
WINDSOR, Royal Library	*Popham and Wilde*								
0117	801 R	—	—	—	156 R	(a) R	—	—	350
3720r	797r R	—	—	—	129 R?	(f) 418 R	—	—	257r
3720v	797v R	—	—	—	129 R?	(f) 419 R	—	—	257v
4370	788 R	—	—	—	12 R	—	—	—	49
12732	794 R	429 R	II p. 29 R	258 R	111 R	—	—	—	197
12733	795 R	—	—	261 R	—	—	—	—	200
12734	792 R	430 R	II p. 25 R	228 R	105 R	—	—	—	248
12735r	798r R	437 R	II p. 196 R	392 R	152(a) R	—	—	—	307r
12735v	798v R	—	II p. 196 R	—	152(a) workshop	—	—	—	307v
12736	799 R	436 R	II p. 196 R	393 R	152(b) R	—	—	—	308
12737r	793r R	421 R	II p. 119 R	234 R	108 R	—	—	P.&G. p. 18 R	288r
12737v	793v R	—	II p. 119 R	235 R	108 R	—	—	—	288v
12738	790 R reworked	427 R	I p. 299 R	130 R reworked	97(a) R	—	—	—	151
12740	833 copy	II p. 493 f copy	II p. 553 copy	379a Giulio?	—	(f) p. 30 Giulio	—	—	Fig. 13
12742	800 R	426 R	II p. 171 R	373 R	154 R	(a) R	—	—	325
12743	392 Granacci?	428 R	II p. 478 R	III p. 136 not R	—	—	—	—	103
12745	805 R?	424 R	II p. 529 R	—	—	(f) p. 24 R?	—	—	not R
12749	808 Perino?	423 R	II p. 275 Penni	—	—	(f) 440 Penni	(j) p. 94 Penni	—	357
12750	803 R	—	II p. 302 copy	—	167 R	(f) 448 R	(j) p. 102 R	H. 5 Giulio	363
12751	802 R counterproof	425 R	II p. 289 R counterproof	(1948) p. 256 counterproof	165(b) R counterproof	(f) 441 R counterproof	(j) p. 96 R counterproof	H. 1a Giulio	359
12754	804 R	433 R	II p. 418 R	(1948) p. 185 R (+ Giulio)	—	(f) p. 68 R	(c) R	—	408
12758r	791r R	—	—	190r	—	—	—	P.&G. p. 19 R	189r
12758v	791v R	—	—	—	—	—	—	—	189v
12759	789 R	438 R	—	79 R	71 R	—	—	—	98
12760r	796r R	431 R	II p. 84 R	246 R	125(b) R	—	—	—	241r
12760v	796v R	—	II p. 84 R	247 R	125(b) R	—	—	—	241v
12798	28 Santi	—	—	—	—	—	—	—	Fig. 1
ZURICH, Kunsthaus									
N. 56III	—	—	—	(1948) p. 362 R	139 R	(f) 397 R	(d) R	—	332

Index

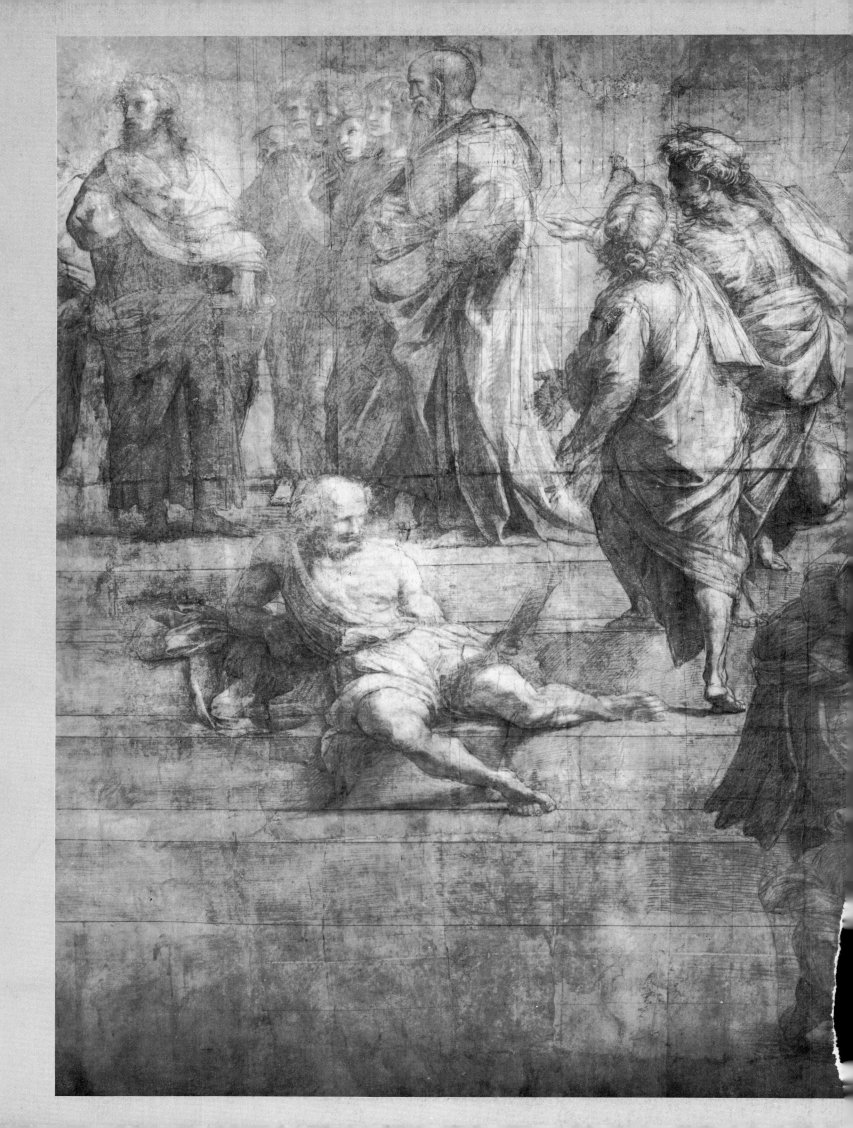